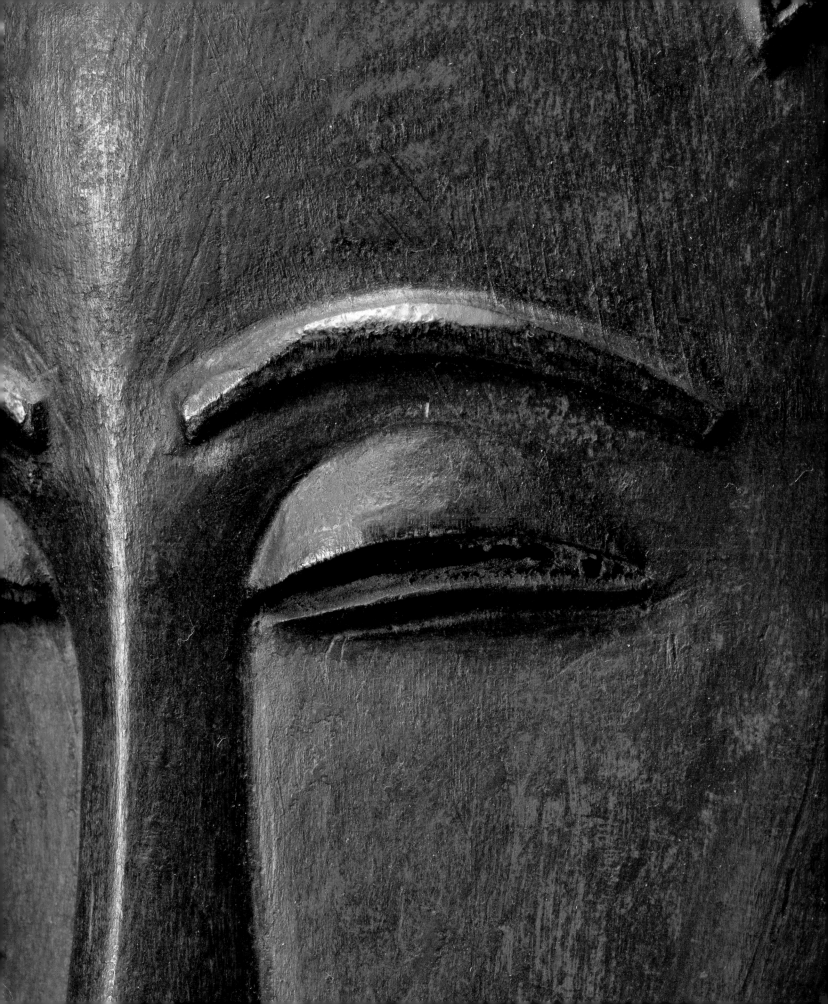

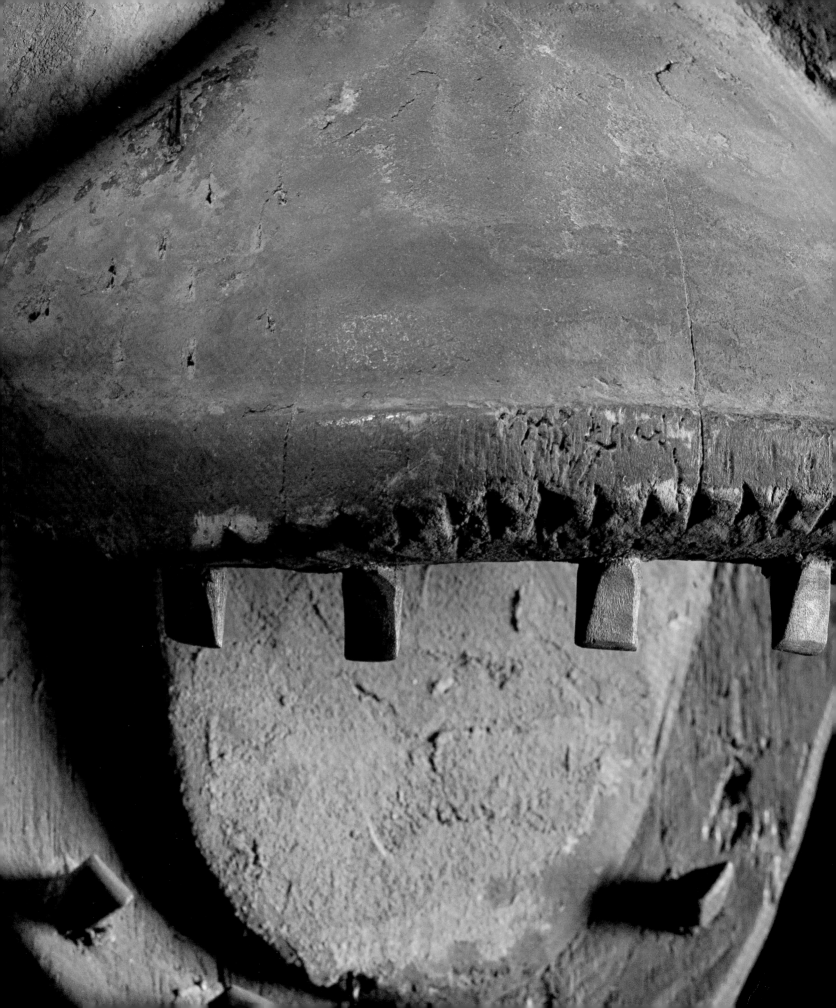

MATERIAL JOURNEYS

COLLECTING AFRICAN AND OCEANIC ART, 1945–2000

Selections from the Geneviève McMillan Collection

by Christraud M. Geary
and Stéphanie Xatart

MFA PUBLICATIONS | A DIVISION OF THE MUSEUM OF FINE ARTS, BOSTON

MFA PUBLICATIONS
a division of the Museum of Fine Arts, Boston
465 Huntington Avenue
Boston, Massachusetts 02115
www.mfa-publications.org

This book was published in conjunction with the exhibition "Material Journeys: Collecting African and Oceanic Art, 1945–2000. Selections from the Geneviève McMillan Collection," organized by the Museum of Fine Arts, Boston, from February 6 to July 25, 2007.

Front cover: Reliquary figure (*mbulu ngulu*), cat. 2, p. 29
Back cover: Yam ornament (*naute*), cat. 84, p. 198
Page 1: Detail of granary shutter, cat. 24, p. 76
Page 2: Detail of mask (*je* or *lo*), cat. 35, p. 99
Page 3: Detail of mask (*glewa*), cat. 17, p. 58
Pages 4–5: Detail of pectoral (*marangga*), cat. 100, p. 225
Page 6: Detail of necklace, cat. 89, p. 204
Page 7: Detail of necklace, cat. 89, p. 204

All illustrations were photographed by Greg Heins and Damon Beale of the Imaging Studios, Museum of Fine Arts, Boston, except where otherwise noted.

ISBN 978-0-87846-715-0
Library of Congress Control Number: 2006934964

Edited by Juanita Marie Holland and Laura Iwasaki
Designed by Zach Hooker
Separations by iocolor, Seattle
Produced by Marquand Books, Inc., Seattle
 www.marquand.com

Available through D.A.P./Distributed Art Publishers
155 Sixth Avenue, 2nd floor
New York, New York 10013
Tel.: 212 627 1999 • Fax: 212 627 9484

FIRST EDITION
Printed and bound in China
This book is printed on acid-free paper.

Contents

DIRECTOR'S FOREWORD

The arts of Africa and Oceania arrived only recently at the Museum of Fine Arts, Boston, but the remarkable collector Mrs. Geneviève McMillan has cherished and enjoyed them for many decades. Her first encounters took place when she was a student in Paris, and when she arrived in the Boston area shortly after the Second World War, she brought a few works along in her suitcase, the nucleus of her fledgling collection. Mrs. McMillan made her home in Cambridge, and she remains in Cambridge to this day—an active member of the community and supporter of many important causes. Artists, filmmakers, scholars, students, and people from all walks of life have enjoyed her friendship, loyalty, and generosity. She was particularly close to Reba Stewart (1930–1971), an artist who attended the School of the Museum of Fine Arts, Boston, and shared Mrs. McMillan's passion for art, discovery, and travel. Several of Stewart's works are now part of the Museum's collections. When Stewart tragically died at the age of forty-one, Mrs. McMillan became the guardian of her estate and has kept her memory alive through foundations and scholarships. This book is dedicated to Reba Stewart.

Everybody who has had the privilege of visiting Mrs. McMillan's home is overwhelmed by the many works from Africa and Oceania that occupy shelves, rafters, and walls everywhere, creating a space that not only reflects the owner's personal taste but also highlights many magnificent artistic traditions. Over the years, Mrs. McMillan acquired numerous objects during her travels to Africa and the Pacific and purchased works in Paris, New York, Boston, and elsewhere. She has also made exchanges with fellow collectors and friends, among them William E. and the late Bertha L. Teel, whose generous donations provided the impetus for the inclusion of African and Oceanic arts in the Museum's collections and programs.

The publication of this book, with Mrs. McMillan's support, and the exhibition of works from her collection that accompanies it are major milestones in the Museum's mission to bring to its public the diversity of world culture. It is with deep gratitude that we acknowledge her exceptional contributions and generosity.

Malcolm Rogers
Ann and Graham Gund Director
Museum of Fine Arts, Boston

CHAPTER 1

COLLECTING AFRICAN AND OCEANIC ART DURING THE SECOND HALF OF THE TWENTIETH CENTURY

The story of the ascent of African and Oceanic objects from curiosities to artifacts to art during the nineteenth and the first half of the twentieth century has been told many times.[1] In Paris, in other major cities in Europe, and finally in the United States, objects from Africa and the Pacific first captivated artists, who were riveted by the extravagant and bold forms that broke with all conventions of Western academic art traditions. The artists' dialogue with these works and subsequent appropriation of non-Western art forms into their visual repertoires focused entirely on form, color, and line. They did not need nor did they desire to know how, by whom, and in which contexts these pieces were made and used. Following the lead of artists and other intellectuals, interest in African and Oceanic arts grew, exhibitions were organized, and publications began to appear. Objects gradually gained recognition for their aesthetic qualities, and their monetary value increased as they moved into the domain of art.

The continuation of this story in the second half of the twentieth century seems less familiar. This is rather astonishing because this

period was the heyday of collecting African and Oceanic "traditional" or "classical"[2] figurative sculpture and masks. After the Second World War, an astounding number and variety of works flowed from the global south to the North Atlantic countries and to Australia, New Zealand, and South Africa, commonly referred to as the West.[3] Private and museum collections in the United States grew at a particularly rapid pace, while many major ethnographic museums and a distinguished group of collectors in Europe had already accumulated important holdings.[4] The complex interactions that accompanied the journeys of objects from their places of origin into museums and private collections, and the debates engendered by these processes, are among the subjects addressed in this book.

Our starting point is a unique collection of African and Oceanic art in Cambridge, Massachusetts, which Geneviève McMillan has built and nurtured over the past sixty years. The collection contains more than one thousand five hundred objects, including works from the Native American realm, India, and other parts of the world along with paintings, prints, and photographs of McMillan's artist friends. In its entirety, the collection reveals the aesthetic vision and particular taste of an independent, enterprising, and free-spirited woman. More importantly, following the paths of the objects McMillan selected over the years, and the ways in which they arrived in Cambridge, illuminates their production, use, and meaning in different settings as well as changes in object trade and collectors' taste. Thus, the collection provides a perfect lens through which to discern not only the larger processes that influenced African and Oceanic art in the second half of the twentieth century but also the role the works themselves played in those developments.

As the book's title, *Material Journeys: Collecting African and Oceanic Art, 1945–2000*, suggests, we are following the physical and conceptual voyages of these objects to Cambridge—their travels over time and space. Reconstructing the life histories or cultural biographies of objects is a common approach in art historical analyses and studies of collections because it reveals the way in which the objects' meanings are transformed as they move from setting to setting.[5] There is another reason to speak of "journeys," for we are also referring to the voyages of collectors, dealers, and scholars. This emphasis on the movement and travels of collectors and objects from around the globe inspired our presentation of the works in this book, for when we describe the objects' journeys, we tend to think of sites or way stations, the hubs through which the objects were funneled, the places collectors visited. Monrovia, Bamako, Abidjan, Kinshasa, Angoram in the Sepik, Rabaul in New Britain, Paris, and finally Cambridge are among the locations in which the stories unfold. Objects moved along pathways to and through these sites, as did people from everywhere. These places in Africa and the Pacific have been "contact zones," to employ a term coined by Marie Louise Pratt in her insightful analysis of travel writing. They are "social spaces where disparate cultures meet, clash, and grapple with each other, often in highly asymmetrical relations of domination and subordination—like colonialism, slavery, or their aftermaths as they are lived out across the globe today."[6] But before we focus on these sites, we examine some of the issues and common perceptions and misperceptions that accompanied the collecting of African and Oceanic arts and the conceptualizations of objects throughout the second half of the twentieth century. They have their roots in earlier notions about Africa and the Pacific and have demonstrated tremendous staying power.

In 1935, the year of the seminal exhibition "African Negro Art" at the Museum of Modern Art (MoMA) in New

York, James Johnson Sweeney, the editor of its catalogue, painted a cautious picture of the art market and the supply of quality African objects for collectors and museums.

> Fine pieces were no longer being produced due to the decadence of the natives following their exploitation by the whites. Soon the traders were reduced to employing natives to manufacture copies for the market. And when this in turn failed to satisfy the demand, white forgeries that soon outdistanced the native copies in "character" began to be turned out on a quantity production scale in Brussels and Paris. Today, save for some rare, hitherto unexploited regions, art as we have known it in its purest expression no longer comes out of Africa . . . we may say, the art of Africa is already an art of the past.[7]

This passage, in one of the most influential English texts of its time, contains elements that reverberate in many later writings about African and Oceanic art. We encounter the "decadent" or "degenerate" African or Pacific Islander who has lost his or her "traditional" way of life, the production-line maker of objects, the faker, and the unscrupulous middleman-dealer. Some of the debates about African and Oceanic art that unfolded in the second half of the twentieth century seem foreshadowed here, among them the notion that African and Oceanic cultures decline, questions of what constitutes an authentic object in its "purest" expression, and the belief that works of art in unexploited regions still await discovery.

Throughout the twentieth century, many art publications subscribed to the credo that the arts from Africa and Oceania have been in aesthetic decline, approaching the objects purely from the perspective of Western connoisseurship. Statements that these visual arts were doomed occur in writings and collectors' letters as early as the late nineteenth and early twentieth centuries, often in combination with the belief that all the "good" objects in a region had been collected, so that the remaining or newly produced ones were stylistically inferior. "Style" loomed large in African and Oceanic art scholarship, for it was assumed that works with particular stylistic features originated within the well-delineated universes of an ethnic group, an island, or a region. Since many objects, when they finally arrived in Western collections, came with little information about their origins, analysis of their formal properties provided a tool for classifying them according to established criteria of style, thus creating a conceptual grid into which newly acquired work could fit.[8]

Stylistic and formal standards provided a framework for the appreciation of African and Oceanic arts based entirely on Western taste and divorced from notions of indigenous aesthetic judgments. As many studies have shown, the aesthetic preferences of Africans and Pacific Islanders may differ radically from those of Western collectors (see, for instance, the discussion of Dogon masks pp. 70–74). To this day, Western connoisseurs usually posit iconic works of art as their point of departure for assessments of an object's quality. In order to gauge the aesthetic merit of an object, specialists might compare a Kota reliquary figure (see cat. 2) with other known examples, preferably nineteenth century, in good condition, and/or with stellar provenance, meaning the record of a work's journey to and through collections in the West. In the case of Kota reliquary figures, the preferred pieces go back to early-twentieth-century collections in Paris, where these objects began arriving in the last decade of the nineteenth century. With this emphasis on familiar and unalterable styles, novelty and innovation seemed suspicious aberrations, since they did not conform to the rigid criteria of Western

connoisseurship. In other words, if more recent objects—even well-made ones—did not follow these criteria, they were judged mediocre, evidence that the arts had declined.

Sweeney also raised the question of authenticity, one of the most vexing problems for curators and collectors of African and Oceanic arts in the second half of the twentieth century. Ateliers that specialized in the production of objects for sale to foreigners often sprang up as soon as the first contact with these potential consumers of African and Oceanic art occurred. Others began to cater to both local and foreign patrons. In addition, outright fakes began to appear on the market, a new phenomenon in the African and Oceanic art worlds.[9] Skilled forgers increasingly took advantage of the booming art business and replicated objects in their formal characteristics, applying faux patinas and simulating the appearance of age. In recent decades, they based their creations on photographs and illustrations in art books, which proliferated from the 1960s onward. While dealers, collectors, and curators initially recognized fakes, "improved" methods and collaboration between middlemen and fakers have made it much more difficult to spot forgeries nowadays. Most art dealers deplore these developments, pointing to the negative impact of fakes on their businesses and noting that increasingly skilled fakers have been able to deceive even the most careful of connoisseurs.[10] In such situations, provenance becomes invaluable.

What then constitutes an authentic work? In 1975, exactly forty years after Sweeney's statement, the journal *African Arts* fired a first salvo in a reenergized debate about authenticity among scholars, collectors, and dealers in the United States and beyond when it published the article "African Art and Authenticity," by Joseph-Aurélien Cornet.[11] He posed the seemingly straightforward question "What are the criteria which differentiate the authentic object

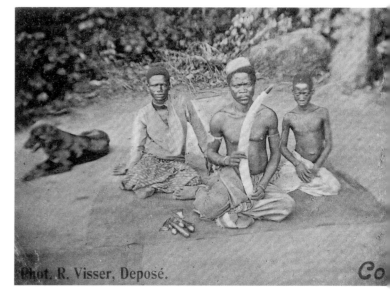

FIG. 1 Ivory carver, French Congo (now Republic of the Congo), about 1890–1900

from the fake?"[12] In his view, a first level of distinction would be "certain qualities [of the authentic object] that speak to the heart," that is, its aesthetic impact. This idea of the object's impact most closely resembles the concept of the "aura" of a work, introduced by Walter Benjamin in his essay "The Work of Art in the Mechanical Age of Reproduction." For Benjamin, the aura is the transmittable essence of an authentic work of art, which withers with its reproduction.[13] Cornet then postulates that "any object created for a *traditional purpose* and *by a traditional artist* may be considered authentic" (Cornet's italics).[14]

This rigid way of gauging authenticity raised a number of interesting questions with contradictory answers. Many works admitted into the canon of authentic art were produced for both local and foreign patrons, such as stone carvings (*ntadi*) from the lower Congo and, beginning in the eighteenth century, Loango ivory carvings (fig. 1). African

artists also successfully appropriated Western visual forms and integrated foreign motifs, as in the case of bronze crucifixes created after the fifteenth-century Christianization of the elite in the ancient Kongo kingdom. In the Oceanic realm, Fijian clubs (see cats. 78, 79), their Marquesan counterparts u'u (which became an export article in the nineteenth century), and the beautifully incised wooden bowls from Tami Island off the New Guinea coast come to mind. Collectors perceive these objects as authentic mainly because they date to the eighteenth and nineteenth centuries and display familiar stylistic characteristics. African and Oceanic artists in the second half of the twentieth century also responded to economic opportunities in the growing art market and worked for both local and foreign clienteles, creating new forms and copying older ones. What then do we make of their works?

Cornet's article fostered a lively debate among scholars, dealers, and collectors. In response, *African Arts* devoted an entire issue to authenticity, appropriately presenting on its cover a Yoruba masquerader with a plastic face mask of Nigerian manufacture. As an example of an African-made piece used in a Yoruba ritual, it challenges seemingly clear-cut distinctions, being a "non-traditional" object used in a "traditional" setting.[15] Indeed, there are many similar examples of African and Oceanic peoples integrating foreign materials and items into their visual repertoires, such as the use of World War II gas masks by the Igbo in Nigeria (fig. 2). The gas-mask shapes fit perfectly into the visual vocabulary of this Igbo masquerade, which took place in 1959 during a yam festival in Ugwuoba village.

There were as many opinions as there were contributors (twenty-nine in all, including academics, curators, gallery owners, and collectors). One contributor wrote, "The issue of fakes can be avoided only if one acquires works of art solely on their aesthetic appeal. This is perfectly legitimate,

and, in the opinion of many, should be the first criterion, but at some point economic considerations begin to overshadow the aesthetic ones and a purchaser is paying for authenticity, age, and scarcity."[16] As this debate continued into the 1980s and 1990s, the desire to establish some sort of order in the seemingly chaotic African art market led to the refinement of taxonomies of authenticity. Categories such as Authentic African Art, Correct Copies, Counterfeit African Art, and Tourist Art emerged.[17] Among collectors, these categories resonate to this day.

Oceanic art, not collected on the same scale as African art, raised similar issues. Questions of authenticity and quality of objects loom large here, and the desire of museum professionals and collectors to categorize objects on

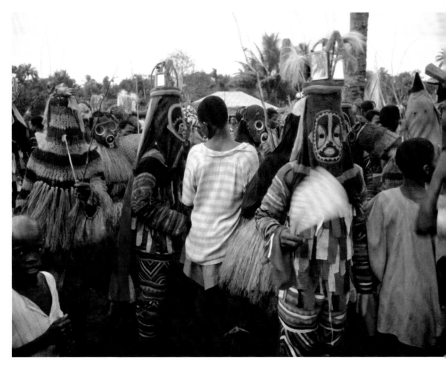

FIG. 2 Masked dancers in yam festival, "Onwasato," in Ugwuoba village, Igbo, Nigeria, 1959

a sliding scale ranging from the authentic work to the fake inspired a 2004 book by Gerd Koch.[18] Koch discusses deliberate fakes and also presents several early instances of arts created for sale to foreigners. He includes as evidence the reports of participants in the 1912–14 Kaiserin-Augusta-Fluss Expedition,[19] who traveled up the Sepik River, bought many objects from the Iatmul, and then discovered newly carved "copies" of their acquisitions being offered to them on their way back.[20] Authenticity remained a thorny issue throughout the second half of the twentieth century, although it was never a helpful construct, as we explain in the following chapters.

In his prescient remarks, Sweeney mentioned another important aspect that received much attention in later writings and was particularly significant in the Pacific because of the region's history. When Sweeney referred to "rare, hitherto unexploited regions" that might still be sources for truly "traditional" works of art, he alluded to the idea of discovery: the opening up of unknown territories as reservoirs of objects for Western museums and collectors. Even in the second half of the twentieth century, many descriptions by collectors and dealers featured the notion of the discovery of "untouched" regions or overlooked sources of objects. In fact, the idea of discovering authentic works of art in flea markets and market stalls, in Africa and in the Western hubs of the trade, and even in one's attic is an important component of the pleasures of collecting.[21]

The notion of discovery derived from the perception that peoples and regions in Africa and Oceania were (and still are) distant, isolated, and suspended in time. History tells us otherwise. One need only consult recent textbooks about African and Oceanic art to fully grasp the dynamic interactions between peoples over time and the impact these relationships had on the arts.[22] By 1935, when Sweeney published his book, most of Africa and Oceania had been absorbed into colonial empires and were economically exploited by their rulers. Riches flowed back to distant metropolises such as Paris, Brussels, London, Lisbon, Amsterdam, and Sydney, Australia, which developed into important hubs for the art trade. Both world wars deeply affected peoples in Africa and Oceania. The First World War saw African troops in combat on behalf of their colonial masters. Senegalese *tirailleurs* fought for France in both world wars, men in Dogon country in Mali were conscripted by the French, and the British sent Africans from Ghanaian, Nigerian, and Cameroonian villages to Burma during the Second World War. If these men were lucky, they returned to their villages or settled in larger towns. During the Second World War, many islands in the Pacific had military installations, were sites of major battles, and sent their men to fight alongside Allied troops. Islanders served in official and unofficial capacities as carriers, guides, and scouts and performed other less glamorous tasks. They also enrolled in infantry or support units such as the first Papuan Infantry Battalion in New Guinea, which consisted entirely of men from the Pacific. Their experiences, like those of conscripted Africans, are a largely untold story.

Since the nineteenth century—even earlier in some regions—the need for work and a desire for new experiences brought African men and women to the expanding cities. As plantations, mines, and factories grew, labor migration became a fact of life. These Africans began their own "discovery" of distant places, came in contact with foreigners, and developed new lifestyles. Men worked in the Firestone plantation in Liberia and labored in gold mines in Ghana's Asante region, while various Belgian enterprises in the Congo Free State (later the Belgian Congo) drew African workers from as far away as Sierra Leone and Nigeria (fig. 3).

Congo. Sierra Léonais employés au chemin de fer.

FIG. 3 Sierra Leonean railway employees in the Congo Free State (now Democratic Republic of the Congo), about 1900

Similar processes unfolded in the Pacific. Islanders, with traditions of seafaring and voyaging over huge distances, had always been in touch with one another. Regular contact with foreigners began with the arrival of European whalers and traders in the early nineteenth century. In those regions that came under colonial domination, new economic ventures required large workforces. In New Guinea and New Britain, for example, the Germans established plantations in the late nineteenth century, procuring laborers not only from these islands but also from places as far away as China, India, and what is now Indonesia.[23]

Movements to free African and Oceanic colonies and protectorates from colonial rule began to gain momentum before the Second World War, and these regions became independent in the late 1950s and early 1960s. The cold war subsequently had an impact on the new countries that emerged. Some maintained strong foreign military and civilian presences, and teachers, businessmen, missionaries, diplomats, and development experts worked in their capitals and rural areas. Anthropologists, members of a discipline that developed in the late nineteenth century and was intimately linked to the colonial period, and a new breed of experts, art historians trained in African and Oceanic art, conducted research. After President John F. Kennedy founded the Peace Corps in 1961, young volunteers from the United States sent overseas encountered African and Oceanic arts for the first time. It is not surprising that a whole generation of American art historians working in these regions started out as Peace Corps volunteers.

After the Second World War, professional art dealers began field collecting and increasingly replaced the expatriates who had brought most of the objects out of the

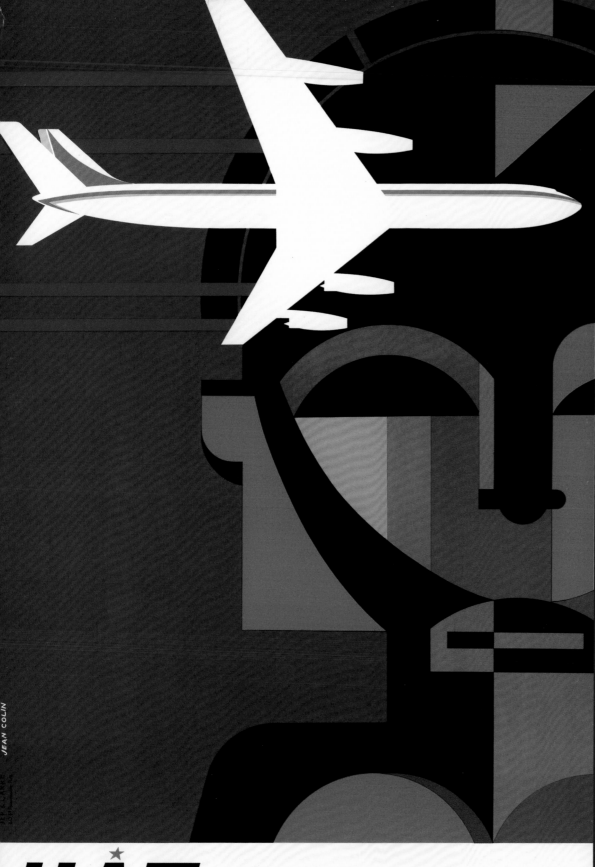

FIG. 4 Poster, "UAT serves Africa
with DC-8 jets," 1961

colonies in the years before independence. Objects poured out of Africa and the Pacific realm into private and museum collections. Africans and Pacific Islanders established themselves as middlemen and dealers, creating trading structures to handle demand. Beginning in the late 1950s, African agents or merchants, known pejoratively as "runners," or *rabatteurs* in French, brought objects to Europe and the United States and became fixtures in the art markets, supplying gallery owners and private collectors.[24]

These African merchants are positioned at a high level in a supply chain that begins in African rural areas with locals who gather objects in their villages. The objects then journey through large African cities to centers of the art trade such as New York and often directly to the doorsteps of collectors and museums. A quick glance at the structures in Côte d'Ivoire, as detailed in Christopher Steiner's 1994 study *African Art in Transit,* is instructive. In the hierarchy of African traders in and around Abidjan, owners of storehouses filled to the brim with objects were at the highest echelon, and clients would visit them regularly. Stallholders in the big central markets sold to tourists and sophisticated clients. Door-to-door traders, often associated with the large storehouses, visited the private homes of resident foreigners, becoming familiar with a client's level of knowledge and taste and catering to each one's particular wishes and needs. The lowest echelon consisted of street vendors, who set up shop at busy intersections or the beach and waited for patrons in front of hotels. Entrepreneurial men could move up in this hierarchy and make an excellent living.[25]

In the second half of the twentieth century, collectors themselves began to travel to Africa and the Pacific, buying objects from local merchants and thus eliminating the middlemen. They were a small group among the growing number of tourists who frequented towns and interior regions in Africa and Oceania from the late 1950s onward, when many countries sought to increase tourism and sold themselves as holiday destinations for Americans, Australians, and Europeans. Airlines such as Air Afrique, Ansett Australia, Pan American World Airways (PanAm) and UTA (Union des Transports Aériens) featured references to purchasing art in their advertisements and even depicted objects on their posters (fig. 4). A 1978 Air Afrique advertisement in *African Arts* referred to Abidjan in Côte d'Ivoire as the "Manhattan of Africa" and compared its open-air markets, where visitors could buy anything from sculpture to trinkets, to New York's largest department stores, Macy's and Gimbels.[26] Ansett struck a similar chord in its 1970 brochure describing tours in Papua New Guinea: "Whilst on the Sepik River visits will be made into interesting and primitive villages where many opportunities present itself [*sic*] to purchase unusual native artifacts of this area."[27] During their journeys, visitors searched for works in villages, frequented the shops of local dealers, and attended festivals and performances of masquerades, where they often bought objects.

In his 1935 exhibition catalogue, Sweeney alluded to many issues that accompanied collecting throughout the second half of the twentieth century. There is, however, one aspect affecting the movement of objects that did not matter to collectors, museums, and governments until quite recently. Concerns of cultural property, patrimony, and repatriation constitute a complex arena at the crossroads of legal, ethical, historical, and cultural considerations, and there are many divergent opinions on how to resolve them.[28] Sweeney and his contemporaries, however, who collected and curated objects at the height of colonialism, had hardly any doubt that the spoils of such activities belong to those who rule, be it in the interests of discovery, science, or connoisseurship.

Following the journeys of individual works in the McMillan Collection and exploring their uses and meanings in their original settings allow us to cast light on the issues and debates that accompanied the flow of African and Oceanic objects—many produced by African and Oceanic artists and workshops for both indigenous and foreign clienteles or, in some instances, purely for the outside market[29]—into Western collections and museums throughout the second half of the twentieth century.[30] We begin our exploration of journeys and sites in Paris, the Mecca of collectors and the European hub of the trade in African and Oceanic art to this day, and in Cambridge, Massachusetts, a center of learning adjacent to Boston, the so-called Athens of America: both are integral connections in Geneviève McMillan's life story and the history of her collection.

NOTES

1. See Rubin 1984a; Paudrat 1984 and Peltier 1984 present now classic overviews of African and Oceanic art in the West; for a more critical view, see Price 1989.

2. We are fully aware of the contested nature of these and similar terms but use them for want of better categorizations.

3. We use the terms "West" and "Westerners" to designate people from these regions, even though the terms are contested.

4. See Vogel 2005, 14, about African collections; Welsch 2005 about Oceanic collections; and Steiner 2002.

5. First suggested in Kopytoff 1986. Many scholars have used this heuristic device, including Arnoldi, Hardin, and Geary 1996, in the section "The Life History of Things"; Gosden and Marshall 1999; and Corbey 2000.

6. Pratt 1992, 4.

7. Sweeney 1935, 13.

8. On the conceptualization of style and its relation to so-called tribal groups for the African realm, see Kasfir 1984. This kind of critique has not been articulated as vigorously in Oceanic art, although the style paradigm was equally important in the 1950s and 1960s; see, for instance, Newton 1961.

9. There have always been outright fakes, objects deliberately made to deceive the buyer. The difference today is in the sheer quantity of fakes and the sophistication of the business.

10. Corbey 2000, an insightful study of Western taste and the art market, contains extensive information about these issues.

11. Brother Joseph-Aurélien Cornet was then the associate director-general of the Institute of National Museums of Zaire in Kinshasa.

12. Cornet 1975, 52.

13. Benjamin 1969 [1936], 221.

14. Cornet 1975, 52.

15. Photograph by Marilyn Hammersley Houlberg, June 1975. *African Arts*, v. 9, n. 3 (April 1976): cover.

16. Seligman 1976, 27. Thomas K. Seligman, then a curator at the de Young Museum in San Francisco, is now Freidenreich Director, Cantor Arts Center, at Stanford University.

17. Robbins and Nooter 1989, 13. One of the most insightful attempts to classify objects from Africa is Vogel 1991, 10–11. See also Steiner 1995 and Phillips and Steiner 1999 for a discussion of authenticity.

18. Koch 2004. The late Gerd Koch was an anthropologist and curator at the Ethnologisches Museum Berlin.

19. Kaiserin-Augusta-Fluss was the German designation for the Sepik River in New Guinea.

20. Koch 2004, 12–13.

21. Steiner 1994, 131–34. It should be noted here that the popular television program *Antiques Road Show* is based entirely on the idea of discovering works of art/commodities.

22. See, for instance, Visonà et al. 2001 and Thomas 1995.

23. Hiery 2001, 296.

24. See Rohner 2000.

25. Steiner 1994, 42–60.

26. Air Afrique 1978.

27. Ansett Airlines of Australia 1970.

28. See Appiah 2006, 115–35, for one of the more thoughtful treatises on this subject.

29. See Vogel 1988 for an important discussion of collecting.

30. In order to trace the history of certain African object types in the West, we frequently consulted five books that were crucial in moving artifacts into the art realm: Carl Einstein, *Negerplastik* (1915); Marius de Zayas, *African Negro Art: Its Influence on Modern Art* (1916); Paul Guillaume and Thomas Munro, *Primitive Negro Sculpture* (1926); Carl Kjersmeier, *Centres de style de la sculpture nègre africaine* (1935–38); and James Sweeney, *African Negro Art* (1935). In the Oceanic realm, we examine the initial settings of several objects and their movements to some of the major cultural centers that sprang up in the area.

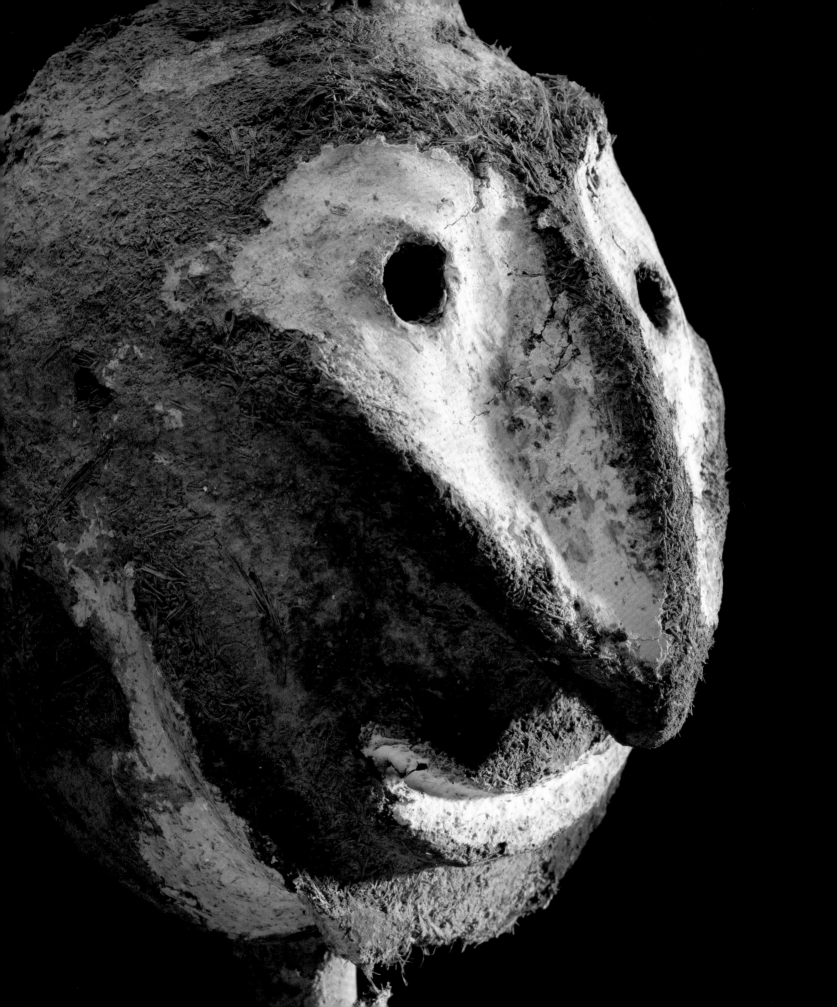

CHAPTER 2

PARIS—CAMBRIDGE, MASSACHUSETTS

Paris was at the heart of the evolving appreciation of arts from Africa and Oceania, which were grouped under the designation *art nègre* (Negro art) in the early twentieth century. Although this book emphasizes post–World War II developments, we include some of the key events in Paris during the 1930s because they shaped the perception of African and Oceanic arts for years to come: the Mission Dakar-Djibouti (1931–33), a research expedition to Africa; the Voyage de la *Korrigane* en Océanie (1934–36), its counterpart in the Pacific; and the opening of the Musée de l'Homme in 1938. These events created a cohort of scholars, intellectuals, collectors, and dealers whose influence persisted well into the second half of the twentieth century.

The 1930s marked a turning point in the understanding of African and Oceanic arts in the French realm. Artists, intellectuals, and dealers initially emphasized formal qualities over contexts, and connoisseurship was at the core of the debates. We encounter famous names: Pablo Picasso, Henri Matisse, and Georges Braque among the artists, and Paul Guillaume, Pierre Loeb, and Charles Ratton among the collectors and dealers who promoted the exhibition, publication, and marketing of African and Oceanic arts. During this decade, scholars at major French institutions began to show

interest in contextualizing objects. Their efforts culminated in two scientific expeditions. Both missions were expressions of a general shift in emphasis away from aesthetic considerations and toward the exploration of the relationships between art, culture, and people as promoted by artists, scholars, and museum professionals.

The first, organized by the Institute of Ethnology of the University of Paris and the Museum of Natural History, was the Mission Dakar-Djibouti, which lasted from May 1931 until March 1933. French intellectuals and anthropologists Marcel Griaule and Michel Leiris, along with nine other scholars, crossed Africa from Dakar, then the capital of French West Africa and now of Senegal, located on the westernmost extension of the continent, to Djibouti, the administrative capital of French Somaliland, later called the Territory of the Afars and the Issas, on the horn of Africa, the continent's easternmost extension. They conducted research, collected documentation, and acquired approximately three thousand six hundred objects, which went to the Musée d'Ethnographie du Trocadéro (MET) (see also p. 70). A March 1931 report to the Finance Commission of the Parliament stated the main objective of the mission: "For a great colonial nation like France, there is capital interest in the study of indigenous peoples, in having accurate and thorough knowledge of their languages, their religions, and their social organization."[1] The expedition was thus closely linked with colonial interests, surveying and controlling the populations in the French territories with the tools of science.

In 1934, the *Korrigane* set sail on its two-year voyage to the Pacific. The itinerary was as ambitious as that of the Mission Dakar-Djibouti. The participants embarked in Marseille, crossed the Atlantic, and traveled through the Panama Canal to the Pacific. After a stop in the Galapagos Islands, they continued on to the Marquesas, Tahiti, the Cook Islands, New Zealand, Fiji, New Caledonia, and other archipelagos, finally reaching New Guinea. They returned to France via Singapore, Ceylon, and the Suez Canal. Members of the expedition, including Etienne and Monique de Ganay and Charles and Régine van den Broek (all from families with large fortunes), and the photographer Jean Ratisbonne collected approximately two thousand five hundred objects for the MET.

Another important shift occurred when the Popular Front, an alliance of left-wing parties including communists and socialists, gained power in France's 1936 legislative elections and made general education a priority. Museologist Georges-Henri Rivière, anthropologist Jacques Soustelle, who specialized in Latin America, and physical anthropologist Paul Rivet created the Association populaire des Amis des musées (APAM), an organization that proposed transforming "museums into instruments for popular cultural education."[2] In conjunction with the 1937 Universal Exhibition in Paris, the MET closed, and the Musée de l'Homme (Museum of Man), an encyclopedic anthropological and ethnographic museum, was established. Rivet, Soustelle, Leiris, and Rivière played key roles in the project and focused on three major goals: education, research, and popularization, or what we would today call outreach.

On June 21, 1938, the new museum, under Rivet's directorship, opened its doors to the public. It legitimated ethnology as a discipline and broke with traditional physical anthropology and sociology; the latter was perceived as hegemonic in that it subjected colonized peoples to its method of interrogation and interpretation. The museum's aims were to show "man" in multiple dimensions, with a "new humanism" that affirmed the dignity and worth of all peoples, and to "rehabilitate the oppressed cultures" at the same time.[3] It opened with a major temporary exhibition,

"Le voyage de la *Korrigane* en Océanie," installed in the central hall, featuring objects and documents from the expedition of the same name conducted a few years earlier.[4] One of the mission's initial mandates had been to document ancient traditions that were disappearing, reflecting the perceptions of the time that the cultures of indigenous peoples were on the verge of extinction. Although the exhibition was a great success, it seemingly failed to convey these concepts, as visitors focused mostly on the exotic and adventurous aspects of the voyage undertaken by a group of popular young members of Parisian society. Nevertheless, the temporary exhibition was revolutionary; it presented the objects in an aesthetic mode, unlike the permanent museum display, which treated them as ethnographic specimens suitable only for research. For a moment in time, the museum thus accommodated both approaches, art and ethnology, under one roof. Many of the objects collected during the *Korrigane* mission remained part of the Musée de l'Homme's permanent collections and are now in the Musée du quai Branly, which opened in 2006.

By 1938, Oceanic art was quite popular, celebrated by many artists, intellectuals, and poets. It appealed to the sensibilities of the Surrealists, a group of politically engaged artists who felt that the poetic qualities of Oceanic works echoed the themes of fantasy and wonder in their own art.[5] Collector-dealers such as Pierre Loeb and Charles Ratton exhibited and sold Oceanic works alongside those of Surrealist artists. Several spectacular pieces from the southern part of Malekula, a large island in the center of the Vanuatu (formerly the New Hebrides) archipelago, were among the objects visitors saw on display at the Musée de l'Homme. Objects from Malekula—in particular small stick puppets modeled from vegetable fiber and clay, often over coconut shells—became highly collectible.[6] A figure of a

small head from the same region is in the McMillan Collection; it was purchased in Paris in 1948 (cat. 1).

Although mostly forgotten now and erroneously considered a minor player, Madeleine Rousseau (1895–1980) is an important part of the McMillan Collection's Paris story. She studied art history at the Ecole du Louvre in the early 1930s and developed an interest in art theories and museology.[7] In 1937, she was employed by the National Museums—a grouping of institutions holding national collections, established in 1895—and taught twentieth-century French art at the British Institute in Paris. Rousseau shared the ideas of Rivet and Rivière; she became an active member of APAM and played a key role in later years, leading museum tours advertised in *Musée vivant* (Living Museum), the APAM publication for youth and workers (fig. 5).

Rousseau established a salon in her modest Quartier Latin apartment near the Sorbonne and invited her many friends to visit and discuss matters of the arts. Among the habitués was Pierre Vérité, a dealer who had trained as a painter and in 1937 opened the Galerie Carrefour, where he sold Oceanic and African art.[8] Marie-Ange Ciolkowska, another well-known collector, also attended at times, and although she did not consider herself an art dealer, she occasionally sold objects with Rousseau's help. Among other art dealers who later joined the group was Michel Huguenin, who operated the Galerie Majestic in the sixth arrondissement from the 1950s onward. African intellectuals pursuing their studies in Paris could also be found at Rousseau's salon. She supported them and sometimes purchased objects they brought from their home countries as a means of financing their education. Like many of her friends, Rousseau also collected and sold or exchanged African, Oceanic, and contemporary art. It is quite probable that she saw the *Korrigane* exhibition and thus began

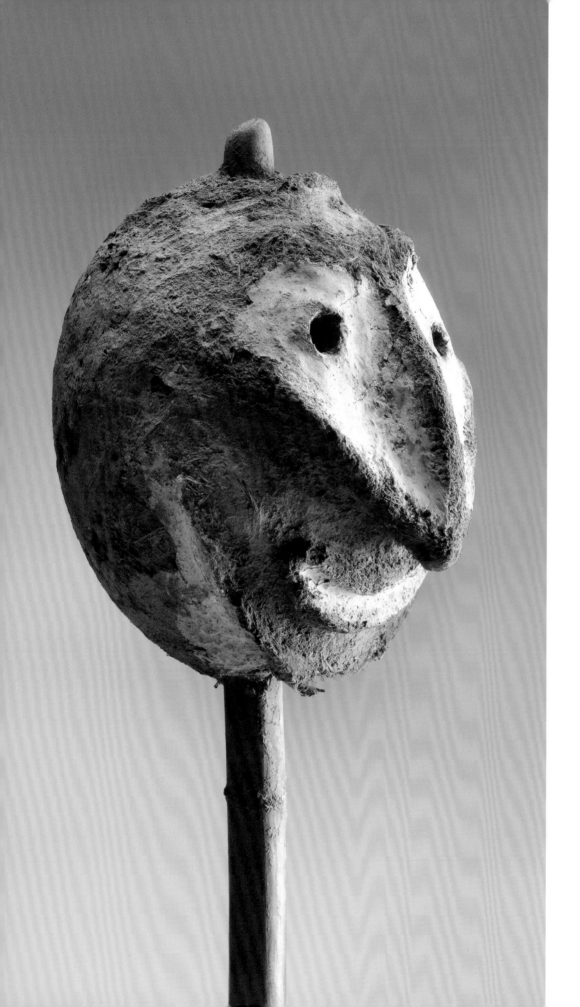

1 *Puppet head* (temes nevimbur)

Unknown artist or workshop
South Malekula or Ambrym, Vanuatu
20th century
Wooden stick, coconut (?), fibers mixed
with coconut milk and breadfruit juice,
pigment
H. 48 cm, w. 11 cm, d. 10 cm (H. 18⅞ in.,
w. 4⁵⁄₁₆ in., d. 3¹⁵⁄₁₆ in.)
Acquired in 1948 from the Galerie
Carrefour (Pierre Vérité), Paris

to develop a taste for the Oceanic art she would later collect, research, and sell.

World War II, the German occupation of Paris, and the Vichy government certainly affected this scene in Paris. In her correspondence, Rousseau states that she discovered African and Oceanic art, during the Second World War at the Musée de l'Homme, which was the only gallery left open during wartime.[9] This comment demonstrates once more the central role of the Musée de l'Homme in making African and Oceanic art available to the public at large. During that period, numerous objects changed hands. In 1951, Rousseau published a book showing many objects from the *Korrigane* exhibition.[10]

In 1943, Geneviève Lalanne, a young woman from the small town of Orthez in the Pyrenees, arrived in Paris (fig. 6). Reared in a middle-class family and given a strict Catholic education, she received a baccalaureate degree in English from the University of Bordeaux and entered the second year at the Institute of Political Sciences in Paris. The young student began to enjoy Parisian life, spending time in cafés and taking part in discussions with her fellow students. After the liberation of Paris in August 1944, she met Robert McMillan, an American officer and an architect by training.[11] He frequented Rousseau's salon and soon invited Lalanne to join him. She fondly remembers the fascinating group of enthusiasts and Rousseau's small, somewhat uncomfortable apartment, which had been transformed into a lively museum. Vanuatu fern-tree grade figures lived next to Upper Sepik bark paintings, while Dogon masks, contemporary prints, oil paintings, and sculpture created startling visual effects.

Lalanne became one of the salon's most faithful visitors, and Rousseau began to mentor her. In the young woman's eyes, the most interesting attendees were fellow students from the French colonies, the future elites of

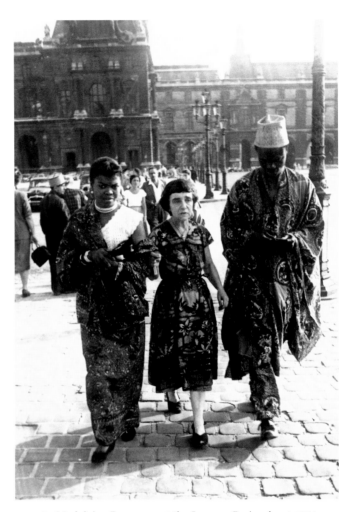

FIG. 5 Madeleine Rousseau at the Louvre, Paris, about 1954

their countries. "They had brilliant careers ahead of them," she recalls.[12] Among them were Léopold Sédar Senghor, the future president of Senegal, and Cheikh Anta Diop, the Senegalese historian and founder of Afrocentrism, whose theories about Egypt's relationship with the rest of the continent and the rich history of Africa challenged common assumptions about the genesis and evolution of humanity and the supremacy of Western culture. Diop

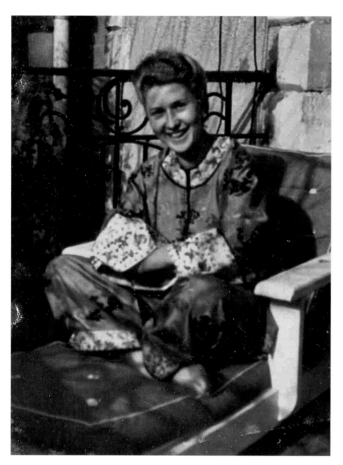

FIG. 6 Geneviève Lalanne (McMillan) in Orthez, 1943

husband.[14] A few African objects from Rousseau's collection traveled with her, among them an extraordinary stool from the Nuna peoples, who live in a region that is now part of Burkina Faso (cat. 3). The three-legged work, almost anthropomorphic in shape, with a spine running up its back, caused amusement and quite a stir among the other passengers, who did not know what to make of the piece or, for that matter, the young woman lounging on it on the ship's deck. She commented, "This is when I realized that the Americans knew so little about African art at that time." McMillan's interest in beautiful utilitarian objects continued through the years, and other stools from all over Africa later entered her collection (cat. 4).[15]

When the couple arrived in Cambridge, she discovered that it was not an active place for collecting African and Oceanic art and found it rather provincial, considering that it was a center of America's intellectual elite. There were some historical collections of African and Oceanic art at the Peabody Museum in Salem and the Peabody Museum of Archaeology and Ethnology at Harvard University.[16] African works had made their first appearance at the Fogg Museum, the fine arts museum of Harvard University, in 1934—a year before the groundbreaking MoMA exhibition. Other than that, one had to look to New York for African and Oceanic art events and sales.

By 1950, McMillan set out on her own. She opened Henri IV, a restaurant with a pastry shop and a nightclub, in Harvard Square. Almost immediately, it became a fixture. Harvard University and Massachusetts Institute of Technology students and professors, Europeans who had recently settled in the United States, and other GI brides became her faithful customers. William and Bertha Teel, then the only major collectors of African and Oceanic arts in town, who shared McMillan's passion, dined there regularly and became her friends.[17]

and Rousseau shared the view that African art was superior to other art traditions and collaborated extensively.[13] Given such an introduction to the aesthetics and beauty of African art, Lalanne's desire to begin collecting African as well as Oceanic art is no surprise. One of her finest objects came from Rousseau: an iconic Kota reliquary figure from Gabon, then part of French Equatorial Africa (cat. 2).

After completing her degree in political science in 1946 and marrying Robert McMillan, the twenty-one-year-old bride crossed the Atlantic on a Liberty ship to join her

2 *Reliquary figure* (mbulu-ngulu)

Unknown artist or workshop
Kota (Obamba) peoples, Gabon
Late 19th–early 20th century
Wood, metal
H. 47 cm, w. 16 cm, d. 8 cm (H. 18½ in.,
w. 6⁵⁄₁₆ in., d. 3⅛ in.)
Acquired in 1945 from Madeleine
Rousseau, Paris
Pub. Adams 1982, 36–37; Exhib. Carpenter
Center, Harvard University 1982

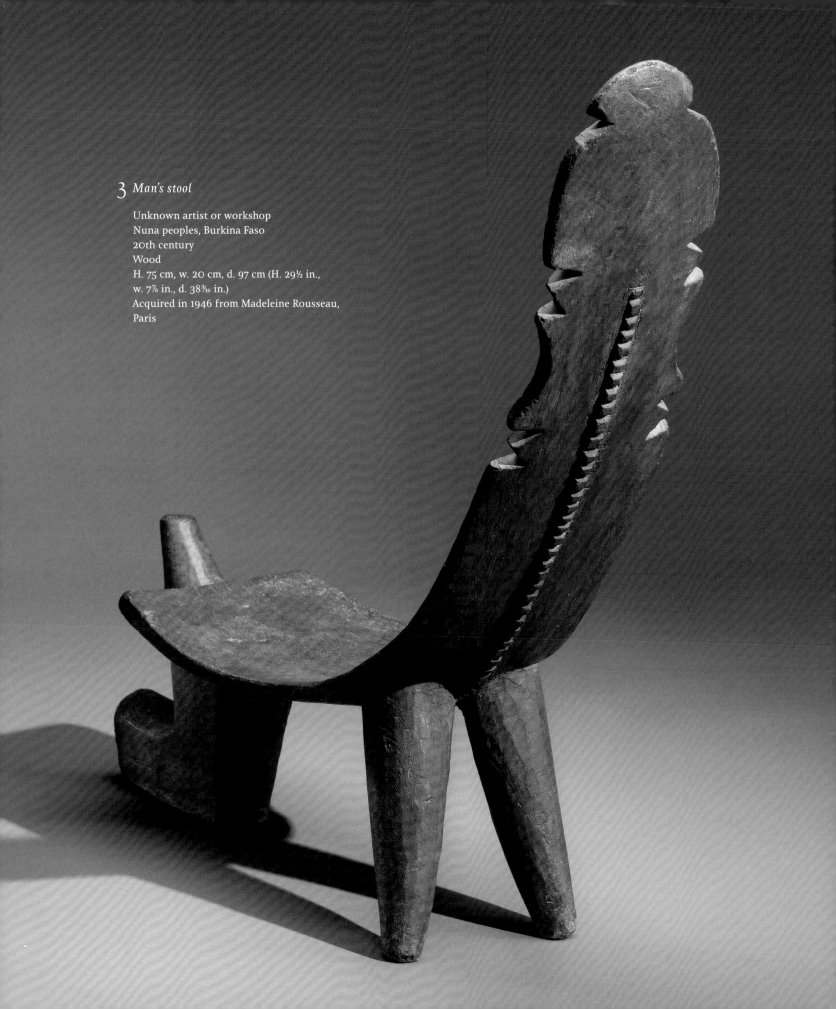

3 *Man's stool*

Unknown artist or workshop
Nuna peoples, Burkina Faso
20th century
Wood
H. 75 cm, w. 20 cm, d. 97 cm (H. 29½ in.,
w. 7⅞ in., d. 38³⁄₁₆ in.)
Acquired in 1946 from Madeleine Rousseau,
Paris

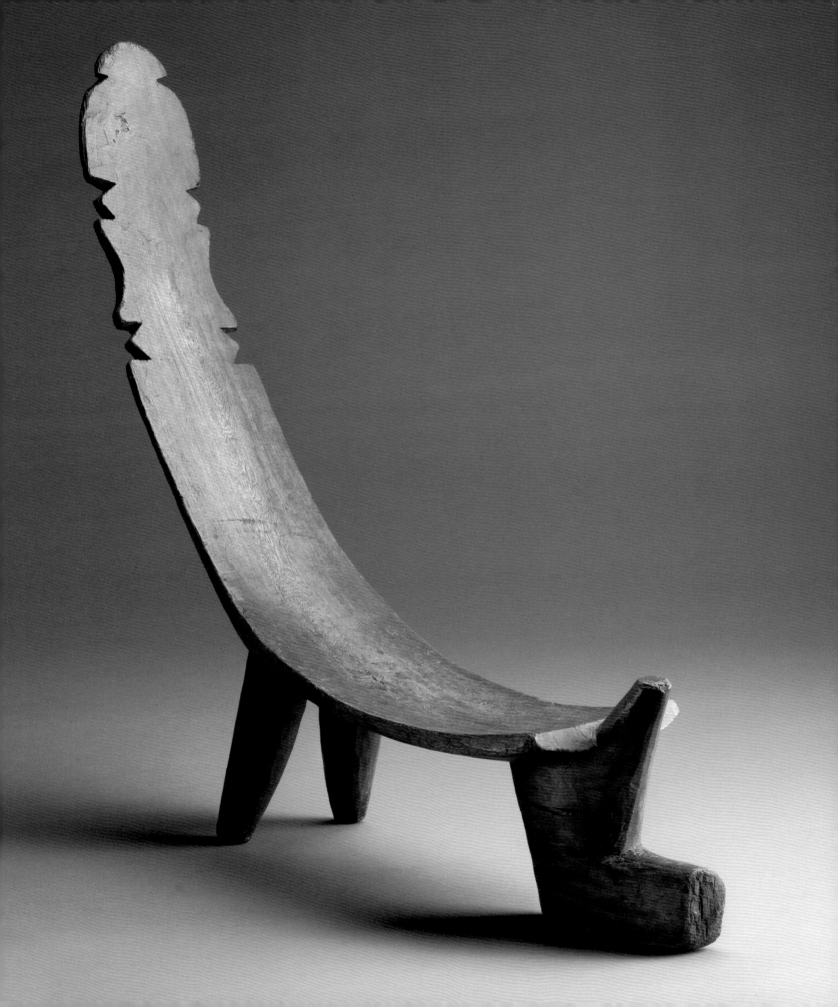

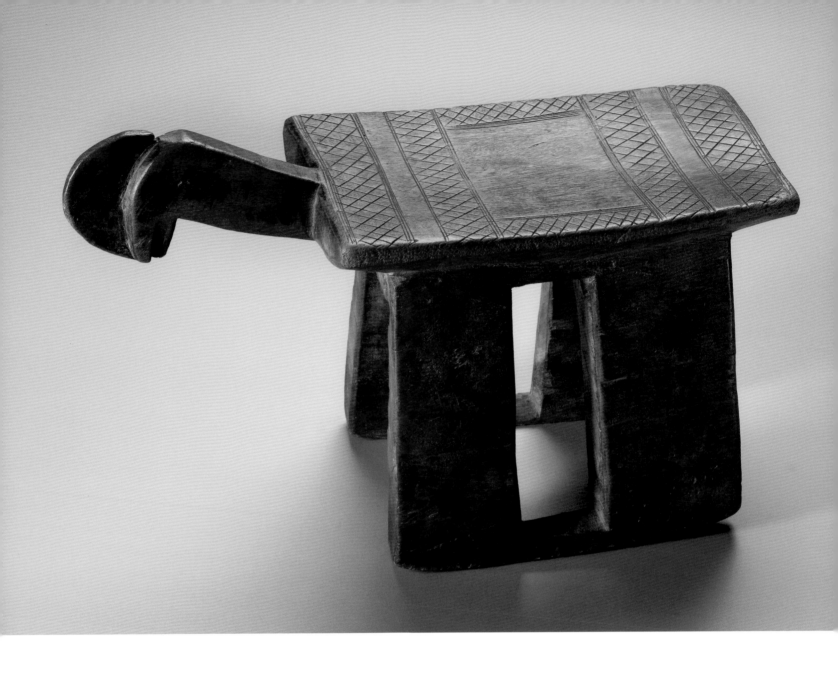

4 *Woman's stool*

Unknown artist or workshop
Bwa peoples, Burkina Faso
20th century
Wood
H. 24 cm, w. 15 cm, d. 38 cm (H. 9⁷⁄₁₆ in.,
w. 5⁷⁄₈ in., d. 14¹⁵⁄₁₆ in.)
Acquired in 1965 from the Galerie Ascher, Paris

McMillan expanded her collection in different ways. During the summers, when Harvard was closed, she went on long journeys. In 1954, she visited New Guinea for the first time during a trip around the world. While traveling, she acquired objects and took photographs, often capturing street and market scenes, that showed an eye for unusual detail (figs. 7, 8). She also traveled in the United States, visiting exhibitions and museums, and even attended the famous Helena Rubinstein sale at the Parke-Bernet New York auction house in 1966. This sale was a turning point for the African art market, because the objects fetched extraordinary prices and now represent some of the most highly valued works in the field of African art collecting.[18] McMillan acquired many objects for her collection that year and visited an impressive number of destinations in Africa: Dakar, Monrovia, Abidjan, Accra, Lomé, Cotonou, Porto Novo, Lagos, Kinshasa, and Tunis. At the end of her tour, she stopped in to see European dealers in Rome, London, Brussels, and Paris. She also maintained contact with friends and gallery owners in Paris and diversified her collection as she became increasingly interested in jewelry and metalwork (cat. 5). Her home in Harvard Square developed into a French-style salon, where she welcomed artist friends, academics, African students, and people from all walks of life.

McMillan grew particularly close to Reba Stewart, a young woman who had studied at the School of the Museum of Fine Arts, Boston. McMillan and Stewart met in 1950 and soon became friends.[19] The young artist shared McMillan's passion for non-Western arts, venturing to Japan and studying woodblock prints with master printers. Her admiration for Japanese and Mayan art inspired many of her works (cats. 6, 7). Stewart also traveled to Africa and started acquiring the kind of objects she had encountered at her friend's place. During a trip

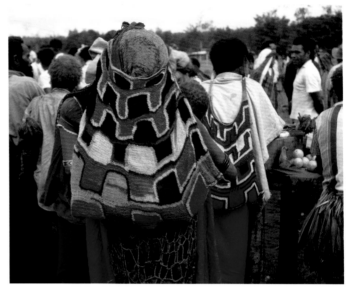

FIG. 7 Women with *bilum* bags, Mount Hagen, Papua New Guinea, 1967

FIG. 8 Display in a market, Republic of Benin, 1966

5 *Hip ornament*

Unknown artist or workshop
Verre peoples, Nigeria and Cameroon
20th century
Copper alloy, cord
H. 50 cm, w. 16 cm, d. 15 cm (H. 19¹¹⁄₁₆ in.,
w. 6⅚₆ in., d. 5⅞ in.)
Acquired in 1965 from the Galerie Carrefour
(Pierre Vérité), Paris
Pub. Adams 1983, 29; Exhib. Boston Athenaeum
1983

to Liberia in 1971, she came upon a game board, a humble piece but one of extraordinary aesthetic appeal, with its minimalist design, worn surfaces, and an indigenous mend necessitated by much use (cat. 8). It was to be Stewart's last acquisition; she contracted malaria on this trip and died at the age of forty-one. McMillan was devastated by the death of her friend. She became the executor and keeper of Stewart's estate, and Stewart's works now mingle with African and Oceanic objects in McMillan's spacious apartments. Other works by Stewart entered museum collections, and a foundation in McMillan's and Stewart's names supports worthy projects in the arts.[20]

McMillan's collection reflects places visited and acquaintances made. Carol Beckwith, for example, an American photographer who works in Africa, purchased an embroidered vest of the kind worn by young Wodaabe men in Niger, when she photographed them for a book project in the 1980s; this vest is now in McMillan's collection (cat. 9).[21] Artists and teachers Carlos Dorrien, Donald Kelley, and Marlene Lundvall are McMillan's close friends, and so are scholars from local universities, who find inspiration in the many remarkable works in the McMillan Collection. Monni Adams, an art historian and writer who often visits McMillan's house, authored the only catalogue about the McMillan Collection to date.[22] McMillan has always supported African students and scholars—in the tradition of Rousseau, her mentor—and her doors are open to African merchants who bring objects to Cambridge. These men (and occasionally women) facilitated the voyages of many pieces into her collection. In retracing these voyages, we gain a clearer picture of the forces—time, place, economic and cultural imperatives, and the actions of individuals— that shaped the understanding of these works and their paths to the McMillan Collection.

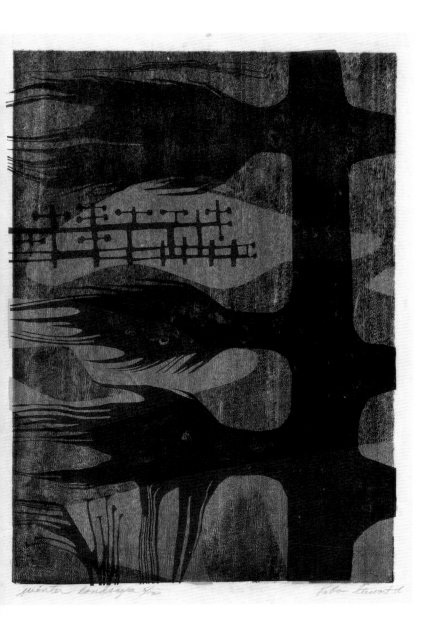

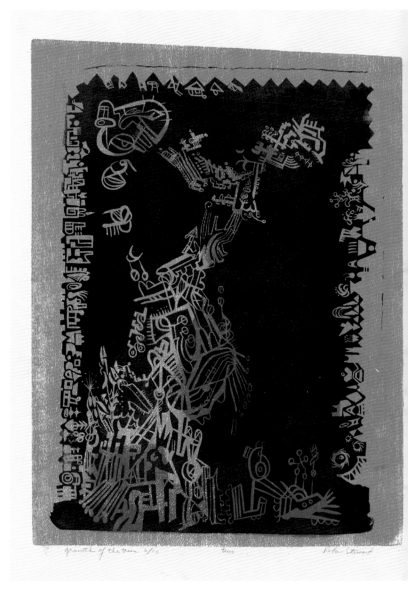

6 *Winter Landscape*

Reba Stewart, American (1930–1971)
1956
Color woodcut on paper
H. 65 cm, w. 49 cm (H. 25⁹⁄₁₆ in., w. 19⁵⁄₁₆ in.)

7 *Growth of the Trees*

Reba Stewart, American (1930–1971)
1954
Color woodcut on paper
H. 58 cm, w. 41 cm (H. 22¹³⁄₁₆ in., w. 16⅛ in.)

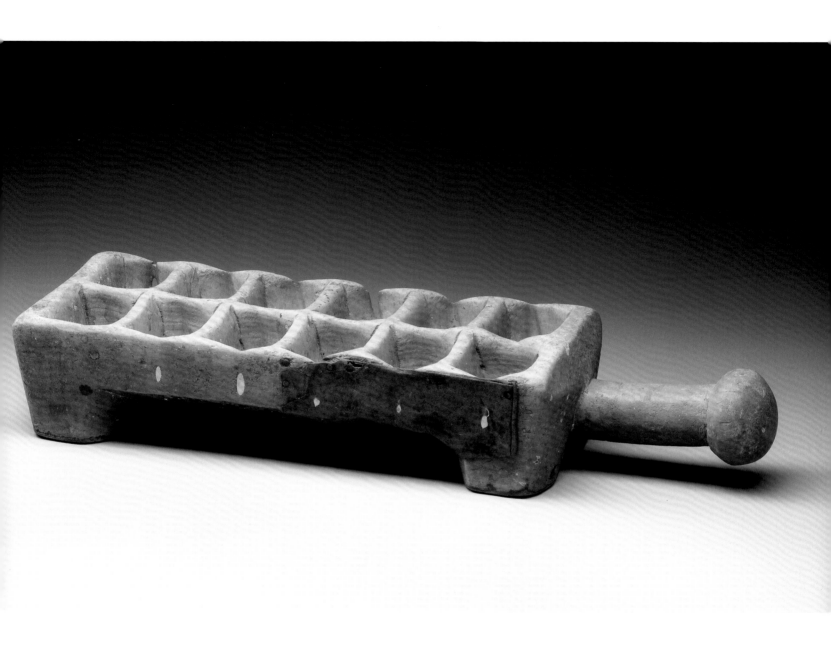

8 *Game board*

Unknown artist or workshop
Dan or neighboring peoples, Liberia and
Côte d'Ivoire
20th century
Wood (with metal repairs)
H. 10 cm, w. 55.5 cm, d. 15.3 cm (H. 3^{15}⁄$_{16}$ in.,
w. 21⅞ in., d. 6 in.)
Acquired in 1971 by Reba Stewart in Monrovia, Liberia
Pub. Adams 1983, 14; Exhib. Boston Athenaeum 1983

9 *Vest*

Unknown artist or workshop
Wodaabe peoples, Niger
20th century
Cotton fabric, yarn, dye
H. 36 cm, w. 29 cm (H. 14³⁄₁₆ in., w. 11⁷⁄₁₆ in.)
Acquired about 1975 from Carol Beckwith

NOTES

1. Quoted in Degli and Mauzé 2000, 90 (translated from the French by the authors).

2. Maurice 2006.

3. See Grognet 2001, 45.

4. Ibid., 46.

5. For a recent analysis of the influence of Surrealist artists on Oceanic art perception, see Peltier 2005.

6. Peltier 1984, 113.

7. We thank Danielle Maurice, a doctoral student at the Ecole des Hautes Etudes en Sciences Sociales (EHESS), Paris, for sharing some of her research about Rousseau with us.

8. See Amrouche 2006.

9. Personal communication, Danielle Maurice, 2006.

10. Rousseau 1951.

11. In 1945, Robert McMillan joined Walter Gropius and several other architects in founding The Architects Collaborative (TAC), in Cambridge, Massachusetts.

12. Interviews with authors, April 24, 2003, and March 15, 2006.

13. Diop and Rousseau 1948; Rousseau 1955, 1960.

14. Liberty ships supplied the front lines during the Second World War. After the war, the American government used them to bring GIs back to the States from Europe.

15. See Roy 1987, 60–64.

16. Geary 2004.

17. Blier 2003; Geary 2006.

18. Parke-Bernet 1966.

19. For a biography of Reba Stewart, see Kelley and McMillan 2006.

20. Stewart's works are at the Museum of Fine Arts, Boston, the Massachusetts Institute of Technology, and others. The Geneviève McMillan and Reba Stewart Foundation supports the Massachusetts Institute of Technology Program in Women's Studies; the W. E. B. DuBois Institute for African-American Research, Harvard University; and the Museum of Fine Arts, Boston. The foundation also provides financial aid to students of the Harvard Medical School and traveling scholarships for students of the Massachusetts College of Art. The Reba Stewart and Geneviève McMillan Award for Distinguished Filmmaking, established at the Harvard Film Archives in 1987, brings distinguished African filmmakers to Harvard.

21. Beckwith 1983.

22. Adams 1983.

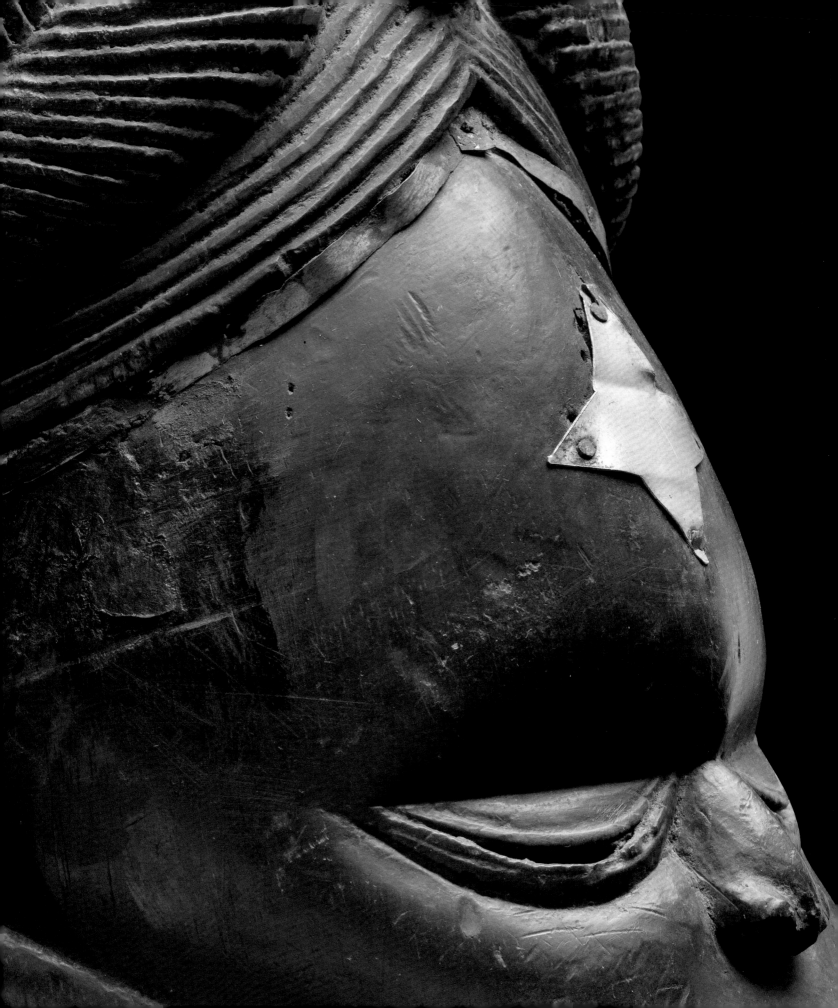

CHAPTER 3

FREETOWN—MONROVIA—BISSAU

The histories of Sierra Leone and Liberia are tied to the slave trade and its aftermath, and thus to Europe and the Americas. Both countries are home to descendants of liberated slaves. The British resettled freed slaves (known there as Krios, or Creoles) in Freetown, Sierra Leone, while liberated African Americans founded Liberia, with Monrovia as its capital, when they journeyed to the continent to seek a new life. The Creoles aspired to the lifestyle and manners of the British, and Americo-Liberians maintained their bonds with the United States. They were educated, traveled, and conducted business up and down the African coast (see fig. 3, p. 17). They looked down on the indigenous peoples in the hinterland, which led to tensions in both countries.

By the 1950s, both Freetown and Monrovia were modern ports with large international populations that included many Americans. Pan Am planes landed weekly in both cities. In Liberia, the U.S. company Firestone ran the world's largest rubber plantation, established in 1926, and employed some twenty-five thousand African workers. Hundreds of Peace Corps volunteers came to both countries from 1961 onward. Anthropologists and art historians conducted research, and dealers and collectors stopped in Sierra Leone and Liberia on their trips along the West African

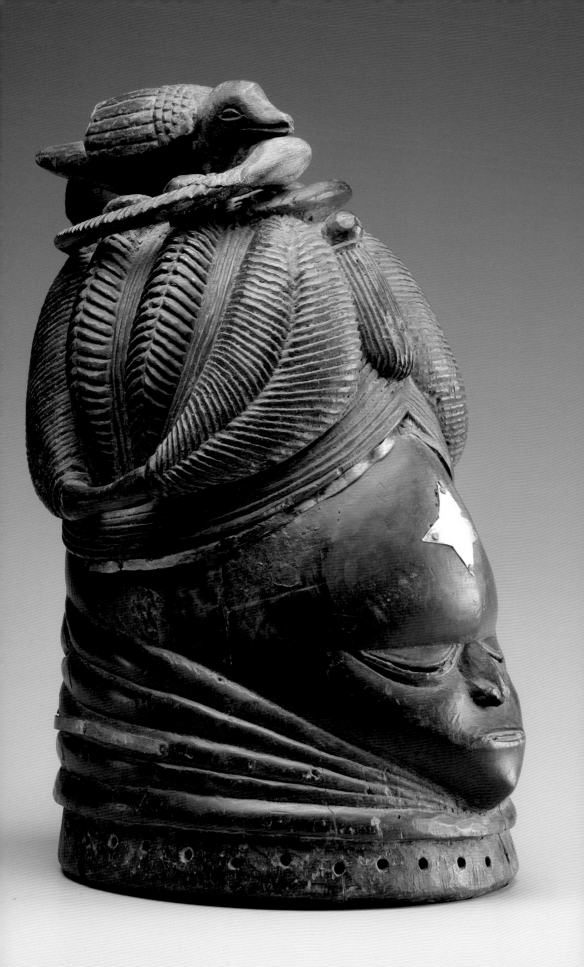

10 *Helmet mask*

Unknown artist or workshop
Gola peoples, Sierra Leone
20th century
Wood, metal
H. 35.5 cm, w. 20 cm, d. 25 cm
(H. 14 in., w. 7⅞ in., d. 9¹³⁄₁₆ in.)
Acquired in 1960
Pub. Adams 1982, 66–67; Exhib. Carpenter
Center, Harvard University 1982

coast, and McMillan was among them. In Monrovia, many visitors from the States stayed at the Intercontinental, sunned on the beach, and enjoyed the relaxed and friendly atmosphere. In the late 1960s, young men and women in Liberia and Sierra Leone listened to the music of James Brown and Marvin Gaye, singers who had large followings in other African countries as well. Well-dressed Monrovians wore high fashion from Europe, and dashikis and Afros were in. Wolof tailors from Senegal made richly embroidered gowns for expatriates and the Liberian elite, while the peoples of the hinterland—or up country, as it is called—often still dressed in their traditional manner. William Tubman was president, and the Christian Americo-Liberian elite ruling the country looked toward America. In their efforts to eliminate "tribalism," they felt that promoting the arts of the peoples up country would impede the quest for national unity. Seen as manifestations of "backward" beliefs, they were not yet protected.[1]

Unlike Abidjan and Douala, Monrovia had no real art galleries. Instead, African merchants, among them Islamic Wolof from Senegal, Mandigo from Guinea, and a few Liberians, displayed their offerings in roadside stands or took them directly to their patrons. Other sources were shops in the international hotels and handicraft centers. The late Daniel Crowley, a professor of anthropology at the University of California at Davis, described the art market along the African coasts in several articles for *African Arts*. Granted that the best pieces of "old" art journeyed directly to the galleries abroad, he wrote in 1970, knowledgeable buyers could still find interesting objects in the grand hotels and open-air markets; this was less likely to occur, however, in the government tourist shops and cultural centers that often sprang up near airports and specialized in trinkets and souvenirs. In his inimitable style, Crowley muses about the types and prices of objects sold in grand hotels: "Even with the markup, their pieces can be excellent buys. The wives of otherwise taciturn museum directors have had forcibly to drag their protesting husbands out of the basement galleries of the Ivoire Hotel in Abidjan, Ivory Coast, perhaps the best of the lot. Lest they convert next year's janitorial budget into Senufo iron lamps and Baule portrait figures."[2]

In Freetown, too, merchants of all backgrounds—from street vendors to Africans from as far away as Nigeria—had a long history of selling things African to visitors and collectors. A constant flow of foreigners moved through the harbor, one of the major ports on the shipping route along the West African coast. Two groups of objects gained more attention than any other works from the region and were much sought after by collectors and museums: the distinctive Sande helmet masks and the many types of masks from the Dan, Konor, Kran, and Wè. Thus, it is not surprising to find seven Sande helmet masks and thirty-five masks from the Dan and neighboring peoples in McMillan's collection.

Shiny, blackened helmet masks representing women with elegant coiffures belong to the Sande or Bundu[3] (Bondo) women's medicine societies or sodalities that socialize young girls into womanhood (cats. 10, 11). In the past, Sande and Poro, the complementary men's association, were important institutions in the region and seem to have maintained their vigor (particularly in rural areas) well into the 1970s, even into the troubled decade of civil war in both Sierra Leone and Liberia. Mende, Temne, Sherbro-Bullom, Vai, and Gola peoples all had these associations and shared closely related ritual practices that were never stagnant but always subject to local modifications and variations over time. What makes the Sande practice unique among African masquerades is that women commissioned the masks and performed the masquerades. Among the Mende, the mask persona embodies

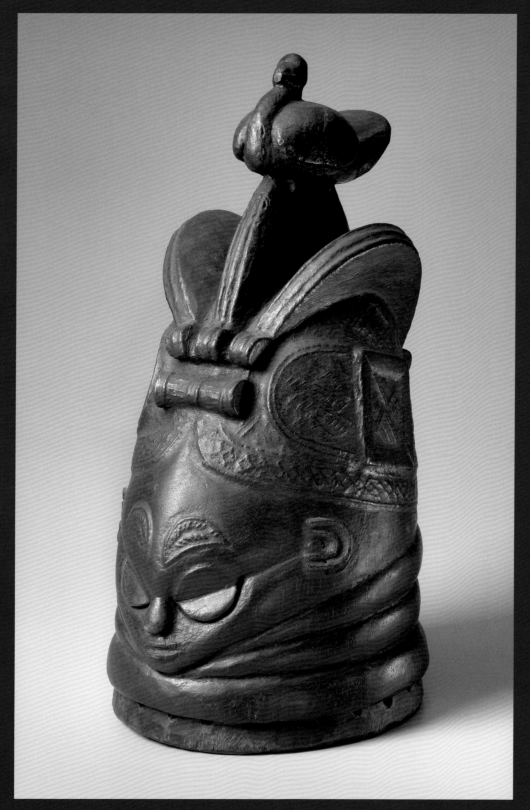

11 *Helmet mask*

Unknown artist or workshop
Mende or Gola peoples, Sierra Leone
20th century
Wood
H. 45 cm, w. 21 cm, d. 26 cm
(H. 17¹¹⁄₁₆ in., w. 8¼ in., d. 10¼ in.)
Acquired in 1983 from the Leonard
Kahan Gallery, New York

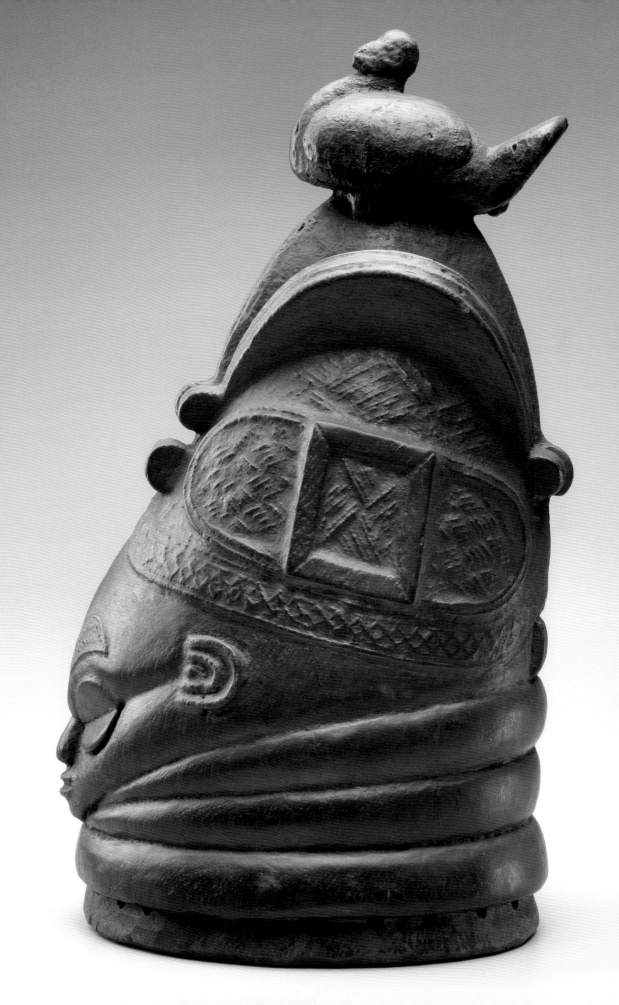

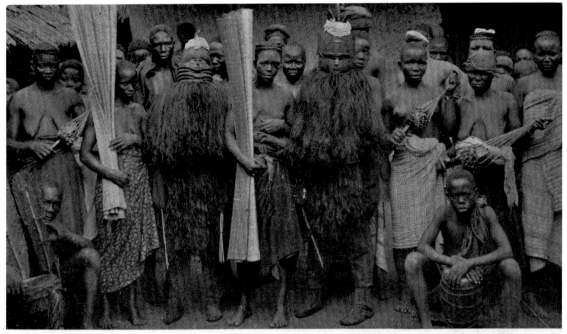

A. Lisk-Carew, Photo., Freetown, Sierra Leone.

BONDU DEVILS, SIERRA LEONE.

FIG. 9 Women of the Bundu sodality, Freetown, Sierra Leone, about 1905

the sodality's female patron spirit (*ngafa*) and visualizes the ideals of womanhood: beauty, grace, appropriate behavior, and fecundity. It also alludes to female power and "personifies the corporate interest and prestige of the female portion of the Mende community on important public occasions."[4]

The sodality belonged to the women of a descent group, meaning there were as many Sande associations as there were important descent groups, which partly explains the considerable number of helmet masks in collections. The associations were organized in a hierarchical fashion; the highest-ranking officials were the *soweisia* (sing. *sowei*), the keepers of both the Sande medicine (*hale*) and the *sowei* masks. Maskers generally appeared at critical moments during the initiation of young women, who were

secluded for several months in special enclosures in the "bush," a term designating the wilderness outside the civilized space of the village. When the girls returned as full-fledged women, the final ritual and celebration unfolded. The sequence of rituals and performances varied among the many peoples who have this institution. The masker could also appear on other occasions, such as the installation or death of a paramount chief. Sande women have also danced for government officials and other visitors since British times and performed more recently during agricultural exhibitions.

Contextual photographs of Sande masqueraders appeared at the beginning of the twentieth century; the best-known are in the books of T. J. Alldridge, the first British Travelling Commissioner in the Sierra Leonean

hinterland, who visited many of the chiefdoms.[5] Other early images seem to have circulated even more widely, among them a depiction, of about 1905, of Sande women by Arthur Lisk-Carew, a Creole photographer who operated a successful studio in Freetown with his brother Alphonso (fig. 9). This image shows two maskers and their attendants in or near Freetown, where Mende and Temne peoples maintained the Sande tradition and also performed the masquerade for onlookers. The presentation appears to have been carefully staged by both the photographer and the women of the association.

The picture is an important document about the masquerade even though it is arranged. The two central maskers wear costumes that include black shirts, trousers, and shoes, entirely concealing their bodies. Black-dyed palm-fiber ruffs give the *soweisia's* bodies a voluminous appearance and swayed gracefully when they danced. White head-ties encircle the tops of the blackened helmet masks the maskers wear when the initiates return from the bush. The color white alludes to unity. Ritual substances and medicines attached to the costume, not visible in this picture, render the masker more attractive and protect her from witchcraft.[6] Both maskers carry switches in their hands. The two women on the left, who hold straw mats to cover the maskers' laps when they sit down, are *ligbeisia*, members of a rank below the *soweisia* in the sodality. Other Sande women with gourd rattles join in the singing and dancing, the most significant part of the performance, and two male drummers accompany the women.

While this was perhaps the most popular of all early images of Sande maskers, the Lisk-Carew brothers offered many other postcards related to Sande and distributed them well into the 1940s. Helmet masks also graced the homes of Creoles and British residents of the colony. Sande masks became so popular with Westerners and

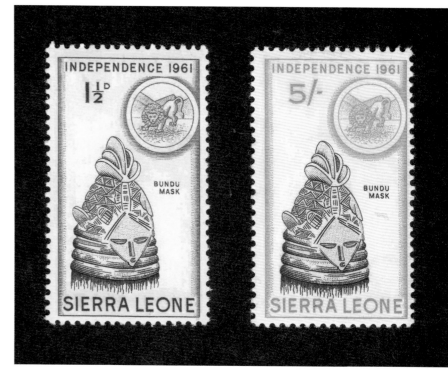

FIG. 10 Stamps celebrating independence, issued by the Republic of Sierra Leone, 1961

Sierra Leoneans that they even appeared on two 1961 postage stamps celebrating the country's independence (fig. 10). The helmet masks began to attract the attention of collectors, albeit later compared to other types of objects from the African continent.

The earliest Sande masks in European museum collections arrived in the 1890s. The first known publication of a Vai Sande mask in a collection dates to 1890, when the Swiss traveler and zoologist Johann Büttikofer presented an engraving in a report on his research in Liberia in 1879–82 and 1886–87.[7] However, these masks did not appear as art until the 1930s. Sweeney overlooks them in his 1935 MoMA exhibition and catalogue, but Kjersmeier's 1936

survey of African art styles contains a full-page photograph of a Mende Sande mask from his own collection, accompanied by a rather short descriptive text.[8]

In the United States, Sande masks gained popularity in the second half of the twentieth century, encouraged by major shifts in interest and market conditions. The association of these helmet masks with women had not gone unnoticed in the literature about Africa, and the growing feminist movement may well have stimulated a closer consideration of these masks by American scholars. In addition, Liberia and Sierra Leone had become primary regions for Peace Corps volunteers and U.S. development experts, many of whom collected according to their respective budgets. African traders, often Muslims from neighboring countries, roamed the region and located old masks, which they offered to European and American dealers and collectors. In most instances, the traders acquired only the wooden headpiece part of the mask persona, because the purchasers usually had no interest in the full costume. The traders made the rounds, visiting regular customers and potential patrons, among them Thomas Seligman, then a Peace Corps art teacher and director of the Africana Museum at Cuttington College, Liberia. He reports that one day in 1970, two or three African dealers brought him some three hundred Sande masks from Sierra Leone, which was in the grip of civil unrest. Seligman ultimately selected two or three masks that he thought were of the highest quality.[9]

After conducting extensive research, several scholars have described the stylistic and aesthetic conventions for a successful helmet mask.[10] Both works from the McMillan Collection depicted here embody these requirements, mirroring and enacting feminine ideals of beauty (see cats. 10, 11). Each feature of the face and head is associated with deeper meaning. The eyes, downcast and mere slits in both masks, allude to the demure and contained composure

expected of Sande graduates. The mouth is small and closed, referring to the ideals of seriousness and silence in the presence of spirits. The high, gently sloping forehead recalls the beauty of an elegant young woman. Rings or lines of the neck, a characteristic of all Sande masks, have been interpreted as signifiers of health and beauty. The black sheen of the smooth surface reflects healthy and youthful skin. Finally, the artists placed the most emphasis on the coiffure, which recalls earlier hairstyles. The three-lobed hairdo of one of the masks, based on a style fashionable at the beginning of the twentieth century, represents the most common type (cat. 11), while the delicately braided style in the other mask (cat. 10) seems more recent. This headpiece displays a bird, possibly a reference to the spirit world. A Mende carver explained the bird-and-snake motif by saying: "The snake is shown watching to catch the bird." He prided himself on carving such innovative motifs.[11]

Besides the masks, sculptors also created female figures projecting the ideals of feminine beauty. A particularly fine example in the McMillan Collection is a graceful freestanding work with a lush blackened surface (cat. 12). Its facial features—the small closed mouth, the downcast eyes, and the pronounced neck lines—echo those of Sande masks. The coiffure with buns and braids represents one of the complex hairdos of Mende women in the first half of the twentieth century, and the elaborate back apron recalls older fashions. This work embodies the refined Mende woman standing erect with her hands placed on her legs. The context of such figures is open to speculation. They may have had protective or curative functions in the rituals of the Sande sodalities. They also served decorative purposes, displayed as prestige items and things of beauty in the houses of influential men. Between 1930 and 1961, paramount chiefs often showcased such figures during exhibits organized by British district officers at official

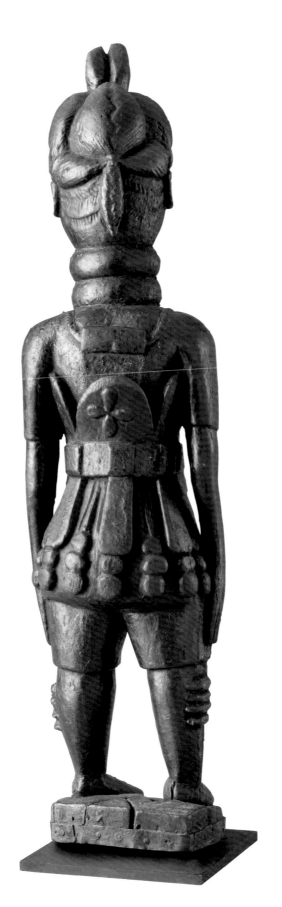
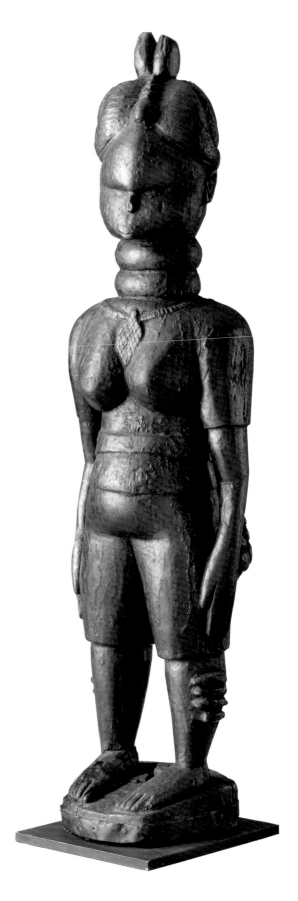

12 *Female figure*

Unknown artist or workshop
Mende peoples, Sierra Leone
20th century
Wood
H. 65 cm, w. 17 cm, d. 14 cm
(H. 25⁹⁄₁₆ in., w. 6¹¹⁄₁₆ in., d. 5½ in.)
Acquired in the mid-1970s from
the Galerie Majestic (Michel
Huguenin), Paris
Pub. Adams 1982, 65; Exhib.
De Cordova Museum 1978;
Carpenter Center, Harvard
University 1982

gatherings. The British awarded financial prizes for the best display to the carvers, a practice that stimulated production.[12]

The development of the market and the ongoing commodification of Sande masks and figures depended on the way local sculptors created and sold helmet masks and how Sande women considered this particular element of the overall mask persona. Carvers among the Mende, Vai, Sherbro, and Gola did not go through a rigorous apprenticeship as did sculptors in some other African settings, nor was their skill derived from specialized knowledge shared in families or clans. Rather, they learned through observation and practice, initially carving small, utilitarian objects for sale, such as bowls, combs, and staffs. The stylistic characteristics for Sande masks were quite standardized, meaning that the artist had to find the delicate balance between the customer's wish for conventionality and his own desire for innovation that would set him apart from his competitors. As a carver's reputation and his patrons' satisfaction grew, he would receive commissions for helmet masks from Sande women. In the past, each important order required that the carver move to the community where his services were needed and stay as a guest until the work was finished. By the 1970s, however, carvers often remained at home and teamed up with traders who marketed their work in the larger region and to foreigners.[13]

Objects went on their journeys for other reasons as well. Women of the Sande sodality often asked carvers to create smooth copies of damaged older masks that were no longer considered appropriate reflections of feminine beauty. Once the new pieces were completed, the discarded masks also entered the market. By the 1970s, the conduits for the sale of Sande masks to and through Freetown and Monrovia were well established. Sande masks also appeared in other West African art and tourist markets, such as Abidjan.

Some came through complicated trading networks, while carvers in Côte d'Ivoire made their own versions, using photographs to study the masks' characteristics. Both modes of supply existed side by side. The recent wars and unrest in Sierra Leone and Liberia seem to have opened the floodgates. One anonymous Parisian art dealer surmised in 2006 that people were selling the masks because they needed money and noted that Sande masks are no longer rare.

Objects from the Dan, the Wè, and several neighboring peoples embarked on similar journeys. Their routes took them to and through Monrovia, but also to Abidjan in Côte d'Ivoire because the Dan and their neighbors straddle the border between the two countries. Dan masks are iconic works of art from Africa and, unlike Sande helmet masks, immediately attracted the attention of artists and collectors when they first appeared in Paris. American photographer Charles Sheeler depicted three masks from this region for an exhibition by Marius de Zayas in 1918 (fig. 11).[14] The 1926 *Primitive Negro Sculpture,* by Paul Guillaume and Thomas Munro, based on the collection of the Barnes Foundation in Merion, Pennsylvania, includes three Dan masks among the forty-one plates, giving arts from this region a prominent place.[15] Sweeney's MoMA catalogue presents five such masks from the collections of Paul Guillaume, Helena Rubinstein, Paul Chardourne, and Charles Ratton, and many more appeared in the exhibition.[16]

There has been much speculation as to whether Dan and related masks inspired Pablo Picasso's 1907 painting *Les Demoiselles d'Avignon,* generally considered the work that opened up new ways of seeing and depicting in Western art. No such masks have been documented in Paris at that time; the first masks from this region arrived in the Musée du Trocadéro, which Picasso visited, between 1931

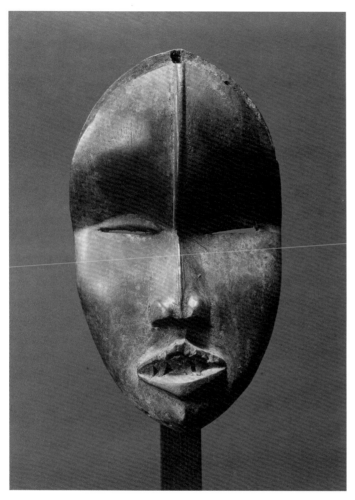

FIG. 11 Dan mask, 1918. Photograph by Charles Sheeler

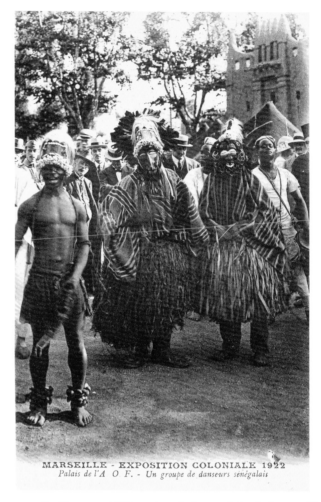

MARSEILLE - EXPOSITION COLONIALE 1922
Palais de l'A O F. - Un groupe de danseurs sénégalais

FIG. 12 Konor and Wè maskers in front of the Sudan pavilion at the Colonial Exposition in Marseille, France, 1922

and 1933.[17] However, there may have been other sources of inspiration and dissemination. In 1922, a troupe of at least seven performers from this region participated in the Colonial Exposition in Marseille (fig. 12).[18] Two maskers, one with what looks like a Konor mask and the other with a Wè mask, danced to the sound of drums in front of a house modeled on architecture in Djenne and Timbuktu

in Mali.[19] It is not unlikely that Dan and related masks came into view at such venues even before they appeared in museum settings and art books.

Two scholars in particular raised the profile of arts from these regions through their writings and other activities. The German anthropologist and medical doctor Hans Himmelheber conducted his first fieldwork among the

Liberian Dan in 1936 and returned to the region many times—later accompanied by his son Eberhard Fischer. The activities of the second scholar, George Harley, a missionary among the Mano in Ganta in northeastern Liberia since 1926, were of particular importance for the Boston area and for American collectors because he was closely associated with Harvard's Peabody Museum of Archaeology and Ethnology. Harley not only wrote influential articles but also sold objects to support his missionary activities.[20] Some of the masks in the McMillan Collection may well have come through him, although their provenance was forgotten as the years passed. Most others arrived from Paris dealers such as Pierre Vérité—one as early as 1947.

According to the considerable literature, the Dan designate all masked manifestations as *gle* (or *ge* in their western and southern realm in Côte d'Ivoire), a term translated as "awesome being."[21] This is a reference to the masked personae, materialized spirit beings that come into the villages from the forest with the mission to educate and enact ideal behavior. Another interpretation describes *gle* as multifaceted phenomena that include the masker and all aspects of the performance.[22] The writings about masking and masquerades among the Dan and their neighbors make clear that Western observers wrestled with the multitude of masquerades and masked beings in their efforts to create taxonomies. The mask characters shared by the peoples in this region range from gentle female masks, associated with boys' initiation; to beautiful female singing masks, which entertain and dance; to grotesque masculine warlike masks; and finally to the great and powerful dispute-settling masks (*glewa* or *gle va,* discussed below). The lines blur, and the meanings of masks may change over time. In fact, some masks may assume different functions as they grow more potent and powerful over their lifetimes. A mask can become a dispute-settling mask, for instance, as the wooden face piece remains the same even though its function and meaning change.[23]

Among the masks from this region in the McMillan Collection is an oval-faced, finely carved wooden headpiece (cat. 13). The central, horizontal mark on its forehead recalls an ancient form of scarification, usually associated with feminine beauty. The lips with six inserted metal teeth are pursed and rimmed, and round eyes protrude from the flat surfaces of the face. Isolated from its costume and devoid of the clues that might emerge from a performance, the mask's meaning remains enigmatic. We know from its stylistic features that it comes either from the northeastern Dan in Liberia or from the southeastern Dan in Côte d'Ivoire, who live in autonomous villages led by chiefs, and that it must have been owned by a patrilineage.[24] This mask most closely resembles those associated with the mask persona known as *bagle,* a male masker who dances during festivals, accompanied by an orchestra, and entertains the crowd with pantomimes.[25] *Bagle* usually wears a wig of cotton threads and rags, and his costume consists of a cape and a voluminous fiber skirt. His moves are often aggressive, and he uses two sticks with hooks to scare away the spectators (fig. 13).

Most of the McMillan Collection masks from this region pose similar problems of interpretation, beginning with one of McMillan's earliest acquisitions from Pierre Vérité (cat. 14). This male mask arrived in the collection in 1947 and impresses the viewer with its bold, elongated features, narrow-set tubular eyes, and arched eyebrows. Incised lines along its sides indicate scarification. The fur beard once covered an attached movable jaw, which disappeared during the mask's journey. Based on stylistic characteristics, it can be assigned to the Konor, northern Mano, or Kpelle, who live in northern Liberia and southeastern Guinea and share many cultural features with the Dan.[26] There is no

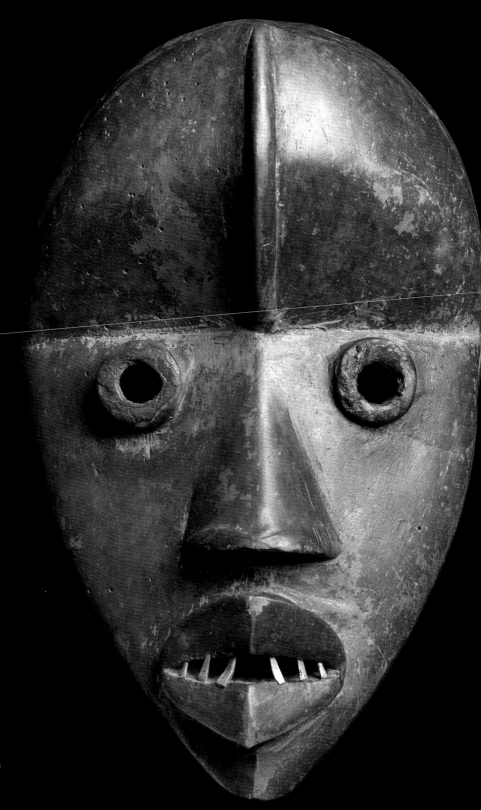

13 *Mask* (bagle)

Unknown artist or workshop
Dan peoples, Liberia and Côte d'Ivoire
20th century
Wood, metal
H. 24 cm, w. 14 cm, d. 9 cm (H. 9⅞₁₆ in.,
w. 5½ in., d. 3⁹⁄₁₆ in.)
Acquired in the 1950s from an African
dealer, Paris

FIG. 13 Dan mask persona *slü*, a mask of the *bagle* genre, in performance,
Nyor Diaple village, northeastern Liberia, 1974

information about the mask's geographic origin, creator, costume, or performance. Since Vérité did not travel to Africa until 1951, one of his many contacts in the colonies or an African seller must have brought it to Paris.[27] We can only admire its features and place it in the general category of masks related to men's associations during judicial proceedings, thus exerting social control, an interpretation that goes back to George Way Harley's "Masks as Agents of Social Control in Northeast Liberia."[28]

Several masks in the McMillan Collection came from the realm of the Wè peoples, also known as the Guéré or Kran. The Wè and Dan interacted and intermarried, and it is telling that some of the sculptors, previously identified as Dan, had Wè fathers and received commissions from both Dan and Wè patrons.[29] The angular forms and fierce expressions of many Wè masks are particularly striking. Two from the McMillan Collection belong in the category of festive masks owned by patrilineages. They appeared during special events, when young men donned fiber skirts and headdresses and transformed themselves into these beings, performing their songs and dances to the delight of their audiences. A threatening male mask—with bulging slit eyes, gaping mouth, heavily painted surfaces, attached fur, and a leather headdress with wooden, animal-teeth-like extensions—embodies one of the spirit beings that came from the realm of the wilderness and appeared in the

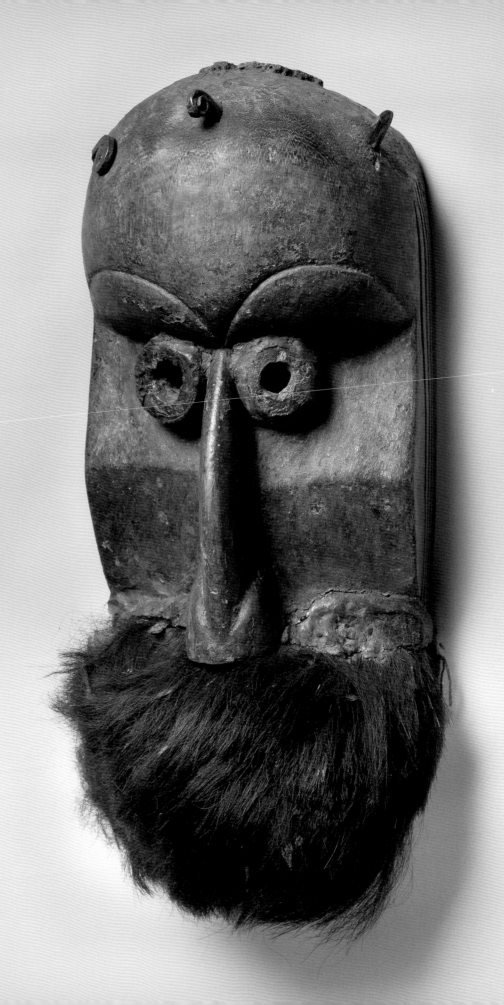

14 *Mask*

Unknown artist or workshop
Konor, northern Mano, or Kpelle
peoples, Guinea and Liberia
20th century
Wood, fur, metal, encrustations
H. 36 cm, w. 14 cm, d. 12.5 cm
(H. 14³⁄₁₆ in., w. 5½ in., d. 4¹⁵⁄₁₆ in.)
Acquired in 1947 from the Galerie
Carrefour (Pierre Vérité), Paris
Pub. Adams 1982, 77; Exhib. Harvard
University 1982

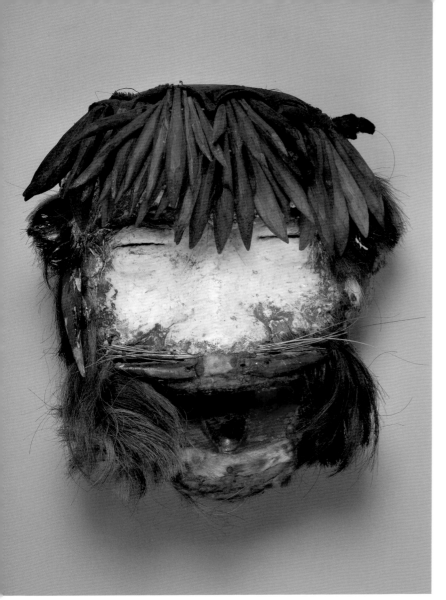

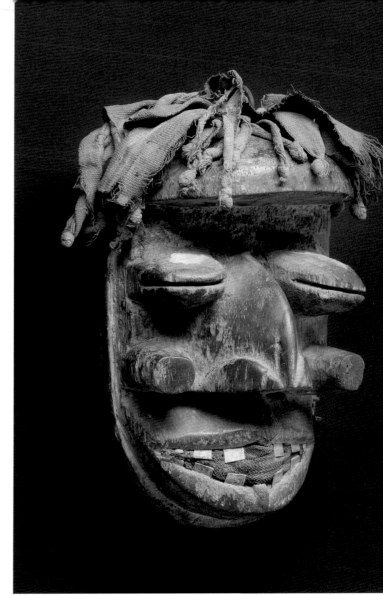

15 *Mask*

Unknown artist or workshop
Wè peoples, Liberia and Côte d'Ivoire
20th century
Wood, pigment, fur, horn, cloth, fibers
H. 32 cm, w. 28 cm, d. 23 cm (H. 12⅝ in.,
w. 11 in., d. 9¹⁄₁₆ in.)
Acquired in 1969 from Mr. Kabah, Paris
Pub. Adams 1983, 6–7; Exhib. Boston
Athenaeum 1983

16 *Mask*

Unknown artist or workshop
Wè peoples, Liberia and Côte d'Ivoire
20th century
Wood, raffia, cloth, metal, nails
H. 24.5 cm, w. 14 cm, d. 12.5 cm (H. 9⅝ in.,
w. 5½ in., d. 4¹⁵⁄₁₆ in.)
Acquired in the 1960s from an African dealer,
Paris

village during festivals (cat. 15). A second mask seems to belong in the same realm (cat. 16). Its tubular cheeks, projecting eyes, and gaping mouth with metal teeth give it a ferocious expression. Narrow slits below the sharply delineated forehead would barely allow the wearer to see his surroundings.[30]

A third mask can be identified as a *glewa* (also *gle va*), which researchers describe as a dispute-settling or judging mask (cat. 17). *Glewa* literally means "great" or "important" masker.[31] The double set of long protruding eyes, the triangular projecting cheeks with incised lines on the outside, and the aggressively projecting horns on the prominent forehead are familiar features of these masks. The strong upper and movable lower jaws, with inserted teeth, gape open to reveal a bright red tongue. The color red also appeared prominently in the costume: red cloth covered the heavy raffia-fiber skirts, and a stiff red cap with leopard skin and white fur adorned the head. Before the introduction of legal systems based on European models, which occurred during the colonial and post-independence periods, these impressive maskers were called upon to settle major disputes and conflicts between villages. As mask performances and meanings evolved over time, however, the judiciary functions of some of these masks receded. Nowadays they adjudicate cases that fall outside the jurisdiction of government courts, such as conflicts in circumcision camps of young men, and assure that people fulfill their obligations to one another.

Monni Adams conducted research among the Wè of Canton Bo in Côte d'Ivoire in 1983–84 and again in 1989–90 and attended festivals during which similar masks appeared. She recorded others' perceptions as well as her own observations of the actual performances, noting that the "villagers interact with the masked figures during the festival in order to gain and demonstrate some degree of control over them. The masked festival is a strategy assuring the Bo villagers that by their own competence and efforts, they can benefit from the maskers' powers, and thus are themselves able to confront the unknown threats or events of the oncoming season."[32] Through the masked festival, the villagers sought to gain prosperity and well-being for the community in the next season.

Collectors have always appreciated masks and figurative sculpture. As time went on, however, tastes changed, interests and the art market expanded, and objects considered craft or artifact in the years before World War II gained appreciation for their aesthetic qualities and entered collections. The McMillan Collection has several utilitarian objects from this region that moved into the art category, among them a spoon, a fine bowl (cats. 18, 19), and a game board (see cat. 8). The spoon and the bowl did not find their way to Cambridge through Freetown or Monrovia, although many similar objects could be purchased there, but arrived by other routes. The bowl came from a dealer in Abidjan and the spoon from a dealer in Cambridge. Both pieces are associated with the female domain: the generosity and hospitality of women, who excel in cooking and hard work, are productive farmers, and host friends and strangers alike. The Dan call them *wunkirlone* (sing. *wunkirle*), and each quarter in a village names and honors one *wunkirle*, who contributes food to feasts organized by the villagers. During the feasts, the *wunkirlone* carry richly decorated ladles as emblems of their achievements. Carvers embellished the ladle handles in different ways. Some handles bear female heads, but this relatively small ladle ends in a graceful animal head and may belong in this complex. The bowl, used to serve rice (the staple of the peoples in this region), was once part of such a setting as well and shows signs of wear. The circular base supports the flaring bowl, its shape combining elegance with utilitarian design,

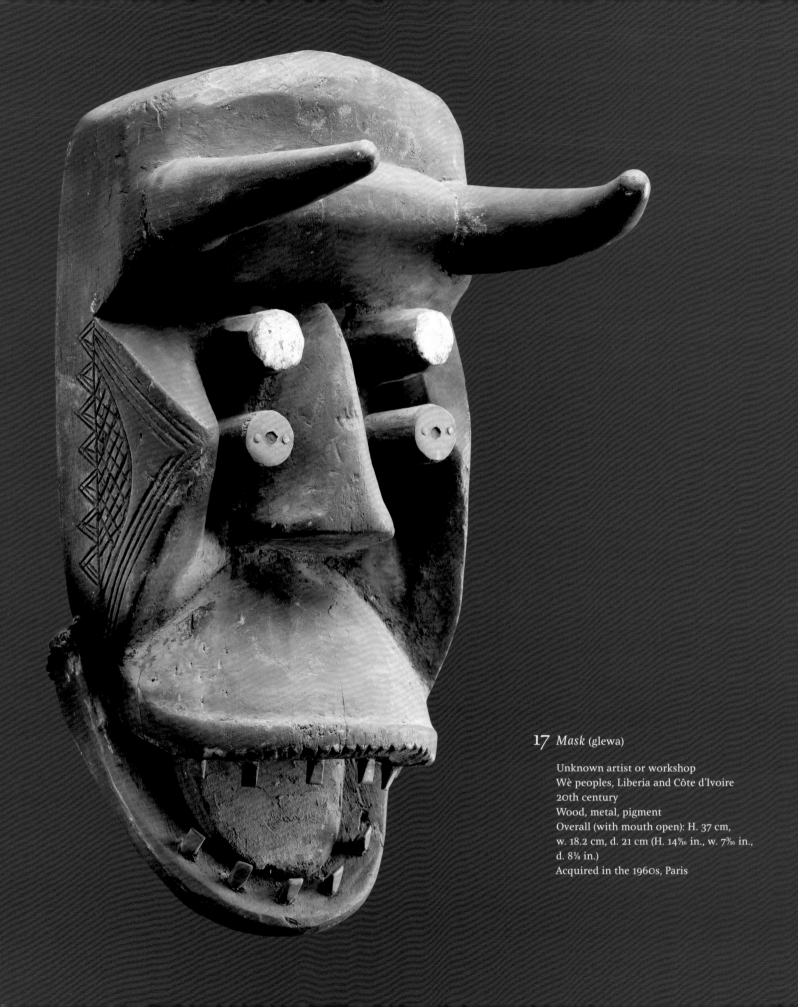

17 *Mask* (glewa)

Unknown artist or workshop
Wè peoples, Liberia and Côte d'Ivoire
20th century
Wood, metal, pigment
Overall (with mouth open): H. 37 cm,
w. 18.2 cm, d. 21 cm (H. 14⁹⁄₁₆ in., w. 7³⁄₁₆ in.,
d. 8¼ in.)
Acquired in the 1960s, Paris

18 *Spoon*

Unknown artist or workshop
Dan peoples, Liberia and Côte d'Ivoire
20th century
Wood
H. 35.3 cm, w. 7 cm, d. 4 cm (H. 13⅞ in., w. 2¾ in., d. 1⁹⁄₁₆ in.)
Acquired in the late 1960s from an African dealer, Cambridge

19 *Bowl on a base*

Unknown artist or workshop
Dan peoples, Liberia and Côte d'Ivoire
20th century
Wood, braided fibers
H. 26 cm, diam. 48 cm (H. 10¼ in., diam. 18⅞ in.)
Acquired in 1966 from Samir Borro, Abidjan, Côte d'Ivoire
Pub. Adams 1983, 8–9; Exhib. Boston Athenaeum 1983

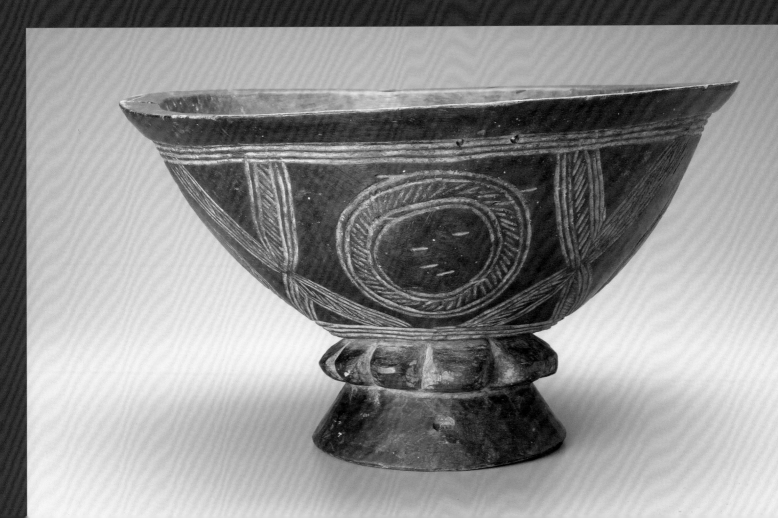

and fine lines contrast with the dark surface. Carvers incised these patterns after they blackened the light wood by either burying it in a swamp or applying a mixture made from boiled leaves.

The nature of our knowledge about African art depends largely on the research emphasis of influential scholars and the evolution of studies in certain areas. As we have seen, Sande helmet masks stimulated interest in the inner workings of the women's Sande sodality and the aesthetics embodied in their form. Among the Dan and neighboring peoples, one of the major areas of study has been the role of artists, first explored by Himmelheber and Eberhard Fischer.[33] Following in their footsteps, Barbara Johnson observed a carver by the name of Dro making a ladle in the Dan village of Tapita, Liberia, in early 1986. She noted some interesting changes in the process that had been described in previous scholarship. Traditionally, the spoon was stained black with palm oil when the carving was complete. Dro, however, applied black hair dye to the spoon's surface and then shined it with shoe polish.[34] The effect—the resulting glossy surface—is the same, even though the carver used different materials.

Scholars' studies also reveal emphases and biases over time. For example, Dro, who was active from the late 1950s onward, also appears in Himmelheber's book on African artists, published some twenty-six years before Johnson's study.[35] The changes in Dro's working methods and clientele bring into sharp focus the ways in which the growing demand for works from this region affected the artists' lives, production modes, and repertoires. Dro grew up in a region where Dan and Wè mingle and showed his talent and interest in carving at a very young age. After eight years of American missionary schooling, he worked at the Firestone plantation, where he honed his artistic skills and sold his early products to foreign workers and missionaries.

Himmelheber does not mention this part of Dro's life history, perhaps in an effort to "traditionalize" such carvers. Dro left the plantation and worked with his great-uncle Zlan, one of the most famous Dan/Wè sculptors, whose creations were cherished by chiefs and patrons across the entire multiethnic region and which entered the great museums of the West.[36] Zlan, who died in the early 1960s, worked exclusively for local patrons, receiving gifts in return for his cherished carvings, while many of the younger artists who learned from him catered to a foreign clientele that included anthropologists. It is telling that Dro felt his work was validated when Himmelheber visited him in his village in 1957. He still carved for local customers then but increasingly sold objects to African traders who came to the villages and towns to buy for the international export market. Johnson found that Dro's newer carvings did not measure up to the older works, for they were created more rapidly and with different techniques. He was able to do this because foreign clients were not as discriminating as local patrons, who knew the requirements for each type of object and appreciated subtle variations within the conventions. Those works that combine unusual features point to another tendency, namely, that artists felt freer to experiment and to integrate new motifs that might become popular in the market and even win admirers among their local patrons.

Objects from the Dan and neighboring peoples usually came through Monrovia and Abidjan, but the journeys of other pieces from this part of Africa cannot easily be traced. Two works in the McMillan Collection, a bovine mask and a shark fin attachment, arrived from Guinea-Bissau, a country about the size of Maryland wedged between Senegal and the Republic of Guinea. They somehow moved to Paris—perhaps through Dakar in Senegal, perhaps through Monrovia or even Abidjan. Bissau, the

capital of the country, was never a destination for travelers or dealers, mainly because of the unsettled political situation. People in Guinea-Bissau, among them the Bidjogo, who live on more than twenty islands off the West Atlantic coast, have long been in contact with Europeans, having encountered the first Portuguese sailors in the late fifteenth century.[37] The Bidjogo were famous for their big boats, navigational skills, and bellicose attitudes. By 1630, Portugal established the "captaincy general" of Portuguese Guinea and in 1765 founded a small settlement, Bissau, to protect its commercial interests in the slave trade. Guinea-Bissau remained under Portuguese rule until 1974. Repeated struggles to overthrow Portuguese colonial domination, ongoing political strife after independence, and difficult economic conditions destabilized the country, a situation that continues today.

The arts of the Bidjogo and other peoples in Guinea-Bissau were unfamiliar to Westerners, and even in Portugal interest in these objects developed late.[38] Few sculptures appeared in the early art books, and Kjersmeier was the first to dedicate a short chapter to the "Bidjougo" in 1935, possibly inspired by the travelogue of Austrian anthropologist and photographer Hugo Bernatzik, who conducted an expedition to Portuguese Guinea in 1930–31. Bernatzik managed to photograph the common bovine masks in situ (fig. 14). Westerners considered them rather peculiar at that time, and even Kjersmeier seemed skeptical regarding Bidjogo arts, stating that they were not of any artistic interest.[39] These views changed, however, and by the 1960s, Bidjogo masks and sculptures, in particular bovine masks with real ox horns, increasingly entered the art market and collections.[40]

These bovine helmet masks are called *vaca bruto*, which means "wild cattle" in Creole, the lingua franca. *Vaca bruto* are associated with a particular age group in a men's initiation

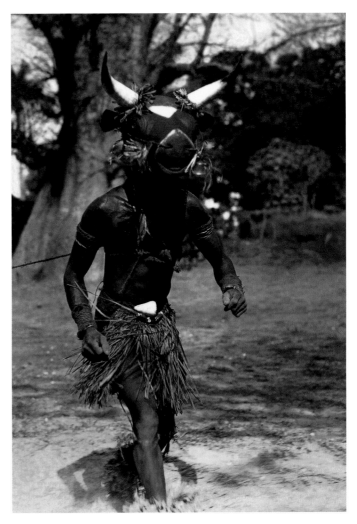

FIG. 14 Bidjogo masker in performance, Portuguese Guinea (now Guinea-Bissau), 1930–31

association, the *cabaro* level, comprising men from the age of seventeen to about twenty-seven (cat. 20). In fact, the mask performance, which takes place during both daytime and nighttime dances, requires strength that only young men can muster. Wearing the wooden helmet attached to wooden neck and shoulder pieces (missing in this mask)

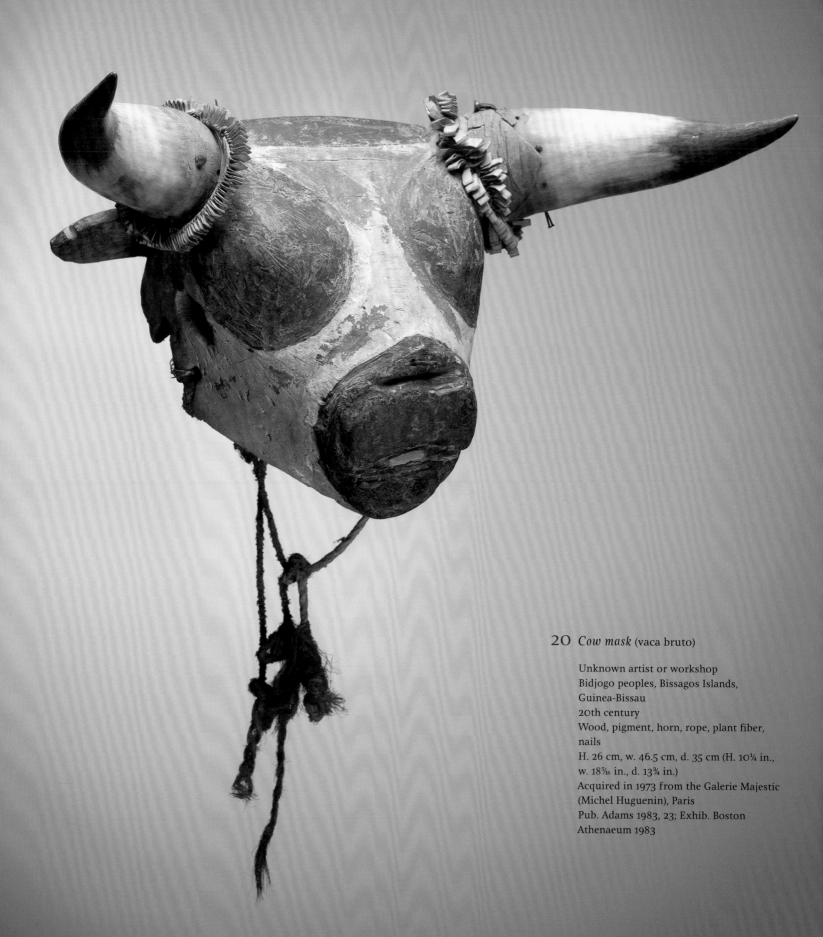

20 *Cow mask* (vaca bruto)

Unknown artist or workshop
Bidjogo peoples, Bissagos Islands,
Guinea-Bissau
20th century
Wood, pigment, horn, rope, plant fiber,
nails
H. 26 cm, w. 46.5 cm, d. 35 cm (H. 10¼ in.,
w. 18⁵⁄₁₆ in., d. 13¾ in.)
Acquired in 1973 from the Galerie Majestic
(Michel Huguenin), Paris
Pub. Adams 1983, 23; Exhib. Boston
Athenaeum 1983

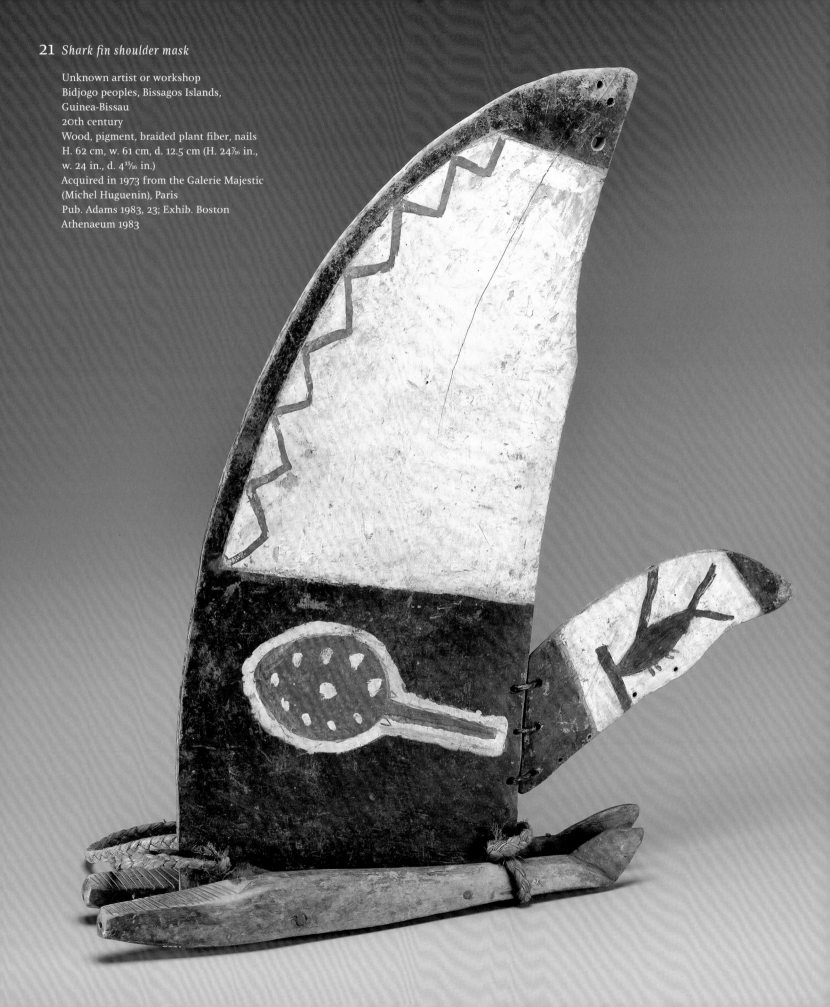

21 *Shark fin shoulder mask*

Unknown artist or workshop
Bidjogo peoples, Bissagos Islands,
Guinea-Bissau
20th century
Wood, pigment, braided plant fiber, nails
H. 62 cm, w. 61 cm, d. 12.5 cm (H. 24⁷⁄₁₆ in.,
w. 24 in., d. 4¹⁵⁄₁₆ in.)
Acquired in 1973 from the Galerie Majestic
(Michel Huguenin), Paris
Pub. Adams 1983, 23; Exhib. Boston
Athenaeum 1983

and fastened with a rope, the masker moves like an untamed animal, crouching on his hands and knees, bucking and tossing to the accompaniment of drums. Danielle Gallois-Duquette, one of the few scholars who conducted research among the Bidjogo, suggests that this energetic performance enacts the young men's condition: not fully initiated, they possess physical strength yet lack the ability to control and tame it; they acquire these skills in the course of the initiatory process. As one would expect of a wooden piece danced with such vigor, the headdress shows sign of wear and damage where it was once fastened by cords. The mask is also missing a rope that was pulled through its nostrils, but some of the delicate fiber decorations around the base of the horns remain. The head has been painted in lively colors: blue for the muzzle and the large eyes, white for the snout, and bright green and red to highlight its features.

Similarly, an object in the form of a shark's dorsal fin displays colorful designs, which include the outlines of a shark and possibly a ray, in an older color scheme of red, black, and white (cat. 21). It was part of a shark costume that also belonged to the young men in the *cabaro* age group. Their performances brought to life a variety of sea creatures, not only several kinds of sharks, such as hammerheads, but also swordfish and other species. With the shark mask, the young man wore a wooden headpiece resembling the head of a shark while the fin was attached to his back. In these masquerades, the Bidjogo enact their relationship to the creatures of the sea, their "wilderness," where they find their livelihood. Masquerades have not ceased, and, as Gallois-Duquette asserts, the Bidjogo are "deeply attached to their traditions despite inevitable acculturation."[41] Like maskers in other African countries, they now perform in different settings as well: for official visits to their villages, on national holidays, and for other state functions. Masquerades live on and adjust to a changing world.

NOTES

1. We thank Thomas K. Seligman, who was a Peace Corps volunteer in Liberia in 1969 and 1970, for his description of life and the art market during these years. Interview, March 3, 2006.

2. Crowley 1970, 44.

3. The term "Bundu" is used by the Temne and Sherbro.

4. Phillips 1995, 77; the following information is based on her findings.

5. Alldridge 1901, fig. 47; Alldridge 1910.

6. Phillips 1995, 87–88.

7. Büttikofer 1890, v. 2, 309.

8. Kjersmeier 1936, v. 2, 11, 40–41, and pl. 5.

9. Personal communication, Seligman, March 3, 2006.

10. See Boone 1986; Lamp 1985; and Phillips 1995.

11. Phillips 1995, 130.

12. Adams 1995b, 472.

13. Phillips also mentions that carvers were hesitant to admit that they engaged in this practice. Phillips 1995, 139.

14. In 1918, de Zayas organized an exhibition at the Modern Gallery in New York entitled "African Negro Wood Sculpture Photographed by Charles Sheeler." A forty-page catalogue in a limited edition of twenty-two copies and signed by Sheeler accompanied the exhibition.

15. Guillaume and Munro 1926, frontispiece, 40, 107.

16. Sweeney 1935, pls. 53, 79, 88, 98, 99, 114.

17. Rubin 1984c, 261; McClusky 2002, 181–83.

18. The caption on the card erroneously describes them as "a group of Senegalese dancers"; Senegalese performers were among the earliest participants in colonial fairs and expositions in Europe.

19. Postcards have played an important role as inspiration for painters, Picasso among them; see Baldassari 1997, in particular 45–61.

20. See Wells 1977; Adams 2005.

21. Fischer 1978, 19.

22. Reed 2003a; 2003b, 98–101.

23. Fischer 1978, 23.

24. Patrilineages trace their descent through the paternal side of a family.

25. I thank Eberhard Fischer for kindly sending me information about all the masks featured in this section. See also Fischer 1978.

26. Adams 1982, 48; Fischer, personal communication, April 2006.

27. Amrouche 2006.

28. Harley 1950.

29. Johnson 1986, xi–xii, 45; Himmelheber 1960.

30. Adams 1982, 6; Himmelheber 1960, 198–234; Harter 1993; Homberger 1997.

31. The following description is based on Fischer 1978, 23; see also Bruyninx 2005.

32. Adams 2005, 197.

33. Himmelheber 1960; Fischer 1963.

34. Johnson 1986, 45–51, 55–56.

35. Here the spelling of his name is "Tro." Himmelheber 1960, 180–81.

36. Zlan (or Sra, another spelling of his name) is one of the artists who figure prominently in Himmelheber's studies. Himmelheber 1960.

37. Gallois-Duquette 2000, 155. This description is based on Gallois-Duquette 1983; see also Adams 1983, 23–24.

38. The Museu Nacional de Ethnologia in Lisbon was only founded in 1947.

39. Kjersmeier 1936, 7–8; Bernatzik 1933, 1944.

40. Irwin Hersey, who for years published the *Primitive Art Newsletter,* confirmed that these works appeared relatively late in the marketplace. Personal communication, March 3, 2006.

41. Gallois-Duquette 2000, 156.

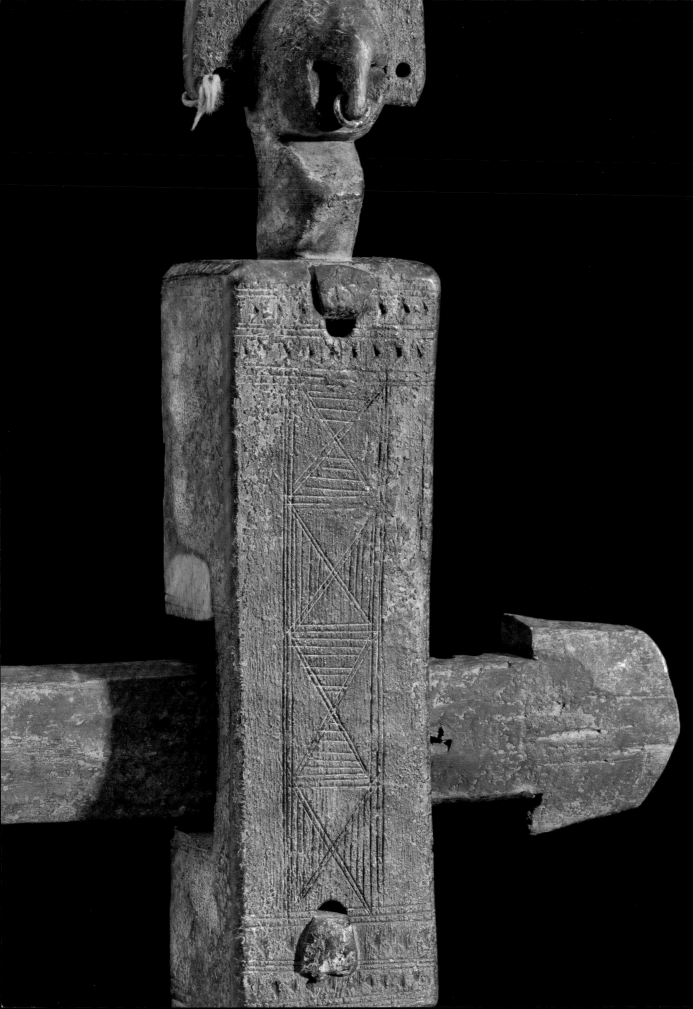

CHAPTER 4

BAMAKO

Bamako, the capital of Mali on the Niger River, is one of the cultural metropolises of western Africa—gateway to Dogon country and Timbuktu, the ancient town that so appeals to the Western imagination. Bamako's beginnings as a commercial and administrative center go back to 1883, when the French commandant Borgnis-Desbordes established a fort during the occupation of the region that became the French Sudan Territory.[1] In the 1950s, Bamako was a lively but rather small town. In a book about the Malian photographer Seydou Keïta, writer Youssouf Tata Cissé evokes the spirit of these times after the Second World War, when African veterans returned from military service and established themselves *en ville* to pursue careers in the colonial city. He describes new buildings, many of them in a French neo-Sudanic style; the Place de la République with its monuments; and the zoological garden. Taxis began to circulate, and Vespa scooters were prized possessions for well-to-do African men. The French Soudan Club admitted a select clientele, while other associations sprang up in the neighborhoods.[2] Keïta's portraits capture the joie de vivre and elegance that characterized Bamako in those days (fig. 15).

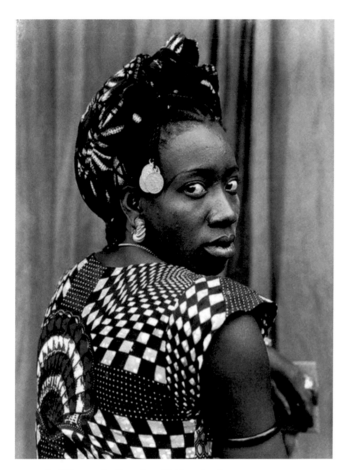

FIG. 15 Woman in Bamako, Mali, 1959–60.
Photograph by Seydou Keïta

FIG. 16 Art dealer Coulibaly (left) and his "brother,"
Bamako, Mali, 1976

On the eve of independence in 1960, Bamako had a small museum, part of the Institut français de l'Afrique noire (IFAN) museums established in many French colonies.[3] It later became the National Museum of Mali, now one of the premier institutions in Africa. Collectors, McMillan among them, stopped over in Bamako, which was a bit provincial compared to the shining cities of Dakar and Abidjan but still a major center of the art trade.[4] They frequented the shops of art dealers in town and combed through their

objects. Pascal James Imperato observed the organization of Bamako's traditional art market at that time.[5] The majority of smaller merchants worked out of their houses, visiting the resident collectors regularly with objects from their regions of origin (fig. 16).[6] Most African art dealers in Bamako were Muslim and thus were not greatly impeded by ritual restrictions when handling objects that came from non-Islamic peoples, restrictions that might endanger those who handled them without proper authorization or ritual

precautions. Many dealers were Malinke of Islamic faith from the neighboring country of Guinea, a pattern already observed in Liberia.

The top art dealers, with stores and galleries in town and as far away as Dakar and Paris, operated on an international level. El-Hadj Gouro Sow, a Fulbe who owned an apparel store in town, sold objects during his buying trips to Paris. Diongassy Almamy, who died in 1974, also traveled to Paris. Perhaps one of the best-known was Mamadou Sylla, of Malinke origin, from Guinea, who also had a store in Paris and died there in 1971. Moussa Diabaté ran a gallery in Bamako-Coura; his offerings ranged from modern copies and less significant works displayed in the front room to extraordinary objects held in reserve in a second chamber to the rear. When buyers entered his store, he would test their knowledge in the front room and take them to the back only if they seemed well informed about the arts. Like other merchants, he permitted only his best clients to see and buy the most important pieces. Thousands of objects went through these merchants' hands, although their names were disassociated from the pieces as soon as foreign buyers took possession. The objects became the European dealers' "discoveries," much as the stereotype of Westerners discovering unknown territories and reservoirs of objects permeated earlier writing about Africa and African art (see p. 16).

A second generation of upper-level art dealers entered the business in the 1980s, among them Mamadou Keita (the son of Niame Keita, another Malinke merchant active in Bamako and Paris until his death in 1989). Raymond Corbey interviewed Keita in Amsterdam, where he sells non-Western arts. When asked how he saw the roles of Africans in the business, Keita deplored the fact that most buyers were more interested in the objects than in the people who made and used them. He also had some disparaging words about the treatment of African merchants: "Some in this business have a tendency to see Africans as people who know nothing about their own culture and have no eye for art. . . . People here like to see the African in the role of the runner who brings things from Africa, which will then be judged by the western connoisseur, dealer, or collector. He [the African merchant] can't have an eye, patience, or love for pieces."[7]

Objects from the Bamana and Dogon peoples were among the most sought after offerings in Bamako. Western appreciation of the art of the Dogon has a particularly interesting history and provides an instructive example of Western attempts to understand and at times "invent" meanings for the arts in their local settings. Dogon country is a vast region extending into northwestern Burkina Faso and covering some fifty thousand square kilometers. The population may well exceed a million by now, living in more than seven hundred villages, many along the steep

FIG. 17 Dogon village near Sanga, Mali, 1976

slopes of the Bandiagara escarpment (fig. 17).[8] Well into the twentieth century, Dogon country remained difficult to access for Europeans, although the French established primary schools in the region after 1910, and Dogon men participated in both world wars for France, migrated to the coastal regions in search of seasonal labor, and returned to their villages with impressions of life abroad. Many of the consultants working with early researchers who studied the Dogon from the 1930s onward belonged to this group of men, a fact acknowledged only in passing in the forewords of the researchers' books.[9]

It took some time for Dogon objects to gain appreciation among Western connoisseurs. Collectors initially favored works closer to Western modes of representation and with fine surface treatments, such as Baule figures and Guro masks (see pp. 96–101). Some of the first Dogon pieces arrived in France with Lieutenant Louis Desplanges, whose 1907 book *Le plateau central Nigérien* contains in situ photographs of Dogon masquerades. Einstein depicted a Dogon piece in his 1915 book *Negerplastik*.[10] The Dogon, then referred to as Habbe, became better known to the French public through postcards, however, when the Dakar-based photographer Edmond François Fortier published images he took on a trip to the French Sudan from late 1905 to early 1906. The colonial exposition in Marseille in 1922 featured a pavilion[11] devoted to the French Sudan, which included an exhibition of Dogon objects, while Dogon dancers appeared at the Paris Colonial Exposition of 1931.

The history of Dogon art is closely connected with Michel Leiris and Marcel Griaule. Both participated in the 1931 Mission Dakar-Djibouti, the research expedition that brought back some three thousand six hundred objects from all over Africa, among them Dogon works not always acquired in ethical ways (see p. 24). The anthropologist Griaule and his disciples later focused their research entirely on Dogon culture, cosmology, and art and constructed a Dogon system of belief according to their own understandings and interpretations.[12] His colleague Leiris based his *L'Afrique fantôme* and other books on this voyage, heightening the fascination with the Dogon and their art.[13]

The intricate Dogon mythology, recounted by Griaule, and stunning masquerades aroused much interest. Visitors started arriving in Dogon country in the 1930s, and tourism on a larger scale began after the Second World War. Headpieces of masked dancers and sculptures—which, depending on scholarly interpretation, depicted creator deities, ancestors, or none of the above—achieved iconic status. By the 1940s, entrepreneurial residents in Sanga, where Griaule had set up his research site, staged masquerades but at the same time continued to perform them in their original contexts—during funerals and ceremonies (*dama*) held every two to three years in order to commemorate and honor the recently deceased. Today, tourists may "request" masquerades for a fee; on a good day, the masked dancers appear at least three times for different visiting groups. Even now, not all masquerades are directed toward outside spectators. Masquerades continue in some villages, although their internal meanings for the Dogon performers and spectators may have changed (see below). It is even misleading to speak of "Dogon masquerades" as a whole, for in a region as large as Dogon country, performances inevitably vary locally and have also mutated over time.[14] Constant adaptation, innovation, and reinvention are salient characteristics of masking traditions everywhere in Africa, although Western observers, in their search for the "traditional" and "primordial," tended to negate these processes.

The Dogon masks in the McMillan Collection left Mali through Bamako: some traveled from there to the art market in Abidjan, others to Paris, and some directly to the United States with African merchants. One of the most

spectacular works, a tall *sirige* mask, arrived in 1964 from the gallery of Claude Vérité, son of Pierre Vérité (cat. 22). The dramatic elongated shape of the mask—in some instances, *sirige* masks are up to five meters (seventeen feet) high—and the vivid geometric designs in red, white, and black pigment create a striking visual effect. In older works, such as this one, the pigments are derived from local substances, such as chalk for white, the sorrel plant for red, and seeds that yielded a black color, among others. More recent masks display the bright hues of imported paints from Europe. Like all *sirige* masks, this example features a rectangular face with strong parallel ridges framing two square eyes. An openwork plank composed of several sections towers over it, although most of the pieces of this mask have been lost. During performance, the masker balances the wooden assemblage on his head, stabilizing it by biting on a wooden crossbar at the back of the mask. It should be noted that, for the Dogon performers and on-lookers, the headpiece is only one part of the mask persona and forms an ensemble with the costume. The *sirige* performance is impressive: the masker, dressed in trousers and a fiber skirt, takes quick steps while balancing the structure on his head (fig. 18). In the most dramatic move of the performance, the *sirige* masker swoops his head forward and touches the ground with the tip of the mask.

While only one *sirige* mask performs during a traditional mask event, the second mask presented here— much more common, yet equally impressive—is danced in groups (cat. 23). *Kanaga* masks show strong, geometric facial features below a long central extension, with two horizontal planks forming a double-barred cross. Based on Dogon interpretations, scholars have identified this shape as a stork, placing it among the groups of other animal masks that appear during masquerade festivals.[15] In a grand spectacle, at times more than twenty maskers—

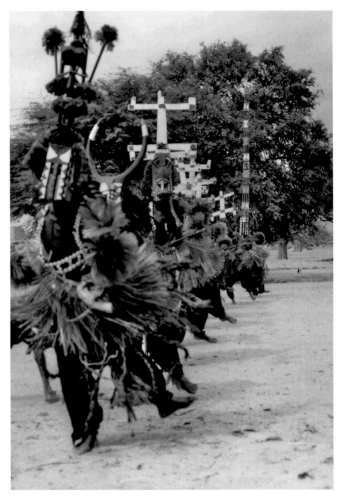

FIG. 18 Dogon *sirige* and *kanaga* masks in performance, Village of Lower Ogol, Cercle of Bandiagara, Mali, 1970

clad in trousers, short fiber skirts, and vests adorned with cowrie shells—appear in single file, vigorously rotating the tall masks in unison and rhythmically striking them on the ground.

The meaning of Dogon masquerades and masks has been open to much speculation, beginning with Griaule's interpretations.[16] Both *sirige* and *kanaga* are among more

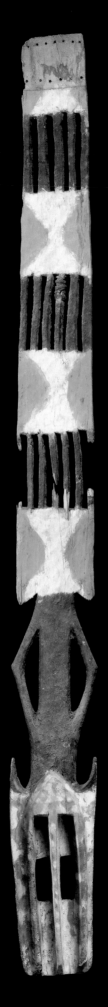

22 *Mask* (sirige)

Unknown artist or workshop
Dogon peoples, Mali
20th century
Wood, pigment, nail, rope
Main element: H. 228 cm, w. 22.1 cm, d. 19 cm
(H. 89¾ in., w. 8¹¹⁄₁₆ in., d. 7½ in.)
Upper fragment: H. 113 cm, w. 13.3 cm,
d. 2.2 cm (H. 44½ in., w. 5¼ in., d. ⅞ in.)
Acquired in 1964 from the Galerie Carrefour
(Claude Vérité), Paris

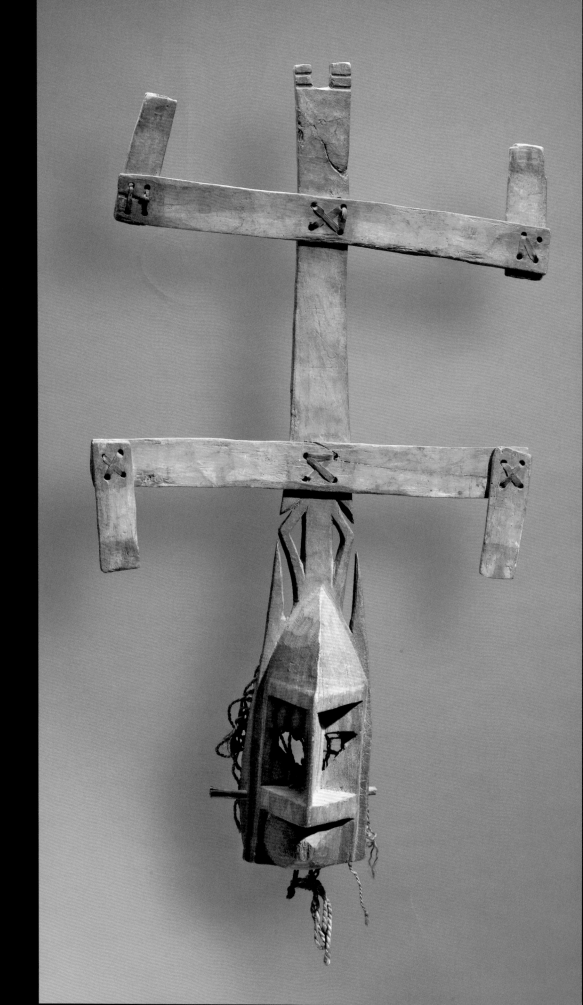

23 *Mask* (kanaga)

Unknown artist or workshop
Dogon peoples, Mali
20th century
Wood, leather, rope, pigment
H. 98 cm, w. 55 cm, d. 21 cm
(H. 38⁹⁄₁₆ in., w. 21⅝ in., d. 8¼ in.)
Acquired in the 1960s, Paris

than seventy-eight different mask types, ranging from animal to human and abstract configurations. Some masks have wooden headpieces manufactured by Dogon blacksmith-sculptors. Others consist of fiber or cloth and attached cowrie shells. Dogon beliefs and associated rituals revolve around ancestor beings who mediate between the realm of the living and the universe. Even though the Dogon began converting to Islam after the Second World War, many elements of the Dogon worldview persist in some form or another. Masquerades, collectively organized by Ava (or Awa), a men's society, were part of complex funerary rituals that facilitated the transition of the deceased into the realm of ancestorhood. When a man died, several maskers with fiber masks and the *sirige* masker appeared two days after his burial to properly mourn his death. As the performance unfolded, every movement and act of the maskers held significance. In a deeply meaningful gesture of mourning, the *sirige* masker touched the ground with the tip of his superstructure during the ritual, a move that has now become an acrobatic highlight during performances for tourists.[17]

The *dama* ritual to commemorate the deceased and give him a proper send-off occurred several years after the death and took months of organizing. From procuring food to carving new masks and producing costumes, the preparations were intense and culminated in a six-day ritual. Several hundred maskers could be in attendance, depending on the importance of the deceased. The largest Dogon mask performance, however, was the *sigi*, a ritual commemorating the mythic death of the first ancestor. It occurred every sixty years and lasted more than six years. The most recent *sigi* took place from 1966 to 1974, and it is not yet known whether another one will follow in 2026.

In the meantime, masking thrives among the Dogon. Masks are fashioned on a regular basis, yet in changing conditions and for different purposes. Carvers create masks in traditional styles, among them *kanaga* and *sirige* types, for frequent tourist events, and visitors often buy the masks after the performances are over. At the same time, people commission masks for their own events, away from the tourist performance spaces in the villages. Polly Richards and Mary Doquet, who studied contemporary Dogon masking, attended such dances and found that, unlike foreigners, who prefer muted colors and ancient motifs, local audiences favor brightly colored masks with Western accoutrements. Richards mentions one type of mask representing a Fulani woman that was adorned with pill packets and monosodium glutamate wrappers.[18] In a rather ironic twist, the locals enjoy novelty and are constantly inventing new mask types, while the foreigners want their African masking experience "pure." Similar phenomena challenge Western notions of authenticity in African art among the Igbo (see fig. 2).

Dogon blacksmith-sculptors created these masks and figures—and other objects, ranging from stools, bowls, and containers to iron objects and necklaces—which found their way into collections. Architectural elements, such as doors with registers of figurative relief carvings and shutters for granaries, attracted attention early on. Leo Frobenius, the German scholar and ethnological entrepreneur, conducted an expedition through the French Sudan from 1908 to 1910 and collected many "ethnographic specimens" such as doors and locks. One of these doors went to the Berlin Museum of Ethnology, and the museum's director published it in 1918, making it possibly the first published image of a Dogon door.[19] From the 1980s onward, such doors often became obsolete as building styles changed. A weathered shutter in the McMillan Collection once protected millet, rice, and other staples in a granary (cat. 24). It was mounted halfway up the structure,

and the small projections at the bottom and the top were inserted into a wooden frame so the door could open and close. The shutter consists of two joined parts with breasts on each side, alluding to fecundity in both farming and human procreation.[20]

A wooden door lock (cat. 25) belongs in the same context. Although these beautifully shaped and deeply meaningful works were utilitarian objects, Western appreciation moved them from ethnographic artifacts to works of art. Similar locks had a wide distribution in this part of Africa and could be found among the Bamana, Senufo, Mossi, Bwa, and other peoples, but in each case structural and formal features differ slightly. One of the earliest depictions of two Dogon locks, with two seated figures representing primordial beings (nommo), appeared in Desplagnes's report about his mission to the French Sudan.[21] Paris galleries carried many locks, especially after the Second World War. They remain one of the favorite items of collectors to this day because they are affordable and beautiful.[22] The most elaborately carved locks (ta koguru) were mounted on the left front of wooden doors, often in granary doors and smaller entryways to rooms in the compound, while larger and plainer locks of a different type secured the entryways to houses. The locks consist of a beam (ta koro), often in figurative form; a horizontal cross beam (ta dagu), which moved back and forth in a hollowed-out area in the back of the vertical beam; and a key (ta i) to secure the lock in place with metal prongs.[23] In many instances, the locks in collections are fragments, missing keys, as in this lock, and cross beams.

The locks, which come in many configurations, project the Dogon worldview and allude to the complex myth of creation documented by Griaule and other researchers.[24] The narrative relates that Amma, the creator god, made the world from clay and created the first human couple,

nommo. In this lock, the vertical beam forms a torso surmounted by a schematic head, barely evoking the human form. Both beams carry fine, pyro-engraved geometric surface designs. The lock may belong to a relatively rare type depicting a single nommo. However, another interpretation suggests that the top part might represent a hitching post for a horse, a prestigious animal and the proud possession of well-to-do Dogon men.[25]

Bamana[26] locks are even more numerous in collections than are their Dogon counterparts, and Bamana figurative sculptures and masks appeared earlier than Dogon objects in art collections in the West. The first Bamana pieces arrived at the Musée du Trocadéro before 1900. In 1910, Joseph Henri, a former missionary among the Bamana, published some of the earliest images of maskers and masks. The photographs, taken by the Révérend Père Dubernet, appeared in the book Les Bambara along with the first depictions of ci wara performances, which would become famous among scholars and collectors in later years (see below).[27] Bamana works went on display at the Galerie Levesque in Paris in 1913 and can be seen in a 1914 photograph of Georges Braque's studio. Einstein published two figures in 1915, and Kjersmeier presented seventeen plates of Bamana masks and figures. Sweeney included many Bamana works in the 1935 MoMA exhibition, highlighting the abstract ci wara headdresses.[28] Robert Goldwater's 1960 catalogue Bambara Sculpture from the Western Sudan, which accompanied the earliest exhibition devoted to one African people, at the newly founded Museum for Primitive Art in New York, influenced scholarship, collecting, and, by extension, the art market in the United States.[29]

The Bamana, whose art caused so much excitement, live in west-central Mali and today number more than 3 million, making them the largest group in that country. They are part of the Mande family of peoples, which

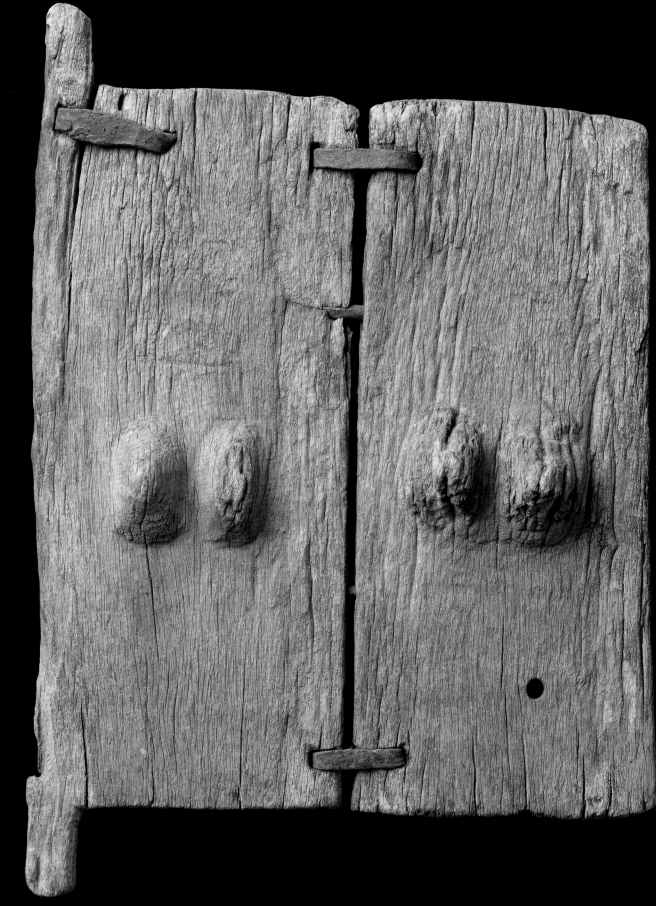

24 *Granary shutter*

Unknown artist or workshop
Dogon peoples, Mali
20th century
Wood, metal
H. 34.3 cm, w. 25.5 cm, d. 4.5 cm
(H. 13½ in., w. 10⅟₁₆ in., d. 1¾ in.)
Acquired in 1974, Bamako, Mali

25 *Door lock*

Unknown artist or workshop
Dogon peoples, Mali
20th century
Wood, metal nails
H. 39.7 cm, w. 37 cm, d. 4 cm
(H. 15⅝ in., w. 14⁹⁄₁₆ in., d. 1⁹⁄₁₆ in.)
Acquired in the 1970s in Bamako, Mali

extends into Senegal, Guinea, and Côte d'Ivoire. The term "Bamana," however, is a classic example of the mistaken effort to compartmentalize African peoples into homogenous ethnic units. The "condition of being Bamana" (*bamanaya*) relates less to a fixed ethnic entity and more to "certain religious representations and practices, a way of explaining the world and acting on it through rituals in order to achieve happiness."[30] It is a pervasive and attractive way of life, and thus Bamana ethnicity is fluid. Like the Dogon, the Bamana initially did not practice Islam, which set them apart from their Muslim neighbors. However, the influences of Islam have been obvious in many domains, including material culture, and today many Bamana have converted.[31] Since Bamana identity has been in constant flux, the distinctions between Bamana, Bozo, Malinke, Marka, and other peoples in the region, who share closely related institutions and worldviews, seem to blur. Consequently, works of art from this region do not fit neatly into the earlier classifications. Bamako is Bamana territory, and while many Bamana have settled in urban areas, the majority remain farmers, cultivating millet and other grains and keeping cattle, goats, and sheep.

There are more than fifty masks, figures, door locks, and heddle pulleys in the McMillan Collection, demonstrating McMillan's appreciation for Bamana artistic creativity and reflecting the canon of Bamana arts in the West. Locks take a prominent place. Like all works in wood and iron, they come from the hands of blacksmith-sculptors (*numuw*). *Numuw* belong to a class of people known as *nyamankalaw*, which includes leatherworkers, potters, poets, and praise singers. They possess special skills and also control *nyama*, a force of power and energy acquired through ritual processes with which they infuse their works.[32] Their carving repertoire encompassed handles for implements and stools, and particularly gifted and skillful artists turned their attention to figurative sculptures, masks, and door locks. Patrons traveled long distances to commission works from sculptors of renown.

The locks, once attached to the doors of houses, granaries, or poultry shelters, are exquisite small carvings with meanings derived from Bamana esoteric knowledge. The three shown here illustrate the standardization as well as the subtle variation of the basic utilitarian form. McMillan acquired her first anthropomorphic lock in 1954 (cat. 26a). This type of lock alludes to *komo*, a power association that imparts its secret knowledge to its male members. *Komo* guides males from birth and boyhood, through initiation into adulthood, through marriage and old age and officiates at their deaths. *Komo* is perhaps best known for its dramatic headdresses—with their powerful accumulations of organic materials, animal horns, fur, and medicinal substances—and its riveting performances.[33] In this lock, a stylized rendering of the *bamada* men's hat, reserved for Bamana elders and *komo* members, tops the figure's head. The tapering, triangular shape of the body recalls the head of a python, which symbolizes the creator god, and the incised geometric patterns also may have meanings beyond sheer decoration. Its fine patina and bloom, which are typical for Bamana locks, are evidence of age and frequent use. The headdress, abstracted face, and prominent neck in a second lock evoke associations with *komo* as well (cat. 26b). A third lock contains the same elements as the first but in a much more angular configuration (cat. 27). The rectangular, elongated body stands on two legs, and triangles adorn its surface.

Today, these locks have essentially disappeared from the Bamana architectural spectrum, replaced by foreign-made types that seem to fit the functional purpose just as well, if not better. In addition, new building styles using different types of doors may have led to the discarding or selling of

26a *Door lock*

Unknown artist or workshop
Bamana peoples, Mali
20th century
Wood, iron
H. 37 cm, w. 6.3 cm, d. 6 cm
(H. 14⁹⁄₁₆ in., w. 2½ in., d. 2⅜ in.)
Acquired in 1954 from the Galerie
Burgui (J. Nicaud), Paris
Pub. Adams 1983, 16; Exhib. Boston
Athenaeum 1983

26b *Door lock*

Unknown artist or workshop
Bamana peoples, Mali
20th century
Wood
Overall: H. 42.7 cm, w. 8.3 cm,
d. 7.5 cm (H. 16¹³⁄₁₆ in., w. 3¼ in.,
d. 2¹⁵⁄₁₆ in.)
Acquired in the 1960s, Bamako, Mali

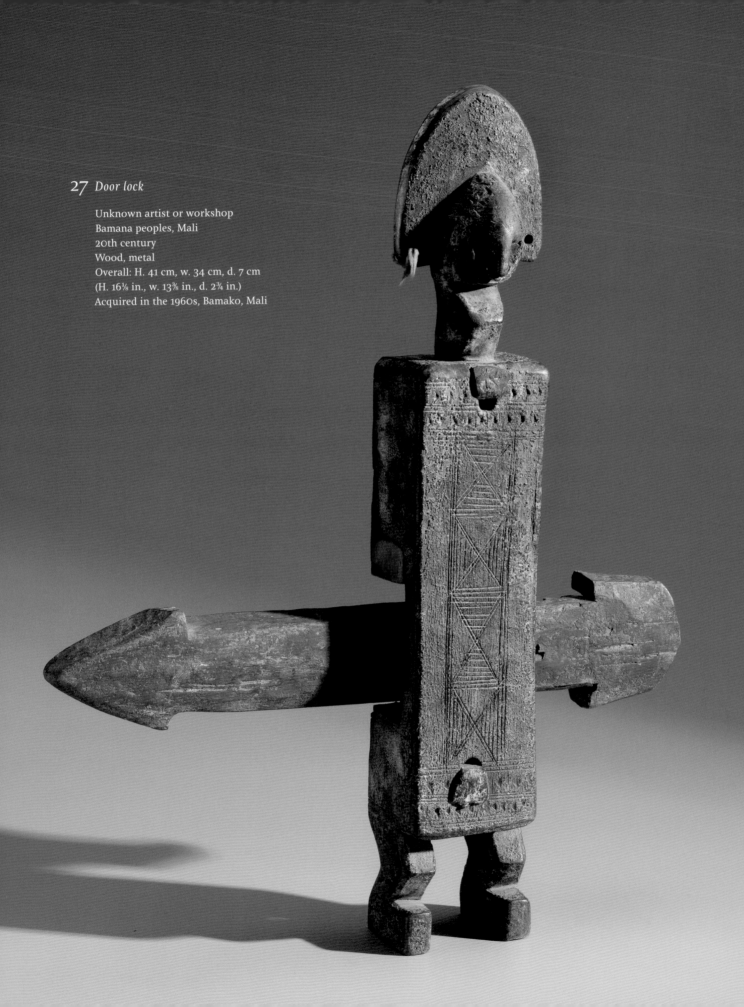

27 Door lock

Unknown artist or workshop
Bamana peoples, Mali
20th century
Wood, metal
Overall: H. 41 cm, w. 34 cm, d. 7 cm
(H. 16⅛ in., w. 13⅜ in., d. 2¾ in.)
Acquired in the 1960s, Bamako, Mali

both locks and doors.[34] The visual associations of the older locks with *bamanaya*—the way of the Bamana—are probably less desirable because an increasing number of Bamana have converted to Islam. A recent iconoclast movement among members of the fundamentalist Wahabiya began to erase any visual allusions to *bamanaya*.

The ethos of *bamanaya* also manifested itself in hunters' shirts and headdresses, stunning accumulations of potent substances to ritually protect and fortify their wearers and set them apart from ordinary people (cat. 28).[35] Initially, such powerful objects were outside the purview of African art collecting and, for that matter, beyond the comprehension of Westerners. They began their journeys into art collections only in the 1960s, when shifts in scholarship and taste integrated textiles and dress into the realm of art. In the United States, Roy Sieber organized the MoMA exhibition "African Textiles and Decorative Arts," which did for textiles and jewelry what Sweeney's 1935 exhibition "African Negro Art" at the same institution had accomplished for African sculpture.[36] Another shift was equally important in moving these works into the domain of art, namely the recognition that in certain areas, African artists and patrons may favor the aesthetics of accumulation, adding to sculptural forms and thus increasing their impact and power over their lifetimes.[37] This hunter's tunic with flowing leather straps, purchased in Bamako, is a perfect example of accumulation. It once belonged to a heroic hunter who ventured into the wilderness outside the cultured space of the village, where he confronted unpredictable spirits and dangerous animals that could jeopardize his mission. The tunic fortified the hunter, because each horn contained strong medicines (i.e., ritual substances), as did the horns attached to the front of the hat. In search of efficacy, Mande hunters also drew on external sources to augment the tunic's potency, attaching imported mirrors and Islamic leather amulets that held inscribed verses of the Koran. Fellow hunters at times also contributed amulets to the work in progress. The hunters, however, did not wear these tunics for actual hunts but donned them during festivals and public manifestations as a sign of distinction and their elevated role in Bamana society.[38]

Most collections formed after the Second World War contain at least one example of one of the most recognizable works of African art: the beloved antelope headdress, part of a mask belonging to the members of the *ci wara* association. Actual terms for these masks include *wara-kun* or *sogo-ni-kun*, among others. *Ci wara* headdresses have been de rigueur in private homes and collections, whether authentically made and used, copied, faked, or even produced in places other than Mali; we know of examples from Cameroon and even from outside the African continent (fig. 19). Their intriguing forms appeal to jewelers, interior designers, and filmmakers (in movies, *ci wara* headdresses distinguish the abodes of sophisticates), while their context has fascinated students of African art since the first *wara-kun* arrived in the Musée du Trocadéro in 1882. De Zayas published a photograph of a headdress from the Trocadéro in 1916, and Kjersmeier included twelve plates of *ci wara* headdresses in his 1935 analysis of stylistic centers of African sculpture, praising their stylization and abstract shapes.[39] One of the eleven *wara-kun* in the McMillan Collection demonstrates some of the striking elements of such sculptures (cat. 29). The headdress consists of several parts: a horizontal animal figure with body and head carved separately and joined at the neck, and the small zoomorphic superstructure. A basket supports the inserted wooden piece. Scholars and collectors noticed that *ci wara* headdresses belong to two types: horizontal *wara-kun* that come from the west of the Bamana region and vertical ones that are typical of the east.

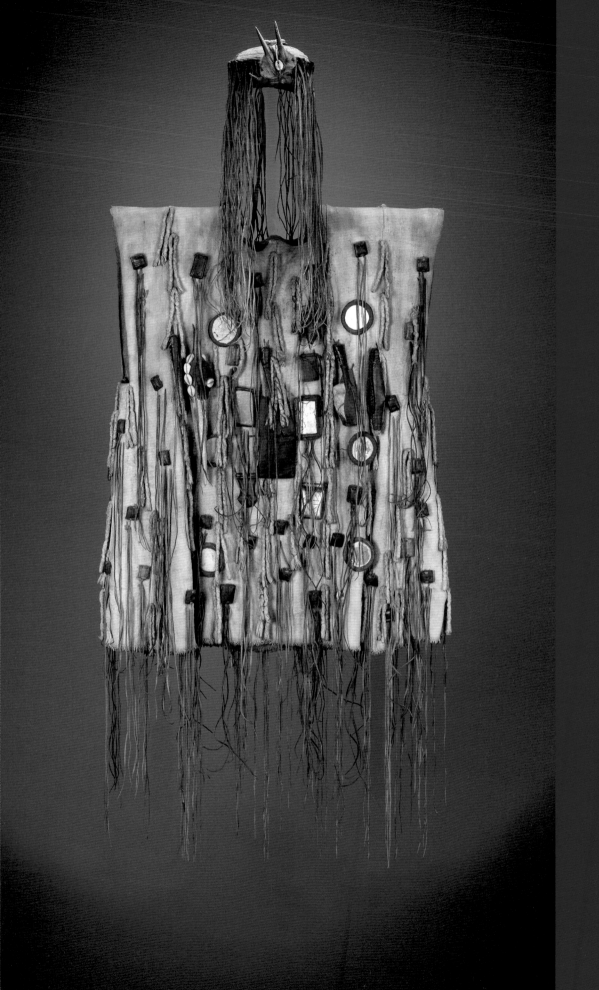

28 *Hunter's tunic and hat*

Unknown artist or workshop
Mande peoples, Mali
20th century
Cloth, leather, mirrors, metal, horn
or bone, shells, bird skulls, fur,
paper, yarn
Overall (tunic): H. 86 cm, w. 66 cm
(H. 33⅞ in., w. 26 in.); overall (hat):
H. 26 cm, w. 16 cm, d. 16 cm
(H. 10¼ in., w. 6⁵⁄₁₆ in., d. 6⁵⁄₁₆ in.)
Acquired in the 1960s, Bamako, Mali
Pub. Adams 1982, 116–18; Van Dyke
2001; Exhib. De Cordova Museum
1978; Carpenter Center, Harvard
University 1982; Fogg Art Museum,
Harvard University 2001

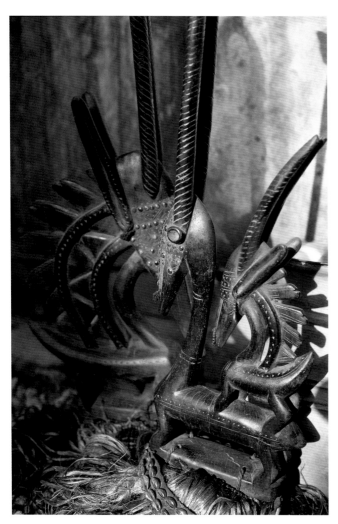

FIG. 19 *Ci wara* headdresses in a workshop, Bamako, Mali, 1978

taught men the art of farming, for they knew the secrets of the earth. Colleyn distinguishes three events at which *ci wara* maskers appeared: agricultural competitions, annual celebrations, and public entertainments. During competitions, two maskers performed in pairs—male and female—their faces covered by red fabric hoods with the headpieces towering over them. Black fiber tunics concealed their bodies. A 1905–6 postcard by Fortier seems to be the earliest widely distributed image of such a masquerade (fig. 20). Carefully staged near the Niger River, it captures the essence of the performance. The two maskers with vertical headdresses, bent slightly forward, support themselves on batons. One of these batons is a *boli*, an object that carries mystical power, for it has received ritual substances and a blood sacrifice to endow it with the vital force *nyama*. To the right, young men demonstrate the hoeing motion and how they compete with one another, quickly completing their rows. To the left, an orchestra of four young men accompanies a chorus of young girls chanting songs to challenge and encourage the young farmers.

Many *ci wara* masquerades no longer take place on a regular basis. Agriculture changed with the advent of modern plows, and young men leave their villages in search of employment. In recent decades, *ci wara* performances have moved to cultural festivals and political events, a tradition that began during French colonial times when maskers appeared at July 14 festivities celebrating the *prise de la Bastille* (France's national holiday). Bamana or other Malians may reinvigorate these masquerades at some future time, much as people in other parts of Africa have revived performances in new contexts. For now, *wara-kun* have become synonymous with Mali—a national emblem, a pan-African icon on postage stamps and in tourist brochures, and much appreciated works of art in many collections (fig. 21).

Contextual analyses reveal the meaning of these fascinating forms.[40] *Ci wara* initiated young men into adult tasks, among them successful cultivation of the fields. This headdress depicts a female antelope combined with a hybrid animal configuration, possibly an anteater or a pangolin. According to Bamana thought, both animals and snakes

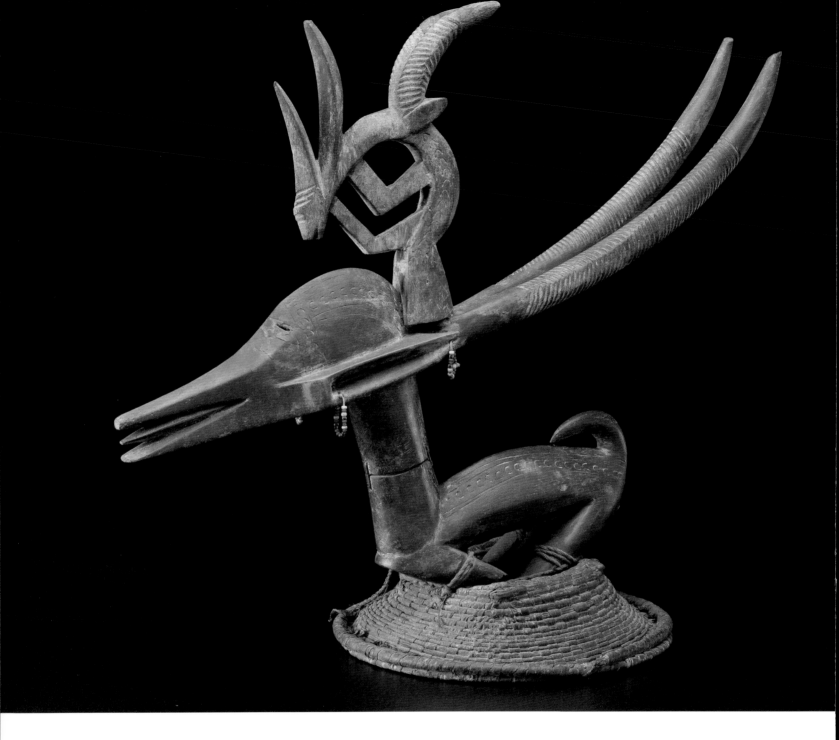

29 *Headdress* (ci wara)

Unknown artist or workshop
Bamana peoples, Mali
20th century
Wood, basketry, metal, beads, string
H. 39.8 cm, w. 21.5 cm, d. 52 cm
(H. 15¹¹⁄₁₆ in., w. 8⁷⁄₁₆ in., d. 20½ in.)
Acquired in the 1960s, Bamako, Mali

In 1989, the National Museum of African Art of the Smithsonian Institution released the video *Togu na and Cheko,* celebrating two other Malian art forms: the Dogon *togu na* or men's meetinghouse, an open structure supported by figurative carved posts, and the *sogo bò,* a puppet theater and masquerade that takes place in many Bamana communities and among the Bozo, the Bamana's closely related neighbors.[41] The film captures vigorous, colorful performances of animal masqueraders accompanied by singing and clapping as well as smaller rod puppets in stagelike settings, their puppeteers hidden within large textile enclosures. Organized by village youth associations, whose male and female members range in age from fourteen to about thirty-five, the theater's aim is entertainment, allowing young men and women to explore the Bamana moral universe and gain knowledge through play, humor, satire, and wit.[42]

Puppets and masks used in these performances entered collections early on, but their context remained evasive, partly because they arrived as fragments removed from their settings. The wooden head of the puppet in the McMillan Collection displays a "Dogonesque" arrow-shaped nose and mouth in lozenge form, deeply set eyes, and pronounced facial planes that attest to the carver's borrowing of forms (cat. 30). Furniture tags, an import from Europe that African artists have integrated into their designs since the nineteenth century (see p. 173), enhance its forehead and headdress. The object's configuration identifies it as a *merekun* puppet, representing a female character that may have been attached to a larger puppet figure. Larger puppets fastened to rods and masks wear various types of clothes that reveal the characters they embody: favorite or promiscuous wives, philandering or miserly husbands, various animals, even politicians and entertainers. They act

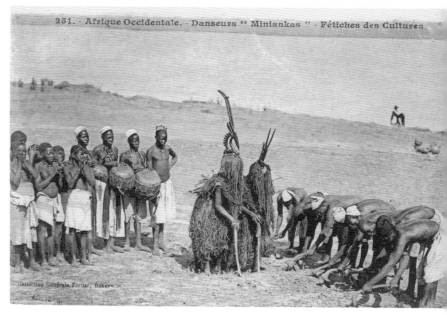

FIG. 20 Bamana *ci wara* maskers, French West Africa (now Mali), about 1906

FIG. 21 Stamp for the Festival Mondial des Arts Nègres, issued by the Republic of Niger, 1966

out scenes that allude to domestic relationships and the shared ideals of the people who reside in the region. Young men move the puppets invisibly from behind an enclosure or perform them and give them voice in songs that focus on a theme, for instance, harmony and cooperation between the sexes. Thus, this particular puppet was most likely part of a male-female pair in performance.

Animal masquerades are the oldest and most common form of performance. In fact, *sogo bò* may be translated as "the animals come forth."[43] The representation of powerful animals, such as the lion and the hyena, allude to the hunter's ethos—the striving to excel and gain prestige through action—while others draw their meanings from different domains. This animal head with the elegantly curving horns and boldly polychromed surfaces represents the sheep (*saga*) and was probably attached to a rod (cat. 31). A huge fiber skirt with a cloth on top once covered the performer who activated it.

Scholars stress the regional identity of these masquerades, which, although common in Bamana farming villages in the Ségou region, most likely originated with the Bozo fishermen who live along the Niger River.[44] The theater began in the second half of the nineteenth century, evidence that African art forms never have been timeless or primordial (a stereotype discussed in chapter 1) but rather are historical phenomena that evolved, changed, and at times went out of fashion. Mary Jo Arnoldi traced the complex histories of the *sogo bò* and their link to economic, social, and political conditions throughout the twentieth century.[45] In the last decades, several Bamana communities have become famous for their inventive *sogo bò* displays, and the Malian Ministère de l'artisanat et du tourisme now mentions these performances on its Web site under *manifestations culturelles* (cultural manifestations). Announcements of puppet theater performances in Markala

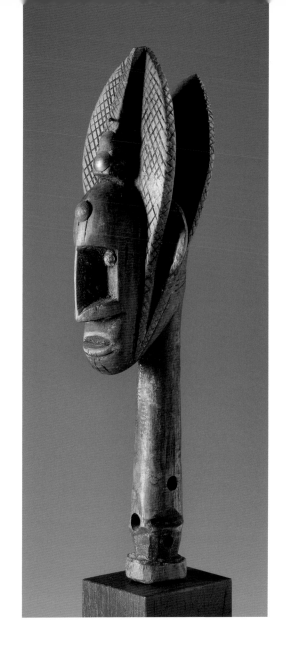

30 *Puppet head* (merekun)

Unknown artist or workshop
Bamana peoples, Mali
20th century
Wood, brass tacks, nail
H. 31 cm, w. 7 cm, d. 8 cm (H. 12³⁄₁₆ in., w. 2¾ in., d. 3⅛ in.)
Acquired about 1955 from the Galerie Carrefour (Pierre Vérité), Paris

31 *Sheep's head*

Unknown artist or workshop
Bamana peoples, Mali
20th century
Wood, pigment, metal
H. 23 cm, w. 38 cm, d. 47 cm
(H. 9 1/16 in., w. 14 15/16 in., d. 18 1/2 in.)
Acquired in the early 1980s from
an African dealer, Cambridge

32 *Sistrum*

Unknown artist or workshop
Bamana peoples, Mali
20th century
Wood
H. 55 cm, w. 34 cm, d. 15 cm (H. 21⅝ in.,
w. 13⅜ in., d. 5⅞ in.)
Acquired in the 1960s from Mr. Coulibaly,
Bamako, Mali

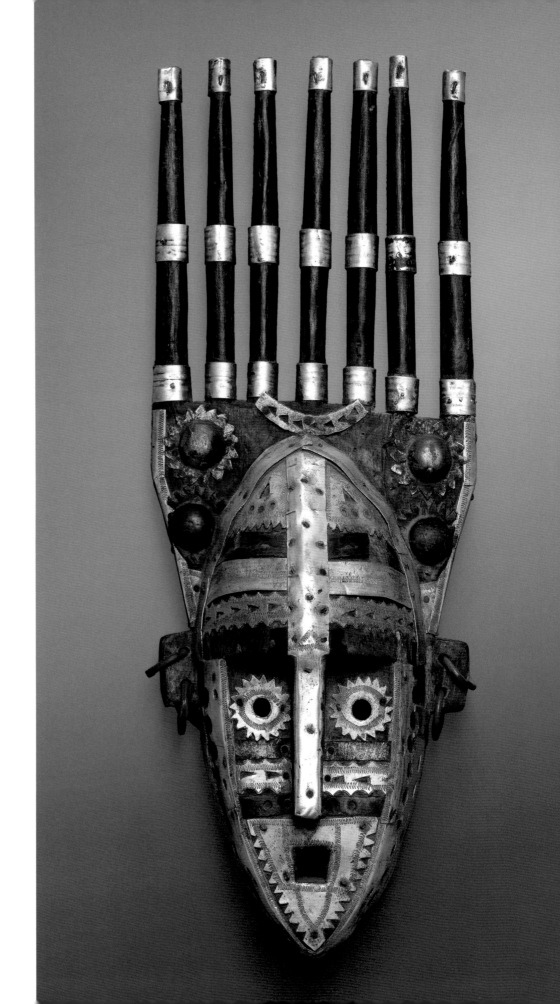

33 Ntomo *mask*

Unknown artist or workshop
Malinke peoples, Mali
20th century
Wood, aluminum alloy
H. 50 cm, w. 19 cm, d. 12.5 cm
(H. 19¹¹⁄₁₆ in., w. 7½ in., d. 4¹⁵⁄₁₆ in.)
Acquired in the 1990s from Mrs. Sillah,
Cambridge

FIG. 22　Indigo-dyed cloth in a market in Brazzaville, Republic of the Congo, 1966

found among the Bamana and their neighbors, such as the Malinke, teaches youngsters to behave properly and readies them for adulthood. Colleyn cites an *ntomo* song as a good example of the ways in which older men and women transmit knowledge. "Close your mouth firmly, close your mouth; the mouth is the enemy," instructs the song, stressing the importance of secrecy, a virtue among the Bamana and their neighbors.[49] *Ntomo* masks are easily recognized by the extensions on top and the embellishments, in many instances, cowrie shells and pieces of mirrors. This mask is typical of the more recent works that reached collections after 1960. It comes from the Malinke realm, and distinctive hammered aluminum strips and decorative elements, reminiscent of Islamic design, cover its face and the horns.[50]

Bamako remains a lively market for collectors of African art. The emphasis, however, seems to have shifted from figurative sculpture and masks to works in leather and beautiful textiles from West Africa (fig. 22). Nowadays, Mali's capital is better known for its active National Museum and many festivals promoting contemporary art and photography. The most famous of these events, the biannual Rencontres de la photographie africaine, brings photographers from all over Africa and around the world to the town on the Niger River, adding to Bamako's international flavor.

and Kayes, two towns in Bamana country, are posted next to listings of Dogon masquerades.

Other works also came to the McMillan Collection through Bamako, such as this sistrum, a type of musical instrument depicted in Goldwater's 1960 catalogue of Bamana arts (cat. 32).[46] One of McMillan's more recent pieces is an *ntomo* mask, which also journeyed through Bamako (cat. 33). These masks are among the favorites of Western collectors. Kjersmeier, for instance, found them harmonious and well proportioned and placed them among the most precious of African masks.[47] One of the first images of such a mask appeared in Henri's book about the Bamana, in which he correctly identifies *ntomo* as a children's association.[48] Indeed, this association,

NOTES

1. In 1880, the French designated the region that is now Mali "Upper Senegal" and in 1890 renamed it "French Sudan Territory." It was one of eight territories of Afrique occidentale française (AOF).

2. Cissé 1995.

3. Institut français de l'Afrique noire, a governmental research branch, became Institut fondamental de l'Afrique noire after the colonies gained their independence.

4. Next to that of Abidjan, the Bamako art market may be the best described of its kind. Hélène Leloup, a Paris art dealer, devotes a lengthy chapter to its expatriate and African players in *Statuaire Dogon*. Leloup 1994, 77-78.

5. We thank Dr. Imperato, a medical doctor in Mali from 1966 to 1975 and an expert on Bamana and Dogon art, for sharing his knowledge about the Bamako art market with us. Telephone interview, April 20, 2006.

6. Imperato stated that merchants regularly came to his house in central Bamako in order to show him their latest offerings.

7. Corbey 2000, 159.

8. Population statistics in many African countries are approximations. These numbers come from Richards 2000, 108.

9. To present just one example, Leiris acknowledges his Dogon assistant Amabara Ambata, who helped him with research on masking. Ambata spoke French, had attended school in Sanga between 1915 and 1919, and spent several months in Bamako. Leiris 1948, x.

10. Desplanges 1907, pl. 81; Einstein 1915, 66.

11. See fig. 12, p. 51, in the background; Leloup 1994, 67-68.

12. See Griaule 1938, 1965; Griaule and Dieterlen 1986.

13. Leiris 1934.

14. Imperato 1971; Richards 2005.

15. Van Beek 1994, 69.

16. *Masques dogons,* more than eight hundred pages long, is one of his classic books. Griaule 1938.

17. Imperato 1971, 33.

18. Richards 2000, 117-18; Doquet 1999.

19. Luschan 1918, fig. 63, p. 103.

20. A similar shutter, probably collected during the same time period, is in the Lester Wunderman Collection at the Metropolitan Museum of Art. Ezra 1988, 92.

21. Desplanges 1907, pl. 53, fig. 112.

22. There are many publications about locks from the Dogon and the Bamana; see, for example, Imperato 1972, 1978, and 2001, and Bilot 2003.

23. Imperato 1978, 54.

24. For a concise version, see Ezra 1988, 18-21.

25. Imperato 2001, 87.

26. The Bamana are also known as "Bambara," an ethnonym introduced by the French based on information they received from neighbors of the Bamana; this term is used in earlier literature.

27. Henri 1910, in particular, 143 and 144; see also Geary 1995.

28. Leloup 1994, 65; Einstein 1915, pls. 6, 25; Kjersmeier 1935, pls. 1-17; Sweeney 1935, 31-33, and pls. 4-12.

29. Goldwater 1960, figs. 45-76; see also Geary 2004, 32.

30. Colleyn 2001a, 19-20.

31. Bravmann 2001.

32. McNaughton 1988.

33. Imperato 2001, 56-61; McNaughton 2001a.

34. Imperato 2001, 35-38. McMillan owns a complete Bamana door with an attached lock.

35. McNaughton 1982.

36. The exhibition included several war and hunters' tunics. See Sieber 1972; McClusky 2002, 64-65.

37. Rubin 1974.

38. McNaughton 1982.

39. de Zayas 1916, pl. 17; Kjersmeier 1935, 16-17 and pls. 6-17.

40. We rely here mainly on Colleyn 2001b, 201-8; Imperato 1970; and Wooten 2004.

41. *Togu na and Cheko* 1989. The video accompanied the exhibition "Icons: Ideals of Power in African Art." Cole 1989.

42. Arnoldi 2001, 77-78.

43. Ibid., 78.

44. See Arnoldi 1995, 2001.

45. Arnoldi 2001.

46. Goldwater 1960, 34.

47. Kjersmeier 1935, 16.

48. Henri 1910, 93.

49. Colleyn 2001c, 95.

50. See the cover of *African Arts* 1997, v. 30, n. 1 (winter).

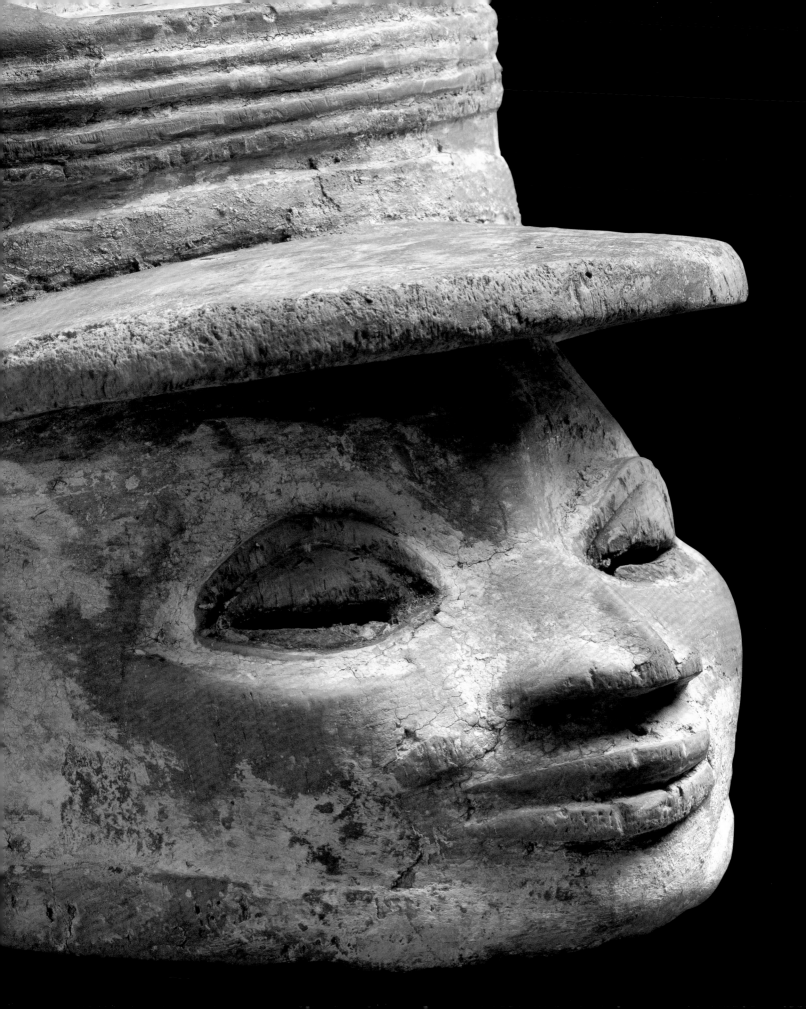

CHAPTER 5

ABIDJAN—ACCRA—KUMASI—COTONOU

Abidjan has played an important role among the cities along the West African coast. Waves of people from the region, Europe, and later the United States moved to and through it, leaving their traces and making it truly cosmopolitan. Until the political situation began to deteriorate in Côte d'Ivoire in 1999, Abidjan was West Africa's most important art market, the turnstile for objects from francophone African countries and beyond. The city had developed at a rapid pace. A sleepy settlement in 1899 and then the administrative seat of the French colony Côte d'Ivoire, it became the thriving capital and economic hub of independent Côte d'Ivoire after 1960.[1] Life in Abidjan was exciting and good. Africans flooded into the city from everywhere, and expatriates and well-to-do Ivoirians enjoyed such amenities as grand hotels and elegant stores. The headlines in *Balafon*, the glossy magazine of Air Afrique, offer a sense of the times: "Un rêve sort de terre: La riviéra africaine" (A Dream Emerges from the Land: The African Riviera) (1971), "Abidjan, carrefour de toutes les Afriques" (Abidjan, the Crossroads of all Africas) (1988), and "Abidjan, perle ivoirienne" (Abidjan, the Ivorian Pearl) (1991).[2]

Daniel Crowley described the art market for the readers of *African Arts* after a quick tour of the city in 1974:

> *Abidjan, Ivory Coast.* This steamy "Pearl of the Lagoons" illustrates the not-so-ancient adage that "The art (or research) goes where the money is." Abidjan's art market in the Central Park of the Plateau has more good pieces than any other West African market visited. The kiosks are full of garish tradegoods, with only a few old bracelets displayed. But if one is persistent enough, trunks are opened and flight bags unzipped to produce at least a few fine Senufo and Baule heddle pulleys, Ashanti combs, an occasional Baule or Guro mask of great elegance, some Dan, Guere [Wè] and other Poro masks and paraphernalia, and Baule and Ashanti goldweights[3] of all degrees of age, beauty and authenticity. The prices are very high indeed, and the Wolof traders are implacable.[4]

Crowley's account alludes to the difficult issues of connoisseurship, taste, authenticity, and discovery—all prominent in the discourse about African arts in these years.

The complex organization of this art market, with its extensive networks through Côte d'Ivoire and beyond, all the way to Europe and the United States, is the topic of Christopher Steiner's 1994 study *African Art in Transit*. He observes that

> art is sold from both open-air and indoor market places where traders display their goods on wooden or concrete shelves in covered stalls. Art is sold from warehouse-like shops, where the merchants conduct their business from rooms jammed full with their stock-in-trade. Art is sold out of merchants' private homes and compounds, where objects are stored in cabinets, dresser drawers, and under beds. Art is sold from roadside stands along the route to the seashore beaches and resorts, as well as on the beaches themselves by ambulant peddlers. Finally, art is sold in up-scale galleries (both independent stores and hotel gift shops), where objects are individually priced, carefully lighted, and displayed in climate controlled surroundings.[5]

Steiner emphasizes the entrepreneurship of Africans involved in the trade and draws a picture of men seeking opportunities to better their lot. In this setting, African art is a commodity, and the dealer's challenge is to gauge the clients' taste and interests. Certain types of objects may evolve into collectors' items, while the popularity of others recedes over time. African merchants must be attuned to these constant changes and aware of demand and supply.

Abidjan was one of the collectors' favorite cities, and McMillan went there several times. Like many visitors, she preferred to shop at the Treichville market, located in an African quarter of town, rather than in the *marché artisanal du Plateau*, in the heart of official Abidjan, the area Crowley visited, which was popular with expatriates and an upscale crowd. Treichville was a maze of stores, goods, smells, and sounds and considered to be more reasonably priced than other markets. Collectors and European dealers also went to art dealer Samir Borro's residence; there, they acquired mostly Baule figures, Guro masks, and Yaure[6] masks—such signature objects of Côte d'Ivoire that they appear on that country's postage stamps (fig. 23)—as well as masks from all over West Africa.

Baule sculptures have been among the favorite works in Western collections. Their relatively naturalistic bodies and facial features, symmetry, refined surfaces, and quiet resolve appealed to collectors. The first objects from the Baule and the neighboring Guro and Yaure arrived at the

Musée du Trocadéro before 1900. In de Zayas's 1918 *African Negro Wood Sculpture*, a Baule figure and a Yaure mask occupy prominent places, both depicted in the catalogue by American photographer Charles Sheeler, who worked on the project with de Zayas (figs. 24, 25). Every major art book contains Baule, Guro, and Yaure works, which were also part of the 1935 MoMA exhibition. Sweeney's catalogue shows a dramatically lit image of a Baule "figure of a man" from the Charles Ratton Collection in Paris. It was photographed by Walker Evans, another American photographer who created portfolios with photographs of all 603 works in the exhibition.[7]

Scholars, first among them Susan Vogel and later Philip Ravenhill, unraveled the profound meaning and uses of these Baule sculptures only in the 1960s and 1970s, when art historical and anthropological fieldwork brought them to Côte d'Ivoire.[8] These male and females figures (or *waka sran*, translated as "people of wood") give form to either nature spirits (*asie usu*) or otherworld men and women (*blolo bla* for female and *blolo bian* for male) who affect people's lives in various benevolent and negative ways. Each Baule man and woman has a mate of the opposite sex in the otherworld (*blolo*), which is also the abode of the dead and spirits of the newborn. In Baule thought, each newborn Baule child comes from a mother in the otherworld. A person's otherworld man or woman must not be neglected, for if not properly cared for, he or she may bring about sexual and other problems. In such a case, the partner will commission a carved representation of the mate, whose tangible form has to be created in consultation with a diviner. This figurative manifestation then receives much attention from its human partner.[9]

The *blolo bla* figure in the McMillan Collection, possibly dating to the 1940s,[10] displays the characteristics of such sculptures: an elegant coiffure, which recalls actual hairdos

FIG. 23 Stamps with Guro masks, issued by the Republic of Côte d'Ivoire, about 1965

of Baule women in the past; a lined neck; slightly lowered breasts, which indicate that the woman has borne children; prominent buttocks; pronounced calves; and scarification patterns on its body (cat. 34). The figure embodies the desirable characteristics of Baule feminine beauty. The hands are placed on its sides and closely follow the form of the torso as in many older such figures, and it stands on slightly flexed legs. Early on, carvers depicted otherworld spouses without clothing (although the figures actually wore a tiny fabric loincloth, as Baule decency required), but this work sports a carved *cache-sexe*[11] and hip beads, attire typical for women living in villages during the period between the two world wars. Other renderings show men and women in Western clothing, for example, the famous *colon* figures, most of which represent not colonials but otherworld mates in distinguished attire that includes pith helmets, Western-style trousers, and button-down shirts. As Ravenhill points out, *blolo bla* figures and their male counterparts, the *blolo bian* figures, reflected the times. As

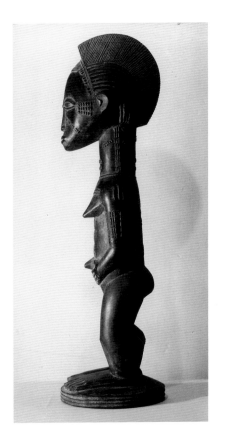

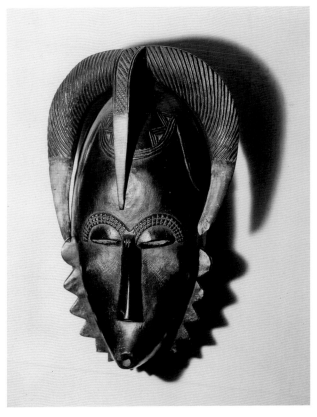

FIG. 24 Baule female figure, 1918. Photograph by Charles Sheeler

FIG. 25 Yaure mask, 1918. Photograph by Charles Sheeler

ways of living, settings, and fashions changed, so did the representation of *blolo bla* and *blolo bian*, which visualize the ideal otherworld mates that appear to Baule men and women in their dreams.[12]

The Guro and Yaure, whose masks have been equally appreciated by collectors, live and intermingle with many other groups. Throughout the larger region, their artists share a common repertoire: head crests, face masks, and heddle pulleys, to name just a few. Thus, the Guro adopted mask performances from their neighbors, who in turn assimilated ideas from the Guro. Since the artists not only worked for Guro patrons but also accepted commissions from the outside, it is not surprising that some began to

supply European, particularly French, and American clients, even as others continued to provide works for local customers only.[13] When demand from the outside increased, some carvers began to cater entirely to the new markets. The life history of the Guro sculptor Sela bi Nanti, whom fellow artists characterized as one of the best in the area, exemplifies the way in which these commercial artists embraced new challenges and opportunities. He began carving for French colonials as a young man (probably in the 1930s or even earlier), working in ivory and wood and making mostly representational figures—women pounding millet, with head loads or babies on their backs, and animals in ivory. But he also carved the famous *zamble*

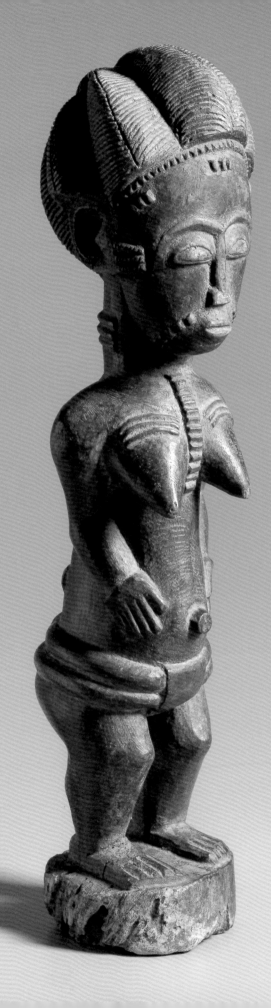

34 *Female figure* (blolo bla)

Unknown artist or workshop
Baule peoples, Côte d'Ivoire
20th century
Wood
H. 39 cm, w. 10 cm, d. 11.5 cm (H. 15⅜ in.,
w. 3¹⁵⁄₁₆ in., d. 4½ in.)
Acquired in 1975 from Mr. Sillah, Cambridge

antelope masks (see cat. 37; see also fig. 23, left), and in an interview Fischer and Homberger conducted with the artist, it became evident that Sela bi Nanti made them for both local and foreign consumption. His biography reflects the rapid onset of Africans working for new markets. We also explore this development in the context of the Bamum kingdom of Cameroon (pp. 136–43).[14]

Because these more recent objects have been in constant movement, it is a challenge to determine their origins. However, at this point in time, we can make some distinctions among these newer works, since the objects produced for foreign clientele can be related to particular workshops and "fashions," and we know that certain types of objects disappeared when they were no longer popular. For example, this Yaure mask, while not rare, is a lovely 1960s example of a well-liked mask type called *je* or *lo*, used in a funerary context (cat. 35). De Zayas had already included a photograph by Sheeler of a similar mask in his 1918 exhibition (see fig. 25).[15] Both early and later masks share certain stylistic characteristics: they are rather flat, with undecorated foreheads and arched hairlines. Horns, combs, and bird effigies may enhance the coiffure. The horizontal eyes are adjacent to the root of the nose and accented by prominent eyebrows. The delicate mouths are circular or slightly arched small openings, and fine triangular tines surround the face. The later mask may have originated in a workshop in Abidjan, for masks of this type were sold there. According to Vogel, even the National Museum employed artists from at least the early 1960s onward, and one of them may even have created this mask.[16] Our ability to date this work to a particular time period based on its stylistic characteristics and by comparing it with other works by these artists suggests that the history of newer pieces can be written using such methods in the future.

A beautiful old Guro buffalo mask, one of the highlights of the McMillan Collection, belongs in the realm of male cult associations, which fulfill political and ritual functions on the village level and are owned by families (cat. 36). A male family member cares for it, making offerings and sacrifices to the mask spirit. In the Guro worldview, these masks belong to *yu*, a class of phenomena and potent things that includes sacred drums and bullroarers used in rituals. Hunters brought the mask beings, thought to be ancient animal-like creatures, into the village from the wilderness. During these appearances, the masker wears a wooden headpiece (*wuo*) and a massive fiber costume and carries ritual paraphernalia—in the case of *zamble*, for example, a leopard pelt and a whip.[17]

This buffalo mask was once part of large mask ensemble of the cult association *dye*, which is concerned with the well-being of the community and the fertility of the land. In performances during the dry season that women were not allowed to attend, a whole universe of animal creatures appeared in the village.[18] Young men with elephant, monkey, antelope, and buffalo headdresses danced vigorously to the accompaniment of a drum-and-whistle ensemble and a chorus, each holding the mask with his teeth by a horizontal bar in the back.[19] This particular mask shares stylistic characteristics with other masks—large smooth features, gently slanted eyes, and harmoniously curving horns—seen, for example, in the elephant headdress depicted on the stamp (see fig. 23, right). Red, white, and black pigments enhance the forehead, eyes, and snout and delicately outline the horns.

Horns are also the trademark of the *zamble* mask being, who portrays the bushbuck antelope and belongs in a similar context (cat. 37). In a performance that women may witness, *zamble* drapes a cloth over its back and the rim of the mask and wears the pelt of a wild cat associated with

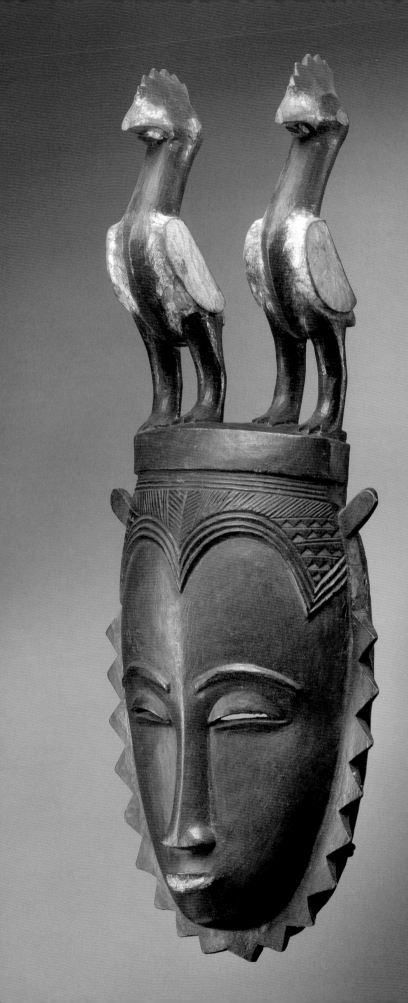

35 *Mask* (je *or* lo)

Unknown artist or workshop
Yaure peoples, Côte d'Ivoire
20th century
Wood, pigment
H. 41 cm, w. 16 cm, d. 8 cm
(H. 16⅛ in., w. 6⁵⁄₁₆ in., d. 3⅛ in.)
Acquired in the 1970s, Cambridge

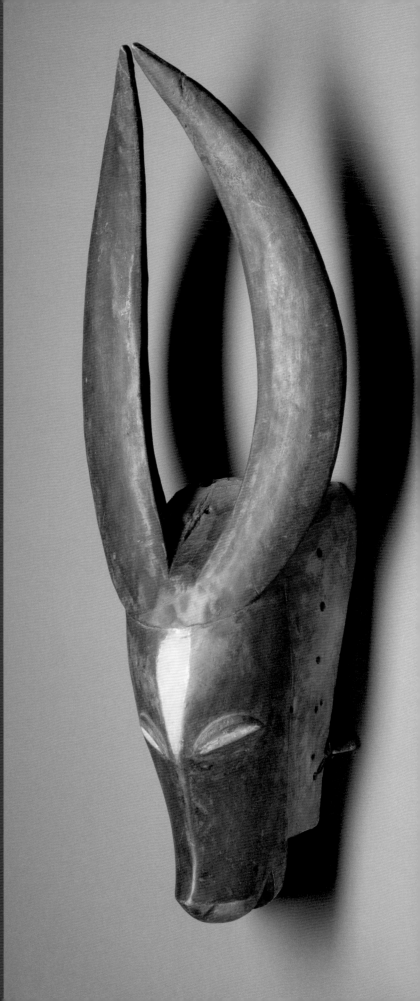

36 *Buffalo mask*

Unknown artist or workshop
Guro peoples, Côte d'Ivoire
20th century
Wood, pigment
H. 67.3 cm, w. 25.5 cm, d. 22 cm (H. 26½ in.,
w. 10⅟₁₆ in., d. 8¹¹⁄₁₆ in.)
Acquired in 1965 from the Galerie Carrefour
(Claude Vérité), Paris
Pub. Adams 1983, 21; Exhib. Boston Athenaeum
1983

the wilderness (the mask being's home), a fiber skirt, and other paraphernalia, such as bells on its arms. Its trademark is a whip, which it cracks forcefully during the performance (fig. 26). *Zamble* masks are in many collections; some are older, such as the ones shown here, and others were recently mass-produced in the many workshops in Côte d'Ivoire and elsewhere.[20]

The Guro, Yaure, and Baule also became famous for their heddle pulleys—little gems reflecting attributes of beauty and recapturing many motifs present in other figurative sculpture by the same artists. Pulleys, which occur in a wide area in West Africa, were primarily functional, because they hold the double heddles of the men's horizontal looms.[21] They consist of two pieces: the spool (often lost) and the U-shaped part supporting it, which the carver embellishes with heads, masks, animal forms, and abstract motifs. Artists in Paris and early collectors recognized the beauty of these works. De Zayas published a photograph of a pulley in *African Negro Wood Sculpture* in 1918, and Paul Guillaume and Thomas Munro illustrated one with several other objects under the heading "Fetish and Utensils" in their 1926 book *Primitive Negro Sculpture.*[22] A recent catalogue of an exhibition devoted entirely to pulleys briefly traces the arrival of pulleys in displays, including an exhibition held at the Théâtre Pigalle in Paris in 1930. Three years later, several pulleys were shown in London, while Sweeney exhibited seventeen pulleys from Côte d'Ivoire at MoMA in 1935 and depicted four in the exhibition's catalogue.[23] Pulleys thus became part of mainstream art collecting.[24]

Three pulleys in the McMillan Collection attest to the inventiveness of the carvers and the intricacy of these miniature works (cats. 38a–c). A bold and angular work from the Senufo peoples, who live in northern Côte d'Ivoire, seems to depict a bird (cat. 38a), as does a Guro heddle pulley (cat. 38b).[25] A piece in the form of a horned being, possibly a mask, by either Baule or Yaure artists,[26] reflects the stylistic conventions encountered in Yaure masks: horizontal eyes adjacent to the root of the nose, prominent arched eyebrows, delicate mouth, and triangular tines surrounding the face (cat. 38c).

Textiles from Côte d'Ivoire did not come to the attention of art collectors in the United States until the 1960s. An exhibition of African textiles at MoMA in 1972 displayed a "skirt" from the Dida peoples of southern Côte d'Ivoire (cat. 39).[27] It came from McMillan, who had noticed the delicate patterning, the interesting design, and the complex technique of this visually exciting piece. Even though it was not *en vogue* at the time, she acquired it because it appealed to her sense of beauty. Dida "skirts," which are actually cloth "cylinders" worn as loincloths by Dida women— and sometimes as garments by men—remained enigmatic until Monni Adams performed follow-up research in the Dida region in 1990.[28] She assembled all references in the literature, checked museum collections (where Dida skirts had begun to arrive as ethnographic specimens in the 1930s), and conducted interviews in the field, trying to learn more about production, contexts, and aesthetics. She found that women interlaced dried fine fibers of the raffia palm by hand and then outlined the placement of the design with stitches in raffia thread. They subsequently tie-dyed areas in yellow, red, and black in sequence, staining the cloth in three different baths.

By the 1970s, Dida cloths had become rare because women had abandoned production, people no longer wore them, and many had sold their family pieces to collectors, whose desire for these "skirts" increased dramatically after the MoMA exhibition. Today, Dida fabrics have experienced a revival. Inside Côte d'Ivoire, Dida people proudly wear them at public events, such as national holidays and political rallies—no longer as loincloths, however, but as

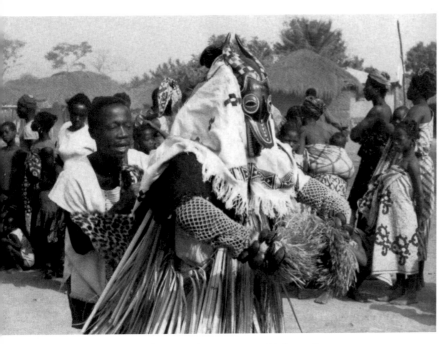

FIG. 26 Guro mask persona *zamble* in performance, Zangofla village, Zuenula region, Côte d'Ivoire, 1975

blouses, skirts, and shirts. They have become a marker of a distinct identity in this multiethnic country. In the external market, Dida cloths have appeared in large quantities and become a major commodity, adding to the earnings of the women who make them and, one would assume, of art merchants in Côte d'Ivoire and elsewhere.

This revival—or, in some instances, continuation—of textile traditions was part of a larger development affecting many areas of Africa, as occurred with Kuba raffia cloth (see cat. 67) and the painted cloths of the Senufo peoples. Men hand-painted and sewed together cotton cloths for costumes of maskers associated with Poro and other men's associations, and one of these found its way to Cambridge (cat. 40). Entrepreneurial textile artists began to decorate cotton cloths with vivid depictions of people, animals, and

scenes, making the cloths suitable for wall hangings. Nowadays, these new types of painted cloths sell well to tourists and appear in stores and markets all over Africa and on the Internet.

Accra was the next stop for travelers along the coast. From a coastal settlement of the Ga peoples at the end of the sixteenth century, it developed into an important center for the slave trade. By the mid-nineteenth century, the British began their imperial expansion along the Gold Coast, as the region was known, because of the precious commodity that flowed from rich inland mines and riverbeds. In 1873, British forces destroyed Kumasi, the capital of the landlocked Asante kingdom, which controlled the gold trade, and soon thereafter declared the Gold Coast a crown colony, with Accra as its capital. In the 1920s, Accra had an astonishing array of businesses run by Africans, West Indians, and Europeans.[29] As rural migrants flooded into town, Accra grew rapidly and is now verging on 2 million inhabitants.

For serious art collectors, Accra remains the gateway to the Asante kingdom. In fact, many of the objects bought in Accra proper came from the workshops of Asante artists. Crowley referred to Accra in the 1950s and 1960s as the "entrepôt of Ashanti art," where carvings such as the iconic *akua'ba* "dolls," stools, goldweights, and Kente cloths awaited the eager buyer.[30] There were several fine hotels along the beaches, and the sounds of Ghanaian highlife music, famous throughout Africa, filled the air. Travelers moved on to Kumasi, the capital of the Asante kingdom, by bus or taxi.

The Asante and their neighbors belong to the Akan peoples, as do the Baule mentioned earlier. The Akan share similar languages, cultural traits, and artistic forms.[31] Among the many Akan states, the Asante kingdom most captured the Western imagination. One of the first reports,

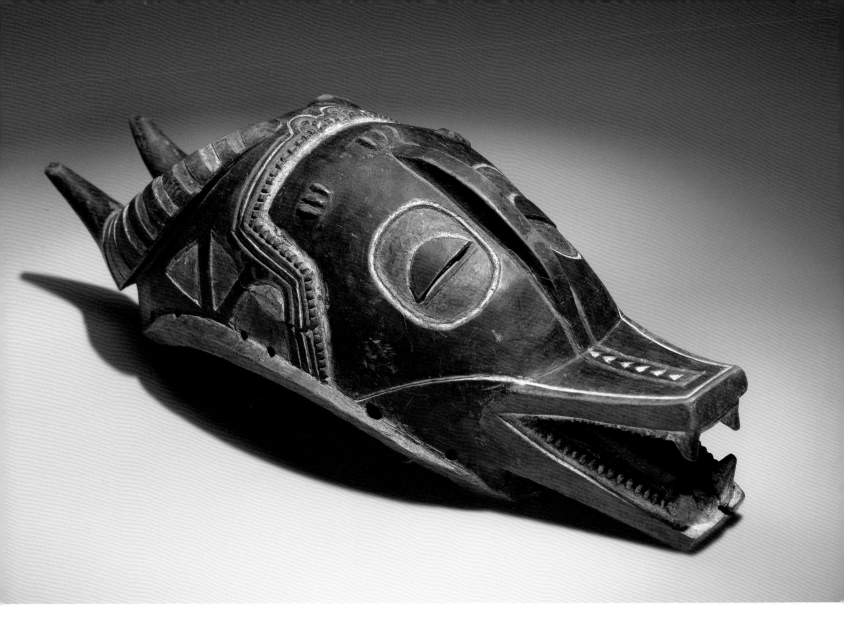

37 *Mask* (zamble)

Unknown artist or workshop
Guro peoples, Côte d'Ivoire
20th century
Wood, pigment
H. 41 cm, w. 15.6 cm, d. 14 cm
(H. 16⅛ in., w. 6⅛ in., d. 5½ in.)
Acquired in 1974, Bamako, Mali

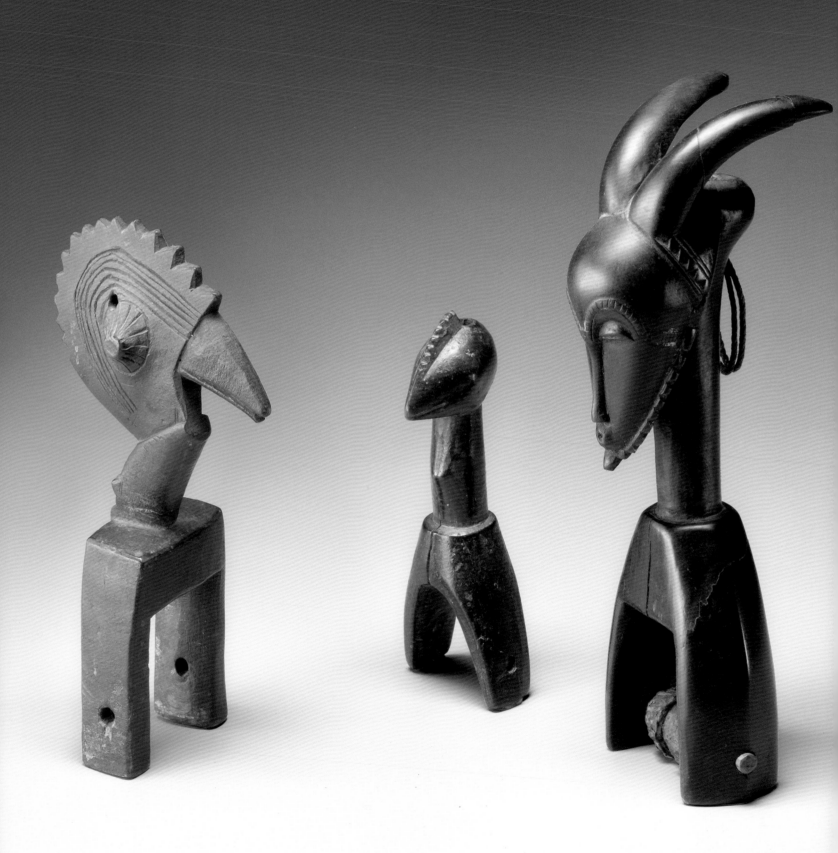

38a *Heddle pulley*

Unknown artist or workshop
Senufo peoples, Côte d'Ivoire
20th century
Wood
H. 20 cm, w. 6.8 cm, d. 10.5 cm
(H. 7⅞ in., w. 2¹¹⁄₁₆ in., d. 4⅛ in.)
Acquired in 1982, Paris

38b *Heddle pulley*

Unknown artist or workshop
Guro peoples, Côte d'Ivoire
20th century
Wood
H. 15 cm, w. 6 cm, d. 5.5 cm
(H. 5⅞ in., w. 2⅜ in., d. 2³⁄₁₆ in.)
Acquired in 1982, Paris

38c *Heddle pulley*

Unknown artist or workshop
Baule or Yaure peoples, Côte
d'Ivoire
20th century
Wood
H. 25 cm, w. 8.5 cm, d. 9 cm
(H. 9¹³⁄₁₆ in., w. 3⅜ in., d. 3⁹⁄₁₆ in.)
Acquired in 1982, Paris

39 *Skirt*

Unknown artist or workshop
Dida peoples, Côte d'Ivoire
20th century
Fiber, pigment
Overall: H. 96 cm, circum. 84 cm
(H. 37¹³⁄₁₆ in., circum. 33⅛ in.)
Acquired in the 1960s, Abidjan,
Côte d'Ivoire
Exhib. Museum of Modern Art,
New York 1972

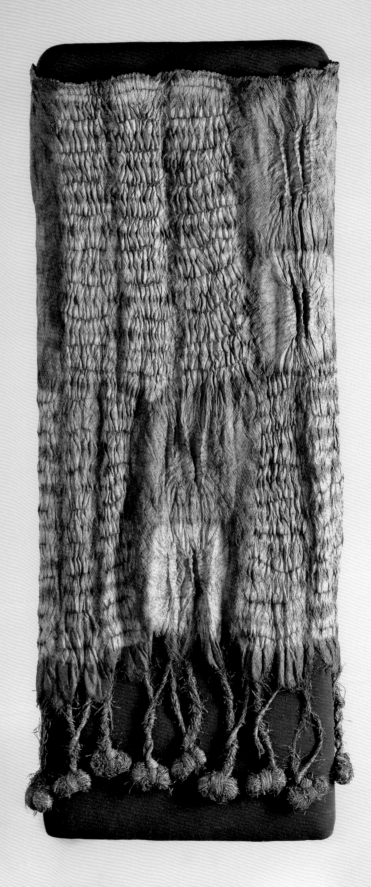

40 *Dance costume*

Unknown artist or workshop
Senufo peoples, Côte d'Ivoire
20th century
Fiber, pigment
H. 136 cm, w. (outstretched) 170 cm
(H. 53⁹⁄₁₆ in., w. 66¹⁵⁄₁₆ in.)
Acquired in the early 1970s from
the Galerie Ascher, Paris

Thomas Edward Bowditch's 1819 *Mission from Cape Coast Castle to Ashantee,* was followed by other publications, ranging from books to magazine and newspaper articles, chronicling the changing fortunes of the kingdom: the destruction of the capital Kumasi in 1873, a second destruction and the deportation of its king in 1896, and the rebirth of the kingdom after his return in 1924.[32] Kumasi's history goes back to about 1700, when the Asante defeated and confederated several nearby kingdoms. Bowditch and other Western visitors praised the capital's architecture and spoke of splendid festivals at the royal court, yet the British did not hesitate to attack the city when the Asante stood in the way of their grand imperial and economic plans. After the Second World War, Kumasi was a bustling town with the Manhyia palace at its core. Always cosmopolitan, it became even more so. Anthony Kwame Appiah writes of his hometown in the late twentieth century: "English, German, Chinese, Syrian, Lebanese, Burkinabe, Ivoirian, Nigerian, Indian: I can find you families of each description. I can find you Asante peoples, whose ancestors have lived in this town for centuries, but also Hausa households that have been around for centuries, too. There are people from all the regions, speaking all the scores of languages of Ghana as well."[33]

Kumasi has been proud of its heritage and offers its arts to foreigners. Crowley captured visitors' experiences in the 1960s and 1970s, when he described this ancient center of the royal arts as a place "where family guilds of artist-courtiers . . . continue to produce [objects] with some of the old richness and elegance." He then mentions the National Culture Centre and its display of stools and robes; the treasures of the Palace Museum established by Otumfuo Opoku Ware II, the king of the Asante; and the artisan villages outside the capital.

In nearby villages one can find more than a hundred craftsmen producing *for the Ashanti* [our emphasis] and for the tourist market: Ntonso for *adinkra* stamped cotton cloth now preferred by nationalist Ghanaians; Bonwire for the incomparable rich and expensive *kente* cloth; Pankronu for fancy pottery; Ehwia for wooden stools, spoons, *akua'ba* dolls, and woodcarvings ranging from Christian religious subjects to *mmoatia* and *asasabonsam* spirits never previously represented in Ashanti sculpture; and Apabame Kofromfrom and Agogo (a place-name worth remembering) for brass weights and covered jars. Although their village ateliers are often infinitely difficult to find, these courtiers are loath to sell to foreign visitors unless they can get the prices of an Accra gallery on the theory that anyone who would come that far must want their product very badly.[34]

What emerges from Crowley's observations is a multilayered picture of clienteles, ranging from locals to foreigners, that includes Ghanaians from other regions of the country. He gives us a sense of traditional genres and invented new forms, of complex market conditions articulated in pricing policies—all of this combined with a tinge of the discovery trope that is typical of so many earlier writings.

Many objects from the Asante realm moved to Cambridge.[35] The iconic *akua'mma* (sing. *akua'ba*) enjoy great popularity because their abstract forms captivated artists and collectors (cat. 41).[36] But equally important were Western perceptions of their meaning; their childlike characteristics and identification as "fertility dolls" fit stereotypical views of African art and culture. Among the earliest depictions is an *akua'ba*-like object that appeared in the French explorer Louis Gustave Binger's 1892 account of his expedition through the Sudan to the Gulf of Guinea.[37] In 1936,

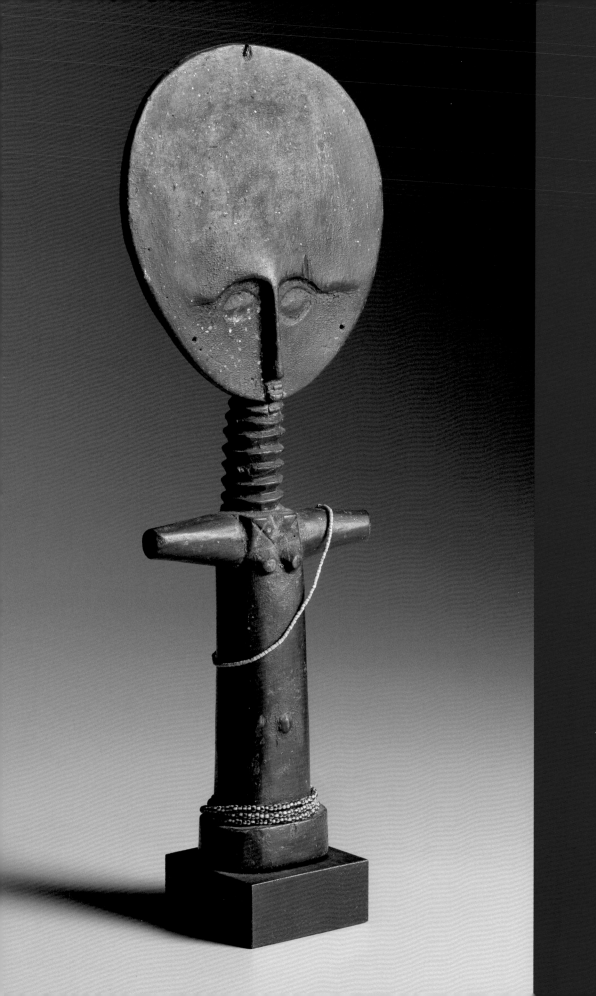

41 *Figure* (akua'ba)

Unknown artist or workshop
Asante peoples, Ghana
Mid-20th century
Wood, pigment
H. 30.2 cm, w. 5.5 cm (H. 11⅞ in.,
w. 2³⁄₁₆ in.)
Acquired in the 1970s from the
Galerie Burgui (J. Nicaud), Paris

Kjersmeier presented a photograph of an *akua'ba* in his possession, referring to *akua'mma* as "the most artistically accomplished [works] in the domain of wood carving."[38]

Among McMillan's *akua'ba* is a nicely carved mid-twentieth-century example that is fully within the stylistic conventions for earlier pieces: the minimalist cylindrical torso with small breasts and horizontal arms; the ringed, elongated neck; and the disklike head with compressed facial features displaying arched eyebrows over almond-shaped eyes. The oval head and high forehead recall the ideal shape of women's heads, achieved by mothers gently modeling their babies' heads. The back of the figure's flat head carries an incised pattern of two triangles. Small strings with tiny glass beads adorn the body, a feature that might have been added by a merchant before the figure went on its journey. Because of the figures' popularity, the meaning and function of *akua'mma* have been discussed by many authors.[39] Carried like babies on women's backs and kept in shrines, *akua'mma* ensure the birth of beautiful and healthy children, preferably girls, because the Asante trace their descent through the female line.

The Akan carvers' repertoire thus included large numbers of *akua'mma* and other common items such as wooden combs (cat. 42). These combs (*duafe*) for women, once used to untangle hair and hold coiffures in place, take many shapes and present a microcosm of Akan iconography. Twenty-three combs in the McMillan Collection come from all over this region, attesting to McMillan's delight in these humble yet beautifully detailed objects. Some show anthropomorphic motifs, while others display delicate openwork configurations and intricately incised surface decoration.

Who produced them? Initially, numerous carving workshops made *akua'mma* and combs for local clients; these products bore interesting designs and were marked by their makers' virtuosity. By the 1970s, this situation began to change. In a fascinating essay that has implications for this study of both collecting and the art market in the second half of the twentieth century, Doran Ross and Raphael Reichert discuss a workshop in Kumasi that specialized in production for international patrons and in outright "fakes."[40] The founder was Francis Osei Akwasi, a distant relative of the famed artist Osei Bonsu (1901–1977), who worked for the royal court. Akwasi's life history reads like those of other young men who sought to make a living in the art market. He had some schooling, trained briefly with Osei Bonsu, and then went to Accra, where he worked for the Arts Council producing souvenirs for tourists. After returning to Kumasi, he received a commission from an Accra-based Hausa[41] trader to carve a Baule mask based on a photograph the merchant supplied. This led Akwasi to a career producing works from images in books, including the 1977 standard work *The Arts of Ghana,* coauthored, with Herbert Cole, by Ross himself. The business turned out to be so lucrative that Akwasi soon enlarged his workshop, and by the time Ross and Reichert visited him in 1979, he had added two artists and fifteen assistants and was calling the workshop "his factory." The authors make a convincing case that the carvers imbue their "modern antiquities" with their personal style yet also examine the deliberate deception taking place. Certainly Akwasi and his fellow carvers were experts in artificially aging objects (the essay provides a long list of different techniques), but the blatant misrepresentation of the objects occurred somewhere up the line, as the pieces migrated from dealer to dealer. Even seasoned connoisseurs were unable to distinguish these fakes from authentic works,[42] which brings us back to authenticity, a notion discussed throughout this book. Ross and Reichert conclude their essay with an interesting observation and kind remarks about the carvers. "We celebrate their talents and have confidence that their methods will continue to

42 *Comb* (duafe)

Unknown artist or workshop
Akan peoples, Ghana
20th century
Wood
H. 27.5 cm, w. 14 cm
(H. 10¹³⁄₁₆ in., w. 5½ in.)
Acquired in the 1970s, Paris

improve at a pace that keeps them several steps ahead of most scholars and collectors, and probably ahead of us as well. The ultimate irony in the problem of fakes in the art market, is that fakes will continue to improve as methods of detecting them improve."[43]

Two other Asante works in the McMillan Collection are rather rare and associated with shrine contexts. One is a hand-formed ceramic vessel with a figurative lid; the other is a unique shrine figure. The vessel (*abusua kuruwa*) is among the so-called family or clan pots, which have different shapes and may vary in function. According to a gender-based division of labor, men made the figurative pots with anthropomorphic and zoomorphic motifs, while women produced utilitarian pottery. Terra-cotta containers play an important role in rituals and shrine settings and vary in shape and execution. However, there is no distinction in use between simpler and more elaborate vessels, except that the more affluent and noble a family, the more intricate the design attesting to the owner's taste, wealth, and standing in society.[44] So-called proverb pots, or *abebudie,* such as this vessel, form a distinct subgroup of the *abusua kuruwa* (cat. 43). This one was likely kept in a shrine or a special room together with ancestral stools commemorating important ancestors. Others would have served as vessels for an important man's drinking water.

The pot's elaborate lid displays several protruding figurative elements and covers the wide round lower body of the pot. Each motif visualizes Akan verbal wisdom and penchant for oratory and can often be linked to more than one proverb or maxim that teaches proper behavior and etiquette. There is an array of representations: the tortoise, the snail, the cock, the chameleon, a cocoa pod, what looks like a staff finial, and an incised heart and key. Of the tortoise it is said, "Tortoise, you are also suffering in your shell," alluding to the fact that even a secure person—

protected like the tortoise—might face hidden trouble. One interpretation of the tortoise and the snail refers to peace and harmony in the family. "If there were only snails and tortoises in the bush, one would not hear a single shot," a proverb states. The chameleon embodies patience. Other motifs came from Europe. Keys demonstrate control over riches that needed to be secured in locked chests. The heart alludes to honesty, patience, and endurance; the motif originated in the West but was endowed with indigenous meanings. This blending of indigenous and foreign motifs was typical for people who had long interacted with Westerners and were once subjects of the British Empire.

One of the most extraordinary works shown here is an enigmatic figure with movable arms—unusual considering that most African sculptures are carved from a solid piece of wood (cat. 44). Its face shows features typical for Asante figures, but the compressed body, squatting on rectangular, barely articulated legs, sets it apart. The figure's stance and the bulging medicinal substances around the torso give it a powerful aura. A 1927 coin attached to its front allows us to date the work to at least this time period.[45] It once belonged in the context of a shrine containing sacred materials ranging from medicinal substances to figurative sculptures, which accumulated over time and added to the power of the site. Certain shrines served as places for propitiating deities, while others warded off witches, antisocial elements threatening the community with disease and death.[46]

Robert Sutherland Rattray, a British colonial officer, describes one such witch-finding shrine located on the shores of Lake Bosomtwe in his classic 1927 book *Religion and Art in Ashanti*.[47] Because his photographs of the interior setting were too dark, he rendered the shrine in a drawing, which depicts three figures (*asuman,* sing. *suman*) that closely resemble the work in the McMillan Collection.[48] In this shrine, the power figures with their medicinal substances,

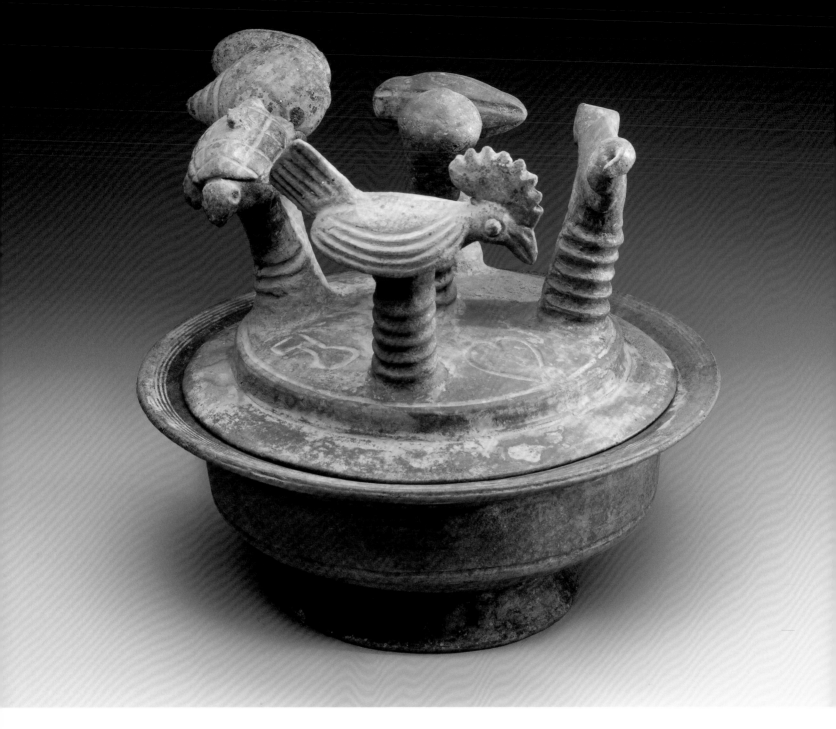

43 *Container* (abebudie)

Unknown artist or workshop
Asante peoples, Ghana
20th century
Terra-cotta
H. 27 cm, diam. 30 cm (H. 10⅝ in., diam. 11¹³⁄₁₆ in.)
Acquired in 1982 from the Leonard Kahan
Gallery, New York
Pub. Adams 1983, 17; Exhib. Boston Athenaeum
1983

44 *Shrine figure with movable arms*

Unknown artist or workshop
Asante peoples, Ghana
Early 20th century
Wood, fabric, cord, beads, metal coin,
encrustation
H. 37 cm, w. 14 cm, d. 15 cm (H. 14⁹⁄₁₆ in.,
w. 5½ in., d. 5⅞ in.)
Acquired in 1967 from Mr. Kabah, Monrovia
Pub. Adams 1983, 8–9; Exhib. Boston
Athenaeum 1983

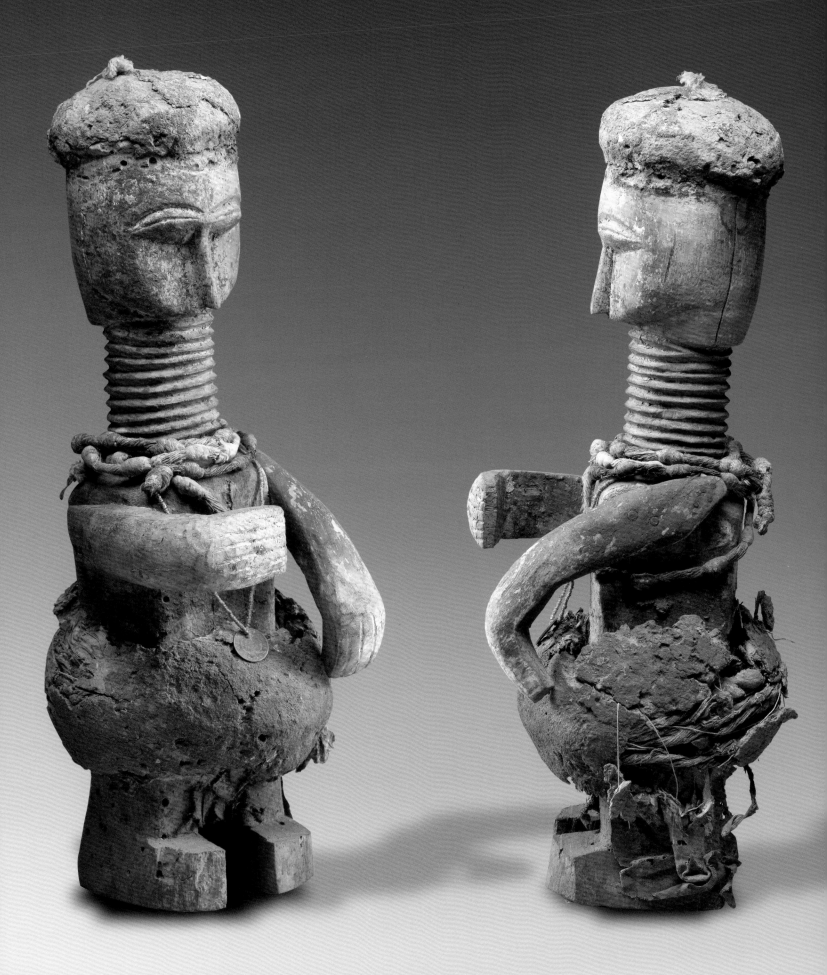

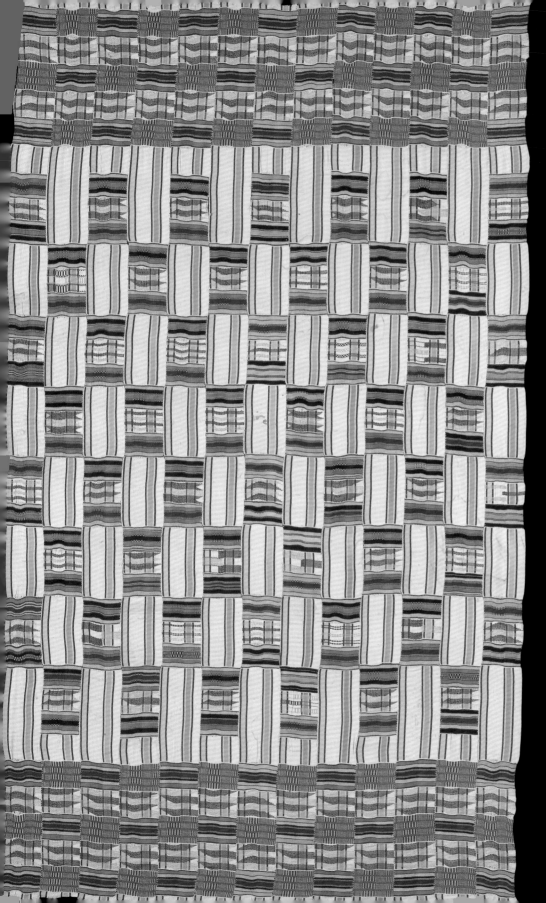

45 *Cloth* (kente)

Unknown artist or workshop
Asante peoples, Ghana
20th century
Rayon, silk
H. 200.7 cm, w. 116.8 cm
(H. 79 in., w. 46 in.)
Acquired in the 1990s from
an African dealer, Cambridge

six in all, sat on and surrounded a clay altar in the shape of female breasts. The principal figure was placed in the center, another was suspended from poles above, and a third one held a knife. All *asuman* visible in the drawing have rounded headdresses (long gone from the McMillan figure), bulging medicine bundles enveloping their torsos, and square legs. Each one had a name; the central figure was Fwemso, which lent its name to the entire shrine. When people in a village feared witchcraft, they called the priests of the shrine, who summoned the figures to detect witches. According to Rattray's findings, "these *suman* themselves assumed the forms of witches, a ball of fire, and by making the witches call *Ka cha! Ka cha! Ka cha!* enticed the real witches to approach them, when they would seize them and wound or kill them, i.e. their *sunsum* (spirit), with the knife that Kwaku [one of the power figures in the shrine] holds."[49] Few figures of this type are in collections, perhaps because of their powerful nature or because the British colonial government suppressed such practices.[50]

Leaving Ghana would be unthinkable without mentioning the most sought after works of art, which might even be considered a commodity, the famous strip-woven *kente* cloths. *Kente* has become synonymous with the Asante, Akan, and Ghana and, at least in the second half of the twentieth century, with being African and African American. A cloth for women, smaller in size than weavings for men, is in the McMillan Collection (cat. 45). It is a single-weave piece in a lovely green and white design—fine, but not extraordinary. Yet it tells an interesting story that contributes to our understanding of African creativity and entrepreneurship and challenges our notions of "tradition" and authenticity. This cloth was woven largely of rayon, which has been used by Akan weavers since the beginning of the twentieth century.[51] The introduction of rayon is part of a long process in which weavers experiment with new materials and techniques, not just in Ghana but also in other parts of Africa where weaving is practiced. In the nineteenth century, before rayon, the innovation was silk, and Akan weavers unraveled imported silk cloths and fashioned the threads into the spectacular *kente* patterns. *Kente* has always been appreciated by Ghanaians, and there is a whole subset of collectors specializing in these cloths. Consequently, the highly skilled male weavers in places such as Bonwire have produced cloths for decades for both the internal and external markets.[52]

As we move along the coast and arrive in Cotonou, the complex story of Yoruba *gelede* masks and their journeys into collections merits mentioning. Cotonou is located in the southeastern Republic of Benin, formerly Dahomey, until it became fully independent from France in 1960. Cotonou has been Benin's major harbor and economic center, although the country's capital is the ancient city of Porto Novo. Many collectors stopped in Cotonou, and so did the intrepid Crowley. In 1974, he found that the market had grown threefold since his last visit in the late 1960s, and that it now had separate areas for Wolof merchants from Senegal, Hausa from all over West Africa, and local Fon[53] merchants. Describing Cotonou as "the best place for Nago and Abomey art," he writes, "they stock a large number of second-rate Ifa divination trays, *ibedjis* [Yoruba twin figures], and occasional polychromed stools as well as new brass genre figurines, weaving, and applique [*sic*] cloths by the descendants of the courtier-artisans of the old Royal Palace of Abomey [the capital of the Dahomey kingdom, some 145 kilometers (90 miles) inland from Cotonou]."[54]

The term "Nago arts" refers to Yoruba arts in general and derives from the Anago, one of the western Yoruba subgroups neighboring the better-known Ketu in an area where many crosscurrents merged and people were intricately connected through trade routes and migrations over

NORDWESTAFRIKANISCHE WAFFEN UND GERÄTE.

FIG. 27 Lithograph of northwest African weapons and tools, 1887. The *gelede* headdress is on the left (center).

centuries. The slave trade had devastating effects in this area, for vessels carried hundreds of thousands of unfortunate people from this coastline (then known as the Slave Coast) to the New World. Nowadays, the border between

Benin and Nigeria divides the region, and Yoruba live on both sides.

Gelede, a popular masquerade, is said to have originated in Ketu during the second half of the eighteenth century. It is a spectacle honoring elder women, referred to as "our mothers" (*awon iya wa* or *awin iya wa*), but the ultimate goal of *gelede* performances was the pacification of Iya Nla, the Mother of All or Great Mother, and the maintenance of harmony in the community.[55] *Gelede* masks and choreography are complex and varied, but fortunately several excellent studies deepen our understanding of Yoruba arts.

Throughout the second half of the twentieth century, *gelede* headdresses were popular with collectors for their extravagant superstructures and the associated context. The first headdresses reached European holdings in the early nineteenth century and began to appear in books and magazines by the 1880s. Friedrich Ratzel, a German geographer, published a three-volume ethnography in 1887 and included a color plate illustrating a *gelede* headdress under the curious heading "Nordwestafrikanische Waffen und Geräte" (Northwest African Weapons and Tools), confirming the object's status as artifact (fig. 27). He also published an engraving of a single *gelede* headdress on the previous page.[56] According to Ratzel's captions, both headdresses came from Dahomey. Carl Einstein presented a *gelede* headdress with an almost baroque superstructure in his 1915 book *Negerplastik,* but in general Yoruba masks are rare in other early art books and are missing in Sweeney's 1935 MoMA catalogue, which focused on the great art tradition of the ancient Dahomey and Benin kingdoms.[57] *Gelede* images, however, circulated in unexpected ways—particularly in the form of postcards. Walwin or J. A. C. Holm, a father-and-son team of Ghanaian origin who operated a successful studio in Lagos, produced this image of three *gelede* maskers in about 1900 (fig. 28). Two maskers wear female

headdresses with stylish coiffures and women's clothing, while the central figure sports an ample gown and headdress with a large, European-style hat, an item that either refers to the modern ways of African men, including the large contingent of foreigners from other parts of Africa and from Brazil, or represents a playful depiction of a European.

The Holmses may have taken this image in or near Lagos during a *gelede* festival, which usually occurred in spring with the first rains. At times, a community held *gelede* performances when it wanted to pay homage to "our mothers," who could harness threatening and destructive as well as nurturing and benevolent powers, which came to them from Iya Nla. Every *gelede* spectacle recognized and encouraged "our mothers" to use their special powers for the good of the community. Male and female elder leaders of the *gelede* society organized the festivals and watched over all tasks, from the choreography and costumes of maskers to the orchestra, chorus, and songs. Men transformed into "mothers," wearing women's multilayered dress and the carved headpieces that represent beautiful women with youthful faces.

The festival has a two-part structure, and neither part can occur by itself. At a nighttime performance (called *efe*), its principal character, a masked singer-poet known by the same name, prays for blessings from the Mother of All, the deities, and the ancestors. The choreographed mask performances reach their climax when Iya Nla, the Mother of All, makes her solemn appearance. The following afternoon, maskers in splendid costumes entertain the general public with performances criticizing antisocial elements and heralding a new beginning. The maskers representing women usually appear in pairs and dance. Other characters in extravagant headdresses and billowing costumes crowd the dancing arena, often appearing in twos, because duality

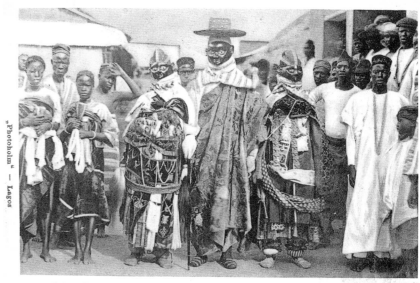

GELEDE · MALES and FEMALES

FIG. 28 *Gelede* performers, about 1900

and complementarity of male and female are among the basic principles of Yoruba thought. These characters playfully allude to social roles—the merchant, the market woman, the blacksmith, a man on a bicycle, the hunter, the Muslim, the loose woman, and the foreigner.

Several *gelede* headdresses in the McMillan Collection demonstrate the inventive and masterful ways in which Yoruba artists let their imaginations play.[58] According to Henry John Drewal, a polychrome male headdress from Ketu or Idahin represents a male warrior who performed during an *efe* (cat. 46). The turban-style head wrap (*lawani*) seems to identify him as Muslim, as does the beard, which is also a sign of elderhood/wisdom. Machetes are depicted at both sides of the headdress. A crescent moon arching over the forehead alludes to hunts at night, when warriors seek out and expose worldly and otherworldly positive or negative forces that affect the community. Another

polychrome headdress might represent a foreigner or a Yoruba man with a *képi*, a French-style military cap (cat. 47). In fact, many *gelede* performances satirize the stranger, whether Fulani, Muslim, French, or British. These kinds of objects were particularly popular with collectors, who found them as amusing as the Baule *colon* figures. Thus, it is not surprising that some carvers included the *gelede* headdresses in their regular repertoire for their foreign clientele. A photograph of an elderly Nago carver who worked in Ketu in 1990 shows him surrounded by such works, among them a headdress with a *képi*.[59]

If we compare the masks of the warrior and the man with a *képi* to another work in the McMillan Collection— the headdress rendered as a woman carrying a heavy head load—we notice that its once brilliant colors have been muted, very likely by art merchants, who catered to the Western desire for "pure" African objects that were not "ruined" by "garish" hues (cat. 48). This headdress comes from the hand or workshop of the Yoruba master carver Duga of Meko, who is portrayed in William Bascom's 1973 "A Yoruba Master Carver."[60] In 1950, Bascom and his wife encountered Duga in his hometown of Meko, located in Nigeria a few miles from the Benin border and part of the kingdom of Ketu, which is mostly in Benin. By then, Duga was about seventy years old and the most distinguished sculptor in the region. Bascom discusses many aspects of Duga's work, from his carving technique to the application of colors, which in earlier times were made from ingredients such as chalk (for white), the leaves of plants (for blue and pink), and stones (for red and tan). Duga also used imported oil paints. His repertoire ranged from utilitarian objects, such as bowls and mortars, to *gelede* masks. In his innovative style, he created this rendering of a woman with delicate facial features in a lightweight wood. Curving elements depict the woman's elaborate head tie, and the

superstructure shows a tray supporting a large bowl with smaller dishes sitting on its removable lid.[61] A rolled-up mat on top completes this image of a woman headed to the market, a sight common all over Yorubaland. Duga's work brought him fame and much praise, and Bascom quotes from a letter he received from Tijani Isiaka, his Meko interpreter. "Duga and other wood-carvers at Meko carved many kinds of Gelede masks when we made the ceremony of Gelede for my late father . . . the people of Meko cannot forget Duga for his sense and for his many kinds of carvings."[62] Duga died in 1960, and a few of his works are now in collections in the West, while others remain in Benin and Nigeria.

These and other objects went on their journeys from Benin, through Cotonou, and may have moved through Abidjan as well. They traveled with merchants to Paris and New York and from there to Cambridge. Benin imposed no export restrictions for works of art, and the trade was conducted legally. However, the scenario in Lagos, our next port of call, was quite different, because the Nigerian government struggled to keep its cultural heritage within its country's borders.

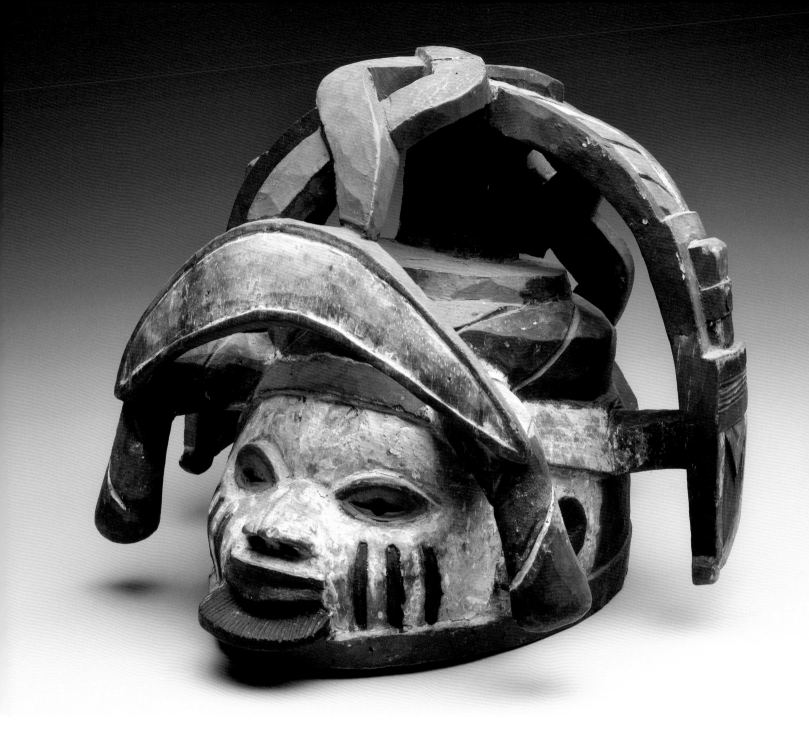

46 Efe *headdress*

Unknown artist or workshop
Yoruba peoples, Republic of Benin
20th century
Wood, pigment
H. 27.5 cm, w. 32 cm, d. 33.5 cm (H. 10¹³⁄₁₆ in.,
w. 12⅝ in., d. 13³⁄₁₆ in.)
Acquired in 1985 from Mr. Omar, Cambridge

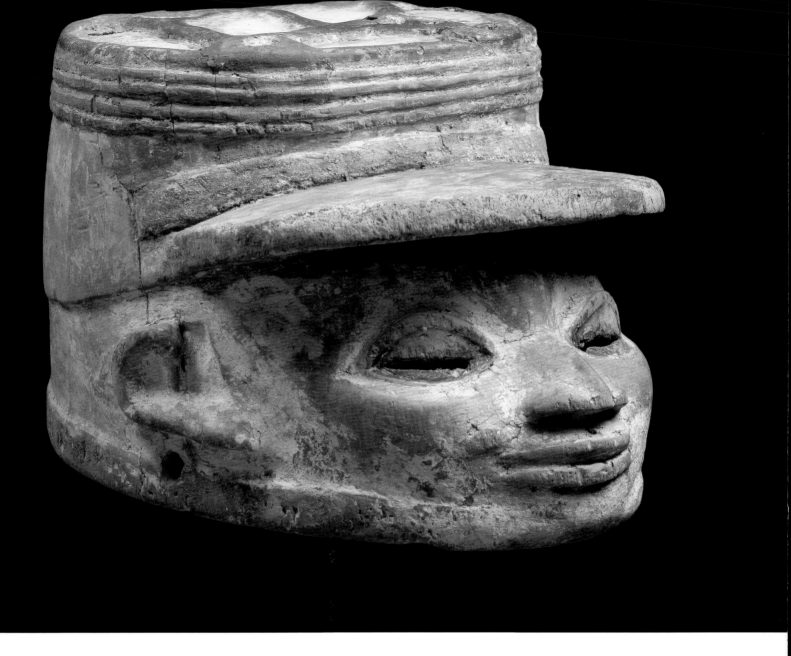

47 Gelede *headdress with* képi

Unknown artist or workshop
Yoruba peoples, Republic of Benin
20th century
Wood, pigment
H. 16.5 cm, w. 20 cm, d. 27.5 cm (H. 6½ in.,
w. 7⅞ in., d. 10¹³⁄₁₆ in.)
Acquired in the 1970s, Paris

48 Gelede *headdress*

Duga of Meko, Nigerian (active 1920–1970)
Yoruba peoples, Republic of Benin
20th century
Wood, pigment
Overall (with lid): H. 54 cm, w. 55 cm, d. 42 cm
(H. 21¼ in., w. 21⅝ in., d. 16⁹⁄₁₆ in.)
Acquired in the 1970s from Mr. Kabah,
Cambridge

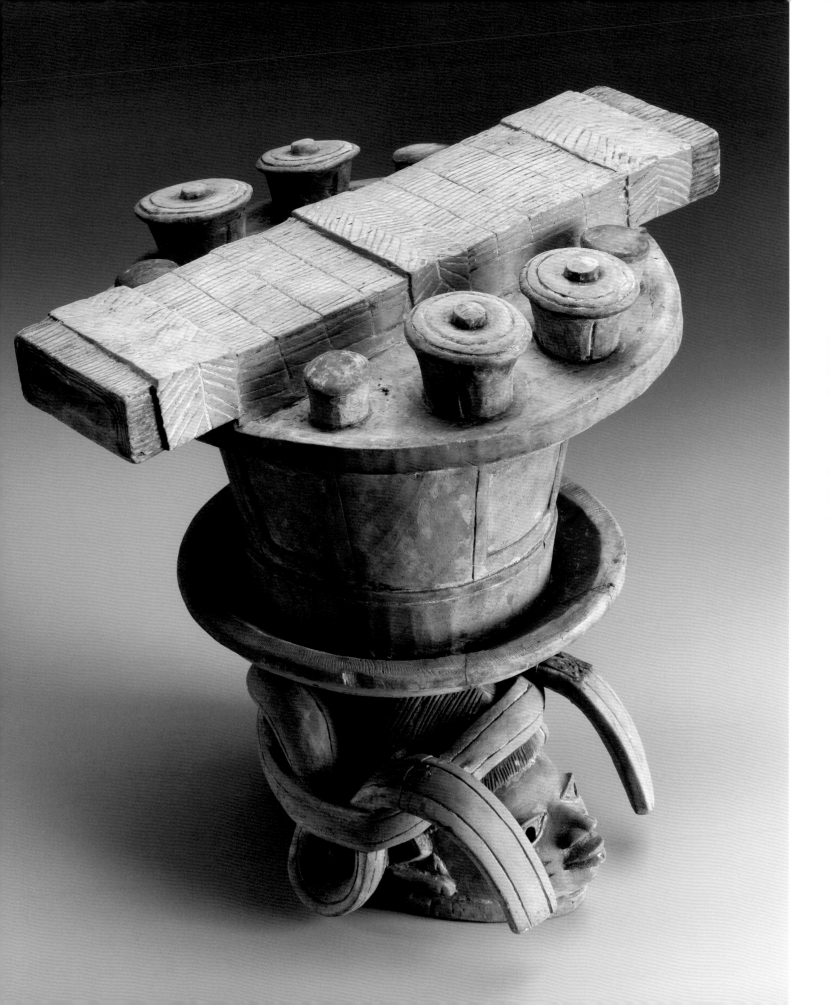

NOTES

1. The French founded their colony Côte d'Ivoire in 1893 and moved its capital several times. They selected Abidjan in 1920, and by 1934 the administration had finally transferred all offices (see Doutreuwe 1993). In 1983, President Houphouët-Boigny moved the official capital to Yamoussoukro in central Côte d'Ivoire.

2. Arrys 1971; Erouart-Siad 1988; Jean 1991.

3. These are actually small brass counterweights for weighing gold dust on scales. Often in figurative forms, they have long been appreciated by Western collectors, including McMillan, who has a fine collection of goldweights.

4. Crowley 1974, 56. It should be noted, however, that by then the Wolof (i.e., Senegalese) traders no longer controlled the market, and works of the best quality were often shown in private homes. Personal communication, Susan Vogel, July 1, 2006.

5. Steiner 1994, 18-19.

6. More recently the ethnonym "Yahure" also appears in the literature.

7. Sweeney 1935, pl. 69; Webb 2000.

8. Vogel 1973; Ravenhill 1996.

9. Ravenhill 1996, 2; Vogel 1997, 240-67.

10. We thank Susan Vogel for this information. Personal communication, July 1, 2006.

11. This French term refers to small coverings for the pubic area.

12. See Ravenhill 1996, 19-27.

13. See Fischer et al. 1993 about the oeuvre and life history of Sabu bi Boti, a Guro artist who worked exclusively for a local clientele.

14. Fischer and Homberger 1985, 58-60.

15. Boyer 1993.

16. Personal communication, Susan Vogel, April 17, 2006.

17. Fischer and Homberger 1985, 75-77.

18. Among many African peoples, masked performances occur most frequently during the dry season, when farming has ceased and ritual preparations for the next planting are under way.

19. Fischer and Homberger 1985, 108-10.

20. Ibid., 137-55.

21. In this region, weaving is the domain of men.

22. de Zayas 1918, pl. 12; Guillaume and Munro 1926, 22.

23. Goy 2005, 25-26; Sweeney 1935, pls. 135, 139, 140, 141.

24. In the 2006 auction of the Vérité Collection, the most important such event in decades, no less than thirty-seven heddle pulleys were among the 514 works offered and fetched exceedingly high prices (*Arts Primitifs* 2006).

25. For a detailed discussion of Guro pulleys, see Fischer and Homberger 1985, 236-53.

26. According to Vogel, most pulleys were produced by the Baule, a much larger group than the Yaure. Personal communication, July 1, 2006.

27. Sieber 1972, 201.

28. Adams and Holdcraft 1992.

29. *Redbook of West Africa*, a register of commercial enterprises in the anglophone colonies and countries in the region, lists twenty-seven African-owned companies in Accra. The community of important businessmen includes natives of Ghana, Jamaica, Sierra Leone, Saint Vincent, Dominica, and British Guyana. MacMillan 1920, 201-28.

30. Crowley 1974, 57.

31. Thus, it is not always possible to assign objects to particular Akan groups, and the term "Akan" appears repeatedly in our descriptions.

32. Bowditch 1819. For an evocative summary of Asante history and art, see McClusky 2002, 79-113.

33. Appiah 2006, 101-2.

34. Crowley 1970, 47.

35. We thank Doran H. Ross for kindly helping us with identification of the works and pointing us to important literature.

36. Cole 2004. Along with Cole and Ross 1977, 103-7, Cole 2004 is the most comprehensive contextual analysis of the *akua'mma* to date, and our descriptions are based on these two sources.

37. The object is designated in translation as "the doll from Kounchi" (Binger 1892, 133).

38. Kjersmeier 1936, 14 and pl. 8 (translated by the authors). Interestingly enough, Kjersmeier's *akua'ba* is a full-bodied sculpture, which Asante describe as a later style, while the *akua'ba* with a cylindrical torso in the McMillan Collection would be the earlier form. Cole and Ross 1977, 105.

39. See, for example, Cole and Ross 1977, 103-7.

40. Ross and Reichert 1983.

41. The Islamic Hausa live all over West Africa and are known for their mercantile talents.

42. Cole and Ross inadvertently included several artificially aged pieces from the workshop in their catalogue *The Arts of Ghana*. See Ross and Reichert 1983, 82.

43. Ibid., 91.

44. Rattray 1927, 293–308; Cole and Ross 1977, 117–22; Ritz 1989. The following description is based largely on these accounts.

45. In this case, the coin fits into the general timeline of the work. Such evidence should be taken with a grain of salt, however, because dealers have been known to plant coins on works of art in order to deceive the buyer.

46. See Cole and Ross 1977, 98–103.

47. Rattray 1927, 9–12, 29–34, fig. 25.

48. We thank Monni Adams, who studied this object in great detail, and Doran Ross for pointing out this reference.

49. Rattray 1927, 32.

50. Several similar figures are in the collections of the Berg en Dal Museum in the Netherlands. See Grootaers and Eisenburger 2002, 254.

51. Made from cellulose, also known as artificial silk, rayon has many of the qualities of cotton and was invented before the First World War.

52. See Picton 1992; Ross 1998.

53. The Fon are one of the largest ethnic groups in Benin and founded the Dahomey kingdom.

54. Crowley 1974, 58.

55. Several outstanding scholars have described *gelede* from an external and an internal point of view, among them Drewal and Drewal 1983; Lawal 1996; and Drewal and Pemberton with Abiodun 1989. The following discussion is based on these three major works.

56. Ratzel 1887, 609 and pl. opp. p. 610.

57. Walker Evans photographed two headdresses that were part of the exhibition. We thank Virginia-Lee Webb for this personal communication.

58. There are ten *gelede* headdresses in the McMillan Collection.

59. Féau, Mongne, and Boulay 2006, 41.

60. We are grateful to Henry John Drewal, who interpreted the warrior mask, identified the carver of this one, and guided us to further reading. See Bascom 1973.

61. For similar renderings of this motif, see Drewal and Drewal 1983, pls. 110, 113.

62. Bascom 1973, 77–78.

CHAPTER 6

LAGOS—DOUALA—FOUMBAN

Lagos—the name alone attracted people to this dazzling city filled with energy, the visual arts, music, and lots of commerce. This was one of the places where Africans, Yoruba mostly, and people from all over the region and around the world met and exchanged ideas. Like many other coastal towns, it emerged during the slave trade. The British claimed the region in 1885, when the European powers divided Africa during a conference in Berlin (the so-called Congo Conference). In 1914, they formally established the Colony and Protectorate of Nigeria, which ultimately became the independent country of Nigeria in 1960. At beginning of the twentieth century, Lagos had a population of more than one hundred thousand.[1] Lagosian businessmen of different origins and backgrounds enjoyed distinguished careers and often owned enterprises with links abroad; newspapers such as the *Lagos Standard* catered to the educated elite. Lagos kept this momentum going well into the second half of the twentieth century. Until the mid-1960s, the town was thriving. Then members of an Igbo[2] secessionist movement founded the Republic of Biafra in the eastern part of the country, and the Biafra War (1966–1970) broke out. The bloody civil war led to their defeat and also deeply affected the arts. These were disastrous times for that region, because people not only parted with important possessions

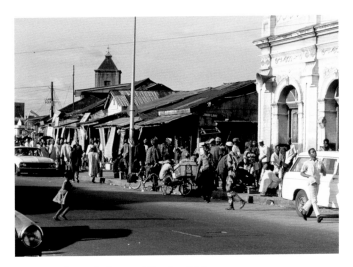

FIG. 29 Street in Lagos, Nigeria, 1970

visited the wonderful National Museum, where dedicated Nigerian and expatriate scholars tried to preserve Nigeria's cultural heritage by collecting works that had not left the country before and during the colonial period and the recent war.[3] They traveled by air-conditioned bus to Benin, the great university town of Ibadan, and other fascinating places farther north.

Three objects in the McMillan Collection, not national treasures but with specific meanings and aesthetic qualities, probably arrived from Nigeria through Lagos. One is the top of a Yoruba wrought-iron staff, the second an Igbo wooden tray for serving kola nuts, and the third a depiction of an African in Western attire on horseback.

Yoruba iron staffs often entered Western collections as incomplete objects.[4] The ornate finials were cut from shafts that were too long to carry in suitcases and too cumbersome to ship; portability was one of the requirements for most acquisitions, although affluent collectors and museums never shied away from transporting huge works.[5] Many of these finials are in collections around the world and are offered by African art dealers, so they may have become part of the repertoire of busy workshops in the Yoruba region and beyond. Initially, museums and collectors considered the staffs ethnographic specimens and artifacts, but as interest in the metal arts increased—which included weapons and metal implements (see pp. 167–73)—the staffs moved into the art market in the 1960s and 1970s. Collectors appreciated their intricate forms, decorative qualities, and particularly the bird motifs.[6] In the original settings, these staffs were associated with the Yoruba deity (*orisha*) Osanyin, the god of herbal medicines, powerful substances that affect his devotees' well-being. Osanyin transmits knowledge to healers and diviners who prepare these substances. The staffs, emblems of these specialists, allude to the primary function of the medicines—battling

for want of money but also could not protect their villages, shrines, houses, and small local museums from plunder and theft. Thousands of works left the country illegally, and some are now on display in large museums in the West. In the 1970s, when the oil boom brought riches to Nigeria, Lagos regained its prominence. Today, Nigeria's fortunes have declined again. Lagos now has more than 8 million inhabitants, and given the economic and political conditions, its star has faded.

In the early 1970s, at the beginning of the oil boom, Lagos enjoyed an excellent reputation among visitors (fig. 29). Juju music performed by King Sunny Adé, I.K. Dairo, and Chief Commander Ebenezer was popular, movie houses showed American and Indian films, and the first test television station broadcast live locally to a small audience, although the hot lights in the modest studio made it almost unbearable for the personnel. Nigerians everywhere talked about the U.S. Apollo 11 mission that had landed on the moon. For collectors of "classic" African arts, however, tough antiquities laws restricted the local pickings. They

49 *Staff with birds*

Unknown artist or workshop
Yoruba peoples, Nigeria
20th century
Iron
Overall (without base): H. 34.5 cm,
w. 18 cm, d. 20 cm (H. 13⁹⁄₁₆ in.,
w. 7¹⁄₁₆ in., d. 7⅞ in.)
Acquired in the 1970s, Cambridge

50 *Kola nut tray* (okwa oji)

Unknown artist or workshop
Igbo peoples, Nigeria
20th century
Wood
H. 23 cm, diam. 41 cm (H. 9¹⁄₁₆ in.,
diam. 16⅛ in.)
Acquired in 1987 from Mr. Omar,
Cambridge

witchcraft, a task of several other works discussed earlier, among them the Asante shrine figure (see pp. 111–15). In the McMillan Collection staff (cat. 49), fifteen birds gather around a central avian image; indeed, sixteen is the number of birds required for all such staffs. Birds are associated with the mystical powers of "our mothers" (see pp. 116–18) and the divination process, and the creatures occur frequently in Yoruba iconography, most prominently on the beaded crowns of Yoruba kings.[7]

A fine kola nut tray comes from the world of the Igbo peoples of southeastern Nigeria (cat. 50). It brings into focus the importance of kola nuts, stimulants that are traded widely throughout West Africa, since not all regions have a suitable climate for growing them or produce high-quality nuts. Kola nuts accompany life. They separate into several parts when divided, and people share and consume them during rituals and on ceremonial occasions. One never enters a house without receiving a drink and a kola nut as a sign of the occupant's hospitality, and the serving trays are important in this context. Carved in hard blackened wood, they vary in execution and motif depending on the means and taste of the owners who commission them. Many elaborate bowls (*okwa oji*) share the same design: a flat circular tray, often with delicate incised patterns around its rim, for the nuts and a central hollow space for sauces and spices. In this example, thin curving lines emphasize the rim of the tray, and the lid of the condiment container ends in fully articulated male bearded heads with facial scarifications and fine hairdos. It compares favorably to similar bowls depicted in the 1984 catalogue *Igbo Arts: Community and the Cosmos*, by Herbert Cole and Chike Aniakor,[8] which no doubt has by now inspired two generations of African carvers to create similar objects and thus make a living in the art market.

A figure from the same geographic region challenges notions of authenticity, defies stylistic attribution, and suggests the many ways in which Africans appropriated and transformed concepts and visual elements from the West and other parts of Africa (cat. 51).[9] Why does this enigmatic figure of a rider in Western clothing on horseback evade interpretation? Perhaps because it incorporates many visual themes, creating a hybrid entity that reflects the general condition of globalization. We see a so-called *colon* figure—the depiction of a European perhaps, to judge by the finely articulated pith helmet, button-down jacket, and short trousers with a belt and belt buckle. But certain details distract. Do the rings around the legs represent knee-high socks—alas, without shoes—or are they metal leg ornaments? And what about the missing shoes? Early photographic portraits of well-dressed Africans confirm that shoes were always worn. The figure's forward-moving stance on the horse recalls riders of power, a genre of African sculpture that is associated with leadership, as does the observation that the figure once carried spears or other objects in its hands, now lost. A plank-shaped Islamic prayer board supports the animal, a combination that Muslims would perceive as blasphemous, rendering this work even more enigmatic.

In contrast to Lagos, Douala in Cameroon was a rich source for the art trade. The settlement in the estuary of the Wouri River, which became Douala, goes back to about 1600. Its inhabitants, the Duala,[10] made their living as fishermen and middlemen in the Atlantic trade, controlling access to the interior and providing Europeans with ivory and slaves in the late eighteenth and early nineteenth centuries. When the slave trade ended, they shifted to dealing in palm oil and palm kernels, as did their close neighbors in the Niger Delta, in what is now Nigeria. Douala developed into a commercial harbor during the German colonial

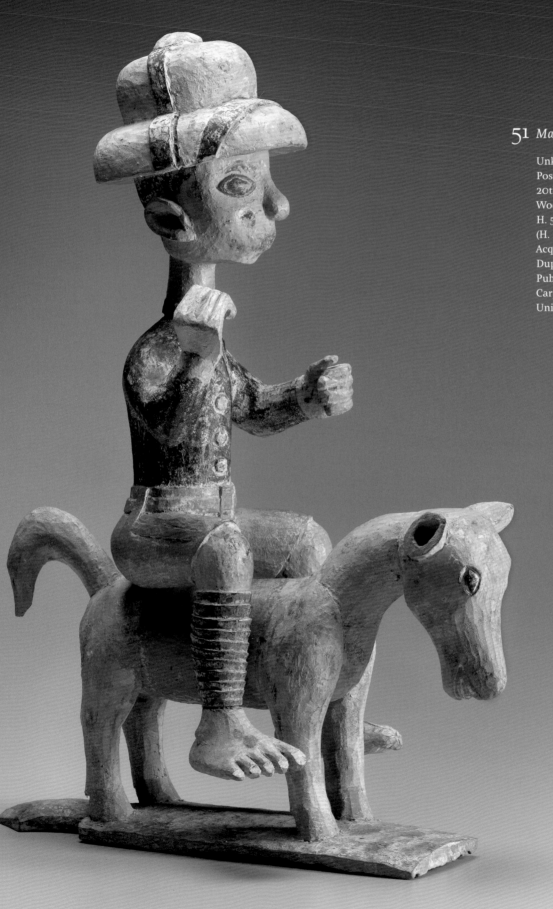

51 *Man on horseback*

Unknown artist or workshop
Possibly Igbo peoples, Nigeria
20th century
Wood, pigment
H. 58 cm, w. 22.5 cm, d. 46 cm
(H. 22¹³⁄₁₆ in., w. 8⅞ in., d. 18⅛ in.)
Acquired in 1978 from the Galerie
Dupeyrier, Paris
Pub. Adams 1982, 126–27; Exhib.
Carpenter Center, Harvard
University 1982

period, which began in 1885 and ended in 1915, when Germany lost all its African holdings as a result of the First World War. Douala and a large part of Cameroon were given to France, while a smaller part in the west came under British rule. On the eve of the Second World War, Douala was a somewhat sleepy town and port. Peoples from the interior migrated to the region to work on plantations on both sides of the border between the British and French territories. The British ruled the peoples in western Cameroon through Nigeria, while the administrative capital Yaoundé gained prominence in the French territory. Cameroon sought and received independence from both colonial powers in 1961, after a plebiscite in which the British-controlled population opted to join its francophone countrymen, thus returning the state to its former German borders. Bilingual and at times plagued by conflict between the two parts of the country, Cameroonians have enjoyed relative political stability under only two presidents—the late Amadou Ahidjo and the current president Paul Biya.

Douala in the 1960s and 1970s was a bustling if steamy center of activity. Tourists, airline personnel, and art dealers from everywhere stayed in the downtown Akwa Palace Hotel, which catered to the upscale crowd. McMillan was among them. African merchants walked by on the sidewalks, pushing their offerings at visitors in attempts to attract their attention. Cameroonian music filled the air; the vivacious rhythms of makossa, Cameroon's contribution to African popular music, replaced the Nigerian highlife, Congolese rhythms, and the rumba sounds of the 1950s. By the 1970s, Eboa Lotin's 45-rpm records were particularly popular, and radio stations broadcast his joyous song "Da Longo" all day long. Cameroonians from all parts of the country flooded Douala, coming to make a living. There were several art galleries in town, perhaps

most notable a place called Ali Baba, run by a Frenchwoman. She offered art from everywhere—Teke masks from the Republic of the Congo (see pp. 159–61); bronze sculptures from Foumban, the capital of the Bamum kingdom in the Cameroon Grassfields; and masks and door frames from other parts of that region, a major art-producing area to the northeast. Crowley found that the "three major dealers [in Douala] and even the street market around the corner from the Akwa Palace Hotel each had at least a few pieces of merit. . . . Prices approach Abidjan and New York, but the overall quality and the importance of individual pieces were higher than anywhere else visited in West Africa."[11]

The more enterprising visitors hopped into cars and taxis and traveled to the Cameroon Grassfields. The Ringroad, then a one-way dirt road in places, swings around the entire mountainous region. Kingdoms and smaller chiefdoms known for their carving traditions dot the countryside. Older masks and architectural elements were available to the buyer, but workshops had sprung up in order to supply the new clientele. The two carving centers of Big Babanki and Babanki Tungo (also known as Kedjom Keku and Kedjom Ketingu), which once served local patrons all over the region, increased their offerings and added slightly different works, such as masks with exaggerated features; other carving centers followed suit (fig. 30). In the 1960s, the Basel Mission created the Handicraft Centre in Bamenda, the administrative capital of the northern Grassfields region, where a Swiss missionary (a cabinetmaker by training) instructed local young men in carving for export. Basing their creations on indigenous forms, they worked hardwoods, applied imported permanent stains, and created an appealing production line of stools and other useful objects.[12] The Handicraft Centre was building on older traditions, however; even before the

FIG. 30 Carver in a workshop, Big Babanki, Federal Republic of Cameroon (now Republic of Cameroon), 1970

Second World War, carving centers turned out certain types of objects for the market, as a 1930s postcard produced by the French missionary society—depicting the production of stools—demonstrates.[13] In fact, one might argue that the more recent carving workshops are an extension of late-nineteenth- and early-twentieth-century loci of craft specialization, with artists distributing their creations throughout the region to indigenous clienteles. In two of these, Babanki Tungo and Babungo, local rulers

not only controlled the trade but created figurative works and thrones themselves. Sculptor-kings are a well-known phenomenon in the Cameroon Grassfields; the most famous among them was Foyn Yu (1865–1912) of the kingdom of Kom.[14]

Many objects from the northern Grassfields made the journey to the McMillan Collection, including the three works we will discuss here. The first is a pair of heavy wooden posts adorned with intricate relief. They are door frames, so unique in the Grassfields that they are easily attributable to an area around Wum, a federation of several small chiefdoms also known as Aghem, in the northern part of the region (cats. 52a, b). In the early 1970s, Wum and the nearby smaller chiefdoms of Weh and Isu were rather remote, linked through the poorly maintained Ringroad with Bamenda and places beyond.[15] Since the time of German colonial rule, men had always left the region: they labored in plantations, served under the British during the colonial period, even participated in the Second World War in Nigeria and places as far away as Burma. They worked along the coast and in some of the larger Cameroonian towns, returning to their villages and erecting their "new-style" rectangular houses, material expressions of their economic success and modern way of life. Thus, building styles changed, moving from square raffia structures daubed with mud and thatched with special grasses, to mud-brick houses with corrugated iron roofs.

The best-known features of the windowless traditional houses were these elaborately carved frames that accentuated entryways no higher than 1.4 meters (4.5 feet). The doors were mounted about 80 centimeters (31.5 inches) above the ground, so that goats, pigs, and other animals roaming the village stayed outside (fig. 31). Entering the dark house through such a doorway was always challenging for foreign visitors, who gingerly stepped on a large stone

placed in front of the door and bowed their heads to pass through the low opening. The frame itself consists of a post on each side of the door opening connected by a smaller lintel on top and a more substantial wooden step on the bottom. The outside of the posts and the part facing the door opening carry rich low-relief carvings. People in Weh distinguished between geometric and figurative motifs, although the meanings of the motifs in the registers seemed long forgotten—with the exception of the stylized figurative elements that are interpreted as "people." Indeed, these anthropomorphic figures resemble similar motifs on bowls and other objects from this region, which came to German museums before the First World War. The posts became obsolete as building forms changed, and mud-brick houses with Western-style doors now affirm the status of well-to-do men.

People in Weh, Wum, and Isu received carvings from several sources. A small group of local carvers satisfied the need for wooden objects, such as masks, stools, and bowls. Men could also commission them from expert workshops and sculptors in nearby chiefdoms in the orbit of the kingdom of Kom; some even bought works from faraway Big Babanki and Babanki Tungo. By 1970, most local carvers had abandoned their craft and no longer created any of these items, including door frames. However, when a German missionary commissioned several posts resembling these door frames for his church in the 1960s, one of the old carvers was still up to the task. Some men in Weh also reintegrated older posts into their new residences because they wanted to maintain tradition; others let them sit near their houses, hesitant to reinstall them.

As these unique objects came slowly to the attention of collectors, people in the region sold them—often to men from Foumban, a town in francophone Cameroon, who passed through the villages in search of marketable

FIG. 31 Doorway in Weh, Federal Republic of Cameroon (now Republic of Cameroon), 1971

objects. Yet information about them remained scarce until two scholars called attention to their existence. Peter Valentin, a Swiss ethnologist, placed a little note in the German ethnological journal *Tribus*. More importantly, Paul Gebauer, an American missionary and expert on Cameroon art, published several pictures of doors in a widely distributed 1979 catalogue.[16] By the time this catalogue appeared, however, most doorposts had left Weh and the nearby chiefdoms. By the early 1980s, only a few remained.

52a, b *Parts of a door frame*

Unknown artist or workshop
Aghem Confederacy, Weh or Isu chiefdoms,
Cameroon Grassfields, Cameroon
20th century
Wood
H. 141 cm, w. 23 cm, d. 14.5 cm
(H. 55½ in., w. 9¹⁄₁₆ in., d. 5¹¹⁄₁₆ in.);
and H. 141 cm, w. 25 cm, d. 14 cm
(H. 55½ in., w. 9¹³⁄₁₆ in., d. 5½ in.)
Acquired in 1967 from an African dealer,
Douala, Cameroon

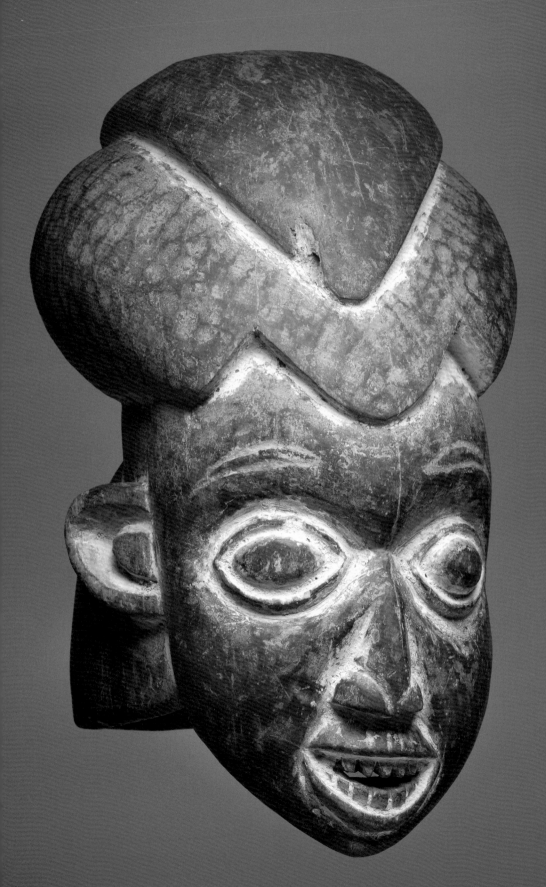

53 *Head crest mask*

Unknown artist or workshop
Northwestern Cameroon Grassfields,
Cameroon
20th century
Wood, pigment
H. 44.5 cm, w. 25 cm, d. 25 cm (H. 17½ in.,
w. 9¹³⁄₁₆ in., d. 9¹³⁄₁₆ in.)
Acquired in 1994 from the Hurst Gallery,
Cambridge

Anthropomorphic and zoomorphic masks and sculptures from the Grassfields had been arriving in German collections since the first decade of the twentieth century. However, with a few exceptions, such as an abstract Bacham mask collected in 1912 and now in the Museum Rietberg, Zurich, the strong features and expressive forms of Grassfields art did not appeal to connoisseurs. Kjersmeier's judgment of the qualities of these arts is typical: "In North-West Cameroon, the sculpture which includes relatively few isolated statues, but numerous masks and an enormous quantity of utilitarian objects decorated with figures—stools, bowls, borders, door and window frames, etc.—is clearly a peasant art, realistic, with great vital power, but on the average low artistic value and without the refined sensibility and technical finish that characterize the sculpture of the main artistic tribes of French West Africa or the Belgian Congo."[17] This view, which exists among connoisseurs to this day, affects the monetary value of Cameroon works, although one object, the so-called Bangwa Queen, now in the Musée Dapper in Paris, fetched the highest price at auction for a work of African art until the sale of the Vérité Collection in 2006.[18]

In the kingdoms of Oku and Kom, masks (*ngoin*), like this one in the McMillan Collection, perform to this day (cat. 53). They belong to important lineage heads in charge of large family units that trace their descent to a common founder. The owners bring out the masquerades during men's death celebrations; nowadays, they also perform at official events, such as visits from the governor or other important political leaders that add to the lineage's prestige. A young man wore this mask on his head like a helmet, holding it with one hand, his face covered with a net and his body concealed under a tuniclike garment. Rattles at his ankles sounded with every vigorous step, and he may

have carried a fan, for he represented a woman, recognizable not only by the helmet-style mask but also by the elaborate female coiffure. In the mask ensemble, she is the first wife of the male leader mask (*kam*), whose flat mask covers his face, stabilized with one hand. She dances with her husband, followed by many other mask beings: a warrior, a man with a basket, a buffalo, a bird, a ram, and an elephant, among others. The group of mask beings brings to life an entire universe inhabited by humans and animals and, in so doing, visualizes the worldview of the peoples in the Grassfields and demonstrates the importance and wealth of the owner.[19] Judging by the stylistic characteristics, the mask might be the work of a carver in one of the large workshops in Babanki. The surface displays adze marks, and kaolin emphasizes the large, rimmed, lozenge-shaped eyes, the gaping mouth with teeth, and the protruding ears—all typical for Grassfields wooden sculpture. Kaolin also outlines the shape of the coiffure.

A tunic-shaped mask gown of raffia fiber and adorned with tufts of human hair is a common mask garment from the same region, although it did not enter into the McMillan Collection with the mask (cat. 54). The mask gown most likely belonged to a male leader mask, but out of its context it is difficult to assign it to a specific mask persona or chiefdom. For masquerade performances today, tunics of European and African factory-made textiles have replaced these older, locally woven fiber ones, which increasingly enter the art market and move into collections.

When it comes to the art trade in this region, no merchants have been more active than the *antiquaires* (antique dealers) at our next stop—Foumban, the capital of the Bamum kingdom. Visitors arriving from hot and humid Douala enter Foumban through a big city gate that dates to the time of King Ibrahim Njoya, the renowned king whom the Germans met when they first came to his capital in

54 *Masker's tunic*

Unknown artist or workshop
Northwestern Cameroon Grassfields,
Cameroon
20th century
Fiber, human hair
H. 110 cm, w. 88 cm (H. 43⁵⁄₁₆ in.,
w. 34⅝ in.)
Acquired in the 1970s from the
Galerie Noir d'Ivoire (Réginald Groux
and Yasmina Chenoufi), Paris

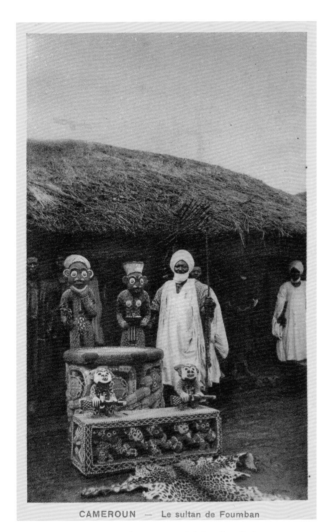

CAMEROUN — Le sultan de Foumban

FIG. 32 King Njoya of Bamum with his beaded two-figure throne in Foumban, French Cameroon (now Republic of Cameroon), about 1920

1902 (fig. 32).[20] They were stunned by his huge palace, the elegance of the princes and princesses, the royal wives, and the hierarchy of hundreds of court officials, servants, and slaves. The arrival of these strangers, who took an immediate interest in the arts of the kingdom, such as the beaded throne shown in the postcard, set in motion a number of processes that stimulated art production for the new clientele and ultimately facilitated Foumban's ascent to its leading role in the art trade today.

The history of the Bamum kingdom begins in the late seventeenth century, when a group of migrants occupied the region around the current town and established a small state. By the nineteenth century, Bamum kings had enlarged the kingdom to include many subjugated populations. The king and his followers regularly conducted wars and military campaigns during the annual dry seasons, or, as the Bamum would say, they went "hunting." The constant expansion of the kingdom increased its wealth and influence in the region. To this day, the warrior ethos among the Bamum finds expression in bellicose performances during festivals, when men with extravagant headdresses and colorful clothes fire their flintlock guns, swing their machetes (called *coupe-coupe* ["cut-cut"]), and—by striking the machetes rhythmically against one another—create the beat for their energetic dance. Their flamboyant garments and headdresses recall the practice of wearing impressive clothing to battle, thus intimidating the enemy with one's appearance. These contemporary performances resemble the festivals and rituals held after warriors returned from a victorious battle, when they displayed calabashes strung with the jaws of slain enemies. As they shook the gourds in rhythm with their dance, their defeated enemies metaphorically sang their praises.[21] Warfare ceased in the early colonial period, but the ancient gourds remained family

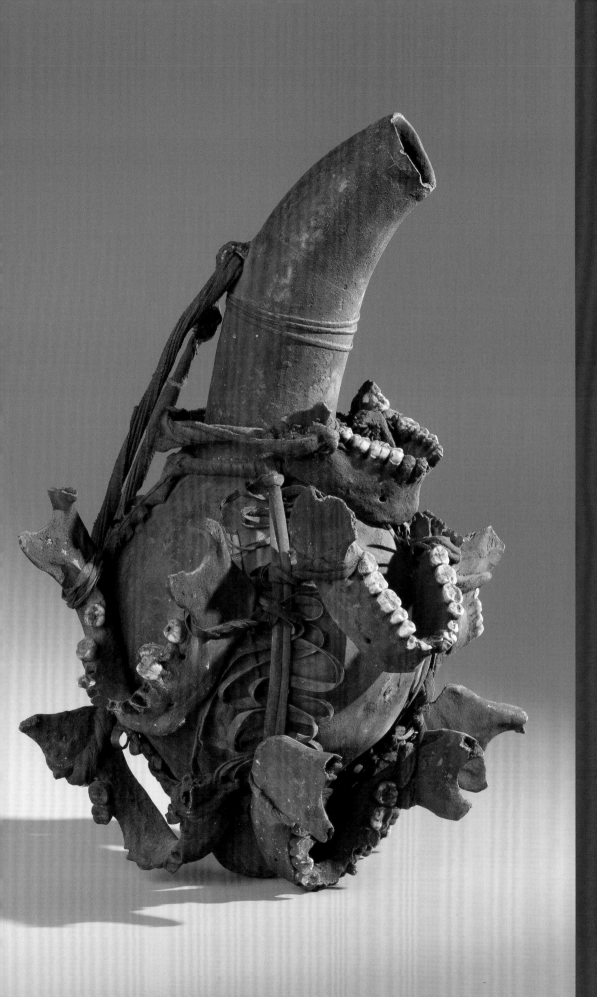

55 *Trophy calabash*

Unknown artist or workshop
Bamum peoples, Cameroon
Late 19th century
Gourd, cloth, human jawbones
with teeth, vines or plant fiber
H. 42.5 cm, diam. 27 cm (H. 16¾ in.,
diam. 10⅝ in.)
Acquired in 1982 from the Galerie
Majestic (Michel Huguenin), Paris

possessions until they became part of the art trade. One gourd, encrusted and blackened over the decades, journeyed into the McMillan Collection (cat. 55).

At the beginning of the twentieth century, specialized groups of artists worked exclusively under royal patronage; they had been resettled near the palace when their chiefdoms of origin succumbed to Bamum's onslaught. The kings centralized the means of artistic production at the palace, thus exerting control over the visual domain, and since many of the objects were activated in rituals and made powerful through potent substances, the practice monopolized efficacy for the monarchy. Bead embroidery was the domain of specialists from the defeated chiefdom of Megnam, and potters came from Marom, located close to the capital. Weavers, too, created luxurious textiles for the palace under the patronage of the king. Among the artists was a group relocated to Foumban from the chiefdom of Nguot. Under the leadership of master carver and brass caster Nji[22] Nkome, they produced many of the early bead-covered thrones and masks (now in the Bamum Palace museum at Foumban and in many collections abroad) and also excelled in bronze casting.[23] To this day, their descendants, also artists, live close to the palace in a part of town called Njinka.

With the arrival of the Germans, King Njoya encouraged the palace artists to increase their production. Along with older works once used in the palace, recently produced beaded stools, drinking horns, and bronze castings flowed into German museums and private collections. The artists began to experiment with new forms and imported precious materials, and the king, his noblemen, and his loyal servants embarked on an ambitious program of innovation in the visual domain. Early photographs, for example, captured experiments with new forms of dress based on European styles, ranging from uniform-type locally produced garments to fantastic creations for the royal women and children.[24] The most important step in this process was King Njoya's official abolishment of strict sumptuary laws, allowing ordinary citizens of Bamum to employ materials and visual motifs once reserved for royalty. These exerpts from a unique document, a chronicle of the kingdom edited by the courtiers at the palace and King Njoya, describe the process:

> He, Nzueya,[25] decrees that everyone may wear any garment whatsoever, even if it was not given by him [the king]
>
> He, Nzueya, decrees that anyone may eat from a metal dish . . .
>
> He, Nzueya, decrees that all Pamom women may wear bead earrings. . . .
>
> He, Nzueya, decrees that the Pamom may sell multicolored bags in the market . . .
>
> He, Nzueya, decrees that people may drink from a horn with a metal-decorated orifice.[26]

Consequently, many artists and the people of Foumban could begin supplying the foreigners. Nji Nkome and the members of his family took the lead, and others soon followed. By the 1920s, the growing Bamum *artisanat* (craft industry) catered to the desires of the French colonials who had taken over from the Germans in 1916 after a short British interlude. The patrons included French administrators, plantation owners who had moved to the region, and a smattering of tourists.

By then, however, the fortunes of King Njoya had changed. He had fallen out of grace with the colonial administration and, tragically, died in exile in Yaoundé in 1933. The French supported his rival Mosé Yéyab, a

FIG. 33 Mosé Yéyab (center) in front of a display of Bamum art for sale in Foumban, French Cameroon (now Republic of Cameroon), about 1930

mission-trained interpreter who enforced their policies in Bamum. Even though he was a commoner, he began to accumulate his own collection, in competition with King Njoya, who had abandoned the royal prerogative to control the visual domain and the production and distribution of objects made from prestige media such as imported beads. Yéyab's collection became the core of the Musée des arts et traditions Bamum, which exists to this day in Foumban. Yéyab also stimulated art production for sale. A postcard from the early 1930s shows him surrounded by works destined for the art market, including beaded thrones with leopard caryatids once reserved for the king, and new types of objects, such as beaded panels intended as wall hangings (fig. 33). This new genre later went out of fashion; by the 1970s, it no longer appeared in the Foumban art repertoire. Most Bamum artists moved

away from the palace area to a street leading up to the new museum, where they established workshops and stores. Art dealers soon followed, and the *rue des artisans* became a major tourist attraction and shopping area after the Second World War.

By the 1970s, art dealers along the *rue des artisans* included El Hadj Yende and others. Nji Nkome's family of carvers and bronze casters, who were loyal to the monarchy, remained in Njinka, next to the palace, where they operated their own workshops. The head of the lineage today, Nji Salifou Njikomo (Nji Nkome), a grandson of the famed sculptor and caster Nji Nkome, lives there in the three-story house surrounded by the bronze-casting workshops of his relatives. A gifted bronze caster himself and mentioned in Gebauer's 1979 catalogue, as El Hadj Salefou Mbetnkom, "the leading caster in today's Fumban," he established a thriving business dealing in artworks from the entire region, including Nigeria.[27] Gallery owners, collectors, airline employees, and occasional tourists all found their way to his bright green *case à étage* in Njinka, and many works, ranging from authentic pieces to new productions, went through his hands. His selling technique was finely honed, and he knew his clients. When expectant buyers entered the house at the lowest level, tourist pieces awaited them. The quality was notably different on another floor, and Njikomo kept the most precious works in his private apartment on the second floor, which many important European and American art dealers and collectors visited. This division of the house into three main areas afforded the buyer a sense of discovery and privilege when he or she was allowed to enter the inner sanctum, the owner's private residence. Here Njikomo displayed his own small collection of ancient objects and a library containing many art books, including copies of Gebauer's book and Tamara Northern's 1984 *The Art of Cameroon*.[28]

56 *Pipe bowl*

Unknown artist or workshop
Banka chiefdom, Cameroon Grassfields,
Cameroon
20th century
Terra-cotta
H. 16 cm, w. 5.5 cm, d. 9.5 cm (H. 6⁵⁄₁₆ in.,
w. 2³⁄₁₆ in., d. 3¾ in.)
Acquired in 1980 from Mr. N'Béreté, Cambridge
Pub. Adams 1983, 26–27; Exhib. Boston
Athenaeum 1983

Njikomo's offerings included objects that had long been favorites with collectors in Foumban as well as others only recently "discovered" by the art market. Take, for example, the history of clay pipe bowls like this one in the McMillan Collection (cat. 56). Figurative pipes in bronze and clay arrived in large quantities in German museums before the First World War and were also depicted in books.[29] Clay pipes came from workshops all over the Grassfields region —near Foumban, from the hands of the skilled potters of Marom—and one wonders whether their large number in pre-World War I collections was the result of the potters' early adjustment to new markets. Pipes lingered among ethnographic artifacts in museums until Father Luitfried Marfurt, a Catholic missionary, and his order established a small ethnographic museum at Mont Phébé, a mountain near the capital Yaoundé (and at that time also the location of the most elegant hotel in town). Many visitors passed through the museum and admired this fine display of clay pipes from the Grassfields.[30] When Pierre Harter, renowned specialist in Cameroon art, published an article about pipes in *Arts d'Afrique noire* (the major French magazine for art collectors) in 1973, pipes had finally arrived in the realm of art.[31] Of course, collectors like McMillan were mostly unperturbed by such developments and followed their own aesthetic sense, yet the connection between such "discovery" processes and the types of objects that came on the market indirectly affected everybody's collecting.

In their local contexts, simple pipes were once part of men's and women's personal possessions, which they carried in their bags. More-elaborate examples, such as this work—which represents a crouching man with strong facial features, a bulging forehead and cheeks, and round eyes—were prestige objects for important men. Their expressive forms resulted directly from the production technique. The artist shaped a lump of special clay into a pipe bowl but then "carved" the features out of the clay using a reductive technique. We can thus compare the pipes to woodcarvings. It is often difficult to pinpoint the exact origin of these pipes, since they come from many specialized workshops in the larger region, but in this case, we can attribute the work to the small chiefdom of Banka.[32]

Examination of two drinking horns in the McMillan Collection adds to our understanding of the transformations that occurred in the Grassfields in the twentieth century. Carving styles and significance place the two animal horns in different contexts and circulation patterns. The older one—a buffalo horn with a smooth patina and finely engraved motifs—is a so-called title cup from the Western Grassfields (cat. 57). It is one of three essential regalia that each lineage head receives at his investiture, when he takes his "title"; the other two ritual objects are his stool and his cap. Title cups have multiple functions and often serve as ritual containers from which the owner pours libations and drinks palm wine. The act of drinking ceremonially from the cup links the lineage heads with the ancestors, for their "breath is around them."[33] Other members of the lineage may drink from the cup, which is believed to have curative and dispute-settling abilities. In Grassfields culture, the title cups are thus deeply embedded in many actions, which is reinforced by their iconography. In this piece, the fully articulated lizard alludes to vitality and the stylized frog motif to fertility and prosperity. Carvers in Big Babanki, neighboring Babanki Tungo, and some other centers specialized in the production of these cups and sold them to patrons throughout the region. When purchased, they were merely beautiful containers—only a ritual rendered them efficacious. Foreign patrons also acquired the horns, which became cherished souvenirs or entered collections. The second, more elaborately carved animal horn seems to belong to a different context (cat. 58).

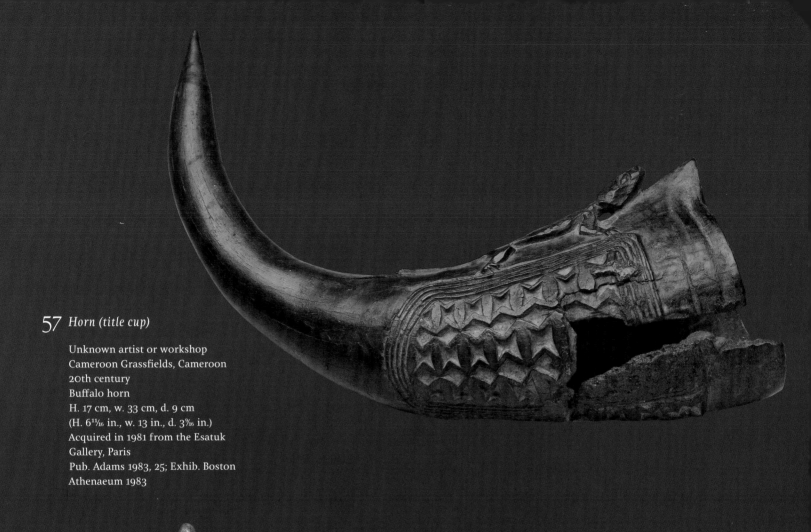

57 *Horn (title cup)*

Unknown artist or workshop
Cameroon Grassfields, Cameroon
20th century
Buffalo horn
H. 17 cm, w. 33 cm, d. 9 cm
(H. 6¹¹⁄₁₆ in., w. 13 in., d. 3⁹⁄₁₆ in.)
Acquired in 1981 from the Esatuk
Gallery, Paris
Pub. Adams 1983, 25; Exhib. Boston
Athenaeum 1983

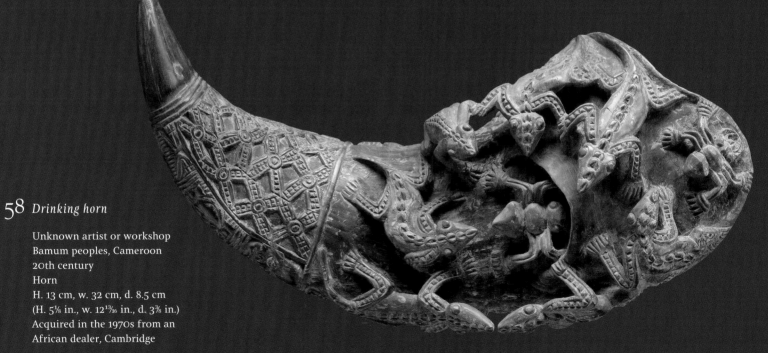

58 *Drinking horn*

Unknown artist or workshop
Bamum peoples, Cameroon
20th century
Horn
H. 13 cm, w. 32 cm, d. 8.5 cm
(H. 5⅛ in., w. 12¹³⁄₁₆ in., d. 3⅜ in.)
Acquired in the 1970s from an
African dealer, Cambridge

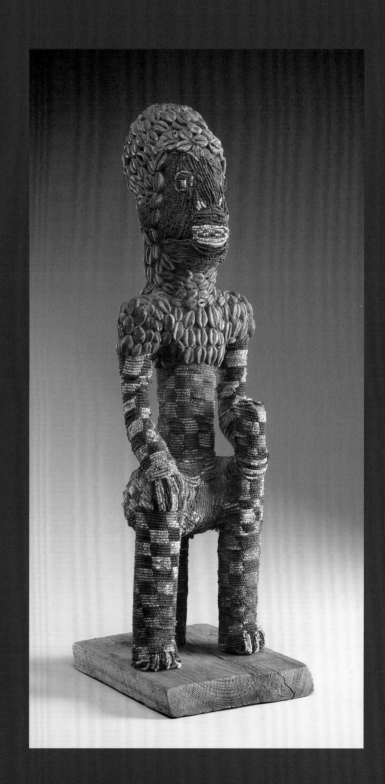

59 *Male figure*

Unknown artist or workshop
Bamum peoples, Cameroon
20th century
Wood, burlap, beads, shells,
string, encrustation
Overall: H. 65 cm, w. 18.5 cm,
d. 16 cm (H. 25⁹⁄₁₆ in., w. 7⁵⁄₁₆ in.,
d. 6⁵⁄₁₆ in.)
Acquired in the 1970s from an
African dealer, Cambridge

FIG. 34 Store display on the *rue des artisans*,
Foumban, United Republic of Cameroon
(now Republic of Cameroon), 1977

FIG. 35 Bronze casters in Foumban, French Cameroon
(now Republic of Cameroon), about 1930

Its openwork style and extravagant motifs indicate that
it is a more recent display piece, perhaps exhibited in the
parlor of an important man or even in the reception hall of
a palace. The carver's varied clientele certainly would have
appreciated the crocodiles, animals associated with rulers;
the earth spider, which played a role in divination; the frog;
the human head on the horn's backside; and the surface
relief. Quite possibly it came from one of the workshops
in Foumban that are turning out carved horns to this day.
However, the carvers now experiment with the horns of
other animals, because buffalo have been decimated and
are no longer hunted. This display piece reminds us that
adaptations and the invention of new types of objects are
crucial to maintaining an edge in the market. Several types
of innovative objects came into and went out of style in
the many decades that Bamum artists have created works
for multiple clienteles.

Two fascinating pieces conclude our brief examination
of the processes set in motion by the arrival of foreign
patrons in the Grassfields and the movement of the arts
into Western collections. One is a beaded figure that also
belongs in a display context, and the second is a brass head
with a fantastic creature on its top.

The beaded figure, a male holding a vessel in its right
hand and sitting on a narrow stool, is more than fifty years
old (cat. 59). Cowries emphasize the shoulders and form
the headdress, and the color scheme is restrained in com-
parison to the bold palette of more recent beaded works
(fig. 34). A sculptor first carved the full figure in wood and
then covered it with burlap, which was fastened with tags
(raffia and, more recently, factory-made cloth have also
been used as coverings). Specialists from the chiefdom
of Megnam then attached the glass beads imported from
Europe as well as cowrie shells from the African coasts.

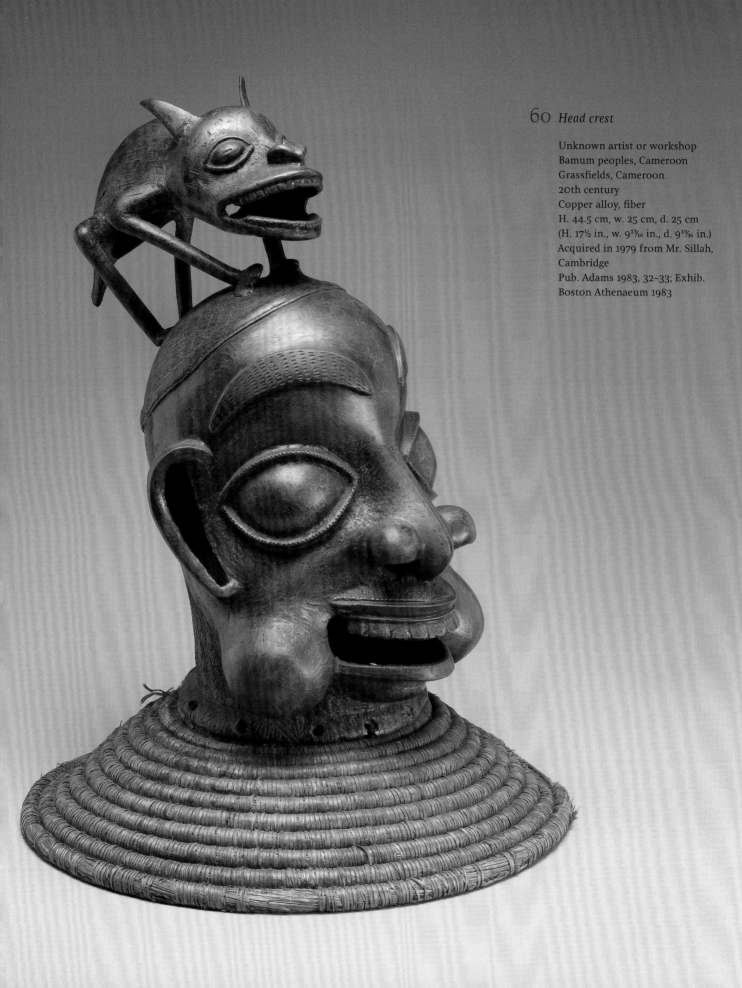

60 *Head crest*

Unknown artist or workshop
Bamum peoples, Cameroon
Grassfields, Cameroon
20th century
Copper alloy, fiber
H. 44.5 cm, w. 25 cm, d. 25 cm
(H. 17½ in., w. 9¹³⁄₁₆ in., d. 9¹³⁄₁₆ in.)
Acquired in 1979 from Mr. Sillah,
Cambridge
Pub. Adams 1983, 32–33; Exhib.
Boston Athenaeum 1983

FIG. 36 Stamp with Bamum bronze mask, issued by the United Republic of Cameroon (now Republic of Cameroon), about 1975

In recent times, women have embroidered the works, a tedious job that may take years in the case of a large throne or stool. Recent beaded sculptures differ from those of the late nineteenth century in style and workmanship; for example, the carvers no longer articulate the facial features, which instead are indicated through beadwork. It would be fascinating to investigate by whom and when these figures were "invented," because they do not belong to the nineteenth-century repertoire of Bamum arts. Today, they seem to have gone out of style, as Bamum carvers increasingly look beyond their borders and consult art books, seeking novelty and interesting object types. They make masks and sculptures in many different styles, among them Dan- and Igbo-inspired pieces. In some ways, the workshops have become "factories," a characterization we have noted in other parts of Africa (see p. 109).

A bronze head crest brings us back to the workshops of the most important artists' lineage in town, the descendants of Nji Nkome (cat. 60). They are excellent carvers and specialists in the lost-wax method of casting bronze objects. In the nineteenth century, bronze was a rare and precious medium reserved for royalty. The supply situation changed with the arrival of the Germans, and the output of the workshops and increasing size of the objects began to reflect the new conditions.[34] The casters enjoyed innovation and always came up with ideas for bigger and more ornate works. By the 1930s, large bronze pipes and figurative face masks with intricate headdresses joined the more traditional repertoire of bronze bells and neck ornaments (fig. 35). Bronze head crests, based on the wooden prototypes that appeared during royal and village masquerades, are among the more attractive inventions of the 1940s and 1950s and were probably never danced. This work shows exaggerated features typical of more recent Bamum sculpture: the round bulging eyes, large cheeks, and gaping mouth with exposed teeth. The creature on the top is one of many mythical beings that also adorn contemporary Bamum works in bronze, a group that now includes forest beings and "pygmies." In Cameroon, these recent Bamum bronzes have become popular display objects synonymous with Bamum artistic achievement. They appear in private homes, and even kings of other Grassfields states preserve in their state treasuries such beaded figures and bronze castings, presented by the Bamum kings over the years as part of traditional gift exchanges.[35] It is telling that one of these recent bronzes, a male face mask with a bird motif headdress, appeared on a Cameroonian postage stamp in the 1970s, suggesting that Bamum art, with its changing repertoire, enjoys appreciation around the country and has become part of the Cameroonian national heritage (fig. 36).

NOTES

1. MacMillan 1920, 50.

2. The Igbo are one of the most numerous peoples in Nigeria.

3. The most infamous case is the 1897 British sack of the Benin kingdom, which led to the plunder of the renowned Benin bronzes.

4. See Lamp 2004.

5. On the successful physical properties of so-called commercial and tourist art, see Graburn 1976, 15. Before the advent of better modes of transportation, large works, such as the wooden slit gongs of the Mbembe peoples in southeastern Nigeria, were simply cut into pieces and reassembled when they arrived in the collections.

6. There is actually a subgroup of collectors specializing in "Birdiania."

7. Drewal and Pemberton with Abiodun 1989, 33–39; LaGamma 2000, 54.

8. Cole and Aniakor 1984, 62–63. This short description is based on their text.

9. See, for example, on this piece, Adams 1982, 126–27. We thank both Susan Vogel and Herbert M. Cole for their brief comments.

10. The spelling of ethnic names and place-names varies widely. While we use the French spelling for place-names, such as the town "Douala," we use phonetic transcriptions of the names of peoples, thus "Duala."

11. Crowley 1974, 58.

12. The missionary, Reverend Hans Knöpfli, also contributed to the growing literature about Grassfields arts and crafts (Knöpfli 1997).

13. The postcard was published by the Mission des Prêtres du Sacré Coeur de St-Quentin and is titled "8. Art indigène: Des Sculpteurs de Tabourets."

14. One of the first scholars to mention this phenomenon is Tamara Northern (Northern 1973). More recently, Notué focused on the sculptor-kings of Babungo (Notué and Triaca 2006).

15. See Geary 1976.

16. Valentin 1977; Gebauer 1979, 68–70.

17. Kjersmeier 1938, 8 (translated by the authors).

18. The phenomenal sum paid for this figure, $3,200,000, was based on the work's dynamic posture (unusual for African sculptures), its early collection date, and its stellar Helena Rubinstein provenance. In 2006, a Fang *ngil* mask offered in the Vérité sale went for almost $7,900,000, breaking the record held by the Bangwa Queen.

19. Koloss 2000, 236–60.

20. King Njoya ruled from about 1885 to 1924, when he was deposed by the French.

21. We thank Doran Ross for pointing out this analogy.

22. "Nji" is a title of nobility.

23. For the Palace Museum, see Geary 1983.

24. Geary 1996.

25. The spelling of the names "Njoya" and "Bamum" differ in the literature.

26. Njoya 1952, 129–31.

27. Gebauer 1979, 121–22. "Fumban" is the German and later English spelling of the town's name.

28. El Hadj Salifou Njikomo still lives in this house as of this writing and still sells art, although many of the business tasks have been taken over by his "brothers," children, and even grandchildren.

29. One 1902 image shows two complete pipes, one with a bowl in the form of an elephant's head, and a pipe bowl. Hutter 1902, 407.

30. Marfurt and Susini 1966.

31. Harter 1973.

32. An almost identical pipe bowl is in Harter 1973, 29.

33. Knöpfli 1997, 18.

34. Geary 1982.

35. The king of Mankon, for example, preserves several Bamum works in his Palace Museum. Notué and Triaca 2005.

CHAPTER 7

KINSHASA—BRAZZAVILLE

Henry Morton Stanley, the famous British adventurer who found David Livingstone and explored Central Africa in the service of Léopold II, King of the Belgians, established a small post on the Congo River in 1881 and named it Léopoldville in honor of the king. Four years later, it became part of the Congo Free State under the king's personal rule. By 1900, out-spoken critics worldwide—among them American writer Mark Twain—attacked the economic exploitation and brutal treatment of the people. Ultimately, the Belgian Parliament annexed the Free State in 1908, renaming it the Belgian Congo. By then, Léopoldville was already the major river port on the Congo, and it became the capital of the colony in 1920. The town grew rapidly (after Cairo and Lagos, it is now the third-largest city on the African continent, with more than 7 million inhabitants). People arrived from as far away as Senegal, Sierra Leone, Benin, and Nigeria, first to work in the Free State and then to find employment with colo-nial enterprises in the Belgian Congo (see fig. 3, p. 17). Many settled in Léo, as the town was called, adding to the international flavor. After independence in 1960, it remained the capital of the country that was named Zaire in 1971 and renamed the Democratic Republic of the Congo (DRC) in 1997. Léopoldville became Kinshasa—or Kin, as locals call it—

in 1966. Both pre- and post-independence histories of the Congo have been tragic at times, yet through it all Kinshasa has kept a certain flair.

More than any other city in Africa, Kinshasa is music and dance. In the 1950s, its orchestras, dancehalls, and nightclubs were renowned. Musicians blended the rhythms of the rumba, mambo, and cha-cha with highlife from West Africa and local sounds, and the hip Kinois listened to Tino Rossi and Georges Guétary, international singers and film stars based in France (fig. 37). Clubs such as the Tout Léo flourished. "This mecca of pleasure has the merit of having welcomed all the musical celebrities of the end of the 1950s, including OK Jazz, African fiesta, Nico and Rochereau, Kwamy, Mujos, as well as the stars of a rising generation such as . . . the Soki Brothers, . . . Papa Wemba, and others," writes Manda Tchebwa in a short essay titled "The Music at the Heart of the City."[1] Well-to-do foreign visitors stayed at the Hans Memling Hotel and later at the Intercontinental. The National Museum of Zaire preserved

objects from the more than two hundred peoples living in this country, an area the size of the United States east of the Mississippi. If Kin was not enough excitement, one could head across the Congo River to Brazzaville, the sister city in the Republic of the Congo, once under French rule. McMillan took this trip when she visited the Congo in 1966, continuing on to the Central African Republic and Chad, where she photographed marketplaces and some of the dance performances staged for tourists (fig. 38).

The art market in Kinshasa had interesting goods to offer—finely designed raffia cut-pile and embroidered cloths (the so-called Kasai velours) by Kuba artists; Luba sculpture; masks from the Pende, Yaka, and their neighbors; and metalwork in the form of swords, knives, and tools. Vendors operated shops along the streets and at large intersections. The popular Ivory Market, with carvings in all different sizes and shapes, attracted tourists and local residents. Like their counterparts in other African

FIG. 37 City 5 Band at Afro-Mogambo nightclub, Kinshasa, Zaire (now Democratic Republic of the Congo), 1967

FIG. 38 Performers in Libenge, Republic of the Congo, 1966

countries, artists in the Congo had quickly adjusted to market demands and new opportunities.

Brazzaville was less interesting for the art collector. Raoul Lehuard, editor of the collectors' magazine *Arts d'Afrique noire,* visited the Republic of the Congo in 1983 and found workshops along one of the main highways but noticed that the carvers worked from art books. His visit to a Teke village yielded nothing to take home, even though the inhabitants showed him several old power figures. Strict antiquities laws prohibited their export.[2]

The objects in the McMillan Collection that came out of central Africa tell fascinating stories. They allow us to explore the trajectories of several masks and examine the arrival of newly "discovered" types of objects, which did not belong in the early canon of African art in the West. The superb Kota reliquary figure in the McMillan Collection came to McMillan through Madeleine Rousseau in Paris (see cat. 2). Reliquary figures of the Kota peoples, who live in southern Gabon and the northern Republic of the Congo, won Western recognition early—partly because artists and collectors responded to their aesthetics and partly because they were available through the art trade. Among the most iconic of all African forms, they began their lives in the West as ethnographic specimens in French and German museums in the late nineteenth century. In 1887, for example, a Kota reliquary figure took center stage in a plate in Ratzel's ethnography (fig. 39).[3] Paris artists later appropriated the objects in their work and acquired the figures as objets d'art for their collections. These Kota works were so admired that Juan Gris produced a 1922 cardboard rendition of a Kota reliquary figure because the notoriously poor artist could not afford the real thing.[4] William Rubin's *"Primitivism" in 20th Century Art* contains numerous images of these figures, thirteen of which were auctioned off in the recent sale of the Pierre

SÜDWESTAFRIKANISCHE WAFFEN UND GERÄTE.

FIG. 39 Lithograph of southwest African weapons and tools, 1887

and Claude Vérité Collection.[5] The reliquary figures found a place in most early exhibitions and publications that presented African objects as art. Kjersmeier summarizes the meaning of these works for connoisseurs: "These statues, which unquestionably must be considered the most imaginative composition based on the human body in African art, consist of a wooden skeleton the face of which is covered with an application of copper or bronze in the front."[6]

In their original settings, the figures (*mbulu-ngulu*) guarded the bones and other relics of important ancestors, which family groups placed in baskets or wrapped in bundles. Kept in a small shelter, these potent reliquaries with their guardian figures protected the living. It has been argued that the entire configuration—the basket with the upright figure above it—represents the human shape. The oversize heads with crescent-shaped and/or winged hairdos and the open lozenge-shaped lower parts suggest the head and shoulders, and the container forms the body. The works in private and museum collections are but beautiful fragments, because people rarely parted with the venerated baskets, which were of lesser interest to the collectors.

The Kota abandoned the use of such reliquaries long ago. When they converted to Christianity at the turn of the twentieth century, missionaries forced them to relinquish the sculptures, but many also parted with them voluntarily.[7] Numerous figures, like this one, left through Brazzaville and found their way into collections. This is a late-nineteenth- or early-twentieth-century work, distinguished from later pieces by finely applied brass sheets and copper strips. It comes from the Obamba subgroup of the Kota, whose *mbulu-ngulu* rank among the most cherished types of Kota reliquaries in the West.[8] Recognizing the impact and importance of these works, present-day governments in their region of origin have proudly placed them on postage stamps and in other official literature as symbols of their peoples' distant past and artistic achievement. Carvers in Central and West Africa now produce copies in large quantities. Kota reliquary figures are well on their way to becoming a pan-African phenomenon.

Central Africa was an inexhaustible reservoir for masks, and four different mask types in the McMillan Collection tell fascinating stories. The journeys of wooden Pende masks (*mbuya*) into Western collections began somewhat later than those of the Kota reliquary figures, mainly because of the history of the Pende region, in the southwestern part of the DRC (cat. 61). Although a trading post existed in Pende territory by 1888, the Pende were not drawn fully into the economy of the Congo Free State until 1901, when a Belgian company founded an enterprise in that region to exploit rubber.[9] Pende masks soon attracted attention, and it seems that Pende sculptors immediately adjusted to the nascent foreign demand; several scholars visiting the Congo in the first decade of the twentieth century collected these masks *outside* of Pende country, indicating that they were already circulating as commodities.[10] Art historical studies among the Pende, from the mid-1950s onward, mostly explored the stylistic characteristics of different types of masks and the masks' geographic distribution in Pende country. This approach emerged from the Belgian tradition of art scholarship and the writings of one preeminent scholar, Father Léon de Sousberghe. His 1959 classic *L'Art Pende* laid the foundation for future work and influenced other scholars, a phenomenon that is also pertinent to the field of Dogon studies, which was dominated for decades by Griaule and his disciples.[11] More interesting in our context is recent research about the evolving meaning of the masks, the proliferation of new types, and the artists' approach to creating them for different clienteles. In her groundbreaking study *Inventing Masks*, Z. S. Strother transports the reader into the heart of Pende thought and artistic practice.[12]

The mask in the McMillan Collection is of the *mbuya* type and belongs in the context of men's fraternities that performed masquerades for the entire community; women were allowed to see but not touch the masks. Each association had a chest with many mask characters, ranging from chiefs and women to jesters, and young men performed them during festivals. The face pieces and mask costume

61 *Mask* (mbuya)

Unknown artist or workshop
Pende peoples, Democratic
Republic of the Congo
20th century
Wood, pigment, cloth, raffia
H. 33 cm, w. 23 cm, d. 21 cm
(H. 13 in., w. 9⅟₁₆ in., d. 8¼ in.)
Acquired in the 1970s from an
African dealer, Cambridge

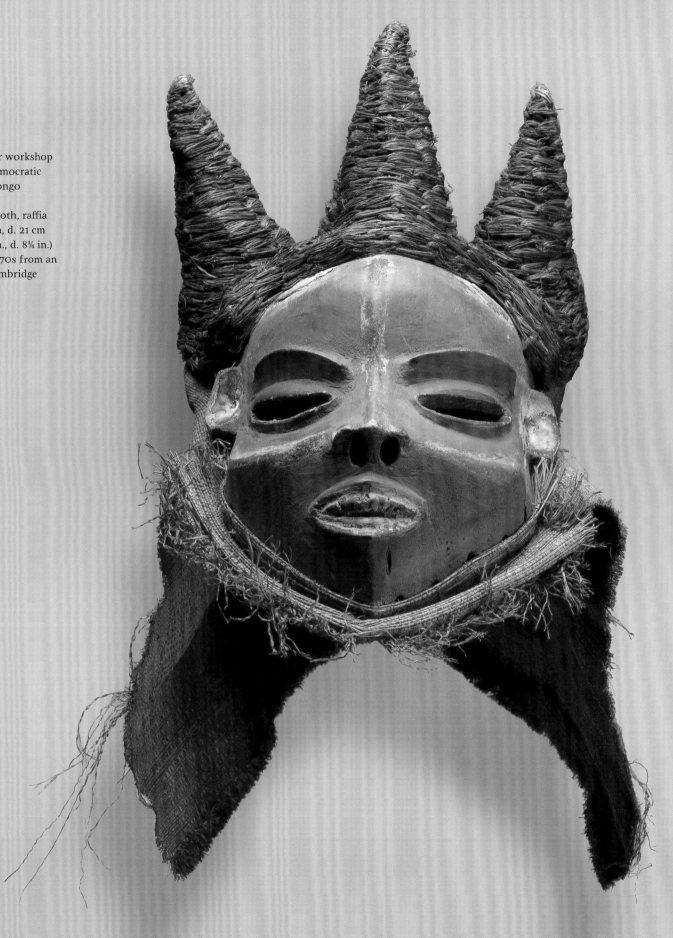

were inseparable, and the character embodied in a mask generally may be determined only by examination of the entire mask persona. This mask, however, can be identified by its horned coiffure with the receding hairline. It represents *pumbu*, the "executioner," a man who killed another human being and thus commanded fear and respect. In a vigorous dance performance, *pumbu* appears with two attendants and ferociously swings a sword.[13] There are regional variations in the Pende masks' meaning and performance, as there are stylistic differences, depending on the place of origin and the moment in time when the artists created them. Many masks show idiosyncrasies. In this mask, for example, the artist emphasized naturalism, rounding the facial features, softening the lines, and opening up the eyes, which are usually downcast in other masks of this type. In addition, most *pumbu* masks in other collections seem more aggressive, as befits their threatening persona. Nevertheless, this *pumbu* compares well to other mid-twentieth-century Pende works.

Invention has characterized Pende masking, especially in the second half of the twentieth century, when comedic types proliferated in response to modern life.[14] Young men, who often had traveled to larger cities and worked outside their home regions, commissioned artists to carve the headpieces after they had determined the nature of the mask personae, and all details for the costumes and accoutrements were in place. Thus, the carving of the headpiece came after the invention of the mask persona. Who were the artists? Strother presents the case study of Gabama a Gigungu (about 1890–1965), whose biography parallels those of his contemporaries, who produced the majority of Pende masks now in museums and private collections.[15] Pende sculptors were first and foremost blacksmiths, whose ability to transform iron into tools was essential for the community and gave them enormous prestige. Gabama

a Gigungu learned his sculpting skills from an uncle, another carver, and in the 1920s set out to find clients. By 1933, he had produced masks for the Belgians and for a Jesuit Mission. He also worked ivory, made jewelry, and began working full-time as a sculptor, although in the beginning he could not support his family on the meager earnings. While he continued to take commissions for masks from young Pende men, his income depended on the commercial art market. His successful workshop was still active in the 1980s, and his strategies set a precedent for other men who aspired to make a living from carving. In 1989, Strother counted seven independent sculptors in the village of Nyoko-Munene, where she did some of her research. They produced objects for the foreign market; one sculptor turned out as many as twenty masks each week.[16] Such observations, especially concerning the first half of the twentieth century, challenge the narrow notions of authenticity discussed in chapter 1.

Yaka masks, with fantastic superstructures in the forms of human figures and animals, are multimedia productions made from wood, cloth, and raffia fibers—and are favorites among collectors (cats. 62, 63). The Yaka in the southwestern DRC became famous for these masks, which are part of *nkanda* initiatory training for young boys and often allude to sexuality and procreation. After circumcision, the adolescents lived in a camp in the bush where senior men instructed them and conducted rituals, a process that might last as long as three years. Masked performances accompanied the rituals, since masks—perceived as images of ancestors and departed culture heroes—embodied powerful collective memories and protected the initiates. When the boys had transformed into men, they reentered the village and celebrated their new status with masquerade performances. They not only wore their masks, usually dancing in pairs, but also displayed them during performance. An

62 *Mask* (ndeemba)

Unknown artist or workshop
Yaka peoples, Democratic Republic
of the Congo
20th century
Wood, pigment, cloth, raffia
H. 60 cm, w. 50 cm, d. 42 cm
(H. 23⅝ in., w. 19¹¹⁄₁₆ in., d. 16⁹⁄₁₆ in.)
Acquired in 1959 from the Galerie
Lemaire, Brussels

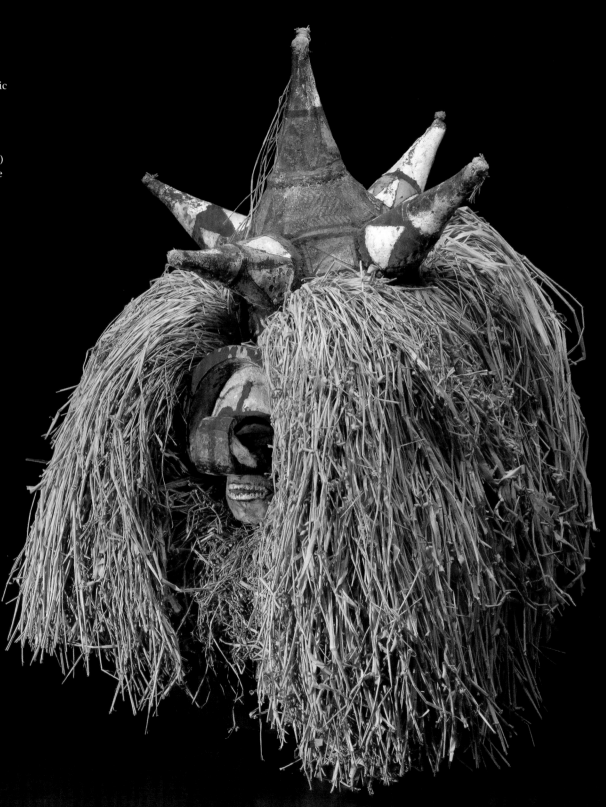

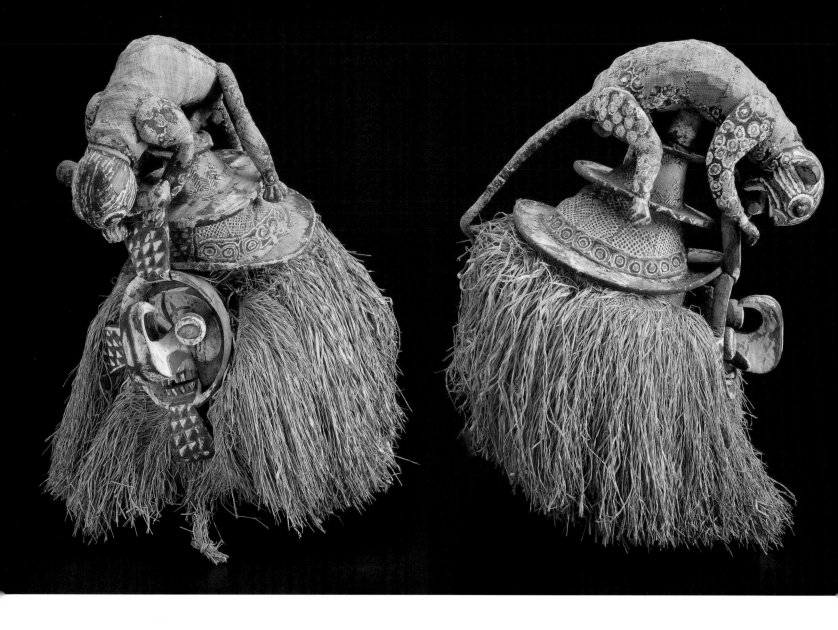

63 *Mask*

Unknown artist or workshop
Yaka peoples, Democratic Republic of
the Congo
20th century
Wood, pigment, cloth, raffia
H. 57 cm, w. 40 cm, d. 44 cm (H. 22⁷⁄₁₆ in.,
w. 15¾ in., d. 17⁵⁄₁₆ in.)
Acquired in 1959 from the Galerie Lemaire,
Brussels
Pub. Adams 1982, 62; Exhib. Carpenter Center,
Harvard University 1982

early postcard, based on a photograph that also shows the mask costumes, illustrates such a display (fig. 40).[17] At the end of the initiation period, the young men destroyed the masks; in the twentieth century, however, many were sold and entered the art market.

Eight different types of masks are involved in the initiatory process—some are powerful and terrifying, while others entertain. One mask, designated as *ndeemba,* shows the typical construction: a wooden face piece, painted in white, red, and blue, with a superstructure (cat. 62). Himmelheber observed the production of such a mask in 1939. According to his description, the sculptor took about a day to carve and paint the facial portion with red and white soil-based pigments. As is typical for Yaka masks, the prominent nose is upturned, and a visorlike form surrounds the face. After completing several wooden face pieces, the sculptor decided which superstructure would complement each one, thus determining the type of mask a wooden piece would become. He constructed the headdress by stretching raffia cloth over a wicker frame, painting it with a resinlike black substance, and then applying other patterns. Artists specialized in certain types of masks and at times produced several from which potential clients could choose; this strategy served them well when foreigners began buying masks.[18] *Ndeemba* masks entertained and delighted with their fanciful headdresses. Some had antenna-like projections, while others with figurative elements alluded to complex ideas about the cosmos and human sexuality. Animals, such as the devouring leopard in another Yaka mask in the McMillan Collection, and puppetlike depictions of men and women frequently appear as appendages, and devising these elements allowed artists to be creative and invent new motifs (cat. 63).

Two other masks in the McMillan Collection illustrate the practice of resurrecting and commodifying certain

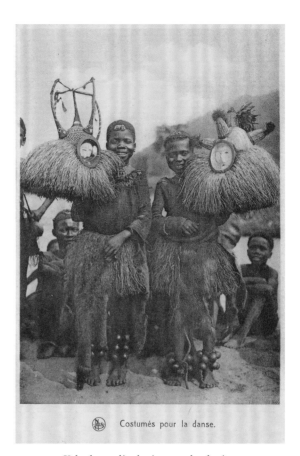

Costumés pour la danse.

FIG. 40 Yaka boys displaying masks during a performance, Belgian Congo (now Democratic Republic of the Congo), about 1920

object types. Teke masks (*kidumu*) are certainly among the most familiar (cat. 64), and their impressive abstract forms and vivid polychroming drew the acclaim of avant-garde artists in the early twentieth century.[19] The Teke, who live in a vast area in Gabon, the Republic of the Congo, and the DRC, including Brazzaville and Kinshasa, came to the attention of Western observers early on.[20] These flat headpieces were part of a mask costume worn in masquerades that go back to the nineteenth century and have been linked with

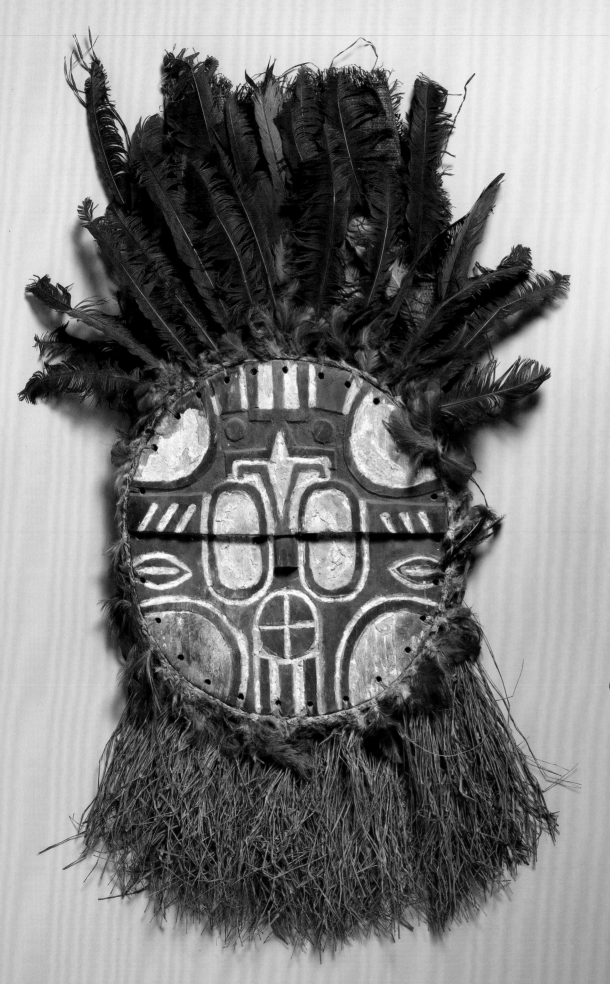

64 *Mask* (kidumu)

Unknown artist or workshop
Teke peoples, Republic of the
Congo and Democratic Republic
of the Congo
20th century
Wood, woven raffia cloth,
feathers, raffia, pigment
H. 35 cm, w. 33 cm, d. 7 cm
(H. 13¾ in., w. 13 in., d. 2¾ in.)
Acquired in 1967, Douala,
Cameroon

the Tsayi, a Teke subgroup. The actual origins of the masquerades—whether they were appropriated from neighbors or invented by individual carvers—remain shrouded in legend. What seems obvious, however, is that they are embedded in Teke history. They did not—as Western observers tend to believe—emanate from a timeless universe but rather have a history of invention, distribution, and, in this particular case, discontinuation.

By the beginning of the twentieth century, *kidumu* masquerades associated with a nature spirit called Nkita were common. Young male members of a society entered the village from the wilderness and performed during ceremonies, executing strenuous, cartwheeling dances. Several scholars and collectors have interpreted the abstract motifs as a "face" and suggest that the "doubling" of the eyes through semicircles alludes to clairvoyance. All elements in the masks appear as mirror images in a symmetrical configuration, one reason why they appeal to Western eyes. In later years, the masquerades slowly disappeared as people converted to Christianity and engaged in economic activities in and outside the region. A few old men guarded both the knowledge and the masks that had not gone to European collections. But when and how did their resurgence begin?

Marie-Claude Dupré, who conducted extensive research among the Teke, carefully reconstructed the events that led to the reappearance of the masquerades in a new environment and to the carving of new *kidumu* masks among the Teke. It began in 1963, with the inauguration of a railway line through Teke territory to Pointe Noire—a major harbor town on the Atlantic coast—when a group of men decided to re-create the masquerade and commissioned new masks. Subsequently, carvers began to produce these masks again, especially when they noticed that their colleagues in neighboring Gabon made good money with renderings of *kidumu*,

FIG. 41 Stamp with Teke mask, issued by the Republic of the Congo, 1966

and certainly when they saw the masks on postage stamps (fig. 41). In 1968, *kidumu* maskers performed during a cultural week in Brazzaville, and by 1970 the production of *kidumu* masks was in full swing. Newly invented and older motifs place the ingenious and colorful masks among the most successful ventures of this kind. Collectors took an interest in the new production, even delivering sketches and photographs of the types of masks they found attractive.[21] The masks soon appeared in art galleries up and down the African coast, including in the Ali Baba gallery in Douala. Attractive and vibrant, they are now part of many art collections around the world and part of Teke identity in contemporary Congo.

Similar stories can be told about the changing nature of other mask forms. Compared to some masking traditions, masks from the Sala Mpasu peoples, who live in the south-central DRC, are rather unfamiliar to Westerners (cat. 65). Their nineteenth-century history is difficult to reconstruct, partly because the Sala Mpasu resisted Belgian occupation well into the late 1920s and the first mission stations in their region opened only in 1929.[22] The masks were connected with warrior associations that warded off intruders. In the hierarchical system of ranks within the warrior associations, older men initiated young members into increasingly complex levels of knowledge, which included access to certain aspects of masking. In a step-by-step process, men fulfilled obligations, among them "payments" in the form of goods, in order to gain access to and "own" masks associated with higher ranks. When a man had reached his goal, he could collect initiation "payments" from younger members, who also wanted to own masks. Possession and display of masks were thus linked with wealth and prestige. There are at least three types of masks: two are wooden headpieces, while the third consists of woven raffia and displays either a knobbed coiffure or a small conical headdress, like the mask in the McMillan Collection.

Sala Mpasu masks, with their distinct bulging foreheads and narrow sunken eyes, were rare in collections partly because the Sala Mpasu resisted the Belgians and remained fiercely independent. In addition, Sala Mpasu masking and the warrior associations were discontinued after independence in 1961, when an iconoclast movement took hold and people deliberately abandoned their old ways, choosing to move into modern times and claim a place in the new Congolese nation. Elisabeth Cameron, a specialist in arts from Central Africa, notes, however, that the supply of masks for the foreign market did not cease. In fact, many masks—including the raffia ones—came on the market in the 1970s.

It may be that Sala Mpasu artists recognized the economic opportunities presented by the art market and continued production. Masks from this time period are now cherished objects in many collections.[23] When Cameron conducted research among the Sala Mpasu in 1989, she found that production for the art market was indeed in full gear, facilitated by the Catholic Church. Thus, she remarks, "this commercial endeavor demonstrates a newer form of wealth associated with masquerades," referring to the connection of wealth and prestige to these masks in the long-defunct warrior associations.[24]

Carved containers from the hand of Kuba artists are among those art forms once considered merely decorative or utilitarian by Western collectors. The Kuba peoples are a cluster of diverse groups who are under the rule of a king (nyim) who resides in Mushenge in the south-central DRC, and are known for their elegant sculptures. The carved portraits of their rulers, the celebrated ndop, engendered many studies exploring their history and meaning. While the oldest ones are now in Western museums, sculptors still produce fine copies, as seen in a carefully staged 1971 photograph of an idyllic compound in Mushenge, which shows a sculptor, a woman making cut-pile embroidered raffia cloth, another woman preparing food, and a man reading a book (fig. 42).

The Kuba kingdom began its ascent in the region during the seventeenth century. Although Europeans had heard about it for years, the first Westerner to cross its border, in 1892, was the African American missionary William Sheppard.[25] He also brought back the first objects directly from the Kuba realm, and his collection of almost four hundred objects is now in the Hampton Art Museum in Hampton, Virginia, and the Speed Museum in Louisville, Kentucky. Other visitors followed Sheppard, often in competition with one another. Emil Torday, a Hungarian-British

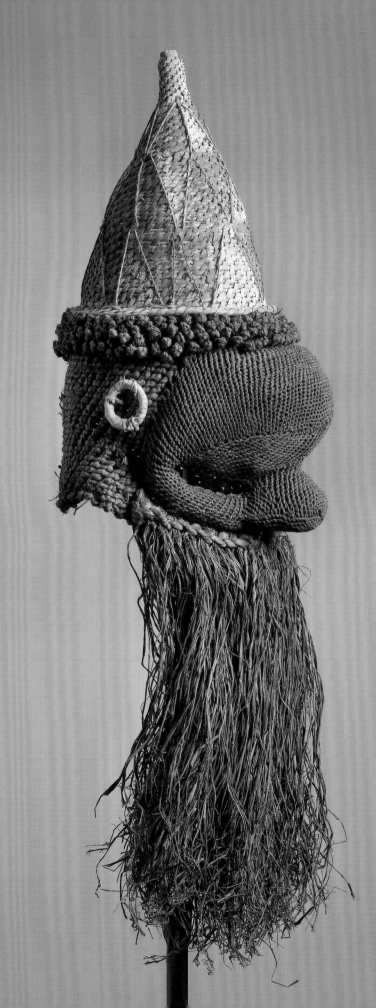

65 *Mask*

Unknown artist or workshop
Sala Mpasu peoples, Democratic
Republic of the Congo
20th century
Raffia fiber, pigment
Overall (without beard): H. 40 cm,
w. 22 cm, d. 32 cm (H. 15¾ in.,
w. 8¹¹⁄₁₆ in., d. 12⅝ in.)
Acquired in the 1980s from an
African dealer, Cambridge

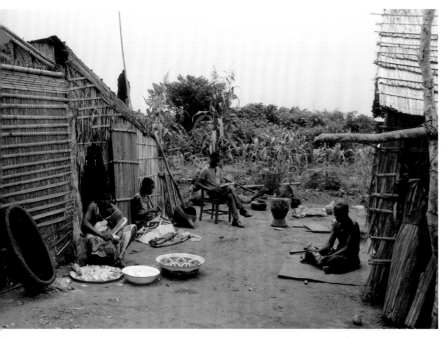

FIG. 42 Kuba woman peeling manioc, woman making raffia cut-pile cloth, man reading a book, and man carving, Mushenge, Zaire (now Democratic Republic of the Congo), 1972

ethnographer, stayed in Kuba country in 1908, and Leo Frobenius, his German rival, spent two years in the Congo from 1904 to 1906, collecting everything he could get his hands on. Both men noticed the delicate surface ornamentation of Kuba utilitarian objects such as cups and boxes. Frobenius depicted three Kuba containers in his expedition account and added the following caption: "Splendid pieces of Bakuba art three wooden boxes."[26] Although he was given to hyperbole, it is interesting to note that he characterizes the pieces as art. Their intricate designs resonated with Westerners, who at that time had developed a taste for and interest in ornament. By 1935, Kuba boxes had been admitted into the canon of art. Although Sweeney did not include any among the plates of the MoMA catalogue, he

mentions them in his essay about the characteristics of African art. "Certain features . . . may stand out. For example the definite character of surface decoration in BaKuba cups and boxes . . . offers a ready contrast to the simpler, more architectonic, though somewhat more naturalistic sculpture of the BaLuba tribe which, like the BaKuba, is also of the Belgian Congo region."[27]

Wooden boxes, a favorite among collectors, served different purposes according to their shapes. The semicircular, so-called moon boxes, named *ngondo* by the Kuba, once contained *tukula,* a reddish powder from the bark of a tree that is pounded and ground on a large stone (cat. 66).[28] Men and women rubbed their bodies, hair, and clothing with this expensive and treasured substance during festive occasions and also used it in ritual settings. The boxes' intricate surface treatment demonstrates the Kuba delight in two-dimensional design, which ranges from adornment of the human body in the form of scarification to geometric patterns in raffia cloth created jointly by men and women using complex techniques (cat. 67). Scholars have described one principle of Kuba aesthetics as *horror vacui,* the artist's reluctance to leave empty spaces, evident in the surface treatment of this and other containers. Designs, all with specific names, cover the entire container. The focal point of this and similar boxes is a stylized face, reminiscent of Kuba anthropomorphic masks. These elaborate boxes belonged in a leadership context, visually expressing the dominant role of the royals and the nobility.

It is not surprising that foreign demand for these boxes stimulated their production and sale. Himmelheber visited Mushenge in 1939, while studying the role and practices of artists in Central Africa. He found that, with the exception of moon boxes, artists no longer made most other types of containers. The older boxes' patina was the result of use because the artists did not stain them.[29] These pieces thus

66 *Moon box* (ngondo)

Unknown artist or workshop
Kuba peoples, Democratic Republic
of the Congo
20th century
Wood
H. 6.5 cm, w. 31 cm, d. 15.5 cm (H. 2⁹⁄₁₆ in.,
w. 12³⁄₁₆ in., d. 6⅛ in.)
Acquired in 1980 from Mr. Keita, Cambridge
Pub. Adams 1983, 26–27; Exhib. Boston
Athenaeum 1983

67 *Raffia cloth*

Unknown artist or workshop
Kuba peoples, Democratic Republic
of the Congo
20th century
Raffia fiber, pigment
H. 69 cm, w. 483 cm (H. 27³⁄₁₆ in.,
w. 190³⁄₁₆ in.)
Acquired in the 1980s, Cambridge

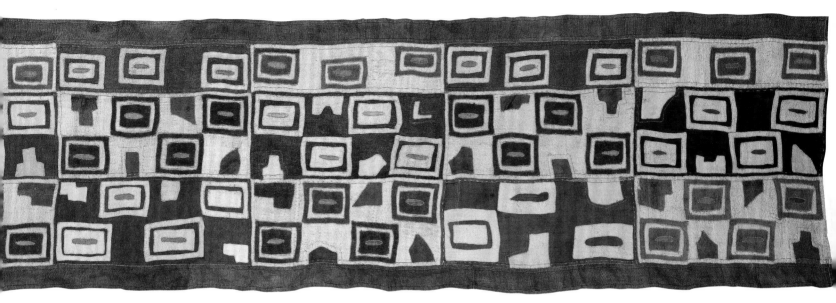

had darkened surfaces and often were so heavily encrusted that they needed "cleaning" in order to bring out the design before they entered the art market. Himmelheber depicted this process in a photograph titled "Kuba men cleaning wooden boxes in Mushenge."[30] By 1939, moon boxes had become a commodity and journeyed into Belgian and other European collections.

The international market for Kuba objects continued to expand, and in the 1950s, priests from the Order of St. Joseph of the Sacred Heart established an art school with the support of the Kuba king. According to Cameron, the Flemish priests

> studied Kuba art, wrote a textbook, and began to teach Kuba men how to create . . . art using European tools, resulting in sculptures that fit western tastes and had an appeal in the art market. The Catholic Church also facilitated the movement of these artworks to the European market. . . . The impact of the school on the art was to make the forms rigid and the designs crisp and precise. Sculptors, both students and others who were willing to abide by the art school's standards, got ninety percent of the profits from the sale which made the school a very attractive place from which to sell.[31]

In other parts of the Congo, Christian missions established similar small art centers, training local artists to maintain quality and even add new types of objects to their repertoire in order to gain a livelihood by selling to Europeans.[32]

Two groups of objects, earlier categorized as solely decorative or utilitarian, cast light on more recent developments in collecting and the expanding art market. Metal implements, adornment, and currency made their way into art

collections in the 1960s, as did headdresses, a subgroup of dress and adornment. Today, some collectors specialize exclusively in these kinds of works. Weapons, such as knives, spears, and—for the Oceanic realm—wooden clubs (see pp. 184–87), were among the first objects collected systematically, beginning in the eighteenth century. Part of the early infatuation with armament related to the task of subjugating peoples during imperial expansion; appropriation of their weaponry was a symbolic act, demonstrating the superiority of the colonial masters. Thus, spears and other weapons are included in most colonial collections. Nineteenth-century books often depict them in 'tasteful tableaux, and early photographs show weapons and tools on walls in private homes and in official museum exhibitions (fig. 43). Inspired by Western aesthetics of display, the curators of the African hall in the American Museum of Natural History in New York, for example, artistically arranged shields, spears, and blades together with zoological specimens, and in the 1930s, private collectors such as Alex van Opstal in Antwerp decorated their parlors in a similar fashion.[33]

In German-speaking countries, weapons and implements became part of scholarly debates because anthropologists assumed that their physical properties and distribution indicated cultural and historical relationships among peoples. According to proponents of this diffusionist theory, certain *Leitfossile* (guiding fossils), a term that evokes archaic and timeless settings, such as bows, knives, or shields, reveal the connections and history of cultures. Even though scholars and colonials were fascinated with weaponry and metalwork, the pieces nonetheless remained outside the realm of art. At the Museum of Fine Arts, Boston, for instance, a few odd weapons strayed into the collection, among them, in 1921, a knife with an ivory hilt from the Mangbetu peoples in the northeastern DRC,

1–10, 14–32 Speere, Lanzen, Schlachtäxte, Wurfkeulen von Kaffern, Kongonegern und Zentralafrikanern (Museum des Berliner Missionshauses, Museum für Völkerkunde, Berlin, und Christy Collection, London); 11–13 Brustschild, Schild und Kriegstrompete von der Ostküste (Christy Collection, London, und Museum des Berliner Missionshauses); 33 Armbrustbogen der Fan (Christy Collection, London). ⅓ wirkl. Größe.

FIG. 43 Woodcut of spears, lances, battle axes, and throwing clubs, 1887

which the museum staff deaccessioned to the Peabody Museum of Harvard University twelve years later.

By the 1970s, several books moved weapons and works in metal into the domain of art, among them the German-English catalogue *Afrikanische Waffen*, by Werner Fischer and Manfred A. Zirngibl, who both had collected weapons

since the early 1950s. They state their agenda in the book's introduction: "It is our intention to give the reader an impression of the skill of the African artisan working with metal, and of the artistic designs of his weapons in order to correct the widely held and false belief that the 'natives' are a backward and primitive people."[34] Their promotion of metal implements and shields as works of art is combined with ideas about their larger mission as collectors. The enterprise attests to the collector's power to create interest in certain object types and to affect the art market.[35] The inventive forms of weapons and other implements increasingly appealed to curators and collectors, and publications and exhibitions multiplied. Today, weapons and blades appear regularly at art auctions and in galleries.[36] Art books by high-end publishers and several major exhibitions completed the ascent of metal implements into the realm of art.[37] This new trend also influenced the art market in Africa. Since outside demand has increased dramatically in the past decade, local-level African dealers now carry metalwork, some operating stands devoted exclusively to iron and bronze objects for foreign patrons. Organized in bins by categories, their wares include throwing knives, swords, hoes, bronze bracelets, and neck ornaments.

Weapons from central Africa dominate the offerings, and certain ornate types enjoy great popularity. Throwing knives have become icons, most notably the blades of the Ngbaka peoples in the DRC (cat. 68). They are fairly common, since all Ngbaka men carried such weapons at the beginning of the twentieth century and used them in fighting and hunting. Ngbaka men threw the knife overhand, sidearm from a standing position, or sidearm from a crouch. The blades balance perfectly around a central point of gravity, which enabled the men to hit the target with amazing accuracy. Even though many of these throwing knives are now in collections, they were still in use in

FIG. 44 Stamps with throwing knives, issued by the Central African Republic, about 1965

the 1990s.[38] Besides functioning as weapons, beautiful blades also enhanced their owners' prestige and wealth and circulated as valuable objects—a form of iron currency. Today, these knives have become material expressions of cultural identity. The Central African Republic, a country relatively poor in wooden sculpture, issued a set of stamps in the 1960s depicting a crossbow and throwing knives

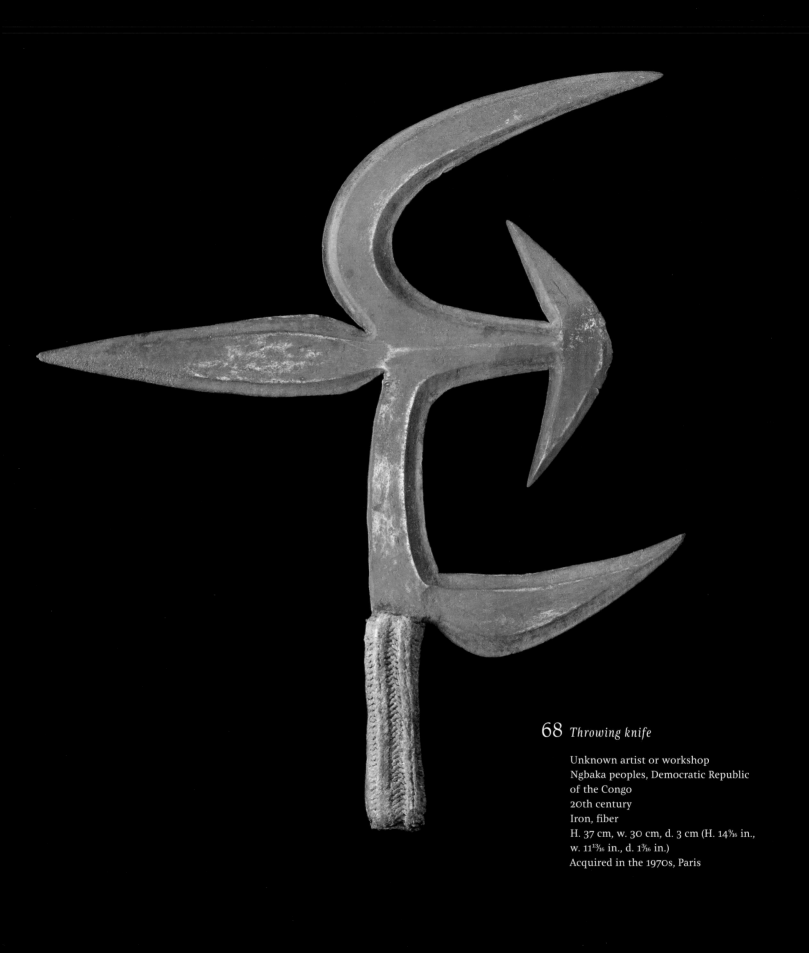

68 *Throwing knife*

Unknown artist or workshop
Ngbaka peoples, Democratic Republic
of the Congo
20th century
Iron, fiber
H. 37 cm, w. 30 cm, d. 3 cm (H. 14⁹⁄₁₆ in.,
w. 11¹³⁄₁₆ in., d. 1³⁄₁₆ in.)
Acquired in the 1970s, Paris

69 *Sickle-shaped knife*

Unknown artist or workshop
Ngala peoples, Democratic Republic
of the Congo
20th century
Wood, iron
H. 72 cm, w. 20 cm, d. 7 cm (H. 28⅜ in.,
w. 7⅞ in., d. 2¾ in.)
Acquired in the 1970s, Paris

70 *Short sword*

Unknown artist or workshop
Kuba peoples, Democratic Republic
of the Congo
20th century
Wood, copper alloy, wire
H. 30 cm, w. 7 cm, d. 6 cm (H. 11¹³⁄₁₆ in.,
w. 2¾ in., d. 2⅜ in.)
Acquired in the 1970s, Paris

from the Gbaya, who are closely related to the Ngbaka and have similar blades, and the Nzakara, whose blacksmiths produced another emblematic type of knife (fig. 44).[39]

Certain types of weapons or implements have been in high demand—be it for their extraordinary forms or their associated context—and there are many of them in the McMillan Collection. In the case of sickle-shaped iron knives with wooden handles from the Ngala, in the north-central DRC, both motivations seem to merge (cat. 69). Fischer and Zirngibl call them "beautiful and effective" and emphasize their use in executions, even presenting an Austrian artist's rendering of such a scene.[40] Kuba short swords (*ikul*) appeal to collectors for the engraved lines on their copper alloy blades, finely inlaid brass on their wooden handles, and their connection to Kuba royalty (cat. 70). A sword with an iron blade, a wooden handle, and a sheath covered with European brass furniture tacks comes from the Ekonda peoples in the central DRC and demonstrates how successfully African artists integrated foreign media into their designs (cat. 71). Like buttons, beads, and other imports from Europe, these rare tacks adorned prestigious objects, indicating the owners' importance in society. Tacks also decorate a curved ax made by Teke blacksmiths and carvers, which belongs in a ceremonial context (cat. 72).

Two ceremonial axes from the Songye realm in the southern DRC demonstrate complex production techniques and attest to the skills of African blacksmiths. Specialists attribute both types of axes to artists of the Nsapo, a Songye subgroup. Such attributions may be problematic, however, because these axes have a fairly wide distribution, and similar styles also exist among neighboring peoples. In the first ax, a central rod is adorned with two faces on each side, and twisted metal and curved elements support the blade (cat. 73). Thin copper sheeting, difficult to produce,

covers the handle. The other ax displays raised rims and perforations accentuated with curvilinear designs (cat. 74). A central openwork copper-alloy inset decorates the blade. Both axes served as prestige objects for high-ranking officials in hierarchically organized Songye society.

Shields also moved from artifact to art during the same time period, and, again, collectors were instrumental in this process. Many shields of African and Oceanic peoples (see pp. 191–93, 217–18) display elaborate designs, and their materials range from wood and fiber to leather and metal. In warfare, flamboyant shields were meant to impress opponents—we would call it psychological warfare today—and strong ritual substances protected shields and warriors. In ceremonial displays, the same shields visually transmitted strength and success. Recent publications compare their aesthetic qualities to modern art; statements such as "The shield is not flat; it has gentle undulations that alter the blackness of the black, much like some modern color field paintings"[41] suggest that the sensibilities that draw collectors to modern and contemporary art may well have influenced the inclusion of shields in the canon of African and Oceanic art. Indeed, a shield with minimalist design and fine surface texture from the Ngombe peoples in the northwestern DRC embodies the qualities that appeal to Westerners (cat. 75).

Toward the end of the twentieth century, African headdresses also entered the domain of art. Museums and private enthusiasts assembled impressive collections, exhibitions began to circulate, and the marketplace was abuzz with activity. "Crowning Achievements," an exhibition with accompanying catalogue at the UCLA Fowler Museum of Cultural History, Los Angeles, was among the first to address the relevance and meaning of headwear in the African setting from an analytic perspective, suggesting that headdresses and hairstyles "transform [people's] heads and

71 *Short sword with wooden sheath*

Unknown artist or workshop
Ekonda peoples, Democratic Republic
of the Congo
20th century
Wood, metal, copper sheet, brass tacks,
wire
Overall: H. 50 cm, w. 15 cm, d. 11 cm
(H. 19¹¹⁄₁₆ in., w. 5⅞ in., d. 4³⁄₁₆ in.)
Acquired in the 1970s, Paris

72 *Prestige weapon*

Unknown artist or workshop
Teke peoples, Republic of the Congo and
Democratic Republic of the Congo
20th century
Wood, iron, brass tacks, wire
H. 38 cm, w. 39 cm, d. 7 cm (H. 14¹⁵⁄₁₆ in.,
w. 15⅜ in., d. 2¾ in.)
Acquired in 1967 from the Galerie Majestic
(Michel Huguenin), Paris
Pub. Adams 1983, 32: Exhib. Boston
Athenaeum 1983

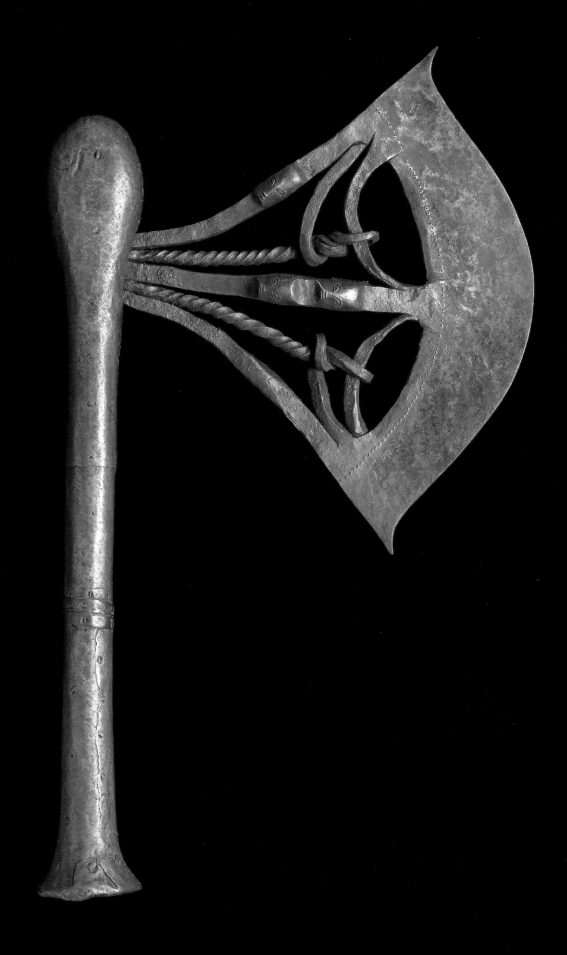

73 *Prestige ax*

Unknown artist or workshop
Songye (Nsapo) peoples, Democratic
Republic of the Congo
20th century
Wood, copper sheet, iron
H. 45 cm, w. 26.5 cm, d. 6 cm
(H. 17¹¹⁄₁₆ in., w. 10⁷⁄₁₆ in., d. 2⅜ in.)
Acquired in the 1970s, Paris

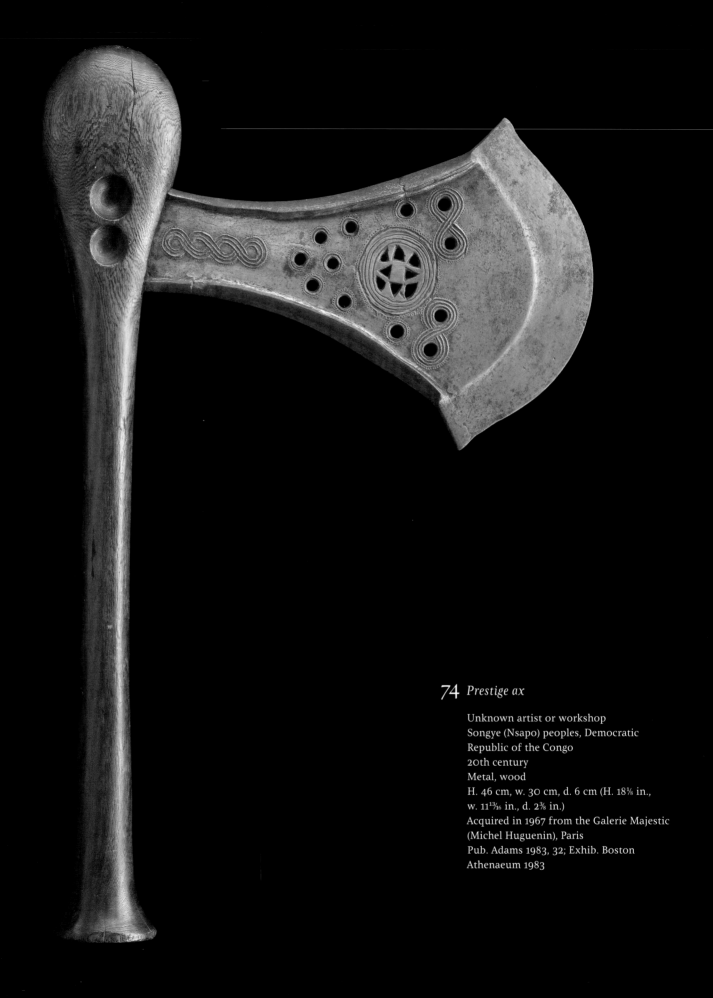

74 *Prestige ax*

Unknown artist or workshop
Songye (Nsapo) peoples, Democratic
Republic of the Congo
20th century
Metal, wood
H. 46 cm, w. 30 cm, d. 6 cm (H. 18⅛ in.,
w. 11¹³⁄₁₆ in., d. 2⅜ in.)
Acquired in 1967 from the Galerie Majestic
(Michel Huguenin), Paris
Pub. Adams 1983, 32; Exhib. Boston
Athenaeum 1983

75 *Shield*

Unknown artist or workshop
Ngombe peoples, Democratic Republic
of the Congo
20th century
Cane, fiber
H. 141 cm, w. 48 cm, d. 18 cm (H. 55½ in.,
w. 18⅞ in., d. 7¹⁄₁₆ in.)
Acquired in 1964 from the Galerie Lemaire,
Brussels

by extension their whole bodies into cultural entities."[42] In several essays, experts moved away from the mere presentation of the hats' formal characteristics to explore their significance, for, in the broadest sense, they indicate a person's status and role in society. Hats also have performative aspects. When, how, and by whom they can be seen become part of their impact and efficacy.

Take, for example, a man's hat from the Lega peoples in the northeastern DRC (cat. 76). Among the Lega, who live in territorial groups loosely governed by patrilineal clans, the *bwami* association for all circumcised adult men and their wives is the tie that binds them together. As members advance through the hierarchy of *bwami,* different types of hats reveal the grade a member has attained in the association.[43] The shape of a hat and each element—ranging from European beads and buttons, to cowrie and mussel shells, to the tail hairs of an elephant—have significance linked to *bwami* esoteric knowledge. Shells, for instance, allude to the waxing moon, while the elephant tail hairs recall the powerful role of the animal, a symbol and alter ego of a leader. Similarly, hats from the Kuba peoples in the south-central region of the DRC are deeply meaningful and visually allude to leadership (cat. 77). In this example, the precious cowries, the rare feathers, and the design place it in the realm of high-status headgear. Thus, these headdresses not only combine materials in fascinating and extravagant ways; they also speak to the deeply rooted practices and beliefs of the peoples who wore them.

76 *Hat*

Unknown artist or workshop
Lega peoples, Democratic Republic
of the Congo
20th century
Basketry, cowrie and mussel shells,
fabric, beads, reeds or quills, wood
Overall (without chin strap): H. 21 cm,
w. 21 cm, circum. 23 cm (H. 8¼ in.,
w. 8¼ in., circum. 9⅟₁₆ in.)
Acquired in the 1980s, Cambridge

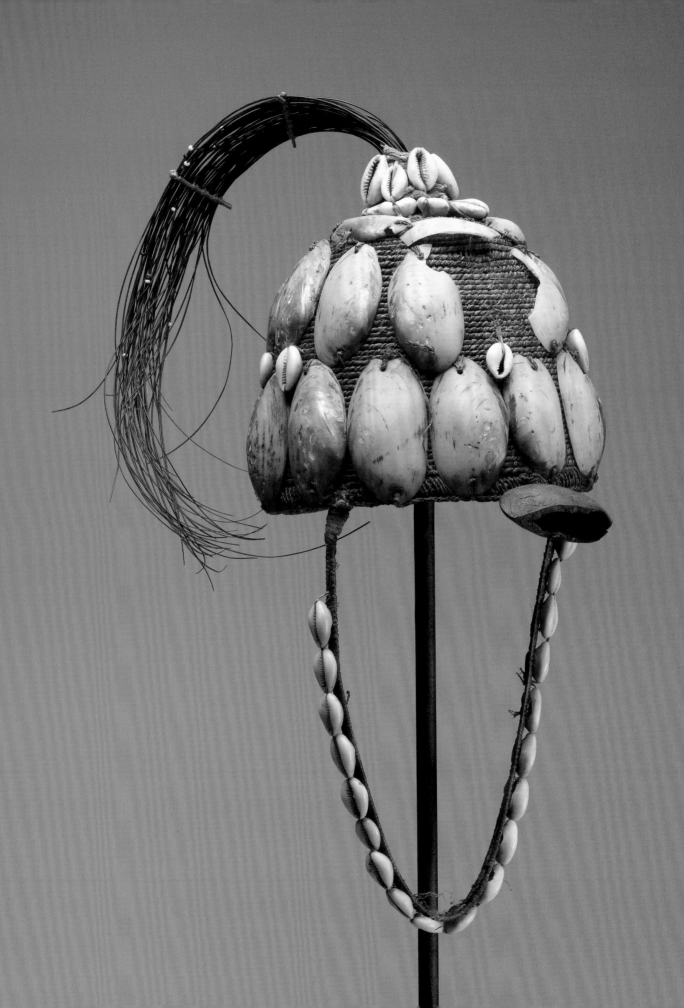

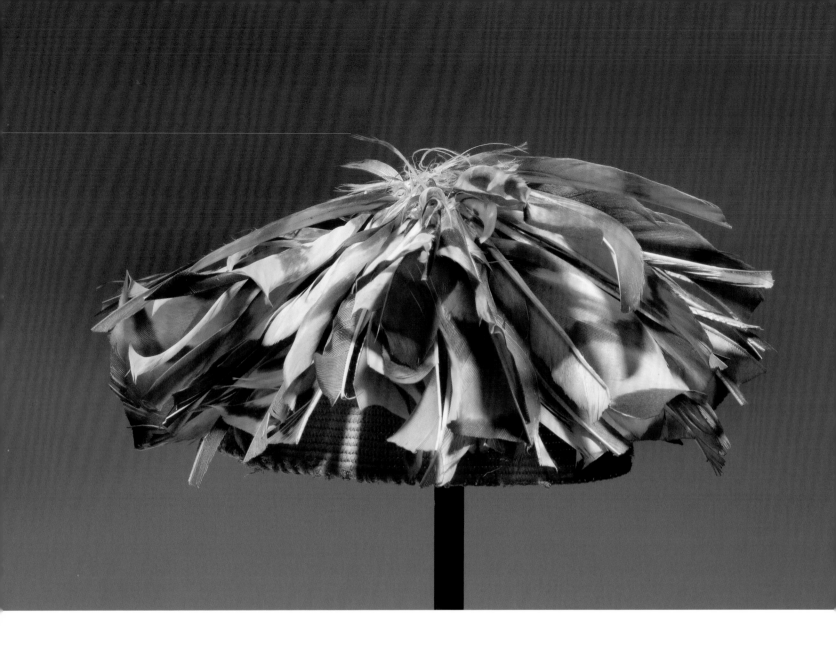

77 *Hat*

Unknown artist or workshop
Kuba peoples, Democratic Republic
of the Congo
20th century
Fiber, feathers, shells
H. 11 cm, diam. 21 cm (H. 4⁵/₁₆ in.,
diam. 8¼ in.)
Acquired in the 1980s, Cambridge

NOTES

1. Tchebwa 2001.

2. Lehuard 1983, 18–19.

3. Ratzel 1887, opp. p. 590.

4. Rubin 1984b, 13–14.

5. *Arts Primitifs* 2006.

6. De Zayas 1916, pls. 21, 22; Sweeney 1935, pls. 377, 379, and eleven figures in the exhibition; Kjersmeier 1938, 15 (translated from the French by the authors) and pls. 22, 23.

7. See the 1917 picture of two Kota-Obamba men who arrived at a Swedish Mission post in French Equatorial Africa to hand over reliquary figures in Corbey 2000, cover.

8. Chaffin and Chaffin 1979, 112–30.

9. Strother 1998, 252.

10. Strother 1999, 29–30.

11. Sousberghe 1959. For a more recent stylistic study, see Petridis 1993.

12. Strother 1998. We are grateful to Zoë Strother for her examination of the Pende mask presented here and for her information about Pende art practice in general.

13. Every part of his costume alludes to his powerful persona; see Strother 1998, 211–17.

14. Ibid., 251.

15. Strother 1999. The following is based on Strother's observations.

16. Ibid., 31.

17. See also a fascinating documentation of a 1939 performance in Himmelheber 1993, 19–56.

18. Himmelheber 1960, 332–36; see also Bourgeois 1984, 140–44.

19. Rubin 1984b, 49; Dupré 1999, 254. André Derain owned a Teke mask, and when it came up for sale at the Hôtel Drouot auction house in Paris, Charles Ratton purchased it; he in turn sold it to Joseph Mueller, whose collection became the core of the Musée Barbier-Mueller in Geneva. See also Lehuard 1996.

20. Dupré 1999. The following is based on Dupré's in-depth research among the Teke.

21. Among the telltale signs of newer masks are evenly shaped holes around the rim, used to attach raffia and feathers. However, intentional fakes may imitate irregular holes.

22. Elisabeth Cameron is one of the few art historians who have investigated these elusive masks. The following description relies on Cameron 1988, 1995b, 2004. Because of the lack of reliable early data, it was difficult for her to establish the range of mask characters among the Sala Mpasu. At times, sources could give names of mask characters but no visual documentation that would allow one to reconstruct the visual aspects of the masks.

23. Cameron 1988, 42.

24. Cameron 2004, 79.

25. We thank Elisabeth Cameron for her suggestions and comments about history and workshops in Mushenge.

26. Frobenius 1907, 240.

27. Sweeney 1935, 21.

28. Himmelheber 1960, 358.

29. Ibid., 372.

30. Himmelheber 1993, 107, fig. 142. Today, the encrustation is considered part of the aura of an object and would be removed with reluctance.

31. Personal communication, Elisabeth Cameron, May 3, 2006.

32. See Verly 1959.

33. *Art/Artifact* 1988, 12; Corbey 2000, 40.

34. Fischer and Zirngibl 1978.

35. Steiner 2002; see also Price 1989 and Errington 1998.

36. See *Waffen* 1985; Felix 1991.

37. See, for example, Ginsberg 2000 and Arnoldi 1998.

38. Northern 1981; Felix 1991; Arnoldi 1998, 32–33.

39. Now that these objects are in the art realm, dealers and collectors tend to treat them, so that the intricate details on the blades literally shine, making them even more acceptable in the art world.

40. Fischer and Zirngibl 1978, 108.

41. Ginsberg 2000, 158; see also Benitez-Johannot and Barbier 2000.

42. Arnoldi and Kraemer 1995, 13.

43. Cameron 1995a.

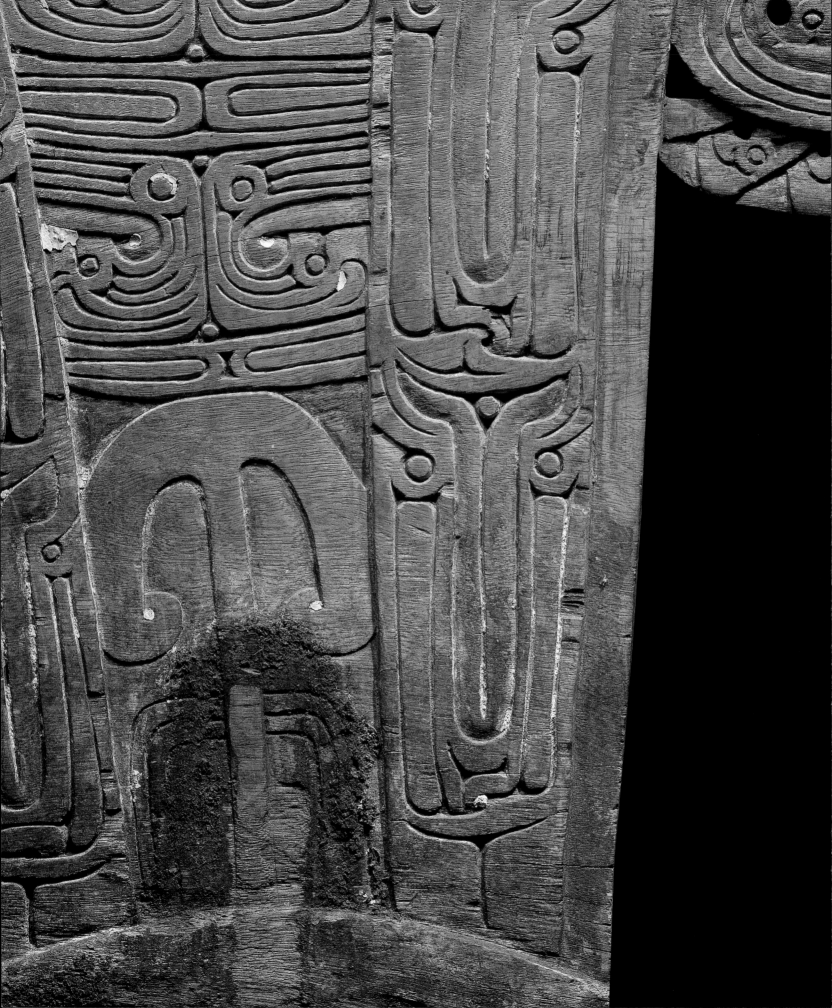

CHAPTER 8

RABAUL—ANGORAM—SOLOMON ISLANDS

The first collections from Oceania arrived in Europe as a result of the grand voyages of discovery, among them the three journeys of Captain James Cook and several scholars who accompanied him to the Pacific between 1768 and 1780. These and other famous collections have been widely documented, researched, and published in the literature.[1] To this day, objects with a provenance attached to such holdings are considered of the best possible quality and "provided the baseline against which we compare the newer contemporary and tourist art forms."[2] Most of the early objects journeyed to Europe from Polynesia, which, along with Micronesia and Melanesia, constitute the Oceanic art realm according to Western classifications.[3] Objects from the inhabitants of the islands of Indonesia are at times also counted among the Oceanic arts.

The movement of objects from the South Seas into the domain of art parallels the trajectory of those from Africa. In the sixteenth century, objects from the South Seas were exotic wonders or strange specimens found in cabinets of curiosities. By the end of the nineteenth century, they had metamorphosed into artifacts studied by anthropologists,

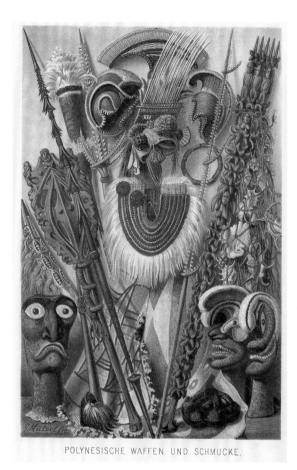

POLYNESISCHE WAFFEN UND SCHMUCKE.

FIG. 45 Lithograph of Polynesian weapons and adornment, 1890

The geographer Friedrich Ratzel devoted a whole section to "Polynesians, Micronesians, and Melanesians" in the second volume of his late-nineteenth-century *Völkerkunde* (Ethnography) and illustrated it with engravings and lithographs (fig. 45). A colorful plate displays Polynesian weapons and adornment, paralleling similar illustrations of African works in the first volume (see fig. 39, p. 153, and fig. 43, p. 168).[4] Weapons from the South Seas made their way to European collections early on. Cook collected clubs and

other arms, and they have remained favorites with collectors who admire the ingenuity of their forms, the purity of their shapes, and their attractive patina (cats. 78, 80). This emphasis on weapons also reflects the scholarly interests of the time period, for the comparative analysis of weapons and tools was seen as a means of tracing human evolution and the development of cultures (see also pp. 168–73). One of the most intriguing types is the so-called headbreaker from the Fiji Islands (cat. 79), dramatically highlighted in one of Ratzel's engravings (fig. 46). While African objects began to enter the realm of art at the beginning of the twentieth century, most Oceanic works underwent the transformation from artifact to art somewhat later, due largely to the Surrealist movement in France.[5]

To this day, African and Oceanic arts are grouped together in public and private collections, at auctions, and in galleries because of their long, shared history in the West, while the academic fields of African and Oceanic art history have become separate specialties. Collectors interested in African art objects sooner or later encounter Oceanic art as well, although there were always fewer objects from Oceania on the market. The aesthetics of these works often appealed to the same sensibilities that drew people to African art, and since the art market in Oceanic works evolved somewhat later than the one for African works, with a corresponding lag in valuation, the first acquisition of an object from the South Seas might have been stimulated by the relatively modest prices.

The journeys of objects from the South Seas to European and American collections also resemble those of their African counterparts, although there are differences resulting from dissimilar histories and diverse actors among the Westerners and the peoples in the Pacific who produced and traded the objects. In both Africa and the Pacific, however, most transactions unfolded in contact

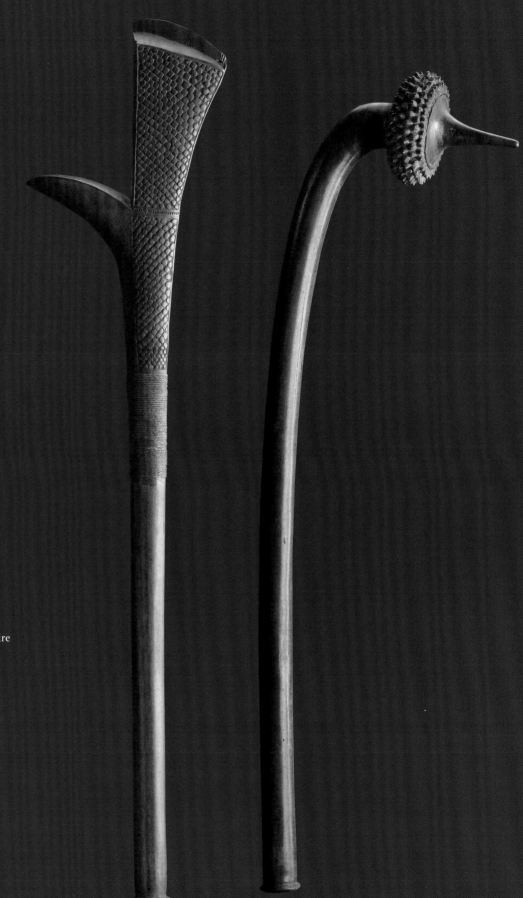

78 *Club*

Unknown artist or workshop
Fiji Islands
20th century
Wood, plaited coconut fiber cord
H. 100 cm, w. 23.5 cm, d. 7 cm (H. 39⅜ in.,
w. 9¼ in., d. 2¾ in.)
Acquired in 1978 from Océanie-Afrique Noire
(OAN) Gallery, New York

79 *Club* (totokia)

Unknown artist or workshop
Fiji Islands
20th century
Wood
H. 90 cm, w. 26 cm, d. 12 cm (H. 35⁷⁄₁₆ in.,
w. 10¼ in., d. 4¾ in.)
Acquired in 1981 from the Hurst & Hurst
Gallery, Cambridge

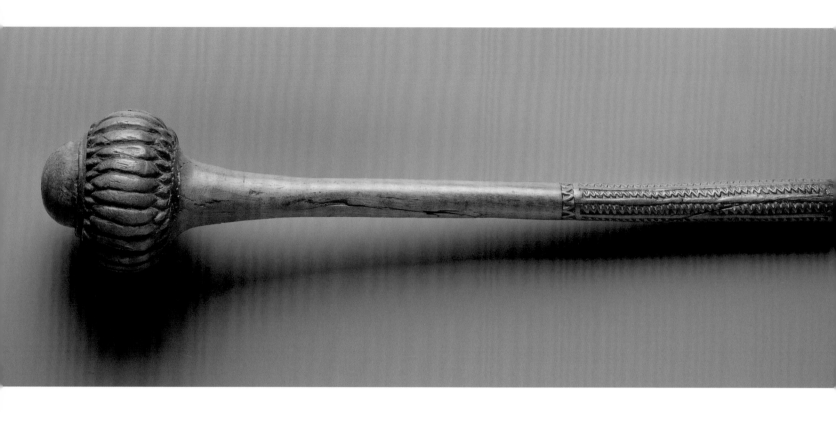

80 *Throwing club* (ula)

Unknown artist or workshop
Fiji Islands
20th century
Wood (*nokonoko*)
H. 42 cm, diam. 8 cm (H. 16⁹⁄₁₆ in.,
diam. 3⅛ in.)
Acquired in 1981 from the Hurst &
Hurst Gallery, Cambridge

zones characterized by domination, subordination, and unequal distribution of wealth, because the peoples in the Pacific also became colonial subjects—of Germany, the Netherlands, Great Britain, France, the United States, and Australia. Most objects moved through hubs of the trade, and as this chapter retraces McMillan's travels, it revolves around three sites: Rabaul, one of the earliest European settlements established by the Germans on the island of New Britain; Angoram, one of the major tourist spots on the island of New Guinea as a center for Melanesian arts; and the Solomon Islands.

Rabaul is a small town of New Britain island in the Bismarck Archipelago, northeast of New Guinea island and part of the nation of Papua New Guinea. European and American seafarers came increasingly to the region in the eighteenth century in search of sperm whales, which migrated regularly through these waters. They returned with precious whale oil, which fueled lamps before the advent of electricity. By the first half of the nineteenth century, European powers had established settlements on many of the islands of Southeast Asia and the Pacific that seemed to have economic potential. German traders and labor recruiters, and competitors from other nations, were active in the Bismarck Archipelago from 1872 onward.[6] The first trading post in East New Britain dealt in copra, dried coconut that yielded an oil used in soap manufacturing. Between 1884 and 1886, during the European scramble for colonial possessions in Africa and Oceania, Germany claimed the northeastern part of the island of New Guinea, the Bismarck Archipelago and a few smaller island groups, the northern Solomon Islands, Samoa, and several Micronesian islands. At that time, the southeastern sections of New Guinea were a British protectorate (British New Guinea) until they were handed over to the Commonwealth of Australia in 1905 and renamed the Territory of Papua.

Ein Krieger von den Fidschi-Inseln (nach Photographie im Godeffroy-Album).

FIG. 46 Woodcut of a man from the Fiji Islands, 1890

During German colonial rule, the new harbor town of Rabaul—located in the caldera of a volcano—was the headquarters of Neupommern, the German name for New Britain. The area has long been exploited for its natural resources: coconut, cocoa, and, more recently, timber. The Commonwealth of Australia took over the German colony after the First World War under a mandate from the League of Nations. Rabaul was the capital of the Mandate Territory of New Guinea until 1941, when the capital was moved to Lae on the island of New Guinea. When the Second World

War broke out and the Japanese attacked the Allies in the South Pacific, Rabaul, now a major military supply base, was bombed and then occupied by the Japanese from 1942 to 1945. From 1946 onward, Australia administered both the northeastern part of New Guinea island, including New Britain, and its southeastern section. Both parts were later joined together, and since independence, they make up the state of Papua New Guinea. Rabaul remained a provincial capital but suffered from continuing volcanic activity. After a catastrophic 1994 eruption, the capital was relocated to Kokopo, some thirteen miles to the southeast.

In the early 1970s, however, Rabaul was still an active commercial town, with expatriates from Australia, New Zealand, and the United States employed in banks, schools, and businesses. Art historian George Corbin, one of several scholars who have studied the arts in New Britain, conducted fieldwork among the Baining peoples in the early 1970s and again in the early 1980s, and he recalls the town as pleasant and refreshing.[7] Tourists flew in from Lae or Port Moresby to enjoy Rabaul's beautiful harbor views and, as did visitors from Japan, view war relics. Reef and wreck diving was a major attraction. A 1970 brochure from the Australian airline Ansett offers this description: "Its native population—longest in contact with Europeans—amongst the most sophisticated."[8] It was a different scene for Corbin when he was traveling in the bush: climbing up and down steep hills, drinking rainwater, exploring Baining masking, and keeping track of where and when dances would take place.[9]

Artists of the Chachet, Kairak, and Uramot Baining, on the Gazelle Peninsula in the northern part of New Britain, created spectacular masks, most of which represent spirit beings. Together with masks from other parts of New Britain and neighboring New Ireland, they form a much sought after group of objects from a region often described as the center of Melanesian masking art.[10] McMillan purchased three Baining masks when she was in Rabaul in 1954. The mask shown here consists of bark cloth stretched over a wickerwork frame (cat. 81). Animals, such as birds and reptiles, and plants from the bush inspired the configuration of the masks, and this particular type is said to represent the spirit of a tree fork. Two concentric circles of thin bamboo twigs form each of the eyes—the mask's focal point. Men painted the masks in black, red, and, more rarely, yellow—colors they produced from plants. Nowadays, they use commercial paint, which is more readily accessible. Corbin attributes this mask to the Uramot Baining peoples.

Masks play an important part in Baining ceremonial life, which revolves around complementary principles such as male/female, daytime/nighttime, village/bush, gardening/hunting, and visible/invisible worlds.[11] The Baining seek the protection and support of spirit beings and ancestors to cope with their daily lives, which are characterized by the hard work of providing food and shelter in the mountainous terrain and dependency on coastal neighbors. During day-dances, night-dances, and fire-dances—which mark seasonal events such as the harvest and rites of passage—masquerades mediate between these realms and unify the community. They also inspire, awe, and frighten onlookers with dramatic performances. Masks acquire their ritual efficacy and the ability to intercede between the two worlds during both the performance and the production process. When men make the masks, they are secluded in the bush and protected by a series of restrictions and interdictions known as taboos. Rituals conducted at different stages in the production process add to a mask's potency.[12]

Corbin recorded and documented a night-dance mask performance in 1983 (fig. 47). In addition to the headpiece, maskers wear specific accoutrements that often include

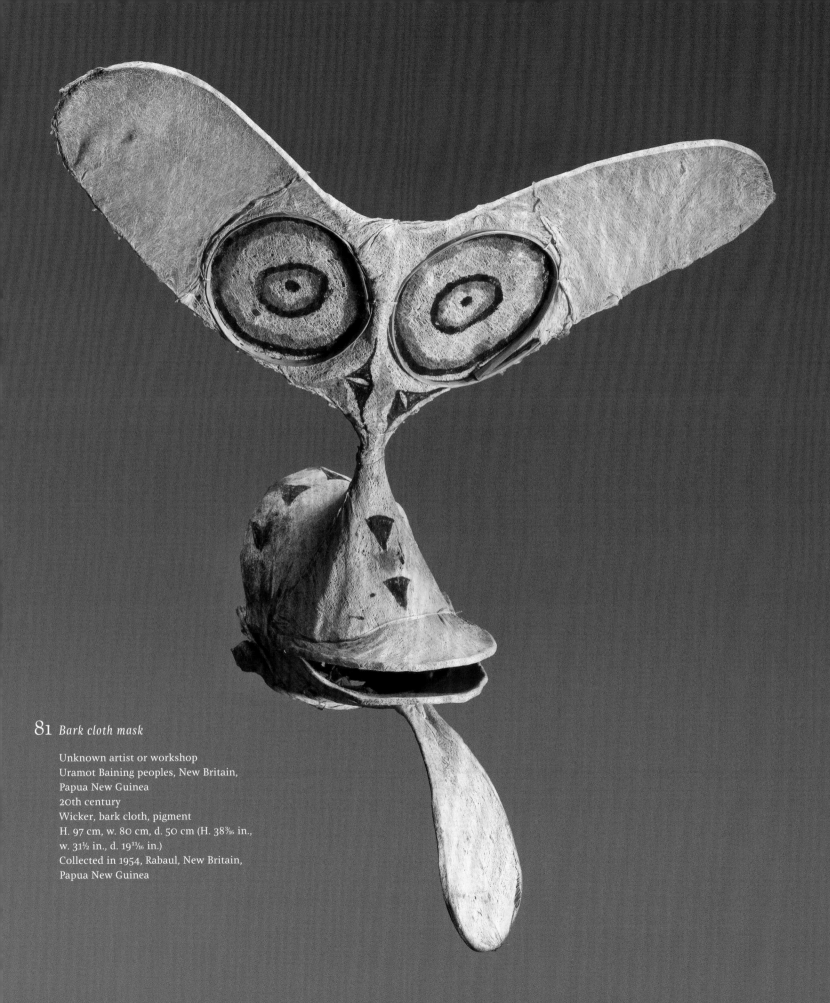

81 *Bark cloth mask*

Unknown artist or workshop
Uramot Baining peoples, New Britain,
Papua New Guinea
20th century
Wicker, bark cloth, pigment
H. 97 cm, w. 80 cm, d. 50 cm (H. 38³⁄₁₆ in.,
w. 31½ in., d. 19¹¹⁄₁₆ in.)
Collected in 1954, Rabaul, New Britain,
Papua New Guinea

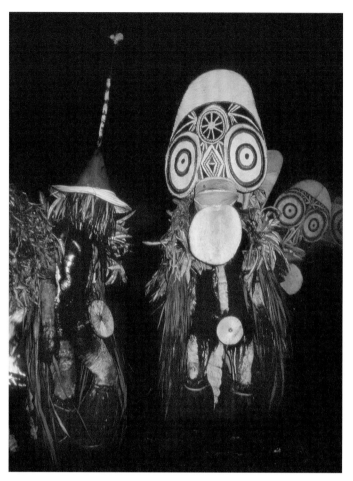

FIG. 47　Baining night-dance mask, New Britain, Papua New Guinea, 1983

witness the spectacle. The full meaning of the masks unfolds only in performance: through costumes, choreography, and the involvement of the spectators. The headdress alone is but a fragment.

The spirits returned to the bush when the ritual was over, and often the masks were discarded and left to decompose. During her stay, McMillan witnessed a night-dance, perhaps one staged for visitors.[13] Although the masks were not specifically offered for sale to foreign spectators, she let people know of her interest in acquiring them. The morning after the performance, someone brought the mask depicted here to her hotel in Rabaul. With McMillan's purchase, the meaning of the mask shifted. The masquerade performed for a foreign audience was a transitory setting on its journey into the collection. It acquired a new meaning with McMillan, as an iconic work of art from the Baining realm and as a souvenir of a particular moment in her life.

Early German collectors—missionaries, government officials, and colonial agents active in the area—favored Baining masks and were able to convince their makers to part with them as an alternate means of disposal. In return, the mask creators also saw this as a way of obtaining goods from the outside. The observations and records of these early collectors provide insights into the history and cultures of the people in this region. Richard Parkinson, a German-British plantation owner and amateur ethnographer who lived in New Britain, published his account, *Thirty Years in the South Seas,* in 1907.[14] The texts left by Father Matthäus Rascher, a late-nineteenth-century missionary in New Britain, are another source.[15] Early German and Swiss collections contain Baining masks, and images in German- and later English-language publications began to circulate.[16] In the United States, important exhibitions contributed to the fame of Baining masks. In 1946, MoMA

penis sheaths and bundles of leaves. They paint their bodies with pigment made from clay and with other paints. When the masks appear from the bush, the spirits of the bush—temporarily embedded in the masks—enter the world of the village and, to the sounds of percussion instruments, incarnate spirits in the light of the fire. Several different types of masks appear in sequence according to a predetermined choreography. Traditionally, only men

exhibited several of them.[17] They became de rigueur for encyclopedic Oceanic art collections and today are relatively numerous in private and public collections in Switzerland, Germany, France, Australia, and the United States.[18] Baining masks are often the highlight of a museum visit and awe viewers with their extraordinary forms.

East New Britain Province now permanently hosts the National Mask Festival, an event first created in 1994 to give "mask culture of Papua New Guinea recognition at the National stage," one of the objectives of the National Cultural Commission Act.[19] Since its first celebration, the festival has undergone a series of adaptations to ensure that protocol requirements and taboos were properly observed; this appears to have become a more prominent concern for the Papua New Guinean authorities as they work to revitalize their country's masking and sculptural traditions.

Just as Baining masks tell stories of transformation and changing meanings, other objects—perhaps considered less spectacular by foreign collectors—also demonstrate the complexities of contact and transition, such as, for example, this shield from the realm of the Arawe peoples who live on the southwest coast of New Britain (cat. 82). The shield is made of three planks of hardwood that are lashed together with rattan ties. Its engraved ornamentation consists of alternate registers of concentric circles arranged in pairs and rows of triangles. Some incised lines are filled with white lime; other decorations are painted in red and black pigments. The design on the back of the shield was meant to match the one on the owner's bark cloth belt; it was an expression of his identity at war and during ceremonies restricted to males, when the shields were in use. Beatrice Blackwood, an anthropologist, collected a large number of objects related to warfare in the region in 1937. A photograph she took shows two men with bark belts holding their shields, posed as if ready to fight (fig. 48). The front

sides of the shields bear common designs, similar to the one on the shield in the McMillan Collection.

Initially, scholars paid little attention to the back sides of shields (addressed in more detail in the next chapter).[20] In the case of the Arawe shields, however, the painted geometric designs on their reverse sides can also indicate their age because the backs of recent Arawe shields were not decorated. But whether this means that they were produced for a foreign clientele remains an open question, as people also use the more recent shields for their own purposes.[21] Over time, the shields' functions have changed for the Arawe. Men increasingly left their communities to engage in wage labor and lived away for extended periods of time. The ceremonies in which the shields played such

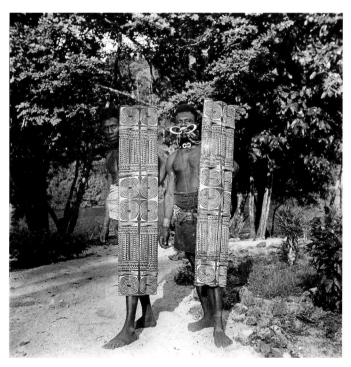

FIG. 48 Two Arawe men with shields, West New Britain, Mandate Territory of New Guinea (now Papua New Guinea), 1937

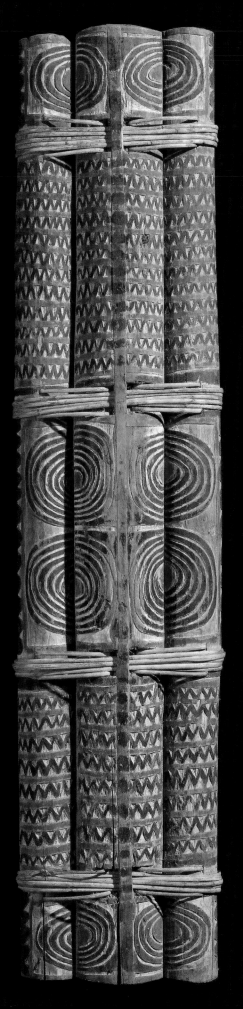

82 Shield

Unknown artist or workshop
Arawe peoples, southwest coast of
New Britain, Papua New Guinea
20th century
Wood, rattan, lime, pigment
H. 129 cm, w. 30 cm, d. 6 cm (H. 50¹³⁄₁₆ in.,
w. 11¹³⁄₁₆ in., d. 2⅜ in.)
Acquired in 1974 from Island Carvings,
Lae, Papua New Guinea

an important part were no longer restricted to men. Women had to take over new responsibilities in the men's absence, ceremonies became community wide, and designs on the reverse sides of the shields disappeared.

The town of Angoram, on the Sepik River on New Guinea island, played a key role in the diffusion of objects after the Second World War, particularly during the 1960s and 1970s. The Sepik area is well known for its varied art forms, which stimulated many collectors' interest in Melanesian arts. In the 1880s, Adolph von Hansemann, a private banker in Berlin, determined that New Guinea would be profitable for Germany and sent Otto Finsch and Captain Dallmann to the north coast to obtain land rights from the local inhabitants. This brought the Sepik River to the world's attention. Traders followed in search of various commodities, such as bird of paradise plumes for the millinery trade in Europe and the United States (fig. 49).[22]

By 1909, the first major ethnographic collection with objects from the Iatmul people, who live in the Middle Sepik region, made its way to Europe. German expeditions continued to explore the Sepik River district, among them the 1912–14 Kaiserin-Augusta-Fluss Expedition, which procured many objects for the Berlin Museum of Ethnology.[23] Missionaries collected objects as well. For example, Father Franz Kirschbaum, a member of the Catholic Society of the Divine Word, was based at the society's station in Marienberg on the Lower Sepik River and procured many objects, some of which went to the Vatican Museum in Rome. He also took photographs, including a 1930s image of men posing with large quantities of objects displayed for sale in Angoram, close to Marienberg.[24] After the First World War, the German colony came under Australian mandate and explorations farther inland continued, led for the most part by Swiss scholars.[25] During the Second World War, the area became a battleground, but research soon resumed,

MELANESISCHE UND MIKRONESISCHE WAFFEN UND GERÄTE.

FIG. 49 Lithograph of Melanesian and Micronesian weapons and tools, 1890

focusing, for example, on the Kwoma in an area known as the Washkuk Hills and the Abelam in the Maprik area.

Most scholars and collectors interested in art from the Sepik area started their trips in Wewak,[26] which had an

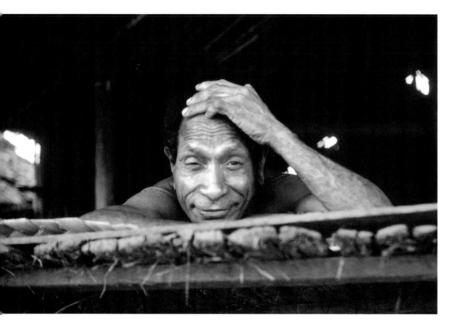

FIG. 50 Villager at rest in Angoram, Papua New Guinea, 1967

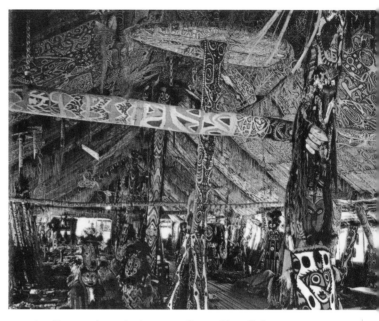

FIG. 51 *Haus tambaran* in Angoram, Papua New Guinea, about 1972

airfield and a harbor, and traveled from there to the Sepik River and then to Angoram. Angoram developed into a strategic base for collecting and buying Sepik art, and museum representatives, art dealers, and private individuals visit to this day.[27] When McMillan first arrived there in 1967, Angoram was not readily accessible by road and could be reached only by plane or boat from Wewak. She recalls that it was a pleasant town with happy people, a memory she has preserved in this photographic portrait of a villager (fig. 50). Travel brochures and Web sites today describe Angoram as a place where "You will see the markets, have the opportunity to purchase valuable artifacts and see a crocodile farm. In the afternoon take a trip up the Keram River to Kambot to see the unique storyboards and spirit houses."[28]

In the center of Angoram, visitors found a large structure, the *haus tambaran,* a term from Tok Pisin, the lingua

franca. *Haus,* a word taken from German, means "house," and *tambaran* means "ancestor spirits" or "ghosts," so the best translation might be "cult house." Traditionally, a Sepik *haus tambaran* chiefly served to safeguard artifacts that belonged to or honored the ancestors. The main purpose of Angoram's *haus tambaran,* however, was to gather and offer objects for sale to visitors. It became a tourist attraction and was marketed as such. A grainy postcard dated about 1972 shows the interior of the house, overwhelming to the eye because art is everywhere (fig. 51).

Helen Dennett, an Australian who first came to Papua New Guinea in 1963 as a teacher, recalled the creation of the *haus.*[29] New Guinea was still under Australian administration as a United Nations Trusteeship (the country became independent in 1975), and the Australian administration encouraged New Guineans to grow tea and coffee.

The Sepik River region was not well suited for such cash crops, and selling art provided an alternative means of earning an income. Sometime in 1963 or 1965, a local government officer in charge of a cooperative society developed the *haus tambaran* project. This was an extraordinary event, and Dennett recalls that "He assembled the villagers to work on a very large building in the form of a traditional cult house. It was one of those incredible moments because people from many places provided bark painting, carved posts, and carved decorations." Particularly extraordinary is the fact that the administrative town of Angoram had never had a traditional cult house—the government official and the people "invented" the house and re-traditionalized their settlement.

Cult houses in Sepik villages have multiple and complex meanings, and their role and function—particularly in reference to art forms that occur in these settings—have been well documented in the scholarship.[30] Built on high stilts to withstand seasonal flooding, they reflect the social organization of the community. The components of the structure, its ornamentation, and its orientation toward a ceremonial ground all have symbolic meanings, as do all ritual objects stored inside or under the house. Initiated men—keepers of rituals that help them communicate with ancestors and spirits—gather and store their valuable objects and sometimes carve them there. Many of the works allude to the realm of the ancestors, and on some occasions, such as initiations of young boys, the initiates play musical instruments and show these otherwise secret carvings.

The *haus tambaran* in Angoram became a lively center of commerce. Carvers, including villagers from neighboring communities and patients staying in town to recover from tuberculosis, offered their objects.[31] Some artists invented new product lines just for the *haus*. Artists from nearby Mundugumor villages, who were known for their bark paintings, made them for sale at the *haus tambaran*. Their colorful works decorated the ceilings and rafters. People in charge of the house made sure that word spread, to attract artists and their products, and sometimes engaged in collecting campaigns, competing with missionaries who also assembled collections for visitors or for sale abroad. The *haus tambaran* project attracted many tourists, and expatriates living in the region soon realized the commercial potential of the local arts. Many collected massively in villages along the Sepik River and its tributaries and began selling objects. Sepik art in large quantities moved through Angoram and other sites into collections in Australia, Europe, and the United States.

Objects from the Abelam peoples were among the great variety of objects available at the *haus* or through local dealers. The Abelam do not live on the Sepik River but occupy a neighboring mountain area to the north, along the coastline, with the town of Maprik as their administrative center. They reside in hamlets dominated by spirit houses with triangular painted facades, which contain images of the ancestors. The Abelam never developed centralized structures of government but are linked through trade networks and rituals that focus on yam, their main staple together with sago. Initiated male experts grow tubers, and complex rituals, which include masked performances, accompany the annual agricultural cycle. The configuration of an Abelam basketry mask (*baba*) in the McMillan Collection recalls the pig, which plays an important role in the Abelam worldview (cat. 83). The mask alludes to male and female pigs that intercede between the realms of the living and the departed and mediate between the wilderness and the village. Maskers perform at initiations and ceremonies as "openers" of rituals. A recent field photograph shows a *baba* masker with his complete costume, dancing at the inauguration ceremony

of a new road—"opening" it (fig. 52). Large circles in white and red emphasize the mask's eyes, and his large fiber skirt is adorned with leaves and fruits. The mask, plaited from a vine (*Lygodium sp.*)[32] and freshly painted for each performance, also features a headpiece, which resembles headdresses worn by cult dancers during initiation rituals and that decorate large yams displayed at harvest contests. In these competitions, men adorn the tubers with symbolic materials and forms, such as bird of paradise plumes, cassowary feathers, and shells, transforming them into images of clan ancestors.[33] One such headdress (*naute*) is part of the McMillan Collection (cat. 84). Its shape alludes to the triangular facade of the spirit house, which initiates entered through a small hole at the bottom, figuratively represented by the hole of the headdress. At one time performed only in these ritual contexts, masquerades have adjusted with the times, as have many in African contexts discussed earlier. It was not difficult in the 1970s to find carvings and other arts from the Abelam area, but today original production has decreased and mass-produced carvings are offered in shops and online.[34]

The *haus tambaran* carried many types of personal adornment: bracelets and armlets, necklaces, and pectorals. One such piece is a local variation of the *kapkap*-type ornament, traded from island to island throughout Melanesia (cat. 85).

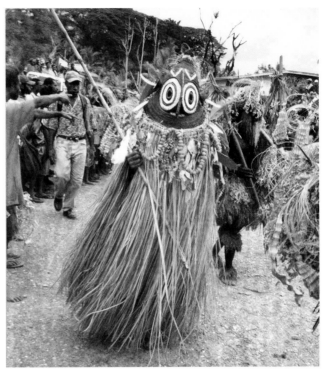

FIG. 52 *Baba* mask at the ceremony for the "opening of the road" (official beginning of the coating of the Sepik Highway) in Maprik, Papua New Guinea, April 2002

83 *Mask* (baba)

> Unknown artist or workshop
> Abelam peoples, Papua New Guinea
> 20th century
> Vine (*Lygodium sp.*), pigment
> H. 34 cm, w. 26 cm, d. 38 cm (H. 13⅜ in., w. 10¼ in., d. 14¹⁵⁄₁₆ in.)
> Collected in 1967, Angoram, Sepik, Papua New Guinea

Men wear *kapkaps*, concave shells with openwork tortoiseshell decoration, as breast ornaments, on the forehead, or in the hair mounted on a pin, the most common use in the Sepik area. Another example is a mouth ornament for male dancers, possibly from the northern coastal region of Astrolabe Bay (cat. 86). Men held objects like this one between their teeth, covering parts of the face and chin, and carried them in their mouths during warfare, an activity that ended many years ago. Tortoiseshell armlets, cherished items of men's adornment manufactured on the coast, spread along trade routes throughout northern New Guinea and became more valuable as they moved farther

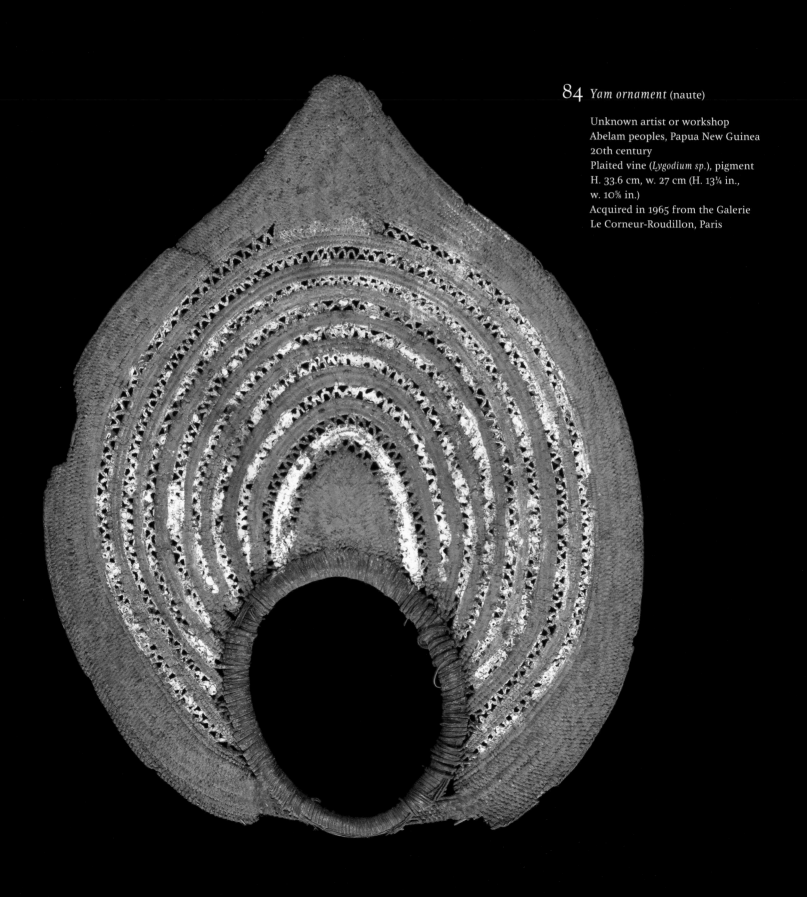

84 *Yam ornament* (naute)

Unknown artist or workshop
Abelam peoples, Papua New Guinea
20th century
Plaited vine (*Lygodium sp.*), pigment
H. 33.6 cm, w. 27 cm (H. 13¼ in.,
w. 10⅝ in.)
Acquired in 1965 from the Galerie
Le Corneur-Roudillon, Paris

85 *Necklace*

Unknown artist or workshop
Sepik, Papua New Guinea
20th century
Melo shell, tortoiseshell, braided fiber
H. 33 cm, w. 16.5 cm, d. 2 cm (H. 13 in.,
w. 6½ in., d. ¹³⁄₁₆ in.)
Collected in 1967 in Angoram, Sepik,
Papua New Guinea

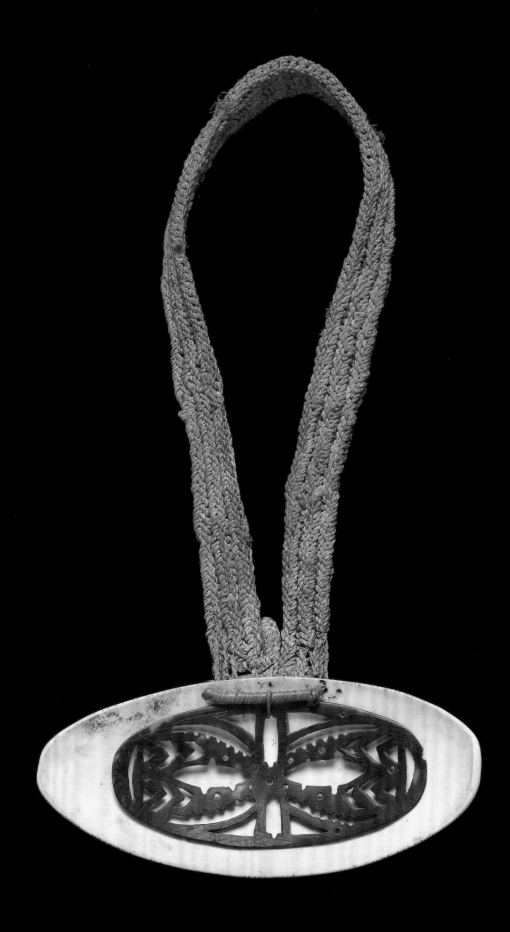

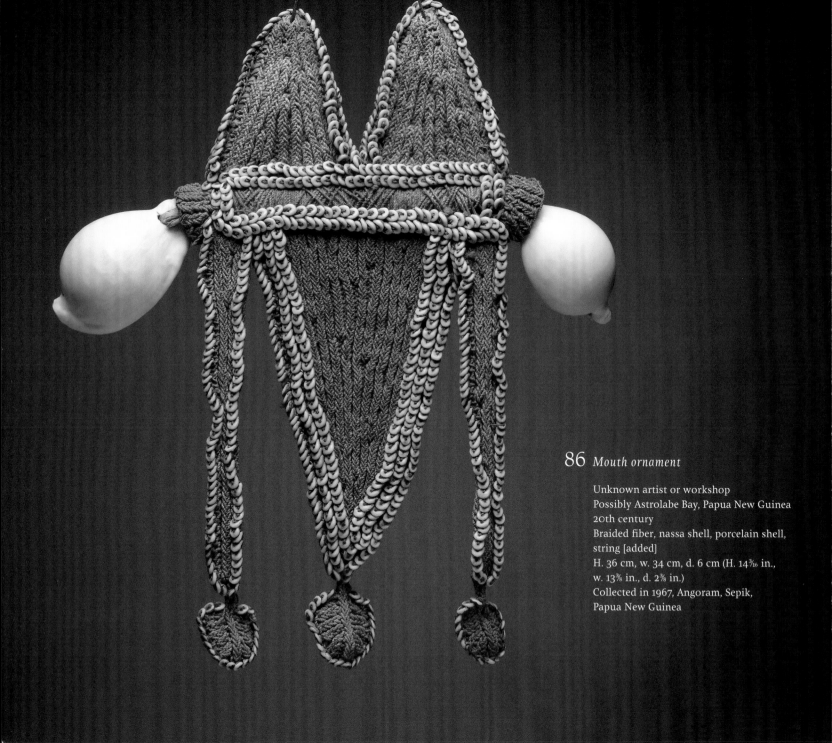

86 *Mouth ornament*

Unknown artist or workshop
Possibly Astrolabe Bay, Papua New Guinea
20th century
Braided fiber, nassa shell, porcelain shell,
string [added]
H. 36 cm, w. 34 cm, d. 6 cm (H. 14 3/16 in.,
w. 13 3/8 in., d. 2 3/8 in.)
Collected in 1967, Angoram, Sepik,
Papua New Guinea

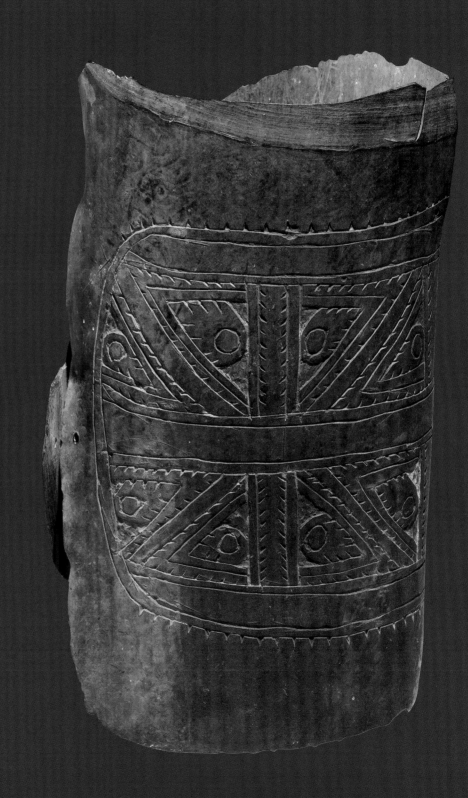

87 *Armlet*

Unknown artist or workshop
Coastal region, Sepik, Papua New Guinea
20th century
Tortoiseshell
H. 19 cm, w. 10 cm, d. 12.5 cm (H. 7½ in.,
w. 3¹⁵⁄₁₆ in., d. 4¹⁵⁄₁₆ in.)
Collected in 1967, Angoram, Sepik,
Papua New Guinea

inland (cat. 87). A men's bark belt from the *haus* compares favorably to other bark belts with geometric patterns from the New Guinea Highlands, particularly those of the Simbu peoples (cat. 88). Shaped when it was still green or by heating the bark, such belts are also part of the dress of peoples along the Papuan Gulf area on New Guinea's southern coast, where they instead display curvilinear designs. Without specific documentation, we cannot trace the belt's journey to the *haus tambaran* and know little about its origin.

As noted earlier, it is often difficult to differentiate objects made for a foreign clientele from those produced for indigenous use. In New Guinea, particularly in urban areas, women create personal adornments out of plastic pieces, beads, or other items from inexpensive necklaces they purchase and disassemble; they then restring the necklaces with old beads and other traditional materials such as flying fox teeth.[35] Clearly, these works qualify as "authentic." However, in the eyes of many Westerners, they are tainted because of the obvious signs of Western contact.[36] A necklace in the McMillan Collection illustrates the incorporation of new materials, with a loop made from traditional braided vine strung with ornate oval bailer shells and a pastel pink plastic piece perfectly shaped to match the shells (cat. 89).

Angoram became a lively center of the trade, and as the art market in New Guinea expanded, expatriates opened shops in other areas. In the 1970s, they established stores in Port Moresby and Lae, a port city on the Huon Gulf in eastern New Guinea. McMillan acquired a canoe splashboard, from the Massim area, through an Australian art dealer in Lae (cat. 90). It is among the iconic works from the Pacific not only because of its aesthetic qualities but also because the canoes were used in the gift-exchange expeditions of the well-known *kula* cycle. The anthropologist Bronislav Malinowski examined this ritual phenomenon, which regulates the ceremonial life of the Trobriand islanders in Milne Bay Province, in his 1922 classic *Argonauts of the Western Pacific*.[37] In the *kula* cycle, valuable objects circulated in gift/counter-gift relationships among men, with the value of the counter-gift equal or superior to that of the initial gift. As necklaces (*sulava*) and bracelets (*mwali*) passed from hand to hand, they gained in value.

The ornamentation of the canoes used in this context is highly symbolic. The transversal board not only protected against water; it also served as an emblem. This example shows large areas of wear and visible traces of its former mounting to the canoe prow. Its intricate curvilinear designs, mixed with anthropomorphic and zoomorphic motifs, announce the prestige of the owner and demonstrate the competence of the artist. A field photograph by Malinowski shows one of these boards attached to a large trading and fishing canoe (fig. 53). One year after this board entered the McMillan Collection, an exhibition at the Museum of Primitive Art in New York added to the fame of arts from the Massim area in the United States. Organized by Douglas Newton, the most eminent specialist of Oceanic art at the time, "Massim: Art of the Massim Area" appealed to collectors and promoted arts from New Guinea, which by then had become very collectible.[38]

Several other objects in the McMillan Collection also journeyed through Lae, among them a tall, hourglass-shaped drum with subtle green hues from the Huon Gulf (cat. 91) and a braided-fiber and nassa shell armband possibly from the distant Solomon Islands (cat. 92).

In the 1960s and early 1970s, professional field collectors systematically combed the Sepik and other regions on the island in order to supply the market and meet the demand from museums. A few years later, with New Guinea's independence on the horizon, their efforts gained urgency, because they felt uncertain about the market's

88 *Bark belt*

Unknown artist or workshop
Western Highlands, Papua New Guinea
20th century
Bark, pigment
H. 14 cm, diam. (as coiled) 27.5 cm
(H. 5½ in., diam. 10¹³⁄₁₆ in.)
Collected in 1967, Angoram, Sepik,
Papua New Guinea

89 *Necklace*

Unknown artist or workshop
Sepik, Papua New Guinea
20th century
Melo shell, pink plastic, nylon thread
H. 42 cm, w. 16 cm, d. 3 cm (H. 16⁹⁄₁₆ in.,
w. 6⁵⁄₁₆ in., d. 1³⁄₁₆ in.)
Collected in 1967, Angoram, Sepik,
Papua New Guinea

90 *Canoe splashboard* (lagim)

Unknown artist or workshop
Massim area, Milne Bay Province,
Papua New Guinea
20th century
Wood, lime
H. 77 cm, w. 69.2 cm, d. 7 cm (H. 30⁵⁄₁₆ in.,
w. 27¼ in., d. 2¾ in.)
Acquired in 1974 from Island Carvings,
Lae, Papua New Guinea

FIG. 53 Fishing canoe with a carved prow, Trobriand Islands, Papua New Guinea, 1915–18

future. It was a collecting of last resort, and many kinds of pieces—some traditionally made, of varying age and aesthetic quality—came from the villages and smaller islands. In many instances, men and women amassed objects in a rush, with very little or no any documentation about the origins of the objects or their meaning. Eventually, a museum (now the National Museum of Papua New Guinea), established in 1963 and funded in part by the Australian administration for Cultural Development, stepped in—controlling the art traffic and issuing export permits.[39] One of its curators, the Dutch scholar Dirk Smidt, oversaw the acquisition of some fifteen thousand objects under the National Cultural Property Act and impounded pieces that should not leave the country.[40] He organized the exhibition "The Seized Collections of the Papua New Guinea Museum" in 1975, composed of the objects seized during 1973.[41] Many have become national treasures of Papua New Guinea.

One of the most interesting—and one of the oldest—works in the McMillan Collection arrived in 1948 through the Galerie Carrefour of Pierre Vérité in Paris: a model bonito canoe from the Solomon Islands, east of New Guinea (cat. 93). Trading or so-called war canoes and related objects from the Solomon Islands gained the admiration of Westerners who visited the region in the early nineteenth century. Essential in economic activities, these canoes also represented the communities that owned them, and thus much effort went into their elaboration. Islanders used another type of boat, the sacred canoe, when they went out to catch bonito, a large fish of the Sarda genus, which was the object of a cult in the Eastern Solomon Islands until the 1950s. Such canoes were "considered the supreme expression of skill and artistry. . . . Once dedicated and launched, they became sacred objects that could not be sold or traded."[42]

Smaller replicas of these bonito canoes were created for various purposes.[43] One type served as a bowl in personal ceremonial feasts or was used to offer food to the ancestors; these, Solomon Islanders did not part with (fig. 54). A second, larger type functioned as a human bone or skull container, charged with the power, or *mana*, of the ancestors through its use and thus inalienable as well. Finally, skillful artists made models of sacred bonito canoes, like the one shown here, replicating all features of an original sacred bonito canoe in both form and production process although the models were intended for sale to the outside world. The maker first lashed five boards together, waterproofed them with a resin from parinarium nuts, and inserted shell pieces to finish the ornamentation. He then varnished the exterior with a mixture of tree sap and ashes. The model's iconography alludes to the bonito cult and features the frigate bird, the bonito fish, the blueback sprat, and a dog. The stylized frigate bird image at the prow represents the bird's integral role, because fishermen locate schools of bonito by watching birds that follow the fish;

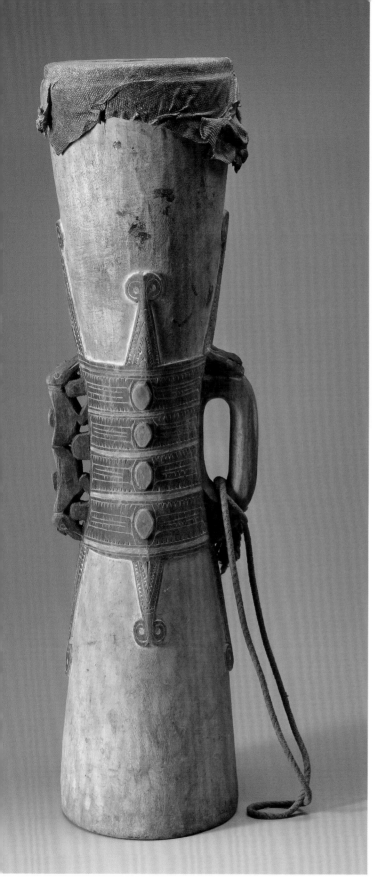

91 *Hand drum*

Unknown artist or workshop
Huon Gulf, Papua New Guinea
20th century
Wood, snakeskin, beeswax, pigment, rope
H. 75 cm, w. 18 cm, d. 21 cm (H. 29½ in.,
w. 7¹⁄₁₆ in., d. 8¼ in.)
Acquired in 1974 from Island Carvings, Lae,
Papua New Guinea

92 *Armband*

Unknown artist or workshop
Possibly Solomon Islands
20th century
Braided vine, nassa shells
H. 9 cm, w. 12.5 cm, d. 8 cm (H. 3⁹⁄₁₆ in.,
w. 4¹⁵⁄₁₆ in., d. 3⅛ in.)
Possibly acquired in 1974, Port Moresby
or Lae, Papua New Guinea

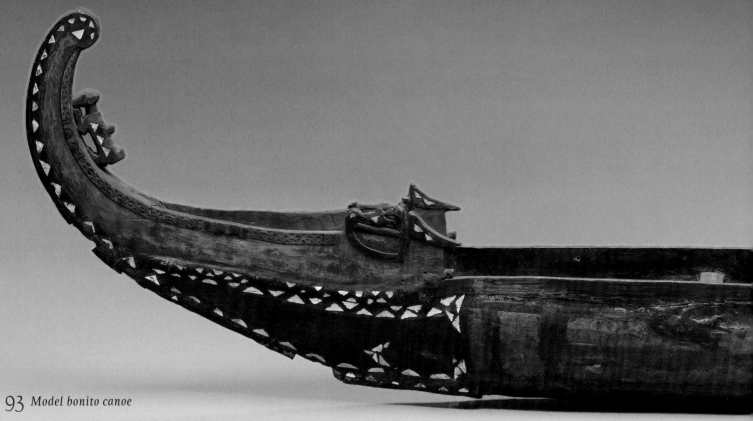

93 *Model bonito canoe*

Unknown artist or workshop
Possibly Ulawa Island, eastern Solomon Islands
20th century
Wood, parinarium nut resin, varnish, nautilus
shell, jute fabric [repair]
H. 33.5 cm, w. 139 cm, d. 13.5 cm (H. 13³/₁₆ in.,
w. 54¾ in., d. 5⁵/₁₆ in.)
Acquired in 1948 from the Galerie Carrefour
(Pierre Vérité), Paris

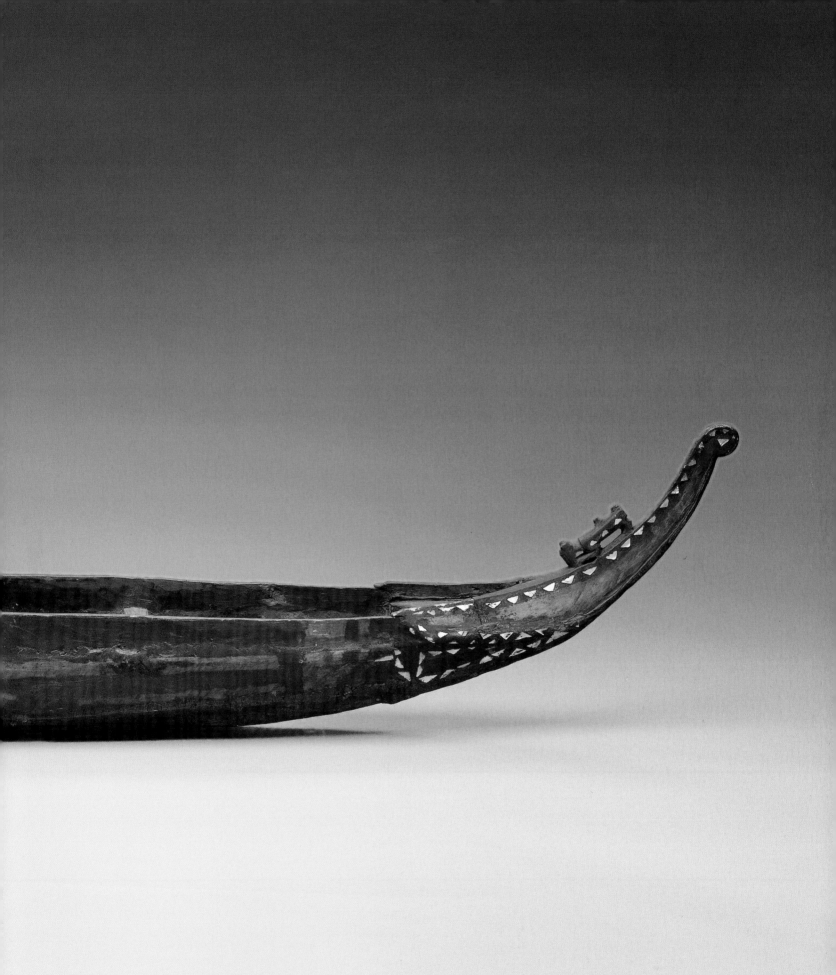

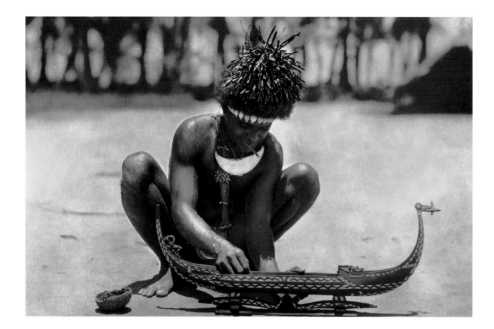

FIG. 54 Man next to a model sacred bonito canoe, Owa Riki Island, Solomon Islands, 1932

next to the bird is a blueback sprat.[44] The dual representation of a dog holding a bonito with its paws and mouth, toward the tip of the prow and at the stern, alludes to a myth from Ulawa Island, allowing us to attribute the object to this particular location.

Solomon Islanders traded these model bonito canoes with other islanders or, beginning in the mid-nineteenth century, made them for sale to foreign visitors—one of the many cases in which production for the Western market began with the earliest contact.[45] Many foreigners came to the eastern Solomon Islands during the Second World War. Japanese troops occupied the region from July 1942 until February 1943, when the Allies retook it. American GIs brought back "souvenirs" ranging from curios to objects taken during military campaigns, including model canoes like this one. Thus, production of model boats intended for the market increased toward the end of the Second World War.[46] In the 1960s and 1970s, the Solomon Islands became a destination for travelers, and McMillan visited there during her frequent journeys to the Pacific.

NOTES

1. See, for example, Kaeppler 1978; Hauser-Schäublin and Krüger 1998.

2. Hanson and Hanson 1990, 161.

3. These broad divisions, established in 1831, appear less and less relevant to today's scholars but still guide collecting of the arts from this region.

4. Ratzel 1890, pl. opp. p. 135.

5. See p. 25; see also Peltier 2005.

6. Hahl 1980, 6; see also Hiery 2001.

7. We thank George Corbin for sharing his experiences with us in several telephone conversations, April 2006.

8. Ansett Airlines of Australia 1970.

9. The lack of good roads in Baining country made life and fieldwork difficult.

10. Kaufmann 1997.

11. Corbin 1979.

12. Corbin 1988, 232–39.

13. According to Corbin, dances were staged for visitors as early as the 1920s. Personal communication, April 2006.

14. Parkinson 1999.

15. Personal communication, Corbin, April 2006.

16. A central Baining mask from the Parkinson collection, housed at the Museum der Kulturen in Basel, Switzerland, is one of the most widely published examples. It is reproduced in Kaeppler, Kaufman, and Newton 1997, ill. 158, p. 259.

17. Linton and Wingert 1946.

18. A fine example is in the William E. and Bertha L. Teel Collection; see Geary 2006, 114.

19. Papua New Guinea Tourist Promotion Authority, http://www.png .aqualagoon.com/eventdetails/maskfestival.html (accessed April 19, 2006).

20. This observation comes from Michael O'Hanlon, an anthropologist and current director of the Pitt-Rivers Museum, who also studied the incorporation of imported motifs on shields in other parts of Papua New Guinea. O'Hanlon 1995.

21. Gosden and Knowles 2001, 174–79.

22. Swadling 1996.

23. Welsch 2005, 11–13.

24. Reproduced in Stöhr 1971, 107.

25. Many prominent Swiss scholars contributed to our knowledge about the Sepik through their fieldwork, among them Fritz and Paul Sarasin, Felix Speiser (1930), Paul Wirz (1950, 1953), Alfred Bühler and René Gardi (1956), and, more recently, the anthropologists Christian Kaufmann and Brigitta Hauser-Schäublin.

26. The town of Wewak, on an estuary on the north coast, is now the administrative center of East Sepik Province of the country of Papua New Guinea.

27. The neighboring Marienberg mission was also an important site for collecting. See Wilson and Menzies 1967.

28. Melanesian Tourist Service, http://www.mtsdiscoverer.com/index9 .shtml (accessed April 15, 2006).

29. We thank Helen Dennett for talking to us and gratefully acknowledge the research she did following the interview on March 29, 2006. Based in Coogee, Australia, she continues her interest in utilitarian objects from the region and also produces films.

30. Christian Coiffier gives an overview with a useful drawing in Meyer 1995. Schuster (1985) presents an analysis centered on the symbolism of the men's house.

31. Wilson and Menzies 1967.

32. The vine is no longer readily available due to agricultural practices that have reduced the secondary forest over the past decades. We thank Ludovic Coupaye for this and other personal communications about the Abelam.

33. See Hauser-Schäublin 1989 for a detailed analysis of Abelam art; see also Kaeppler, Kaufman, and Newton 1997, 575–77.

34. The process has been examined in Dark 1999.

35. The flying fox is a fruit-eating bat with reddish fur.

36. Graburn 1976, 1–32.

37. Malinowski 1922. This text is required reading for all anthropology students to this day.

38. Newton 1975.

39. Welsch, Webb, and Haraha 2006.

40. Corbey 2000, 201–13.

41. Smidt 1975.

42. Davenport 1986, 101.

43. We thank Sandra Revolon for this information and the analysis of the model boat. Interview, March 2006.

44. Both frigate birds and bonito feed on juvenile blueback sprats.

45. Waite 1983, 137.

46. Revolon, personal communication, March 2006. For the development of tourist production in the Solomon Islands, see Mead 1973.

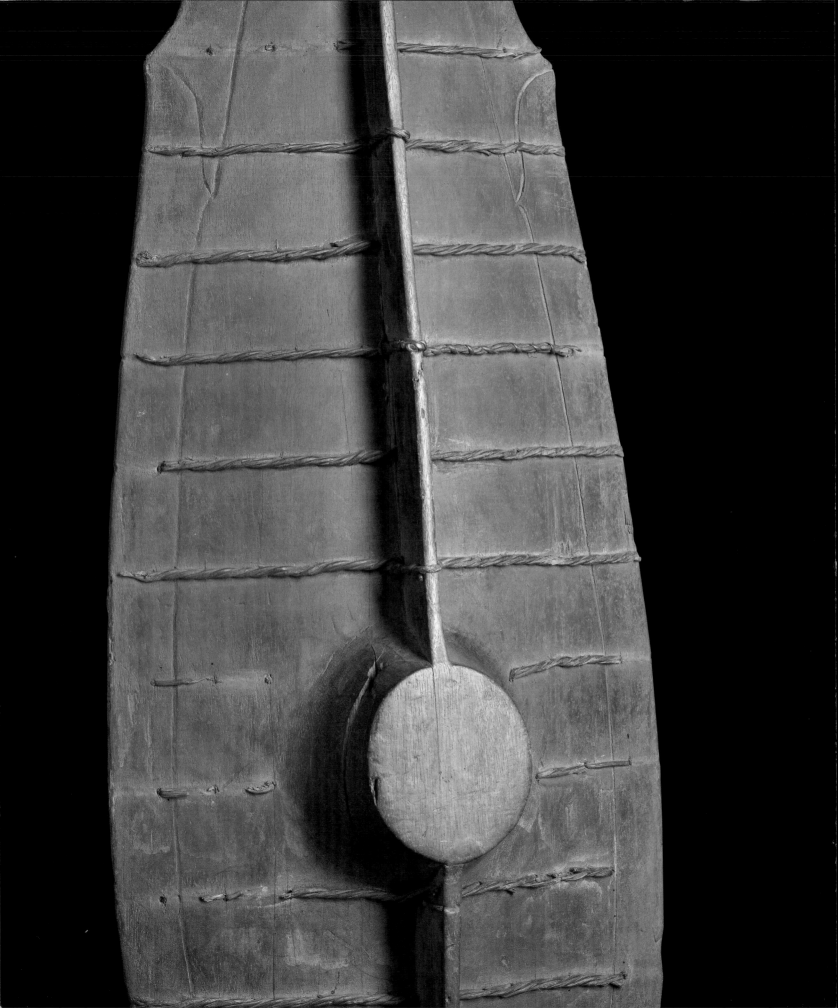

CHAPTER 9

PAPUA—BALI—AND BEYOND

From the 1950s onward, collectors embraced arts from the Melanesian realm and also developed a greater interest in the so-called tribal arts from the many small and large isles of Indonesia as well as other island groups in the Pacific, such as the Philippines. In the context of these arts, the problematic term "tribal," which occurs in much of the literature from this time period and has now gone out of style, refers to the objects of peoples who lived in the orbit of ancient kingdoms and Islamic, Hindu, and Buddhist artistic traditions but maintained their own identity. For most of the second half of the twentieth century, Western classifications counted objects from the islands of Indonesia and beyond among the Oceanic arts. There are, however, a number of inconsistencies that make even the grouping of "Indonesian tribal arts" an unwieldy subcategory. Irwin Hersey, a New York–based collector and scholar, pointed to these problems in his 1991 collectors' guide on Indonesian "primitive art," as it was called in the terminology of the times. The difficulties arise when considering complex historical and cultural linkages over vast geographic areas complicated by modern political boundaries. Thus, collectors and scholars of Indonesian arts have explored traditions as far afield as those of

Taiwan, the Philippines, some parts of the Indian subcontinent, and Vietnam, because of shared ancient histories.[1] To confuse matters even more, the western part of the island of New Guinea, Papua Province, belongs to the nation-state of Indonesia.[2] Its inhabitants, who are closely related to other peoples of New Guinea, have been in contact with inhabitants from neighboring Indonesian regions for millennia, and their art forms reflect these influences.

In the early twentieth century, Western connoisseurs appreciated the arts and architecture of the ancient kingdoms and sultanates on islands such as Sumatra, Java, and Bali and ranked them with the classic traditions of India, Japan, and China. However, the visual expressions of the people on their margins were perceived as ethnographic objects. These works thus participated in a conceptual shift from artifact to art, as did their counterparts from Africa and other islands in Oceania, although they were among the last to embark on this journey. The majority of the early objects from Indonesia that arrived in Europe came with Portuguese navigators who reached these shores in the sixteenth century. Attracted by the lucrative spice trade, the Dutch soon followed and dominated the region from the seventeenth century onward. The area has long been a reservoir for other goods, such as bird of paradise plumes, sea cucumbers, damar resin, massoy tree bark, and copra. More recently, minerals have been exploited on a large scale.[3] In 1815, the region known as the East Indies became a Dutch colony. Museums and collectors in the Netherlands accumulated their largest holdings of works from Sumatra, Borneo, and western New Guinea around the turn of the twentieth century. The Tropenmuseum in Amsterdam is famous for its collections: Batak objects from Sumatra, which arrived in the late nineteenth century; thousands of pieces from the Tanimbar archipelago south of the Moluccas; and important holdings from Papua Province in New

Guinea.[4] Dutch missionaries brought back those objects they did not burn in their effort to eradicate "idols" of paganism. Before the Second World War, Dutch and German scholars began to study the peoples in the islands, but outside these circles, their arts remained unfamiliar. It is interesting to note that no objects from the Indonesian realm appeared in William Rubin's 1984 encyclopedic publication on primitivism.[5]

The notion of "discovery" colored the descriptions of collectors and scholars, when works from these regions first came to their attention in the 1960s and 1970s.[6] Major collectors—among them Jean-Paul Barbier and the Richmans in New York—contributed to the ascent of Indonesian "tribal" arts through exhibitions at the Musée Barbier-Mueller in Geneva and the Metropolitan Museum of Art in the 1980s and 1990s, which completed the objects' transformation from artifacts to works of art in the United States.[7] However, the joy of discovery was soon tinged with concerns about the rapid disappearance of these arts and the role the market played in this process (see below).

The few works in the McMillan Collection from the country of Indonesia came through dealers in the United States and Paris, even though McMillan visited the region and spent time in Bali on several occasions. One of the pieces, a string bag (bilum) attributed to the Asmat, who live in Indonesia's Papua Province, took a different route (cat. 94).[8] It made its way to the McMillan Collection on the occasion of a fund-raising event for an organization supporting indigenous rights.[9] Although unassuming, bilum bags have great cultural significance. Women spend countless hours fashioning them from fiber, creating innovative designs, and using new materials such as cotton and nylon thread. This bag displays geometric patterns, dyed in natural ocher and white, which resemble other Asmat two-dimensional designs. Common throughout New Guinea,

94 *Net bag* (bilum)

Unknown artist or workshop
Asmat peoples, Papua, Indonesia
20th century
Braided vine, dye
Overall: H. 79 cm, w. 31 cm, d. 23 cm
(H. 31⅛ in., w. 12³⁄₁₆ in., d. 9 in.)
Acquired in the 1980s from Cultural
Revival Bazaar, Cambridge

bilum bags are versatile utilitarian objects, used to carry everything from food products to babies. They usually display motifs representative of their area of origin (see fig. 3, p. 33) and also convey strong mythical and symbolic meanings. In some areas, they serve as dowry and circulate in exchanges that establish and confirm relationships among those involved in the transactions. The bags, which are associated with the identities of their users on the local level, have also become markers of New Guinean cultural identity to the outside world. Logos and written messages appear frequently in the designs of the more contemporary pieces.[10] Bags like this one came directly from the Asmat region to the United States through handicraft cooperatives and churches, centers that revitalized declining art traditions for the export market and created economic opportunities for the Asmat. The United Nations and the Catholic Church successfully supported a revival movement in the late 1970s that transformed Asmat carvings into symbols of Indonesian identity.[11] Another route for items from Papua Province would have been through the Abidjan of Indonesia: Denpasar, on the island of Bali.

From an economic and cultural point of view, the island and administrative province Bali, east of Java, is one of the most important regions of Indonesia. For hundreds of thousands of visitors, the international airport in Bali's capital, Denpasar, has been the major gateway to Indonesia. Tourism grew tremendously from the 1970s onward, and travel brochures praised Bali's landscape and coastline, calling it "the Island of Ten Thousand Temples." The lush beauty of the hillsides terraced with irrigated rice paddies and the pristine beaches charmed visitors (fig. 55). Among its other attractions, this hub of Indonesian art offered a wide spectrum of objects. Laurence A. G. Moss, a development planner, anthropologist, and art collector who first arrived in Indonesia in 1971, draws a vivid picture

FIG. 55 Bali, Indonesia, 1962

of the Bali art market.[12] In organization, it bears an uncanny resemblance to West African trade structures. A top level of expatriate residents (often Australian) and a few Indonesian dealers sold quality "tribal" art alongside their mainstay—classic Indonesian arts, such as shadow puppets, which collectors and museums had acquired since the nineteenth century. Their suppliers were often Indonesians of Chinese descent, or Bugis of Malayan descent who inhabit Sulawesi and are famous for their mobility and seafaring skills. Like their African counterparts who traveled to villages, they visited the islands, extracting objects that they then funneled to high-end dealers. Street vendors, the *tukan antic*, were either in the employ of these shops or sold objects they had found and acquired for themselves on some of the islands. The Bali market soon developed into a trading center for objects from more distant regions, and it was not unusual to

find pieces, such as bowls, from Taiwan or even the Philippines (see below).

Foreign art dealers frequently stopped over in Bali and usually purchased from the dealers, but they also ventured to other islands, looking for goods at the source. Collectors even undertook surveying trips. Perhaps the best known are Jean-Paul Barbier's five visits to the Toba Batak region on Sumatra between 1974 and 1980, for the purpose of establishing the origin and meaning of works he had purchased for his collection.[13] Other collectors followed suit, among them Hersey, initially an African art collector who felt that he could "acquire at the time an excellent piece of Indonesian art for an amount that would only match a mediocre African piece."[14] Hersey purchased most of his collection through art dealers in the United States and Europe and traveled to Indonesia in the 1980s.

Shields were among the earliest types of "tribal" objects that came to the attention of foreigners and have a place in most collections of Indonesian arts.[15] Their association with warfare made them particularly attractive, for they played into preconceived Western notions of savagery among groups such as the Dayak, who had a reputation as ferocious warriors (fig. 56).[16] Indonesian shields began to arrive in collections toward the end of the nineteenth century, when the Dutch had consolidated their holdings and put an end to indigenous warfare. As a result, the cultural relevance of these weapons diminished, many types became obsolete, and some vanished altogether.[17] In their original settings, shields had both utilitarian and symbolic functions: they were used as offensive and defensive devices and also signified prowess and success in war during ceremonies. In Western collections, they were transformed into exotic souvenirs; examples of beautiful craftsmanship; indicators establishing cultural relationships between peoples, as in the case of African throwing knives (see pp. 169–73);

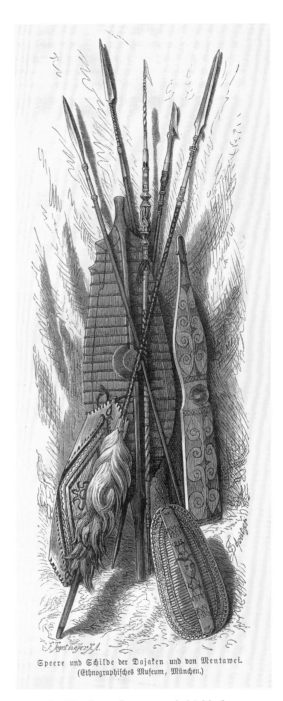

Speere und Schilde der Dajaken und von Mentawei.
(Ethnographisches Museum, München.)

FIG. 56 Woodcut of spears and shields from the Dayak and Mentawei, Indonesia, 1890

family heirlooms; and, ultimately, works of art. This light-weight shield (cat. 95) comes from the island of Nias, located west of the much larger island of Sumatra. Nias's history has been linked to the slave trade, which contributed to the wealth and power of local chiefs who competed for status and authority.[18] Nias warriors' equipment included metal jackets, iron helmets, swords, rattan balls with amulets, spears, and this kind of shield, called *baluse*. Made of lightweight wood with a protrusion at the top, it is reinforced horizontally by fiber lashes. Its shape may allude to the head of a crocodile, an animal that instills fear and awe.[19] With the end of warfare, the shields gradually acquired different meanings. Today, respected visitors may be greeted at the entrance to a village by a warrior in ceremonial dress holding a shield, who then leads them to the village's headman.[20] Warrior dances, which traditionally occurred on occasions such as rites of passage, have now become spectacles for tourists, who pay a large fee to the village headman and the performers.[21] By the 1980s, most ancient *baluse* shields had departed to collections, and people in Nias replaced the originals with modern copies in their homes.[22]

Another type of shield found in many collections comes from the Dayak, who live on the island of Borneo (cat. 96). This protective device was used in warfare and is probably the most common of all shields among the Dayak group of the Iban of Sarawak and Kalimantan in central Borneo.[23] It is made of light brown wood and is reinforced horizontally with four rows of rattan lashes in a slightly concave rectangular form, with triangular extensions at the top and bottom. Old examples of this common type were still available in the 1990s, in the antique shops in Bali and in Jakarta, the capital of Indonesia.[24] Shields intended for ceremonial purposes, while more ornate, present the same formal characteristics. Painted motifs, sometimes with attachments of

human hair or horsehair on their fronts, protected the shield's owner from harm and the enemy. The inside of these ceremonial shields also carried decorations whose meanings were known only to the shields' owners.

Objects related to religious beliefs also intrigued collectors because, in the Western hierarchy of mankind's arts, the most beautiful creations emanate from the spiritual domain (e.g., medieval cathedrals and religious paintings or music). Thus, objects linked with ritual practice have always enjoyed high esteem. A fragment in gray ironwood possibly comes from the Bahau Dayak, who inhabit the dense rain forest in the interior of the large island of Borneo (cat. 97). In the original context, its octagonal flat back formed the end piece of a small coffin that was featured in elaborate funerary ceremonies.[25] The aggressive posture of the figure, round eyes inset with flat sections of shell, protruding mouth with bared teeth, and arms curving up on the sides of the face to grasp the ears are intended to be menacing and intimidating. The monster here assumes the role of a ritual guardian.

Another work in the collection, a so-called book for magic (*pustaha*) from the Batak peoples on the northern part of the island of Sumatra, also belongs in the ritual sphere (cat. 98). The Batak lived in the orbit of Hindu-Buddhist kingdoms established in coastal Sumatra and came in contact with Islamic and Christian ideas. Thus, they developed a script inspired by Sanskrit characters from southern India.[26] Only a few, highly regarded individuals possessed writing skills. Among them was the *datu*, or ritual specialist, who kept written records, prescriptions, formulas for ritual healing, and agricultural procedures in this book of the knowledge of his predecessors. The *datu* was responsible for protecting the souls of the living from malevolent spirits such as the *begu*, an ancestral spirit that felt neglected if it had not received offerings for a long time. The Batak held

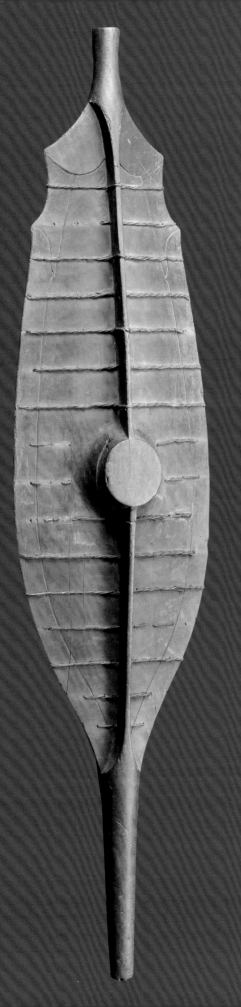

95 *Shield* (baluse)

Unknown artist or workshop
Nias, Indonesia
20th century
Lightweight wood, fiber
H. 126.5 cm, w. 29.5 cm, d. 10 cm
(H. 49¹³⁄₁₆ in., w. 11⅝ in., d. 3¹⁵⁄₁₆ in.)
Acquired possibly in 1960–61 from
the Galerie Argiles, Paris

96 *Shield*

Unknown artist or workshop
Dayak peoples, Kalimantan, Borneo, Indonesia
20th century
Wood, rattan
H. 111 cm, w. 40.5 cm, d. 10 cm (H. 43¹¹⁄₁₆ in.,
w. 15¹⁵⁄₁₆ in., d. 3¹⁵⁄₁₆ in.)
Acquired possibly in 1960 or 1977 from the
Galerie Argiles, Paris

97 *Figure* (hampatong)

Unknown artist or workshop
Dayak peoples (possibly Bahau), Kalimantan,
Borneo, Indonesia
20th century
Ironwood, shell, pigment
H. 38 cm, w. 32.5 cm, d. 18.5 cm (H. 14¹⁵⁄₁₆ in.,
w. 12¹³⁄₁₆ in., d. 7⁵⁄₁₆ in.)
Acquired in the 1980s from the Galerie
Dupeyrier, Paris

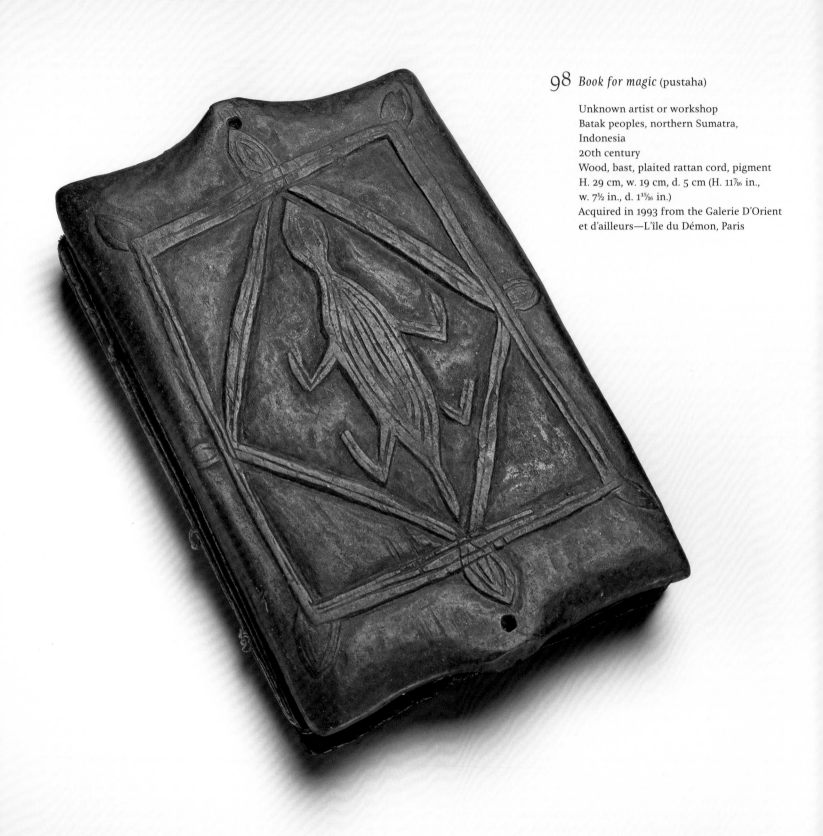

98 *Book for magic* (pustaha)

Unknown artist or workshop
Batak peoples, northern Sumatra,
Indonesia
20th century
Wood, bast, plaited rattan cord, pigment
H. 29 cm, w. 19 cm, d. 5 cm (H. 11⅞ in.,
w. 7½ in., d. 1¹⁵⁄₁₆ in.)
Acquired in 1993 from the Galerie D'Orient
et d'ailleurs—L'île du Démon, Paris

such spirits responsible for seizing a deceased person's soul and subsequently causing death and illness among the living.[27] This *pustaha* consists of bast-fiber pages folded in concertina fashion and inserted between two wooden panels. The bast pages, smoothed and prepared with a rice flour paste, are inscribed with characters on both sides, and some show drawings of figures or marginalia. Like the text in other *pustaha*, this one may allude to the art of preserving and destroying life and the art of divining. On the wooden front panel, a delicate diamond-shaped frame encloses a lizard, an animal that lives between water and land. In the eyes of the Batak, this creature connects the two realms and has special powers; it also alludes to fertility.

Shields and Batak books showed up in the Bali art market, as did works from Sumba to the east, an island roughly the size of Massachusetts that belongs to the Lesser Sunda Islands, which is now known as Nusa Tenggara, or Southeastern Islands. The inhabitants of eastern Sumba are divided into nobles (members of ancient patrilineal clans), commoners, and descendants of slaves who, in the 1970s, still lived in economic dependency. Smaller ethnic groups reside in the western part of the island. Sumba is famous for its beautifully woven textiles, rich personal adornments, and finely shaped utilitarian objects. Westerners have long appreciated Sumbanese textiles, but ornaments and utilitarian objects moved into the market and were transformed from artifacts into works of art only when interest in Indonesian arts grew in the 1970s. Among these objects were delicate tortoiseshell diadems, called *hai kara jangga,* from eastern Sumba (cat. 99). Fathers traditionally gave them to their daughters at puberty.[28] The tortoiseshells were shaped by heat, and the carved openwork upper registers reveal a repertoire of forms: figurative motifs such as cock, deer, crayfish, and horse alternate with geometric patterns. This example has two pairs of roosters on top,

confronting each other, perhaps an allusion to the cock-fights commonly arranged by Sumbanese. The central image, repeated in the lower register, probably depicts an *andung,* or skull tree, a bare tree trunk adorned with the heads of the vanquished and erected in front of the clan leader's house. Such trees served as village ritual sites and assured fertility.[29]

Other forms of adornment from Sumba include pectorals (*marangga*) from the western part of the island (cat. 100). Blacksmiths, who initially arrived on Sumba as itinerant workers from neighboring Savu, created them from precious metals such as gold or silver. *Marangga* were among the heirlooms clans accumulated over time and displayed during feasts. These objects visualized the wealth of their owners, embodied history, and alluded to ritualized exchanges of valuables between families that reenacted and confirmed alliances, such as marriage transactions. Their elegant shape places them among the most iconic works from Indonesia, and more recently, as in this example, artists have fashioned them from metal alloys.[30]

Other precious goods, including ikat textiles, also circulated in the extensive gift exchanges that took place during marriage transactions and on other occasions (cat. 101). Made by women, the textiles were the female contribution to the transactions, whereas metal objects were male gifts. These valuables signified the complementarity of the sexes and the harmony between them. Ikat is a complex resist-dye process in which threads, reserved and dyed before weaving, form the motifs and produce intricate patterns in subtle coloring. The most striking Sumba textiles may be the *hinggi,* made for both common and elite men, who wear one around the waist and another over the shoulder.[31] Ordinary cloths for commoners move through one dye bath, producing white patterns on an indigo background, while cloths for wealthy men undergo a second process

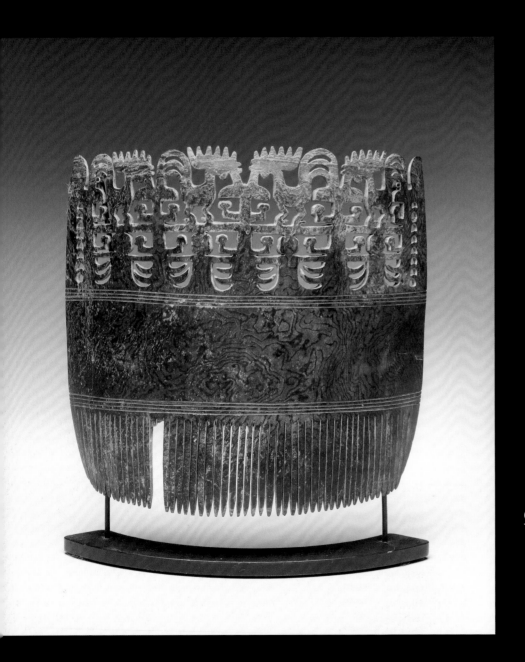

99 *Diadem* (hai kara jangga)

Unknown artist or workshop
East Sumba, Nusa Tenggara, Indonesia
20th century
Tortoiseshell
H. 16 cm, w. 18 cm, d. 5 cm (H. 6�5⁄16 in.,
w. 7¹⁄16 in., d. 1¹⁵⁄16 in.)
Acquired in New York (date unknown)

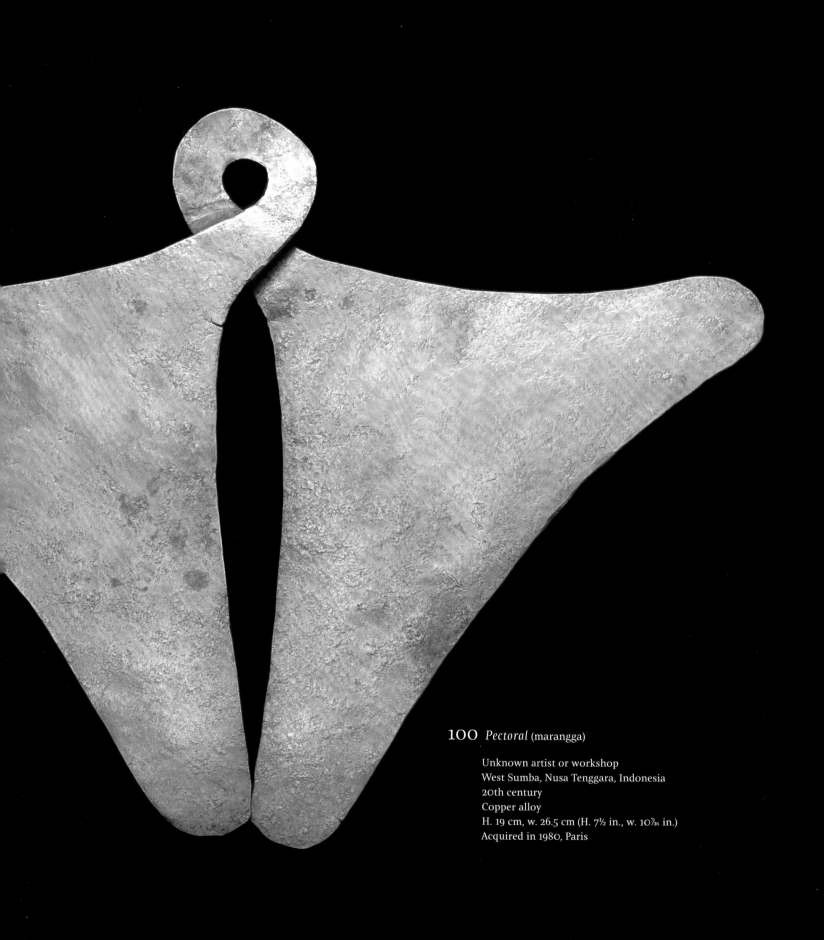

100 *Pectoral* (marangga)

Unknown artist or workshop
West Sumba, Nusa Tenggara, Indonesia
20th century
Copper alloy
H. 19 cm, w. 26.5 cm (H. 7½ in., w. 10⁷⁄₁₆ in.)
Acquired in 1980, Paris

that adds red to the color scheme. These prestigious *hinggi*—more common in the eastern part of the island—display representational motifs arranged in registers, among them mythic creatures such as dragons and heraldic elements such as the lion, inspired by Dutch imagery. The *hinggi* in the McMillan Collection depicts jumping horses (which the Sumbanese raise) arranged on a red background, alternating with rows of snakes or dragons on an indigo background. The central band, with ornate geometric designs, is a *patola*, a Sumbanese term for complex continuous designs.

The process by which these cloths became commodities provides insight into the dynamics of the market. Beginning in the 1920s, *hinggi* in particular enjoyed high esteem in Europe and the United States; missionary exhibitions in the Netherlands featured them, Dutch and German museums acquired them, and Dutch middle-class households showcased them as tablecloths.[32] In the United States, publications and exhibitions moved Sumba textiles into the limelight in the 1970s.[33] Moss, who traced the development of the trade and its impact, noted that these textiles probably had circulated from Sumba to other islands for centuries and provided income for the female weavers.[34] Thus, producing for an outside market was not new for these women. The increased demand from Bali eventually depleted the supply of ancient cloths, although people were reluctant to part with them. Weaving villages now cater to the tourist trade.[35] As in the African context, the speed of production increased, the quality declined, the textiles became more repetitive, and industrial dyes entered the picture. Nevertheless, some of these new cloths circulated back to the Sumbanese, who continued to use them for their original purposes, a practice of reintegration that also occurred in some African settings. Beyond continued local production, the lucrative business attracted imitators,

and textile mills in Java now turn out Sumba-style cloth in continuous yardage.

As mentioned earlier, the art market in Bali also offered objects from farther afield. It is likely that several fine bowls from the Philippines traveled through Indonesia before they arrived in the McMillan Collection. Utilitarian bowls such as these were caught up in the general transition of practical objects into the art category (cats. 102a–c) The bowl on the left comes from the Ifugao peoples of the central Cordillera region in northern Luzon (cat. 102a). Food was served to wealthy men in footed bowls with notched rims and other smaller containers, while ordinary families ate from larger, shared dishes.[36] This bowl probably owes its shiny black patina to the application of duck fat or lard combined with soot from the cooking fire. The small bowl at the center is a coconut shell, with delicate, incised, diagonal stripes over the entire outer surface and an ornate band of an incised X pattern encircling the rim (cat. 102b).

Objects from the entire region still come to Bali, which remains a hub of the art trade. However, collectors frequently complain about the decline in the quality of the objects and the preponderance of fakes, which emerged as soon as the market became lucrative in the early 1970s.[37] Tourism dropped off after several terrorist attacks at the beginning of the twenty-first century, and the situation remains precarious. It seems then that the fortunes of some of the major sites of transit for works of art in the second half of the twentieth century, in Africa and Oceania, declined as political and art market conditions changed.

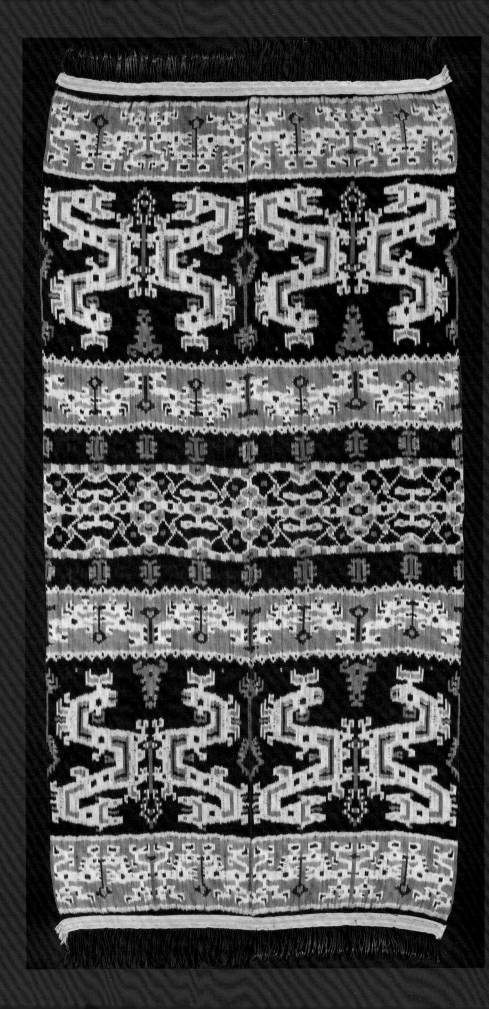

101 *Men's textile* (hinggi ikat)

Unknown artist or workshop
East Sumba, Nusa Tenggara, Indonesia
20th century
Cotton, dye
H. 238.8 cm, w. 101.6 cm (H. 94 in., w. 40 in.)
Acquired in the 1970s from Perry Kenner,
New York

102a *Bowl*

Unknown artist or workshop
Ifugao peoples, Luzon, Philippines
20th century
Wood
H. 10.5 cm, diam. 19 cm
(H. 4⅛ in., diam. 7½ in.)
Acquired in the 1980s from the
Galerie Majestic (Michel Huguenin)
or the Galerie Antipodes, Paris

102b *Bowl*

Unknown artist or workshop
Philippines
20th century
Coconut
H. 8.5 cm, diam. 14 cm
(H. 3⅜ in., diam. 5½ in.)
Acquired in the 1980s from the
Galerie Majestic (Michel Huguenin)
or the Galerie Antipodes, Paris

102c *Bowl*

Unknown artist or workshop
Philippines
20th century
Wood, metal [repair]
H. 8 cm, diam. 19.2 cm
(H. 3⅛ in., diam. 7⁹⁄₁₆ in.)
Acquired in the 1980s from the
Galerie Majestic (Michel Huguenin)
or the Galerie Antipodes, Paris

NOTES

1. Hersey 1991, 5.

2. Indonesia claimed western New Guinea as its province in 1969. The region was known as Irian Jaya from 1973 to 2002, when the government changed its name to Papua and granted it more autonomy under pressure from Papuan separatists.

3. For a comprehensive history of the trade cycles in outer Southeast Asia, see Swadling 1996.

4. Corbey 2000, 26–27.

5. Rubin 1984a.

6. See, for example, the chapter "Discovering an Art" in Moss 1994; or Hersey 1991, vii–viii.

7. Barbier and Newton 1988; Capistrano-Baker 1994.

8. We thank Joshua Bell, Nick Stanley, and Karen Jacobs for their comments about the *bilum*.

9. Anthropologists of Harvard University founded Cultural Survival in 1972 in Cambridge, Massachussetts. They market works by peoples considered to be endangered in order to raise funds in their support.

10. See the back cover of O'Hanlon 1993, which has the following caption: "The image of Papua New Guinea as paradise is embodied in a netbag and offered for sale to visitors."

11. Stanley 1999; Konrad and Konrad 1996.

12. Moss 1986, 8–9.

13. Barbier 1983, 9–10.

14. We thank Irwin Hersey for talking to us about his collecting of Indonesian art, April 19, 2006.

15. See, for example, the collection of the Musée Barbier-Mueller, now at the Musée du quai Branly in Paris. Benitez-Johannot and Barbier 2000, 144-73.

16. See Hersey 1991, 19.

17. Alpert 1995.

18. Bodrogi 1972, 22–33.

19. Benitez-Johannot and Barbier 2000, 144.

20. See photograph reproduced in Taylor and Aragon 1991, ch. 2, fig. II, no. 35, p. 89.

21. Taylor and Aragon 1991, 92.

22. Newton 1999, 23, n. 3.

23. The Iban are a Dayak group in Sarawak, a Malaysian province on Borneo. Politically, the island is governed by Malaysia (Sarawak) and Indonesia (Kalimantan).

24. Benitez-Johannot and Barbier 2000, 150.

25. Feldman 1994, 68.

26. Taylor and Aragon 1991, 109; Sibeth 1991.

27. Capistrano-Baker 1994, 57.

28. Sedyawati 1998, 33.

29. This interpretation of motifs is based on Adams 1969, 129–51.

30. Hoskins 1988, 134.

31. See Adams 1969, 153; Hoskins 1988, 128.

32. Moss 1994, 93–94.

33. Gittinger 1979.

34. The following is based on Moss 1986, 25–27.

35. For a recent analysis of the phenomenon, see Forshee 2001.

36. Casal et al. 1981, 201–5.

37. See Barbier 1983, 177–99, about fakes of Batak works.

Epilogue: Into the Twenty-first Century

The pursuit of collecting African and Oceanic arts is changing rapidly in the twenty-first century. New domains of interest have opened up, including contemporary arts such as photography by artists who travel in international circles in Paris, London, New York, Dakar, Johannesburg, Sydney, and elsewhere. At the same time, interest in other areas has receded or can no longer be pursued with the same vigor and emphasis. Objects that left Africa and Oceania in the first half of the twentieth century, such as the Vanuatu puppet (cat. 1) and the Kota reliquary figure (cat. 2), have become rare commodities—circulating only through top auctions and high-end collections. Works by known artists or workshops—such as the *gelede* headdress by Duga of Meko (cat. 48), which forty or fifty years ago would not have drawn much attention—now engage scholars and collectors alike. In fact, as we look back at the years between 1945 and 2000, many art forms that were then perceived as new and less desirable, among them bronze head crests cast in the Bamum kingdom for local and foreign clienteles, have become historic expressions, for they are no longer produced (cat. 60). Works that demonstrate how African and Oceanic artists integrated foreign forms and media into their repertoires, such as the enigmatic rider on horseback from Nigeria (cat. 51) and the neck adornment with pink plastic from New Guinea (cat. 89), were once considered inauthentic visual expressions but now speak to ingenuity, innovation, and the global connectedness of their creators and users.

What about the key issues and questions that accompanied collecting in the time period under consideration and that echo in this book? What has happened to "authenticity" and the related notions of "authentic arts," "correct copies," and "tourist pieces"? Several case studies in this book, and the work of many scholars, suggest that we need to move beyond those narrow confines or even discard these concepts—largely the results of age-old Western stereotypes about African and Oceanic peoples and their artists and the innate desire to bring order to ever-changing processes that ultimately defy categorization. In a telling passage about terms such as "primitive," "tourist," "folk," and "popular," which label objects produced by African and Oceanic artists and reflect the same urge to classify, Paul Taylor remarks that "the indigenous discourses may not recognize any of these categories, and indeed the distinctions are only problematic for museums, collectors, appraisers, exhibitors, and the like. They are of no importance

to the makers of these art forms."[1] What does seem relevant is these makers' delight in novelty and adaptation as well as their entrepreneurship and ability to respond to the demands of external and internal markets—the trademarks of African and Oceanic artists.

Following the physical voyages of objects from the McMillan Collection, and tracing some of the transformations in meaning that occurred during their journeys from their places of origin to Cambridge, have allowed us to discern some of the processes that shaped and accompanied collecting in the second half in the twentieth century. However, the material and conceptual journeys of objects from the African and Oceanic realms are by no means things of the past. Indeed, they continue in many forms and are aided by various intermediaries: collectors, curators, dealers from all over the world, and that revolutionary twenty-first century tool, the Internet. African and Oceanic arts have truly gone global.

NOTE
1. Taylor 1994, 5.

Bibliography

Adams, Marie Jeanne [Monni]. 1969. *System and Meaning in East Sumba Textile Design: A Study in Traditional Indonesian Art.* New Haven: Yale University, Southeast Asian Studies.

Adams, Monni. 1982. *Designs for Living.* Cambridge, MA: Carpenter Center for the Visual Arts, Harvard University.

———. 1983. *Private Visions: African Art from the Collection of Geneviève McMillan.* Boston: Boston Athenaeum.

———. 1995a. "Agency and Control in Masked Festivals among the Bo People, Southwestern Côte d'Ivoire." *Zeitschrift für Ethnology,* v. 130, n. 2: 195-221.

———. 1995b. "Female Standing Figure; Helmet Mask, Mende, Sierra Leone." In *Africa: The Art of a Continent,* ed. Tom Phillips, 472-73. Munich and New York: Prestel; London: Royal Academy of Arts.

———. 2005. *Both Sides of the Collecting Encounter: The Harley Collection of Liberian Masks.* Unpublished lecture.

Adams, Monni, and T. Rose Holdcraft. 1992. "Dida Woven Raffia Cloth from Côte d'Ivoire." *African Arts,* v. 23, n. 3 (July): 42-51, 100-101.

Air Afrique. 1978. "Note: Elephants Have the Right of Way." Advertisement. *African Arts,* v. 11, n. 3 (April): inside cover.

Alldridge, Thomas J. 1901. *The Sherbro and Its Hinterland.* London: MacMillan and Co.

———. 1910. *A Transformed Colony: Sierra Leone As It Was, and As It Is, Its Progress, Peoples, Native Customs and Undeveloped Wealth.* London: Seeley and Co.

Alpert, Steven. 1995. "Indonesian Shields." In *Protection, Power and Display: Shields of Island Southeast Asia and Melanesia,* ed. Andrew Tavarelli, 19-35. Boston: Boston College Museum of Art.

Amrouche, Pierre. 2006. "The Pierre and Claude Vérité Collection: The Unknown Masterpiece." In *Arts Primitifs: Collection Vérité,* xxxiv-xl. Paris: Enchères Rive Gauche.

Ansett Airlines of Australia. 1970. *New Guinea Holidays.* Advertisement.

Antiri, Janet Adwoa. 1974. "Akan Combs." *African Arts,* v. 8, n. 1 (autumn): 32-35.

Appadurai, Arjun, ed. 1986. *The Social Life of Things: Commodities in Cultural Perspective.* Cambridge and New York: Cambridge University Press.

Appiah, Kwame Anthony. 2006. *Cosmopolitanism: Ethics in a World of Strangers.* New York and London: W. W. Norton & Company.

Arnoldi, Mary Jo. 1995. *Playing with Time: Art and Performance in Central Mali.* Bloomington: Indiana University Press.

———. 1998. *Beauty in the Blade.* Kansas City: University of Missouri-Kansas City, Gallery of Art.

———. 2001. "The *Sogow:* Imagining a Moral Universe through *Sogo bò* Masquerades." In *Bamana: The Art of Existence in Mali,* ed. Jean-Paul Colleyn, 77-84. New York: Museum for African Art; Zurich: Museum Rietberg; Gent: Snoek-Ducaju & Zoon.

Arnoldi, Mary Jo, Kris Hardin, and Christraud M. Geary, eds. 1996. *African Material Culture.* Bloomington: Indiana University Press.

Arnoldi, Mary Jo, and Christine Mullen Kraemer. 1995. *Crowning Achieve-ments: African Arts of Dressing the Head.* Los Angeles: Museum of Cultural History, University of California at Los Angeles.

Arrys, Phillipe. 1971. "Un rêve sort de terre, La riviéra africaine en Côte d'Ivoire." *Balafon,* n. 21: 18–22.

Art/Artifact. African Art in Anthropology Collections. 1988. New York: Center for African Art; Munich: Prestel.

Arts Primitifs: Collection Vérité. 2006. Paris: Enchères Rive Gauche.

Baldassari, Anne. 1997. *Picasso and Photography: The Dark Mirror.* Paris: Flammarion; Houston: Museum of Fine Arts, Houston.

Barbier, Jean Paul. 1983. *Tobaland: The Shreds of Tradition.* Geneva: Musée Barbier-Müller.

———, ed. 1993a. *Art of Côte d'Ivoire from the Collections of the Barbier-Mueller Museum.* 2 vols. Geneva: Barbier-Mueller Museum.

———. 1993b. "Concluding Remarks." In *Art of Côte d'Ivoire from the Collections of the Barbier-Mueller Museum,* vol. 1, ed. Jean Paul Barbier, 402–11. Geneva: Barbier-Mueller Museum.

Barbier, Jean Paul, and Douglas Newton, eds. 1988. *Island and Ancestors: Indigenous Styles of Southeast Asia.* Munich: Prestel.

Bascom, William. 1973. "A Yoruba Master Carver: Duga of Meko." In *The Traditional Artist in African Society,* ed. Warren L. d'Azevedo, 62–78. Bloomington and London: Indiana University Press.

Batéké: Peintres et sculpteurs d'Afrique centrale. 1999. Paris: Musée national des arts d'Afrique et d'Océanie.

Beckwith, Carol. 1983. *Nomads of Niger.* New York: Harry N. Abrams.

Benitez-Johannot, Petty, and Jean Paul Barbier. 2000. *Shields. Africa, Southeast Asia and Oceania from the Collections of the Barbier-Mueller Museum.* Munich, London, and New York: Prestel.

Benjamin, Walter. 1969 [1936]. "The Work of Art in the Age of Mechani-cal Reproduction." In *Illuminations,* ed. and intro. Hannah Arendt, trans. Harry Zohn, 215–51. New York: Schocken.

Bernatzik, Hugo Adolf. 1933. *Geheimnisvolle Inseln Tropen-Afrikas. Das Reich der Bidyogo auf den Bissagosinseln.* Berlin: Deutsche Buch-Gemeinschaft.

———. 1944. *Im Reich der Bidyogo, geheimnisvolle Inseln in Westafrika.* Leipzig: Koehler & Voigtländer.

Bilot, Alain. 2003. *Serrures du pays Dogon.* Paris: A. Biro.

Binger, Louis Gustave. 1892. *Du Niger au Golfe de Guinée par le pays de Kong et le Mossi.* Paris: Hachette et Cie.

Blier, Suzanne Preston, ed. 2003. *Art of the Senses: African Masterpieces from the Teel Collection.* Boston: MFA Publications.

Bodrogi, Tibor. 1972. *Art of Indonesia.* Greenwich, CT: New York Graphic Society.

Boone, Sylvia Ardyn. 1986. *Radiance from the Waters: Ideals of Feminine Beauty in Mende Art.* New Haven: Yale University Press.

Bourgeois, Arthur P. 1984. *Art of the Yaka and Suku.* Meudon, France: Alain et Françoise Chaffin.

Bowditch, Thomas Edward. 1819. *Mission from Cape Coast Castle to Ashantee.* London: John Murray.

Boyer, Alain-Michel. 1993. "Art of the Yahure." In *Art of Côte d'Ivoire from the Collections of the Barbier-Mueller Museum,* vol. 1, ed. Jean Paul Barbier, 246–88. Geneva: Barbier-Mueller Museum.

Bravmann, René. 2001. "Islamic Ritual and Practice in Bamana Ségou, the 19th Century 'Citadel of Paganism.'" In *Bamana. The Art of Existence in Mali,* ed. Jean-Paul Colleyn, 35–43. New York: Museum for African Art: Zurich: Museum Rietberg; Gent: Snoek-Ducaju & Zoon.

Bruyninx, Elze. 2005. "Face Mask: Gle Va." In *Resonance from the Past: African Sculpture from the New Orleans Museum of Art,* ed. Frank Herreman, 42–43. New York: Museum for African Art; New Orleans: New Orleans Museum of Art.

Büttikofer, Johann. 1890. *Reisebilder aus Liberia. Resultate geographisher, naturwissenschaftlicher und ethnographischer Untersuchungen während der Jahre 1879–1882 und 1886–1887.* 2 vols. Leiden: Brill.

Cameron, Elisabeth Lynn. 1988. "Sala Mpasu Masks." *African Arts,* v. 22, n. 11 (November): 34–43, 98.

———. 1995a. "Lega Hats: Hierarchy and Status." In *Crowning Achievements: African Arts of Dressing the Head,* ed. Mary Jo Arnoldi and Christine Mullen Kraemer, 147–57. Los Angeles: Fowler Museum of Cultural History, University of California at Los Angeles.

———. 1995b. "Mask (*kasangu*), Sala Mpasu, Zaire." In *Africa: The Art of a Continent,* ed. Tom Phillips, 260. Munich and New York: Prestel; London: Royal Academy of Arts.

———. 2004. "Dancing a New Face: Contemporary Sala Mpasu Masquerades." *African Arts,* v. 37, n. 2 (summer): 74–79, 96.

Capistrano-Baker, Florina H. 1994. *Art of Island Southeast Asia. The Fred and Rita Richman Collection in the Metropolitan Museum of Art.* New York: Metropolitan Museum of Art.

Casal, Gabriel, Regalado Trota Jose, Eric S. Casino, George R. Ellis, and Wilhelm G. Solheim II. 1981. *The People and Art of the Philippines.* Los Angeles: Museum of Cultural History, University of California, Los Angeles.

Chaffin, Alain, and Françoise Chaffin. 1979. *L'art Kota: Les figures de reliquaire.* Meudon, France: Alain et Françoise Chaffin.

Cissé, Youssouf Tata. 1995. "Seydou Keita." In *Seydou Keita,* not paginated. Paris: Centre National de la Photographie.

Cole, Herbert M. 1989. *Icons: Ideals and Power in African Art.* Washington, D.C.: Museum of African Art and Smithsonian Institution Press.

———. 2004. "The Aura of Power and Mystery: An Asante Figure (*Akua'ba*)." In *See the Music, Hear the Dance: Rethinking African Art at the Baltimore Museum of Art,* ed. Frederick John Lamp, 156–57. Munich: Prestel.

Cole, Herbert M., and Chike C. Aniakor. 1984. *Igbo Arts: Community and the Cosmos.* Los Angeles: Museum of Cultural History, University of California, Los Angeles.

Cole, Herbert M., and Doran H. Ross. 1977. *The Arts of Ghana.* Los Angeles: Museum of Cultural History, University of California, Los Angeles.

Colleyn, Jean-Paul, ed. 2001a. *Bamana: The Art of Existence in Mali.* New York: Museum for African Art; Zurich: Museum Rietberg; Gent: Snoek-Ducaju & Zoon.

———. 2001b. "The *Ci-wara*." In *Bamana. The Art of Existence in Mali,* ed. Jean-Paul Colleyn, 201–33. New York: Museum for African Art; Zurich: Museum Rietberg; Gent: Snoek-Ducaju & Zoon.

———. 2001c. "*Ntomo* and *Kore*." In *Bamana: The Art of Existence in Mali,* ed. Jean-Paul Colleyn, 95–129. New York: Museum for African Art; Zurich: Museum Rietberg; Gent: Snoek-Ducaju & Zoon.

Corbey, Raymond. 2000. *Tribal Art Traffic. A Chronicle of Taste, Trade and Desire in Colonial and Post-Colonial Times.* Amsterdam: Royal Tropical Institute, Netherlands.

Corbin, George A. 1979. "The Art of the Baining, New Britain." In *Exploring the Visual Art of Oceania: Australia, Melanesia, Micronesia, and Polynesia,* ed. Sidney M. Mead and B. Kernot, 159–79, Honolulu: University of Hawaii Press.

———. 1988. *Native Arts of North America, Africa, and the South Pacific.* New York: Harper and Row.

Cornet, Joseph, F.R.C. 1975. "African Art and Authenticity." *African Arts,* v. 9, n. 1 (October): 52–55.

Crowley, Daniel J. 1970. "The Contemporary-Traditional Art Market in Africa." *African Arts,* v. 4, n. 1 (autumn): 43–49, 80.

———. 1974. "The West African Art Market Revisited." *African Arts,* v. 7, n. 4 (summer): 54–59.

Dark, Philip J.C. 1999. "Of Old Models and New in Pacific Art: Real or Spurious?" In *Art and Performance in Oceania,* ed. Barry Craig, 266–88. Honolulu: University of Hawaii Press.

Davenport, William H. 1986. "Two Kinds of Value in the Eastern Solomon Islands." In *The Social Life of Things: Commodities in Cultural Perspective,* ed. Arjun Appadurai, 95–109. Cambridge and New York: Cambridge University Press.

de Zayas, Marius. 1916. *African Negro Art: Its Influence on Modern Art.* New York: Modern Gallery.

———. 1918. *African Negro Wood Sculpture Photographed by Charles Sheeler.* New York: Modern Gallery.

Degli, Marine, and Marie Mauzé. 2000. *Arts premiers. Le temps de la reconnaissance.* Paris: Gallimard and Réunion des Musées Nationaux.

Desplanges, Louis. 1907. *Le plateau central Nigérien: Une mission archéologique et ethnographique au Soudan français.* Paris: Emile Larose.

Diop, Cheikh Anta, and Madeleine Rousseau. 1948. *Problèmes culturels de l'Afrique noire: 1848, abolition de l'esclavage, 1948, évidence de la culture nègre.* Le Musée Vivant No. 36–37. Paris: A.P.A.M. [Association populaire des amis des musées].

Doquet, Anne. 1999. *Les masques dogon: Ethnologie savante et ethnologie autochtone.* Paris: Karthala.

Doutreuwe, Françoise. 1993. "La Côte d'Ivoire." In *Rives coloniales. Architectures, de Saint-Louis à Douala,* ed. Jacques Soulliou, 105–34. Paris: Editions Paranthèses and Editions de l'Orstom.

Drewal, Henry John, and Margaret Thompson Drewal. 1983. *Gelede: Art and Female Power Among the Yoruba.* Bloomington: Indiana University Press.

Drewal, Henry John, and John Pemberton III with Rowland Abiodun. 1989. *Yoruba. Nine Centuries of African Art and Thought.* New York: Center for African Art in association with Harry N. Abrams.

Dupré, Marie-Claude. 1999. "Les Tsayi de la forêt, peintres des invisibles." In *Batéké: Peintres et sculpteurs d'Afrique centrale,* 242–67. Paris: Musée national des arts d'Afrique et d'Océanie.

Edge-Partington, J. 1906. "Decorated Shields from the Solomon Islands." *Man,* n. 6: 129–30.

Einstein, Carl, 1915. *Negerplastik.* Leipzig: Verlag der weissen Bücher.

Erouart-Siad, Patrick. 1988. "Abidjan, carrefour de toutes les Afriques." *Balafon,* n. 86: 36–43.

Errington, Shelly. 1998. *The Death of Authentic Primitive Art and Other Tales of Progress.* Berkeley: University of California Press.

Ezra, Kate. 1988. *Art of the Dogon. Selections from the Lester Wunderman Collection.* New York: Metropolitan Museum of Art.

Féau, Etienne, Pascal Mongne, and Roger Boulay. 2006. *Arts d'Afrique, des Amériques, et d'Océanie.* Paris: Larousse.

Feldman, Jerome. 1994. *Arc of Ancestors: Indonesian Art from the Jerome L. Joss Collection at UCLA.* Los Angeles: Fowler Museum of Cultural History, University of California at Los Angeles.

Felix, Marc L. 1991. *Kipinga: Throwing-Blades of Central Africa/Kipinga: Wurfklingen aus Zentralafrika.* Munich: Verlag F. Jahn.

Fischer, Eberhard. 1963. "Künstler der Dan: Die Bildhauer Tame, Si, Tompieme und Sõn: Ihr Wesen und ihr Werk." *Baessler-Archiv,* v. 10, n. 2 (June): 161–263.

———. 1978. "Dan Forest Spirits: Masks in Dan Villages." *African Arts,* v. 11, n. 2 (January): 16–23, 94.

Fischer, Eberhard, Barbara Fischer, Hans Himmelheber, and Ulrike Himmelheber. 1993. *Boti, ein Maskenschnitzer der Guro, Elfenbeinküste: Notizen zu Persönlichkeit, Werkverfahren und Stil eines traditionellen Bildhauers in Westafrika.* Zurich: Museum Rietberg.

Fischer, Eberhard, and Lorenz Homberger. 1985. *Die Kunst der Guro, Elfenbeinküste.* Zurich: Museum Rietberg.

Fischer, Werner, and Manfred A. Zirngibl. 1978. *Afrikanische Waffen. Messer, Dolche, Schwerter, Beile, Wurfwaffen.* Passau, Germany: Prinz-Verlag.

Forshee, Jill. 2001. *Between the Folds: Stories of Cloth, Lives, and Travels from Sumba.* Honolulu: University of Hawaii Press.

Frobenius, Leo. 1907. *Im Schatten des Kongostaates: Bericht über den Verlauf der ersten Reise der D.I.A.F.E. von 1904–1906, über deren Forschungen und Beobachtungen auf geographischem und landwirtschaftlichem Gebiet.* Berlin: G. Reimer.

Gallois-Duquette, Danielle. 1983. *Dynamique de l'art Bidjogo (Guinée-Bissau): Contribution à une anthropologie de l'art des sociétés africaines.* Lisbon: Instituto de Investigação Científica Tropical.

———. 2000. "The Bidjogo Peoples of Guinea Bissau." In *In the Presence of Spirits: African Art from the National Museum of Ethnology, Lisbon,* ed. Frank Herreman, 155–82. New York: Museum for African Art; Gent: Snoek-Ducaju & Zoon.

Geary, Christraud M. 1976. *We: Die Genese eines Häuptlingtums im Grasland von Kamerun.* Studien zur Kulturkunde 38. Wiesbaden: Steiner Verlag.

———. 1982. "Casting the 'Red Iron': Bamum Bronzes." In *The Art of Metal in Africa,* ed. Marie-Thérèse Brincard, 71–78. New York: African-American Institute.

———. 1983. *Things of the Palace: A Catalogue of the Bamum Palace Museum, Foumban (Cameroon).* Studien zur Kulturkunde 60. Wiesbaden: Steiner Verlag.

———. 1995. "Photographic Practice in Africa and Its Implications for the Use of Historical Photographs as Contextual Evidence." In *Fotografia e storia dell'Africa,* ed. Alessandro Triulzi, 103–30. Naples: Istituto Universitario Orientale.

———. 1996. "Political Dress: German-Style Military Attire and Colonial Politics in Bamum Kingdom (Cameroon)." In *African Crossroads: Intersections between History and Anthropology in Cameroon,* ed. Ian Fowler and David Zeitlyn, 165–92. Oxford: Berghahn Books.

———. 2004. "On Collectors, Exhibitions, and Photographs in African Art: The Teel Collection in Historical Perspective." In *Art of the Senses: African Masterpieces from the Teel Collection,* ed. Suzanne Preston Blier, 25–41. Boston: MFA Publications.

———, ed. 2006. *From the South Seas. Oceanic Art from the Teel Collection.* Boston: MFA Publications.

Gebauer, Paul. 1979. *Art of Cameroon.* Portland, OR: Portland Art Museum; New York: Metropolitan Museum of Art.

Ginsberg, Marc. 2000. *African Forms.* Milan: Skira.

Gittinger, Mattiebelle. 1979. *Splendid Symbols: Textiles and Tradition in Indonesia.* Washington, D.C.: Textile Museum.

Goldwater, Robert. 1960. *Bambara Sculpture from the Western Sudan.* New York: University Publishers.

Gosden, Chris, and Chantal Knowles. 2001. *Collecting Colonialism: Material Culture and Colonial Change.* Oxford and New York: Berg.

Gosden, Chris, and Yvonne Marshall. 1999. "The Cultural Biography of Objects." *World Archaeology,* v. 31, n. 2: 169–78.

Goy, Bertrand. 2005. *Poulies Pulleys.* Paris: Galerie Renaud Vanuxem.

Graburn, Nelson H.H., ed. 1976. *Ethnic and Tourist Arts: Cultural Expressions from the Fourth World.* Berkeley: University of California Press.

Griaule, Marcel. 1938. *Masques dogons.* Université de Paris. Travaux et mémoires de l'Institut d'Ethnologie 33. Paris.

———. 1965. *Conversations with Ogotemmêli: An Introduction to Dogon Religious Ideas.* London: Oxford University Press.

Griaule, Marcel, and Germaine Dieterlen. 1986. *The Pale Fox.* Chino Valley, AZ: Continuum Foundation.

Grognet, Fabrice. 2001. "Le nouveau musée de l'Homme et l'exposition de 1938." In *Le voyage de la Korrigane dans les mers du Sud,* ed. Christian Coiffier, 44–47. Paris: Hazan.

Grootaers, Jan-Lodewijk, and Ineke Eisenburger, eds. 2002. *Forms of Wonderment: The History and Collections of the Afrika Museum, Berg en Dal.* Berg en Dal, Netherlands: Afrika Museum.

Guillaume, Paul, and Thomas Munro. 1926. *Primitive Negro Sculpture.* London: Jonathan Cape.

Hahl, Albert. 1980. *Albert Hahl: Governor in New Guinea.* Ed. and trans. P.G. Sack and D. Clark. Canberra: Australian National University Press.

Hanson, Allan, and Louise Hanson, eds. 1990. *Art and Identity in Oceania.* Honolulu: University of Hawaii Press.

Harley, George Way. 1950. "Masks as Agents of Social Control in Northeast Liberia." *Papers of the Peabody Museum of Archaeology and Ethnology, Harvard University,* n. 32: 2.

Harter, Pierre. 1973. "Les pipes cérémonielles de l'ouest camerounais." *Arts d'Afrique noire,* n. 8: 18–43.

———. 1993. "We Masks." In *Art of Côte d'Ivoire from the Collections of the Barbier-Mueller Museum,* vol. 1, ed. Jean Paul Barbier, 184–221. Geneva: Barbier-Mueller Museum.

Hauser-Schäublin, Brigitta. 1989. *Leben in Linie, Muster und Farbe: Einführung in die Betrachtung aussereuropäischer Kunst am Beispiel der Abelam, Papua-Neuguinea.* Basel and Boston: Birkhäuser.

Hauser-Schäublin, Brigitta, and Gundolf Krüger, eds. 1998. *Gifts and Treasures from the South Seas: The Cook/Forster Collection.* Munich and New York: Prestel.

Henri, Joseph. 1910. *L'âme d'un peuple Africain: Les Bambara. Leur vie psychique, éthique, sociale, religieuse.* Münster, Germany: Aschendorffsche Buchhandlung.

Hersey, Irwin. 1991. *Indonesian Primitive Art.* Singapore and New York: Oxford University Press.

Hiery, Hermann Joseph, ed. 2001. *Die deutsche Südsee, 1884–1914.* Paderborn, Germany: Schöningh.

Himmelheber, Hans. 1960. *Negerkunst und Negerkünstler.* Braunschweig, Germany: Klinckhardt & Biermann.

———. 1993. *Zaire 1938/39. Photographic Documents on the Arts of the Yaka, Pende, Tshokwe and Kuba.* Zurich: Museum Rietberg.

Homberger, Lorenz, ed. 1997. *Masken der Wè und Dan, Elfenbeinküste: Die Sammlung des Schweizer Malers Charles Hug, Paris 1928–31.* Zurich: Museum Rietberg.

Hoskins, Janet. 1988. "Arts and Cultures of Sumba." In *Islands and Ancestors: Indigenous Styles of Southeast Asia,* ed. Jean Paul Barbier and Douglas Newton, 120–49. Munich: Prestel.

Hutter, Franz. 1902. *Wanderungen und Forschungen im Hinterland von Kamerun.* Braunschweig, Germany: Friedrich Viehweg und Sohn.

Imperato, Pascal James. 1970. "The Dance of the Tyi Wara." *African Arts,* v. 4, n. 1 (autumn): 8–13, 71–80.

———. 1971. "Contemporary Adapted Dances of the Dogon." *African Arts,* v. 5, n. 1 (autumn): 28–33, 68–72, 84.

———. 1972. "Door Locks of the Bamana of Mali." *African Arts,* v. 5, n. 3 (spring): 52–56, 84.

———. 1978. "Dogon Door Locks." *African Arts,* v. 11, n. 4 (July): 54–57, 96.

———. 2001. *Legends, Sorcerers, and Enchanted Lizards. Door Locks of the Bamana of Mali.* New York and London: Africana Publishing Company.

Jean, Frédéric. 1991. "Abidjan, perle ivoirienne." *Balafon,* n. 97: 42–46.

Johnson, Barbara. 1986. *Four Dan Sculptors: Continuity and Change.* San Francisco: Fine Arts Museums of San Francisco.

Kaeppler, Adrienne L. 1978. *"Artificial Curiosities": Being an Exposition of Native Manufactures Collected on Three Pacific Voyages of Captain James Cook, R.N., at the Bernice Pauahi Bishop Museum, January 18, 1978– August 31, 1978, on the Occasion of the Bicentennial of the European Dis- covery of the Hawaiian Islands by Captain Cook, January 18, 1778.* Honolulu: Bishop Museum Press.

Kaeppler, Adrienne L., Christian Kaufmann, and Douglas Newton. 1997. *Oceanic Art.* New York: Harry N. Abrams.

Kasfir, Sidney Littlefield. 1984. "'One Tribe, One Style?' Paradigms in the Historiography of African Art." *History in Africa,* n. 11: 163–93.

———. 1999. *Contemporary African Art.* London: Thames & Hudson.

Kaufmann, Christian. 1997. "Melanesia." In *Oceanic Art,* ed. Adrienne L. Kaeppler, Christian Kaufmann, and Douglas Newton, 552–612. New York: Harry N. Abrams.

Kelley, Donald, and Geneviève McMillan. 2006. *Reba Stewart: A Legacy.* Boston: Massachusetts College of Arts.

Kjersmeier, Carl. 1935. *Centres de style de la sculpture nègre africaine.* Vol. 1: *Afrique Occcidentale Française.* Paris: Editions Albert Morancé; Copen- hagen: Illums Bog-Afdeling & Fischers Forlag.

———. 1936. *Centres de style de la sculpture nègre africaine.* Vol. 2: *Guinée Portugaise, Sierra-Leone, Libéria, Côte d'Or, Togo, Dahomey et Nigéria.* Paris: Editions Albert Morancé; Copenhagen: Illums Bog-Afdeling & Fischers Forlag.

———. 1938. *Centres de style de la sculpture nègre africaine.* Vol. 4: *Cameroun, Afrique Equatoriale Française, Angola, Tanganyika, Rhodésie.* Paris: Edi- tions Albert Morancé; Copenhagen: Illums Bog-Afdeling & Fischers Forlag.

Knöpfli, Hans. 1997. *Crafts and Technologies: Some Traditional Craftsmen of the Western Grasslands of Cameroon.* British Museum Occasional Paper 107. London: Trustees of the British Museum.

Koch, Gerd. 2004. *Falsch und Fälscher. Verdächtige Werke aus der Südsee.* Leipzig: Editio Failima.

Koloss, Hans-Joachim. 2000. *World-View and Society in Oku (Cameroon).* Berlin: Dietrich Reimer.

Konrad, Gunter, and Ursula Konrad, eds. 1996. *Asmat: Myth and Ritual. The Inspiration of Art.* Venice: Erizzo.

Kopytoff, Igor. 1986. "The Cultural Biography of Things: Commoditi- zation as Process." In *The Social Life of Things: Commodities in Cultural Perspective,* ed. Arjun Appadurai, 64–91. Cambridge: Cambridge University Press.

LaGamma, Alisa. 2000. *Art and Oracle. African Art and the Rituals of Divination.* New York: Metropolitan Museum of Art.

Lamp, Frederick. 1985. "Cosmos, Cosmetics, and the Spirit of Bondo." *African Arts,* v. 18, n. 3 (May): 28–43, 98–99.

———. 2004. "Overture: A Consideration of the Fragment." In *See the Music, Hear the Dance. Rethinking African Art at The Baltimore Museum of Art,* ed. Frederick John Lamp, 19–26. Baltimore: Baltimore Museum of Art; Munich: Prestel.

Lawal, Babatunde. 1996. *The Gèlèdé Spectacle: Art, Gender, and Social Har- mony in an African Culture.* Seattle: University of Washington Press.

Lehuard, Raoul. 1983. "Un voyage au Congo." *Arts d'Afrique noire,* n. 46 (summer): 17–22.

———. 1996. *Les arts Bateke: Congo-Gabon-Zaïre.* Arnouville, France: Arts d'Afrique noire.

Leiris, Michel. 1934. *L'Afrique fantôme.* Paris: Gallimard.

———. 1948. *La langue secrète des Dogons de Sanga (Soudan Français).* Paris: Institut d'ethnologie.

Leloup, Hélène. 1994. *Statuaire Dogon.* Strasbourg: Daniele Amez.

Linton, Ralph, and Paul Wingert. 1946. *Arts of the South Seas.* New York: Museum of Modern Art and Simon and Schuster.

Luschan, Felix von. 1918. "Zusammenhänge und Konvergenz." *Mitteilun- gen der Anthropologischen Gesellschaft in Wien,* v. 48 (new ser. 3, n. 18): 1–117.

MacMillan, Allistair. 1920. *The Red Book of West Africa. Historical and Descriptive Commercial and Industrial Facts, Figures, & Resources.* London: W. H. & L. Collingridge.

Malinowski, Bronislaw. 1922. *Argonauts of the Western Pacific: An Account of Native Enterprise and Adventure in the Archipelagoes of Melanesian New Guinea.* London: Routledge.

Maurice, Danielle. 2006. *Madeleine Rousseau.* Unpublished paper.

Marfurt, Luitfried, and Jean Susini. 1966. *Pipes du Cameroun*. Cahors, France: Impr. France-Quercy-Auvergne.

McClusky, Pamela. 2002. *Art from Africa: Long Steps Never Broke a Back*. Seattle and Princeton, NJ: Seattle Art Museum and Princeton University Press.

McNaughton, Patrick R. 1982. "The Shirts that Mande Hunters Wear." *African Arts*, v. 13, n. 3 (May): 54-58, 91.

——. 1988. *The Mande Blacksmiths: Knowledge, Power, and Art in West Africa*. Bloomington: Indiana University Press.

——. 2001a. "More than Objects: Bamana Artistry in Iron, Wood, Clay, Leather and Cloth." In *Bamana: The Art of Existence in Mali*, ed. Jean-Paul Colleyn, 45-51. New York: Museum for African Art; Zurich: Museum Rietberg; Gent: Snoek-Ducaju & Zoon.

——. 2001b. "The Power Association: Kòmò." In *Bamana. The Art of Existence in Mali*, ed. Jean-Paul Colleyn, 175-83. New York: Museum for African Art; Zurich: Museum Rietberg; Gent: Snoek-Ducaju & Zoon.

Mead, Sidney M. 1973. *Material Culture and Art in the Star Harbour Region, Eastern Solomon Islands*. Toronto: Royal Ontario Museum.

Meyer, Anthony J.P. 1995. *Oceanic Art = Ozeanische Kunst = Art Océanien*. Cologne: Könemann.

Moss, Laurence A.G. 1986. *Art of the Lesser Sunda Islands: A Cultural Resource at Risk*. San Francisco: Craft and Folk Art Museum.

——. 1994. "International Art Collecting, Tourism, and a Tribal Region in Indonesia." In *Fragile Traditions: Indonesian Art in Jeopardy*, ed. Paul Michael Taylor, 91-121. Honolulu: University of Hawaii Press.

Newton, Douglas. 1961. *Art Styles of the Papuan Gulf*. New York: Museum of Primitive Art.

——. 1975. *Massim: Art of the Massim Area, New Guinea*. New York: Museum of Primitive Art.

——, ed. 1999. *Arts of the South Seas: Island Southeast Asia, Melanesia, Polynesia, Micronesia*. Munich: Prestel.

Njoya, Sultan de Foumban. 1952. *Histoire et coutumes des Bamum (Redigée sous la direction du Sultan Njoya. Traduction du Pasteur Henri Martin)*. Centre du Cameroun Série Populations 5. Douala, Cameroon: Institut Français de l'Afrique.

Northern, Tamara. 1973. *Royal Art of Cameroon. The Art of the Bamenda-Tikar*. Hanover, NH: Hopkins Center Art Galleries, Dartmouth College.

——. 1981. *The Ornate Implement*. Hanover, NH: Dartmouth College Museum & Galleries.

——. 1984. *The Art of Cameroon*. Washington, D.C.: Smithsonian Institution Traveling Exhibition Service.

Notué, Jean-Paul, and Bianca Triaca. 2005. *Mankon: Arts, Heritage and Culture from the Mankon Kingdom*. Milan: 5 Continents Editions.

——. 2006. *Babungo: Treasures of the Sculptor Kings in Cameroon*. Milan: 5 Continents Editions.

O'Hanlon, Michael. 1993. *Paradise: Portraying the New Guinea Highlands*. London: British Museum Press.

——. 1995. "Medusa's Art: Interpreting Melanesian Shields." In *Protection, Power and Display: Shields of Island Southeast Asia and Melanesia*, ed. Andrew Tavarelli, 74-104. Chestnut Hill, MA: Boston College Museum of Art.

Parke-Bernet Galleries. 1966. *The Helena Rubinstein Collection: African and Oceanic Art*. New York: Parke-Bernet Galleries.

Parkinson, Richard Heinrich Robert. 1999 [1907]. *Dreissig Jahre in der Südsee* [Thirty Years in the South Seas]. Trans. John Dennison. Honolulu: University of Hawaii Press.

Paudrat, Jean-Louis. 1984. "The Arrival of Tribal Objects in the West: From Africa." In *"Primitivism" in 20th Century Art: Affinity of the Tribal and the Modern*, vol. 1, ed. William Rubin, 125-75. New York: Museum of Modern Art.

Peltier, Philippe. 1984. "The Arrival of Tribal Objects in the West: From Oceania." In *"Primitivism" in 20th Century Art: Affinity of the Tribal and the Modern*, vol. 1, ed. William Rubin, 99-123. New York: Museum of Modern Art.

——. 2005. "Oceania: Objects of Revelation and Desire." In *New Guinea Art. Masterpieces from the Jolika Collection of Marcia and John Friede*, vol. 2, 57-72. San Francisco and Milan: Fine Arts Museums of San Francisco in association with 5 Continents Editions.

Petridis, Constantijn. 1993. "Pende Mask Styles." In *Face of the Spirits: Masks from the Zaire Basin*, ed. Frank Herreman and Constantijn Petridis, 63-76. New York: Museum for African Art; New Orleans: New Orleans Museum of Art.

Phillips, Ruth. 1995. *Representing Women: Sande Masquerades of the Mende of Sierra Leone*. Los Angeles: Fowler Museum of Cultural History, University of California at Los Angeles.

Phillips, Ruth B., and Christopher B. Steiner. 1999. "Art, Authenticity, and the Baggage of Cultural Encounter." In *Unpacking Culture. Art and Commodity in Colonial and Postcolonial Worlds,* ed. Ruth B. Phillips and Christopher B. Steiner, 3-19. Berkeley, Los Angeles, and London: University of California Press.

Picton, John. 1992. "Tradition, Technology, and Lurex: Some Comments on Textile History and Design in West Africa." *History, Design, and Craft in West African Strip-Woven Cloth. Papers presented at a symposium organized by the National Museum of African Art, Smithsonian Institution, February 18-19,* 13-52. Washington, D.C.: National Museum of African Art.

Pratt, Marie Louise. 1992. *Imperial Eyes: Travel Writing and Transculturation.* London and New York: Routledge.

Price, Sally. 1989. *Primitive Art in Civilized Places.* Chicago and London: University of Chicago Press.

Rattray, Robert Sutherland. 1927. *Religion and Art in Ashanti.* Oxford: Clarendon Press.

Ratzel, Friederich. 1887. *Völkerkunde.* Vol. 1: *Die Naturvölker Afrikas.* Leipzig: Bibliographisches Institut.

———. 1890. *Völkerkunde.* Vol. 2: *Die Naturvölker des Stillen und des Indischen Ozeans.* Leipzig: Bibliographisches Institut.

Ravenhill, Philip. 1996. *Dreams and Reverie. Images of Otherworld Mates Among the Baule, West Africa.* Washington, D.C., and London: Smithsonian Institution Press.

Reed, Daniel B. 2003a. *Dan Ge Performance: Masks and Music in Contemporary Côte d'Ivoire.* Bloomington and Indianapolis: Indiana University Press.

———. 2003b. "The Transformation into Spirit through a 'Constellation of Arts': A Dan Mask (*Tankë Ge*)." In *See the Music, Hear the Dance: Rethinking African Art at the Baltimore Museum of Art,* ed. Frederick John Lamp, 98-101. Munich and New York: Prestel.

Richards, Polly. 2000. "'Imina Sangan' or 'Masques à la Mode': Contemporary Masquerade in the Dogon Region." In *Re-visions: New Perspectives on the African Collections of the Horniman Museum,* ed. Karel Arnaut, 107-23. London: Horniman Museum and Gardens, London; Coimbra, Portugal: Museum Antropológico da Universidade de Coimbra.

———. 2005. "*Masques Dogons* in a Changing World." *African Arts,* v. 38, n. 4 (winter): 46-53, 93-94.

Ritz, Ute. 1989. "'Niemand zerbricht einen Wassertopf beim ersten Stolpern.' Zur Analogie von Topf und Mensch bei den Asante." *Paideuma,* n. 35: 207-19.

Robbins, Warren M., and Nancy Ingram Nooter. 1989. *African Art in American Collections: Survey 1989.* Washington, D.C., and London: Smithsonian Institution Press.

Rohner, John R. 2000. *Art Treasures from African Runners.* Niwot: University Press of Colorado.

Ross, Doran H. 1998. *Wrapped in Pride: Ghanaian Kente and African American Identity.* Los Angeles: UCLA Fowler Museum of Cultural History.

Ross, Doran H., and Raphael X. Reichert. 1983. "Modern Antiquities: A Study of a Kumase Workshop." In *Akan Transformations: Problems in Ghanaian Art History,* ed. Doran H. Ross and Timothy F. Garrard, 82-91. Monograph Series 21. Los Angeles: Museum of Cultural History, University of California, Los Angeles.

Rousseau, Madeleine, ed. 1951. *L'Art Océanien, sa présence.* Paris: A.P.A.M. [Association populaire des amis des musées].

———. 1955. "L'Afrique noire berceau des Arts Plastiques." In *L'Art Africain, Exposition au cercle Volney,* 13-19. Paris: Les amis de l'Art.

———. 1960. *Blancs et Noirs au jour de vérité.* Paris: La Nef de Paris Editions.

Roy, Christopher. 1987. *The Art of the Upper Volta Rivers.* Paris: Alain et Françoise Chaffin.

Rubin, Arnold. 1974. *African Accumulative Sculpture: Power and Display.* New York: Pace Gallery.

Rubin, William. 1984a. *"Primitivism" in 20th Century Art: Affinity of the Tribal and the Modern,* 2 vols. New York: Museum of Modern Art.

———. 1984b. "Modernist Primitivism, an Introduction." In *"Primitivism" in 20th Century Art: Affinity of the Tribal and the Modern,* vol. 1, ed. William Rubin, 1-81. New York: Museum of Modern Art.

———. 1984c. "Picasso." In *"Primitivism" in 20th Century Art: Affinity of the Tribal and the Modern,* vol. 1, ed. William Rubin, 240-343. New York: Museum of Modern Art.

Schuster, Meinhard. 1985. "The Men's House: Centre and Nodal Point of Art in the Middle Sepik." In *Art of the Sepik River, Papua New Guinea: Authority and Ornament,* ed. Suzanne Greub, 19-26. Basel: Tribal Art Centre, Edition Greub.

Sedyawati, Edi, ed. 1998. *Indonesian Art: Treasures of the National Museum, Jakarta.* North Clarendon, VT: C. E. Tuttle.

Seligman, Thomas K. 1976. "An Indigenous Concept of Fakes?" *African Arts,* v. 9, n. 3 (April): 27–29.

Sieber, Roy. 1972. *African Textiles and Decorative Arts.* New York: Museum of Modern Art.

Smidt, Dirk, ed. 1975. *The Seized Collections of the Papua New Guinea Museum.* Port Moresby: Creative Arts Centre and University of Papua New Guinea.

Sousberghe, Léon de. 1959. *L'Art Pende.* Brussels: Palais des académies.

Stanley, Nick. 1999. "Museums and Indigenous Identity: Asmat Carving in a Global Context." In *Proceedings of a Special Session of the Pacific Arts Association: Festschrift to Honor Dr. Philip J. C. Dark,* ed. Robert L. Welsch, 434–45. Hanover, NH: Pacific Arts Association.

Steiner, Christopher B. 1994. *African Art in Transit.* Cambridge: Cambridge University Press.

———. 1995. "The Art of the Trade: On the Creation of Value and Authenticity in the African Art Market." In *The Traffic in Culture. Refiguring Art and Anthropology,* ed. George E. Marcus and Fred R. Myers, 151–65. Berkeley, Los Angeles, and London: University of California Press.

———. 2002. "The Taste of Angels in the Art of Darkness." In *Art History and Its Institutions. Foundations of a Discipline,* ed. Elizabeth Mansfield, 132–45. London and New York: Routledge.

Stöhr, Waldemar. 1971. *Melanesien: Schwarze Inseln der Südsee. Eine Ausstellung des Rautenstrauch-Joest-Museums für Völkerkunde der Stadt Köln.* Cologne: Kunsthalle Köln.

Strother, Z. S. 1998. *Inventing Masks. Agency and History in the Art of the Central Pende.* Chicago and London: University of Chicago Press.

———. 1999. "Gabama a Gingungu and the Secret History of Twentieth-Century Art." *African Arts,* v. 32, n. 1 (spring): 19–31, 92–93.

Swadling, Pamela. 1996. *Plumes from Paradise: Trade Cycles in Outer Southeast Asia and Their Impact on New Guinea and Nearby Islands until 1920.* Boroko, Papua New Guinea: Papua New Guinea National Museum in association with Robert Brown & Associates.

Sweeney, James Johnson, ed. 1935. *African Negro Art.* New York: Museum of Modern Art.

Taylor, Paul Michael, ed. 1994. *Fragile Traditions. Indonesian Art in Jeopardy.* Honolulu: University of Hawaii Press.

Taylor, Paul Michael, and Lorraine V. Aragon. 1991. *Beyond the Java Sea: Art of Indonesia's Outer Islands.* New York: Harry N. Abrams.

Tchebwa, Manda. 2001. "The Music at the Heart of the City." In *Les Photographes de Kinshasa,* ed. N'Goné Fall, 78–79. Paris: Revue Noire.

Thomas, Nicholas. 1995. *Oceanic Art.* London: Thames and Hudson.

Togu na and Cheko: Change and Continuity on the Art of Mali. 1989. Washington, D.C.: National Museum of African Art, Smithsonian Institution. [Videorecording]

Valentin, Peter. 1977. "Geschnitzte Türen der Fungom (Kamerun). *Tribus,* n. 26: 63–69.

van Beek, Walter E. A. 1994. "Enter the Bush: A Dogon Mask Festival." In *Africa Explores: 20th Century African Art,* ed. Susan Vogel, 56–73. New York: Center for African Art; Munich: Prestel.

Van Dyke, Christina. 2001. *Marking Places. Spatial Effects of African Art.* Harvard University Art Museums Gallery Series, Number 32. Cambridge, MA: Fogg Art Museum.

Verly, Robert. 1959. "Vue du Kasai: L'art africain et son devenir." *Problèmes d'Afrique centrale,* v. 44, n. 2: 145–51.

Visonà, Monica Blackmun, et al. 2001. *A History of Art in Africa.* New York: Harry N. Abrams.

Vogel, Susan Mullin. 1973. "People of Wood: Baule Figure Sculpture." *Art Journal,* v. 33, n. 1: 23–26.

———, ed. 1988. *The Art of Collecting African Art.* New York: Center for African Art.

———. 1991. *Africa Explores. 20th Century African Art.* New York: Center for African Art; Munich: Prestel.

———. 1997. *Baule: African Art, Western Eyes.* New Haven and London: Yale University Press.

———. 2005. "Whither African Art? Emerging Scholarship at the End of an Age." *African Arts,* v. 38, n. 4 (winter): 12–17, 91.

Waffen aus Zentral-Afrika. 1985. Afrika-Sammlung 2. Frankfurt am Main: Museum für Völkerkunde.

Waite, Deborah. 1983. *Art of the Solomon Islands from the Collection of the Barbier-Müller Museum.* Geneva: Musée Barbier-Müller.

Webb, Virginia-Lee. 2000. *Perfect Documents: Walker Evans and African Art, 1935.* New York: Metropolitan Museum of African Art and Harry N. Abrams.

Wells, Louis. 1977. "The Harley Masks of Northeast Liberia." *African Arts,* v. 10, n. 2: 22–27, 91.

Welsch, Robert Louis. 2005. "One Symphony from Many Voices: Collectors, Collecting Activities, and the Culture of Collecting since 1870." In *New Guinea Art. Masterpieces from the Jolika Collection of Marcia and John Friede,* vol. 2, 8–29. San Francisco and Milan: Fine Arts Museums of San Francisco in association with 5 Continents Editions.

Welsch, Robert Louis, Virginia-Lee Webb, and Sebastian Haraha. 2006. *Coaxing the Spirits to Dance: Art and Society in the Papuan Gulf of New Guinea.* Hanover, NH: Hood Museum of Art, Dartmouth College.

Wilson, R. Kent, and K. Menzies. 1967. "Production and Marketing of Artifacts in the Sepik Districts and the Trobriand Islands." *New Guinea Research Bulletin,* n. 20: 50–75. Canberra: New Guinea Research Unit, Australian National University.

Wooten, Stephen R. 2004. "Where Is My Mate? The Importance of Complementarity: A Bamana Headdress (*Ciwara*)." In *See the Music, Hear the Dance: Rethinking African Art at the Baltimore Museum of Art,* ed. Frederick John Lamp, 168–69. Munich and New York: Prestel.

ACKNOWLEDGMENTS

Journeys of various kinds are the theme of this book, and it seems only fitting to express our gratitude to all those who enabled us to embark on our intellectual voyages in connection with this project, dividing our explorations according to our respective areas of expertise. Both of us are deeply grateful to Mrs. Geneviève McMillan for making the entire undertaking possible, for her patience with our questions and constant demands on her time, and most of all for her vision and support of our novel approach to an African and Oceanic art collection. Mrs. McMillan's own fascinating life history and openness to new ways of seeing deeply influenced our emphasis on the sites of encounters and the movements of objects. Her engagement with contemporary developments in Africa and Oceania—to this day, she reads newspapers and listens to broadcasts devoted to many regions of the world—stimulated our interest in the agency of people from Africa and the Pacific and encouraged us to speak about the histories of artists and more generally about the market and trade in these arts. Several of Mrs. McMillan's close friends were most helpful in our project, among them Kibebe Gisaw (Springfield, Virginia), Rose Coleman (Cambridge), and Donald Kelley (Charlestown, Massachusetts).

Along the way, we consulted with many colleagues, experts, and friends of African and Oceanic art, who not only looked at some of the objects but also shared published and unpublished research with us and kindly allowed us to use some of their images. Our thanks go to Monni Adams (Peabody Museum of Archaeology and Ethnology, Harvard University); Pierre Amrouche (Paris); Mary Jo Arnoldi (National Museum of Natural History, Smithsonian Institution, Washington, D.C.); Joshua Bell (Sainsbury Centre for Visual Arts, University of East Anglia, UK); Elisabeth Cameron (University of California, Santa Cruz); Herbert M. Cole (University of California, Santa Barbara); Kevin Conru (Brussels and Paris); George Corbin (Lehman College, New York); Ludovic Coupaye (Sainsbury Centre for Visual Arts, University of East Anglia, UK); Helen Dennett (Coogee, Australia); Henry John Drewal (University of Wisconsin); Diane Englund (Concord, Massachusetts); Kate Ezra (Columbia College Chicago); Eberhard Fischer (Museum Rietberg, Zurich, Switzerland); Irwin Hersey (New York); Lorenz Homberger (Museum Rietberg, Zurich, Switzerland); Astrid de Hontheim (Université Libre de Bruxelles, Belgium); Michel Huguenin (Paris); James Pascal Imperato (New York); Karen Jacobs (Sainsbury Centre for Visual Arts,

University of East Anglia, UK); Danielle Maurice (Ecole des Hautes Etudes en Sciences Sociales, Paris); Magali Mélandri and Philippe Peltier (Musée du quai Branly, Paris); Ruth Phillips (Carleton College, Canada); Sandra Revolon (Centre de Recherche et de Documentation sur l'Océanie, Marseille); Doran H. Ross (Fowler Museum of Cultural History, University of California, Los Angeles); Thomas K. Seligman (Cantor Arts Center, Stanford University, California); Nick Stanley (Birmingham Institute of Art and Design, University of Central England); Amy J. Staples (National Museum of African Art, Smithsonian Institution, Washington, D.C.); Z. S. Strother (University of California, Los Angeles); Susan Vogel (Columbia University, New York), who also kindly allowed us access to the James J. Ross Archive of African Images 1800–1920, an online database of published images of African art (RAAI); and Virginia-Lee Webb (Metropolitan Museum of Art, New York).

At the Museum, many staff members moved the project along, and we are grateful for their support. Greg Heins and Damon Beale creatively photographed the objects, and Sarah McGaughey, Terry McAweeney, and Jodi Simpson facilitated the production process of this book. We appreciate the guidance of editors Juanita Holland, Laura Iwasaki,

and Marie Weiler (Marquand Books), and we thank Zach Hooker (Marquand Books) for ably designing the catalogue. Last, but not least, we would like to acknowledge the major contributions of Abraham Schroeder, who helped with documenting the McMillan Collection, and of our intern, Caroline Queeny, who—despite her young age—was most instrumental in this project.

Our appreciation—as always—to our husbands John and Pascal and to Sibylle and Albane, who never wavered in their support.

FIGURE ILLUSTRATIONS

CHAPTER 1
FIG. 1: Ivory carver, French Congo
(now Republic of the Congo)
Photograph by Robert Visser, about
1890–1900
Postcard, publisher unknown
Courtesy Christraud M. Geary

FIG. 2: Masked dancers in yam festival
"Onwasato," in Ugwuoba village, Igbo, Nigeria
Igbo peoples, Nigeria
Photograph by Eliot Elisofon, 1959
Image No. EEPA 3777
Eliot Elisofon Photographic Archives,
National Museum of African Art,
Smithsonian Institution

FIG. 3: Sierra Leonean railway employees
in the Congo Free State (now Democratic
Republic of the Congo)
Photographer unknown, about 1900
Postcard, publisher unknown
Courtesy Christraud M. Geary

FIG. 4: "UAT serves Africa with DC-8 jets"
Poster by Jean Colin, 1961
Courtesy Musée Air France —
www.airfrancemusee.org —
all rights reserved

CHAPTER 2
FIG. 5: Madeleine Rousseau at the Louvre,
Paris
Photographer unknown, about 1954
Courtesy Musée des Civilisations, Saint-Just
Saint-Rambert

FIG. 6: Geneviève Lalanne (McMillan)
in Orthez
Photographer unknown, 1943
Courtesy Geneviève McMillan

FIG. 7: Women with *bilum* bags, Mount
Hagen, Papua New Guinea
Photograph by Geneviève McMillan, 1967
Courtesy Geneviève McMillan

FIG. 8: Display in a market, Republic of Benin
Photograph by Geneviève McMillan, 1966
Courtesy Geneviève McMillan

CHAPTER 3
FIG. 9: Women of the Bundu sodality,
Freetown, Sierra Leone
Photograph by Arthur Lisk-Carew, about 1905
Postcard, published by the Lisk-Carew
Brothers, Freetown, Sierra Leone
Courtesy Christraud M. Geary

FIG. 10: Stamps celebrating independence,
issued by the Republic of Sierra Leone, 1961
Courtesy Christraud M. Geary

FIG. 11: Dan mask
Photograph by Charles Sheeler, 1918
© The Lane Collection

FIG. 12: Konor and Wè maskers at the Colo-
nial Exposition in Marseille, France, 1922
Photographer unknown, 1922
Postcard, publisher unknown
Courtesy Christraud M. Geary

FIG. 13: Dan mask persona *slü*, a mask of
the *bagle* genre, in performance, Nyor Diaple
village, northeastern Liberia
Photograph by Eberhard Fischer, 1974
Courtesy Eberhard Fischer

FIG. 14: Bidjogo masker in performance,
Portuguese Guinea (now Guinea-Bissau)
Photograph by Hugo Bernatzik, 1930–31
Courtesy Kevin Conru, Brussels

CHAPTER 4
FIG. 15: Woman in Bamako, Mali
Photograph by Seydou Keïta, 1959–60
Print by Philippe Salaün, 1990–2000
Museum of Fine Arts, Boston, Horace W.
Goldsmith Foundation Fund for Photography
2000.939
© Seydou Keïta Estate. Courtesy J. M. Patras.

FIG. 16: Art dealer Coulibaly and his
"brother," Bamako, Mali
Photograph by Geneviève McMillan, 1976
Courtesy Geneviève McMillan

FIG. 17: Dogon village near Sanga, Mali
Photograph by Geneviève McMillan, 1976
Courtesy Geneviève McMillan

FIG. 18: Dogon *sirige* and *kanaga* masks in
performance, Village of Ogol, Cercle of
Bandiagara, Mali
Photograph by Pascal James Imperato, 1970
Courtesy Pascal James Imperato

FIG. 19: *Ci wara* headdresses in a workshop,
Bamako, Mali
Photograph by Geneviève McMillan, 1978
Courtesy Geneviève McMillan

FIG. 20: Bamana *ci wara* maskers, French
West Africa (now Mali)
Photograph by Edmond Fortier, about 1906
Postcard, published by Edmond Fortier,
Dakar
Courtesy Christraud M. Geary

FIG. 21: Stamp for the Festival Mondial
des Arts Nègres, issued by the Republic
of Niger, 1966
Courtesy Christraud M. Geary

FIG. 22: Indigo-dyed cloth in a market in
Brazzaville, Republic of the Congo
Photograph by Geneviève McMillan, 1966
Courtesy Geneviève McMillan

CHAPTER 5
FIG. 23: Stamps with Guro masks, issued by
the Republic of Côte d'Ivoire, about 1965
Courtesy Christraud M. Geary

FIG. 24: Baule female figure
Photograph by Charles Sheeler, 1918
© The Lane Collection

FIG. 25: Yaure mask
Photograph by Charles Sheeler, 1918
© The Lane Collection

FIG. 26: Guro mask persona *zamble* in
performance, Zangofla village, Zuenula
region, Côte d'Ivoire
Photograph by Eberhard Fischer, 1975
Courtesy Eberhard Fischer

FIG. 27: Northwest African weapons and tools
Lithograph
Ratzel 1887, plate opp. p. 610
Courtesy Christraud M. Geary

FIG. 28: "Gelede: Males and Females"
Photograph by Walwin or J. A. C. Holm,
about 1900
Postcard, collotype, about 1906–8
Published by Photoholm, Lagos, Nigeria
West Africa Postcard Album A1992-0003-035
Eliot Elisofon Photographic Archives,
National Museum of African Art,
Smithsonian Institution

CHAPTER 6
FIG. 29: Street in Lagos, Nigeria
Photograph by Christraud M. Geary, 1970
Courtesy Christraud M. Geary

FIG. 30: Carver in a workshop, Big Babanki,
Federal Republic of Cameroon (now Republic
of Cameroon)
Photograph by Christraud M. Geary, 1970
Courtesy Christraud M. Geary

FIG. 31: Doorway in Weh, Federal Republic
of Cameroon (now Republic of Cameroon)
Photograph by Christraud M. Geary, 1971
Courtesy Christraud M. Geary

FIG. 32: King Njoya of Bamum with his
beaded two-figure throne, Foumban, French
Cameroon (now Republic of Cameroon)
Photographer unknown, about 1920
Postcard, published by Société des Missions
Evangéliques, Paris
Courtesy Christraud M. Geary

FIG. 33: Display of Bamum art for sale,
French Cameroon (now Republic of
Cameroon)
Photographer unknown, about 1930
Postcard, published by Catala Frères, Paris
Courtesy Christraud M. Geary

FIG. 34: Store display on the *rue des artisans*,
Foumban, United Republic of Cameroon
(now Republic of Cameroon)
Photograph by Christraud M. Geary, 1977
Courtesy Christraud M. Geary

FIG. 35: Bronze casters in Foumban, French
Cameroon (now Republic of Cameroon)
Photograph by George Goethe, Douala
Postcard, published by George Goethe,
about 1930
Courtesy Christraud M. Geary

FIG. 36: Stamp with Bamum bronze mask,
issued by the United Republic of Cameroon
(now Republic of Cameroon), about 1975
Courtesy Christraud M. Geary

CHAPTER 7
FIG. 37: City 5 Band at Afro-Mogambo
nightclub, Kinshasa, Zaire (now
Democratic Republic of the Congo)
Photograph by Eliot Elisofon, 1967
Image No. EEPA 6032
Eliot Elisofon Photographic Archives,
National Museum of African Art,
Smithsonian Institution

FIG. 38: Performers in Libenge, Republic of the Congo
Photograph by Geneviève McMillan, 1966
Courtesy Geneviève McMillan

FIG. 39: Southwest African weapons and tools
Lithograph
Ratzel 1887, plate opp. p. 590
Courtesy Christraud M. Geary

FIG. 40: Yaka boys displaying masks during a performance, Belgian Congo (now Democratic Republic of the Congo)
Photograph by Van Dorselaar, about 1920
Postcard, published by Mission des RR. P.P. Jésuites au Kwango (Congo Belge) and Nels, Belgium
Courtesy Christraud M. Geary

FIG. 41: Stamp with Teke mask, issued by the Republic of the Congo, 1966
Courtesy Christraud M. Geary

FIG. 42: Kuba woman peeling manioc, woman making raffia cut-pile cloth, man reading a book, and man carving, Mushenge, Zaire (now Democratic Republic of the Congo)
Photograph by Eliot Elisofon, 1972
Image No. EEPA 7145
Eliot Elisofon Photographic Archives, National Museum of African Art, Smithsonian Institution

FIG. 43: Spears, lances, battle axes, and throwing clubs
Woodcut
Ratzel 1887, 171
Courtesy Christraud M. Geary

FIG. 44: Stamps with throwing knives, issued by the Central African Republic, about 1965
Courtesy Christraud M. Geary

CHAPTER 8
FIG. 45: Polynesian weapons and adornment
Lithograph
Ratzel 1890, plate opp. p. 135
Courtesy Christraud M. Geary

FIG. 46: Warrior from the Fiji Islands (based on a photograph in the Godeffroy Album)
Woodcut
Ratzel 1890, 287
Courtesy Christraud M. Geary

FIG. 47: Baining night-dance mask, New Britain, Papua New Guinea
Photograph by Sarah F. Corbin, 1983
Courtesy Sarah F. Corbin

FIG. 48: Two Arawe men with shields, West New Britain, Mandate Territory of New Guinea (now Papua New Guinea)
Photograph by Beatrice Blackwood, 8 June 1937
© Pitt-Rivers Museum Archives, University of Oxford BB.P.13.222

FIG. 49: Melanesian and Micronesian weapons and tools
Lithograph
Ratzel 1890, plate opp. p. 240
Courtesy Christraud M. Geary

FIG. 50: Villager at rest in Angoram, Papua New Guinea
Photograph by Geneviève McMillan, 1967
Courtesy Geneviève McMillan

FIG. 51: *Haus tambaran* in Angoram, Papua New Guinea
Photograph by Uwe Steinward, about 1972
Postcard, published by Garrick Press
Courtesy Uwe Steinward

FIG. 52: *Baba* mask at the ceremony for the "opening of the road" (official beginning of the coating of the Sepik Highway) in Maprik, Papua New Guinea
Photograph by Ludovic Coupaye, April 2002
Courtesy Ludovic Coupaye

FIG. 53: Fishing canoe with carved prow, Trobriand Islands, Papua New Guinea
Photograph by Bronislaw Malinowski, 1915–18
Courtesy London School of Economics and Political Sciences (LSE/Malinowski/3/4/72)

FIG. 54: Man next to a model sacred bonito canoe, Owa Riki Island, Solomon Islands
Photograph by Hugo Bernatzik, 1932
Courtesy Kevin Conru, Brussels

CHAPTER 9
FIG. 55: Bali, Indonesia
Photograph by Geneviève McMillan, 1962
Courtesy Geneviève McMillan

FIG. 56: Spears and shields from the Dayak and from Mentawei, Indonesia
Woodcut
Ratzel 1890, 405
Courtesy Christraud M. Geary